VOLUME 2

DIGITAL PAINTING
techniques

3DTOTAL.COM LTD

VOLUME 2

DIGITAL PAINTING
techniques

Digital Painting Techniques: Volume 2

Published by 3DTotal.com

3DTotal.com Ltd

1 Shaw Street

Worcester

WR1 3QQ

UK

First edition 2010

Correspondence: dam@3dtotal.com

www.3dtotal.com

ISBN: 978-0-9551530-1-3

Printed and bound in China

10 11 12 13 11 10 9 8 7 6 5 4 3 2 1

For information on all 3DTotal publications
visit our website at www.3dtotal.com

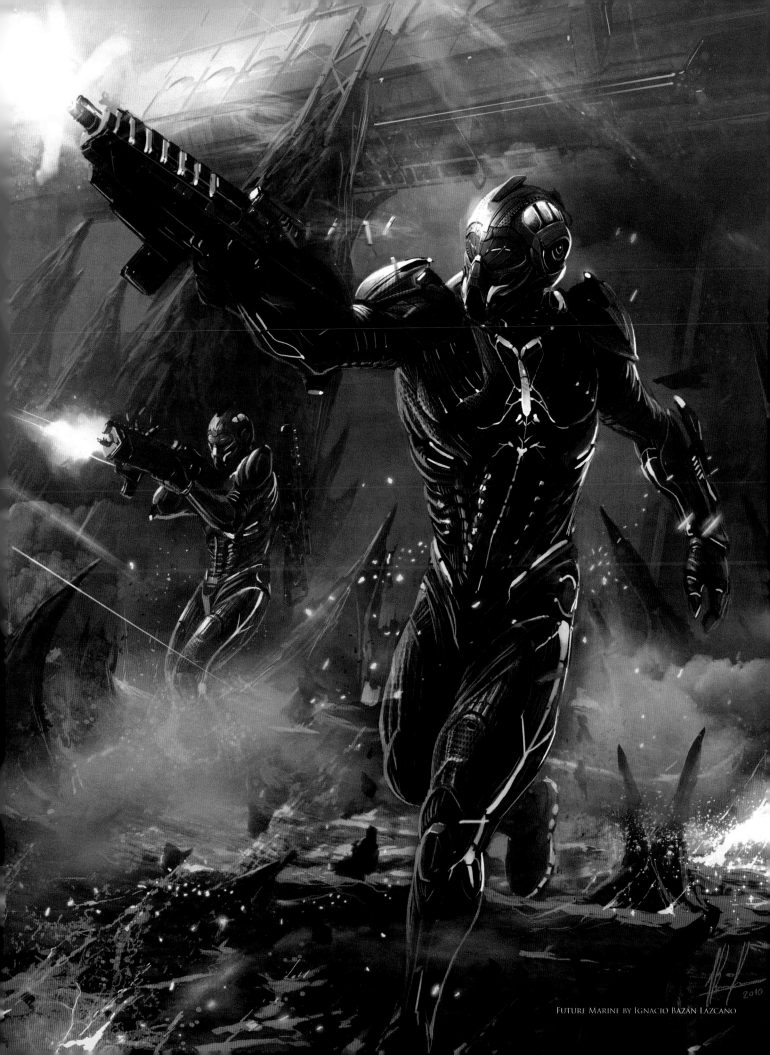

chapter 01 – characters

DYNAMIC AND EXAGGERATED POSES
MARK McDONNELL
12

DYNAMIC CAMERA PLACEMENT AND FRAMING
DAVID SMIT
16

PAINTING A JUNGLE MONSTER
MATT DIXON
26

PAINTING A VAMPIRE
RICHARD TILBURY
34

PAINTING A ZOMBIE
RICHARD TILBURY
42

FUTURISTIC MARINES
IGNACIO BAZÁN LAZCANO
50

CARICATURES
JASON SEILER
56

KING ARTHUR AND EXCALIBUR
SIMON DOMINIC
66

chapter 02 – science fiction

SCI-FI VEHICLES: SPACESHIPS
CHEE MING WONG
74

SCI-FI TRANSPORT - CAPITAL SHIPS
CHEE MING WONG
84

SCI-FI TRANSPORT - SPACE STATIONS
CHEE MING WONG
92

SCI-FI ENVIRONMENT - COLONIZED PLANETS
CHEE MING WONG
100

SCI-FI ENVIRONMENT - SPACE BATTLE
CHEE MING WONG
108

chapter 03 – fantasy

MEDIEVAL MARKET
IGNACIO BAZÁN LAZCANO
118

FANTASY CITY ON STILTS
JESSE VAN DIJK
126

MEDIEVAL SLUMS
RICHARD TILBURY
134

chapter 04 – vehicles

DESIGNING A CONCEPT RACING CAR
DWAYNE VANCE
142

DESIGNING AN INDUSTRIAL VEHICLE
HOI MUN THAM
154

chapter 05 - speed painting

166 THE SLEEPY VILLAGE NEVER SAW THE HORROR APPROACHING
NATHANIEL WEST

170 AS NIGHT FELL, THE DARKNESS CAME ALIVE
EHSAN DABBAGHI

174 THE APPROACHING SWARM LOOKED BIBLICAL IN SCALE
JUSTIN ALBERS

178 THE MACHINE WAS THEIR ONLY MEANS OF ESCAPE
EMRAH ELMASLI

180 FEAR ENGULFED THEM AS THEY REALISED THEY WERE ABOUT TO DIE
EMRAH ELMASLI

chapter 06 - custom brushes

184 CUSTOM BRUSHES FOR FABRIC AND LACE
NYKOLAI ALEKSANDER

192 CUSTOM BRUSHES FOR ROCK/METAL/STONE TEXTURES
CARLOS CABRERA

196 CUSTOM BRUSHES FOR TREES, LEAVES AND BRANCHES
ROBERTO F CASTRO

204 CUSTOM BRUSHES FOR CROWDS
RICHARD TILBURY

chapter 07 - painting from a 3d base

210 USING GOOGLE SKETCHUP AS A BASE FOR DIGITAL PAINTING
RICHARD TILBURY

214 SCI-FI ROBOT
CARLOS CABRERA

220 TRAIN DEPOT
IOAN DUMITRESCU

226 ABANDONED FACTORY
SERG SOULEIMAN

chapter 08 - complete projects

234 THE MAKING OF "THE BEAST"
JAMA JURABAEV

238 THE MAKING OF "HOT HOUSE"
KENICHIRO TOMIYASU

242 THE MAKING OF "DUST"
CHASE STONE

248 THE MAKING OF "ARETHA FRANKLIN"
JASON SEILER

256

the gallery

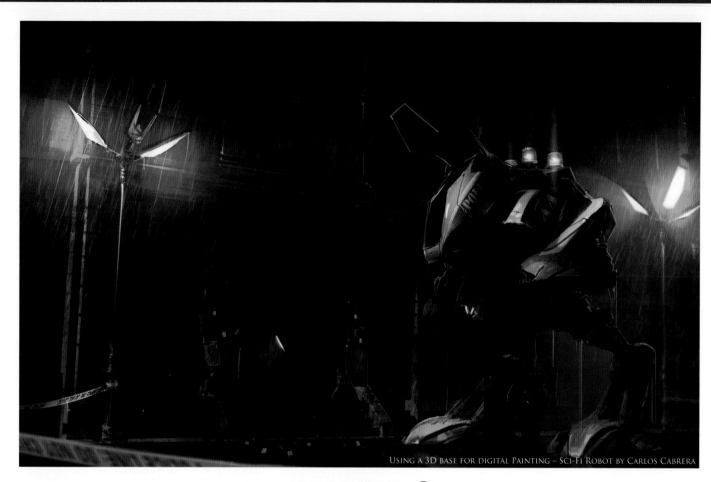

USING A 3D BASE FOR DIGITAL PAINTING – SCI-FI ROBOT BY CARLOS CABRERA

VOLUME 2
DIGITAL PAINTING
techniques

COMPILED BY THE 3DTOTAL TEAM

TOM GREENWAY SIMON MORSE CHRIS PERRINS RICHARD TILBURY

3DTotal.com Ltd, 1 Shaw Street, 3rd Floor, Worcester, WR1 3QQ, United Kingdom

INTRODUCTION

Throughout the history of mankind, ages have been defined and shaped by the artistic styles of the period, from Renaissance, Romanticism and Neoclassical through to the present age, the Digital age. *Digital Painting Techniques: Volume 2* is just a small insight into this exciting and creative age that drives so much of what we see and enjoy in the modern entertainment industry. Art surrounds us, we look at it every day, sometimes without even realizing it. As digital artists and their techniques improve and develop, more and more of this art is being created digitally using the skills described in this book.

Throughout the pages of this book, you will find detailed tutorials on varying subjects and themes that provide a great starting point for anyone planning to take-up digital art, or anyone aiming to improve

and build upon their existing skill set. Digital artists employ many differing methods to create art, from speed painting and custom brushes which make the painting process more efficient and help move the process on at a quicker rate, to painting over a base made in 3D which allows the artist to be more accurate and detailed, these are all techniques instructed in this book.

Although digital art creates new possibilities and provides us with tools that can help our artistic processes, it is also important to remember that the art fundamentals like composition, color, light and design cannot be avoided or cheated. Within the pages of this book you will find that the exceptionally talented artists that have created these tutorials will guide and instruct you on all of these subjects, from composition basics, to character and vehicle design, through to ensuring your epic landscape doesn't look flat, but draws in the eye with a captivating sense of depth.

Digital Painting Techniques: Volume 2 does not only provide useful tutorials but is also brimming with artistic inspiration, not only from the tutorials but also from the gallery section which features work from some of the most talented artists in the world today. For anyone interested in digital art this is an invaluable resource.

SIMON MORSE
CONTENT MANAGER, 3DTOTAL

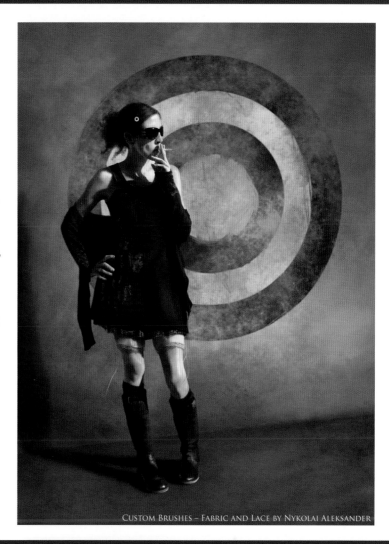

CUSTOM BRUSHES – FABRIC AND LACE BY NYKOLAI ALEKSANDER

free resources

Some of our *Digital Painting Techniques* tutorial artists have kindly supplied, where appropriate and possible, free resources to accompany their tutorials for you to download to follow along with their teachings. You will find free custom brushes donated by Ignacio Bazán Lazcano, Richard Tilbury, Nykolai Aleksander, Roberto F Castro, Carlos Cabrera and Jama Jurabaev. On top of these, 3DTotal are also providing the 3D base images to accompany the 'Using a 3D base for Digital Painting' by Carlos Cabrera, Ioan Dumitrescu and Serg Souleiman.

download your free resources for digital painting techniques: volume 2

All you need to do to access these free resources is to visit the new 3DTotal micro site at www.3dtotal.com/dptresources, go to the "Free Resources" section, and there you will find information on how to download the files. Simply look out for the "Free Resources" logo which appears on articles within this book that have files for you to download from.
www.3dtotal.com/dptresources

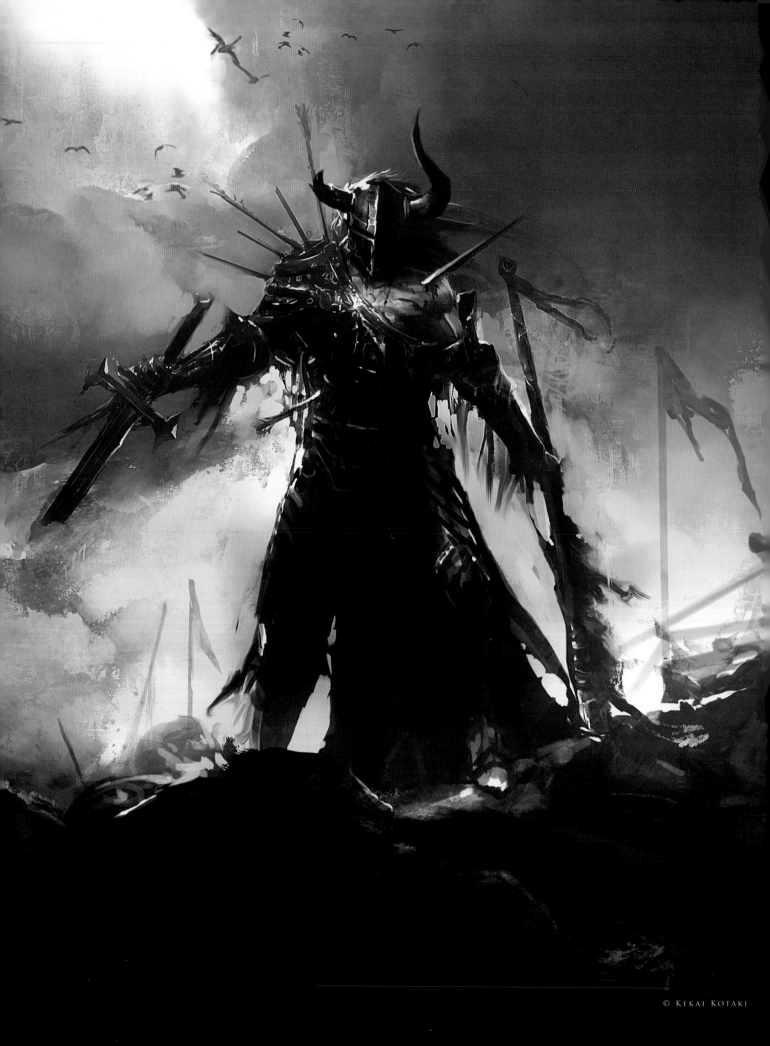

characters

Creating a character is a tough but very rewarding experience for any artist. Story plays a big part in painting one. Getting that story to show through is the tough part. Whether happy or sad, stoic or emotional, recognizing and respecting what your character is about makes them stand out and defines him/her. There are countless ways to do this, and almost limitless possibilities of what makes a character special. It is important to recognize that it is also necessary to have the technical proficiency to properly execute your idea. Having the draftsmanship to be able to draw your character in any moment of time will better allow you to tell the story of your character.

KEKAI KOTAKI
kekai.k@gmail.com
http://www.kekaiart.com

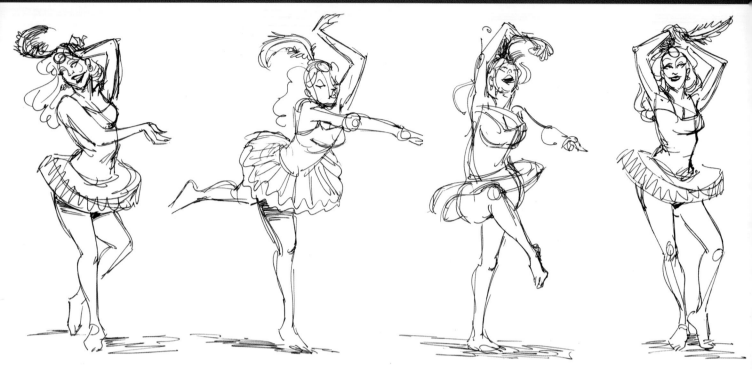

DYNAMIC & EXAGGERATED POSES
BY MARK MCDONNELL

INTRODUCTION

To create a dynamic and exaggerated pose is to push the limits of human (or animal) physics. This becomes much easier if one has an understanding of the anatomical make-up of the human body. Many artists have spent lifetimes figuring out the mechanics, and how the "human machine" performs under various stresses. It can take a lifetime to perfect the mechanics of the body's movements and gain the understanding of how all the pieces fit together to form the perfect puzzle. For the sake of using this information to help you perform in the animation and entertainment industry, simplifying is just as important as understanding the complexities of the human (or animal) form.

In figure drawing, this is an incredible practice that must remain in one's studies until we

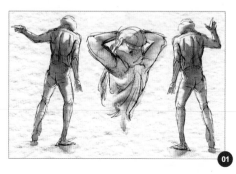

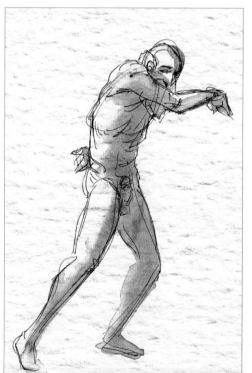

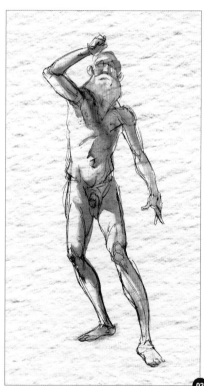

have all grown the long white beard worn by those giants that have come before us (ladies, please excuse the beard reference). Giants such as Michelangelo, Rembrandt, Raphael, Parmigianino and countless others, all spent a lifetime accumulating the knowledge of the human body to plaster images on high ceilings

of religious institutions and various cultural meeting spots.

These images are various studies I have drawn recently (**Fig.01 – 03**). In the following images, however, you'll see more of a purpose than in these initial ones.

That purpose is simply: **the story**.

STORY

The story should always be in your head when you are after anything that deals with gesture drawing, for any medium or platform you are designing for. Imagining what the person, character or beast is thinking will make your work transcend the typical study we happen upon on various portfolios, blogs or websites as we scour the internet for sources of inspiration.

As you can see in these quick sketches (**Fig.04**), there is a thought behind the sketches, not just an application of how light falls upon the form. Perhaps thinking in terms of feeling ill, worriedly on the lookout, or yelling something specific will determine a better understanding of not just the pose but the story of what's happening for this particular pose. This type of thinking is the first step in creating a dynamic and story-driven "interpretation" of how to approach sketches that will lead to final rendered pieces. Without this first step you may have a beautiful, well-rendered piece full of incredible and dramatic lighting that suggests the ultimate battlefield, strewn with the bodies of warriors placed under the foot of the victor, yet it may appear dead or somewhat

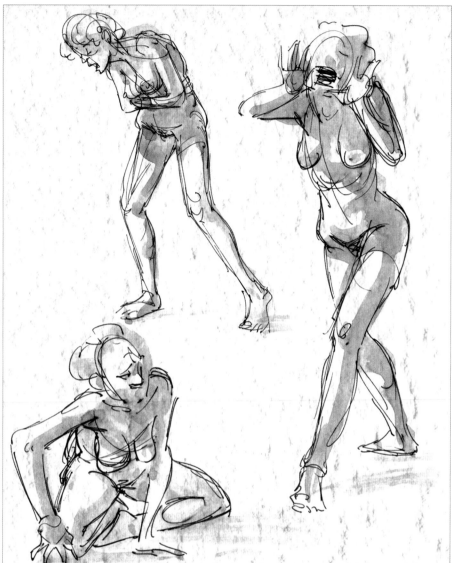

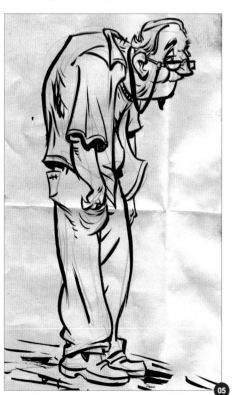

soulless. This is generally due to a lack of dynamic and exaggerated posing.

STANDING POSES

Let's start with an example of a person standing at the bus stop waiting for the bus to come and pick them up to carry them to their destination. Pulling out the trusty sketchbook and observing life is just as important as sharpening a needle-sharp pencil to do figure drawing or holding a stylus ready to begin an illustration!

Please note: I am an artist who primarily works in the animation industry and my personal preference is in finding a character and pushing the pose to support the action and personality that a particular individual would exhibit.

In the first example, perhaps an elderly man is waiting by the bus stop, happily content to get to his next destination. As a character designer and visual development artist, one is always concerned not only about the personality, but the overall shape a person has, and how that shape will read from a great distance. This is something to always consider when sketching. There will be hits and misses, but always think about the overall silhouette, and if/how that pose reads to *clearly* describe who that person is, or what their specific action is. The clearer the better! This is why exaggerating the pose is so important and necessary in the animation and entertainment industry.

Sometimes – as with this example of the elderly man (**Fig.05**) – subtleties are more important than a bold action. Knowing when

to use what is just as important as the actual drawing itself. In the elderly man you can see he is slightly off kilter and not as sure footed as some of the other characters waiting at the bus stop in this next illustration (**Fig.06**). Generally speaking, the wider the feet are from the center of the body, the sturdier the posture will be due to a greater balance of weight from the center point of the body.

In pose **A**, we can see the character is leaning in to see around the corner for the bus that she is so eagerly waiting for. She also is holding her hands behind her back, showing even more of an uncomfortable wait that may cause her to be late for an important function.

In pose **B** we can see the woman is slightly more aggressive just from her stance. Her posture suggests more of someone "on guard" – her legs are further apart, increasing her center of gravity, giving her a stronger stance.

In pose **C** we can see this lady is slightly more withdrawn and kept to herself. We can see that by the way she's enclosed her hands and is crossing her arms. She's balanced in her stance but ready to move quickly, if need be.

In poses **D** and **E** we can see these two are a couple straight out of a Hollywood roadside.

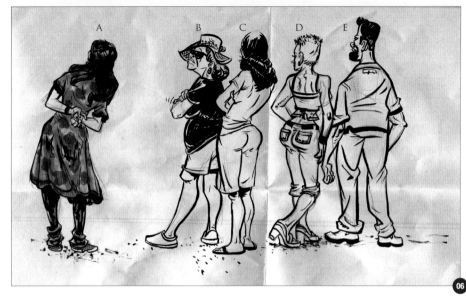

Their close proximity suggests they are together. It is also shown by their general look. She's strongly stanched to look good, while he's more in command and ready for anything that comes his way in an effort to protect her, based upon his widened stance, similar to pose **B**.

MOVEMENT

In the following illustration examples, we'll be approaching more movement-based drawings.

By taking the same knowledge from the sketchbook drawings and applying it to life

drawings, the sketches will appear much clearer and grasp more of the "spark of life" others are so drawn to, such as the examples in **Fig.07**. Certain situations call for more dynamic, "pushed" poses, while other poses demand a more subtle style of dynamics. For example, the sketchbook pages of the patrons waiting to be picked up from the bus stop show these subtleties. A more dramatic, or a subtle push, can both be accomplished by focusing on the overall silhouette. This will automatically exaggerate the pose and make it far more dynamic than merely copying what you are seeing in front of you. From here, adding the

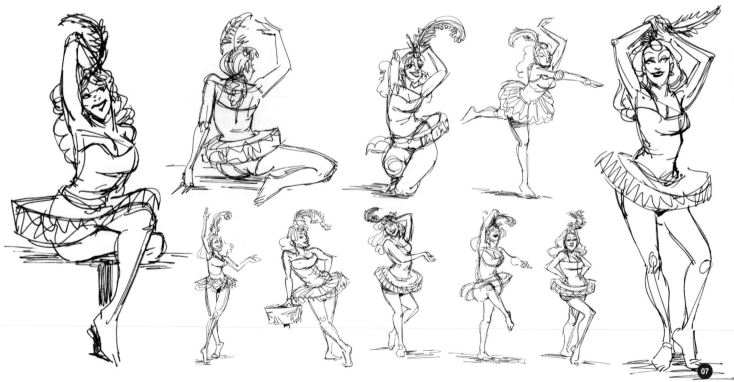

subtleties of what the character or person is thinking will generally push the drawing over the edge and into the "unique" category.

But always remember: be it figure drawing, character design, concept design, film design or anything in-between, the root of it all is capturing the correct amount of "life" that will be appropriate to the particular project that is being worked on. This is why figure drawing is such an amazing and unending source of inspiration. It's unending because you will be practicing whatever you are interested in experimenting with, whilst tackling the challenge of figure drawing.

Quick Tip : One good rule to always follow is to leave the facial features or expressions until last. It's my personal feeling that the entire body language without the face should communicate what the action is in the pose, or poses. It's really the icing on the cake and can be the greatest exclamation mark at the end of a statement. Take a look at some of the sketches here to see some gestural approaches to feeling out the pose, and more importantly, the character that is posing (**Fig.08 – 12**).

From the ballerina sketches to here, you can see that pushing the pose into a more dynamic and exaggerated way will increase the storytelling aspect of a drawing or concept, as well as give you that "spark of life" you are searching for in any piece of artwork. With that being said, this process of gesture drawing is cross-platform – from animation, illustration, film design, storyboarding, concept design, visual development, character design and everything in-between. It's the root of all things. It's the first step and the last adjustment to any amazing illustration and should not be overlooked in an effort to finish a piece for production purposes or otherwise.

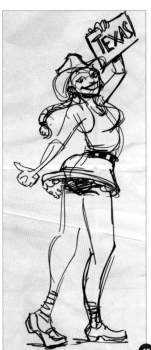

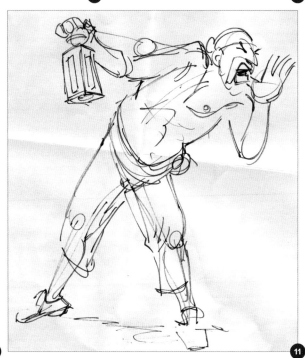

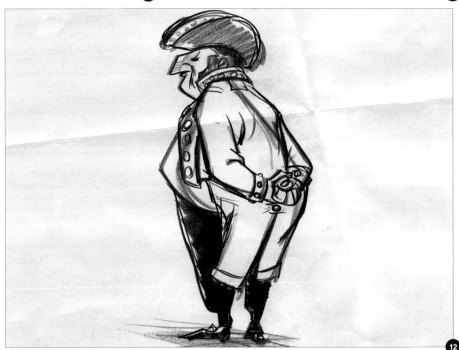

DYNAMIC CAMERA PLACEMENT AND FRAMING
BY DAVID SMIT

A perfect character design – a brilliant idea, just brilliant! If people could see this you would be the god of all forums, an instant 5-star wonder!

You've worked for weeks on your character; every detail fits perfectly and you know exactly what kind of environment to put your character in. All that remains is to make the final shot, after days (and days) of hard labor, getting everything exactly right. You – you hero, you! – have just created a masterpiece! You upload it to the forums … here you go: you're on the fast track to fame now. You refresh your browser … and again. No replies yet. Ah, but it's only been there for a few seconds, everybody is probably still sleeping – it is 5am, after all. You go to bed, and wake up in the morning all excited because you just know you've hit the jackpot. You turn on your computer, go straight to the forums to check your thread, and there you have it: a grand total of absolutely no replies at all. It stays quiet all day, and the next day. You start getting nervous. Five days later someone replies, "Hey, nice work, took me a few minutes to figure out what you meant but cool idea." That's it, that's all you get for your hard, intense work! Can nobody see the brilliance? What went wrong…?

We've all been there, I guess (or at least I've been there plenty of times). You messed up the final composition: you didn't place the camera right and it suggests the wrong thing for the wrong character. Instead of people being impressed by your dark, über giant with a glowing sword, they actually think it's a cute little character with tiny dots on the ground scattered all around him. So what did go wrong?

This is something I'll try to shine a little light on in this tutorial about camera placement, framing and other things to keep in mind to convey the right things for your image.

INTRODUCTION
When I was first asked to write this tutorial I immediately agreed. What a great opportunity to write something about a part of image creation that I really like, and also a good exercise for me to structure the knowledge I have about this topic? So I sent the email back, saying I agreed with it and I would be more than happy to write something. Not too long after I wrote that email though, I thought and realized what it actually meant: writing about camera positioning and framing. In a way, you

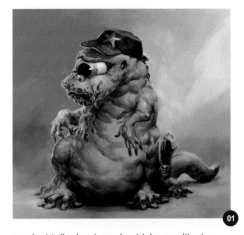

can just talk about overlay tricks, positioning and what it does to the subject, but the basics – or the fundamentals – of those theories and tricks are basic rules of composition.

Now, composition is a slightly different story. People study composition for years, and most artists never really completely figure composition out perfectly. It's a fascinating topic as well as a frustrating one. It's an important topic, but a difficult one. And most of all, it's a humongous, ridiculously over-the-top big topic! I've only just started to explore the world of composition and definitely haven't figured it out yet. I focus on a quite specific

element of composition and try to give lots of examples and tricks on improving dynamic framing, but there is no escaping composition theory. So I've also included some of that in here, too. Of course it's short, cut down to fit into the story and it's not, by far, a complete view on composition or dynamic framing and camera position, but hopefully it will become a small guide for you into the wondrous world of it all!

COMPOSITION

So let's kick off with a little bit about the fundamental background of the whole thing: composition. When you say "composition", most people will think about the placement of dark and light elements on a canvas or the "golden rule of thirds", etc., which of course is true. But there is much more to composition than that! Composition is basically how you arrange your scene for the viewer. This can be purely down to aesthetics, or to tell a story; it can be 2D or 3D; it can be the design of an outfit or a landscape – anything and everything is or can be seen as composition (yep, it's that big).

The thing with composition is that you can learn everything there is to know about it from text books, completely understand it, and still not be able to do it. It takes years of experience to even get the basics; to truly understand them and be able to apply them. I have to cut the whole thing down a bit in order for me to finish this tutorial before I'm 80, so for the sake of this article and to keep it to an acceptable size, I'm going to focus on story-driven composition with a special focus on camera placement and

framing for dynamic characters. That being said though, I would advise everyone to read up on composition separately to this tutorial (I actually should start re-reading a lot of things myself as I'm sure I've forgotten some of it already).

Official composition rules are a great way to learn how to place things, but most of all they are great analytical tools to help you see what you've done wrong – or right. But I do feel that these formal composition rules, in my opinion, should be considered as guidelines and not laws, for it is always about what you want to tell or show, and any or every rule should be bent or broken for that purpose.

CAMERA PLACEMENT

Now that we have established that the whole problem with camera placement and framing is composition, where does it leave us? In exactly the same place as before, unfortunately! I have included the information though because I think it's important for people to realize that most of these problems are compositional ones. But for the sake of our tutorial, I'll be taking the opposite road to the solution: not from *how* you want to tell it, but from *what* you want to tell. First and foremost, you need to know what you want to tell. This is the most important thing in a story-driven image, and a necessity in order to choose a correct camera angle and a frame.

STORY

What do you want to tell?

What is the main element of your story? The scared face of your beautiful night elf just seconds before it gets smashed in by the ridiculously big hammer of an orc? Maybe the extreme size of the orc compared to your cute little night elf? Is it the tiny pink rabbits that are trying to flee the site of danger before they get elf blood on their pretty fur? Or maybe it's the army of frustrated worms who have had it with the constant ground shaking, jumping and running of the stupid orc, and have decided to take action by mobilizing the entire worm family, arming themselves with advanced, high-tech nano weapons, and under the command of the most feared Worm General in history they stride to battle to take down the orc? All this is one scene?!

The question is: what story do you want to tell? For any one of those above, I would pick a different camera angle. If you don't know exactly what you want to tell then go to a cafe, have a drink and try to figure it out. If you don't figure it out before you start then there is a small chance it will work out, but there's a much bigger chance you'll get a grand total of absolutely no replies on the pro art forums and you *won't* be on your fast track to internet fame!

GETTING YOUR STORY READY

Okay, so how exactly do you get your story ready? One way, as I said before, is to have a drink. Alcohol works for me (most of the time), but let's assume you're not a drinker and want to figure this out in a bit more of a structured and analytical way. So the first thing you should always do is choose your story. I can't really help you with that one; it's your choice if you want to display the elf being smashed by the hammer, or not. I would personally go for the worm family, of course – it's so ridiculous that it should be fun!

The next question is: what elements do you *have* to display in the scene? Which things are fundamental to the story? I'm always in favor of showing as little as possible without compromising the story. First of all, it leaves much more for the viewer to interpret for themselves. Or, to put it in other words, more people are bound to like it since everybody fills in their own details. Some will applaud you for your funny image and nice rendering

skills, whilst the next person will go down on his knees because of your amazing intellectual depth in the image (of course, in reality you have no idea it could even contain "intellectual depth", but whatever, just play along!). Secondly, it usually makes the image a bit calmer, since there are fewer elements to distract the viewer. And last but certainly not least, it's less work. It can save you up to hours (or days), which you can then spend playing videogames or making your next internet-famous image.

Something I've learned from game design is a little thing called the 'MSCW list' (Moscow-list – easier to remember), which is basically: **M**ust contain; **S**hould contain; **C**ould possibly contain; **W**ould be nice to have. This is a way of creating a hierarchy of importance. Now I can tell you that *Could* never happens. Pretty much the same thing goes for *Would*. We can use a similar tactic to organize the information we have. So let's focus on *Must* and *Should*. *Must* in the image with the worms is of course the worms; in particular the Worm General with the advanced, high-tech nano weapon. Secondly, since it's an army of worms, we need more worms – at least enough to suggest an army.

So here is our Worm General (**Fig.01**).

We're going to need the orc with a hammer as well. Preferably, we need to see the elf, but a suggestion of her could be enough.

KEEP IT SIMPLE!

Don't try to solve all the stories and problems in one image. You'll fail! Pick one thing that you

want to tell, and leave the rest for a second, third of whatever image. If you put too much into one scene, the viewer will get lost and confused, and that's the last thing you want with this kind of image.

People in general look at a webpage for about seven seconds. Seven! And that's if it contains a lot of text, etc. If it's just an image, usually surrounded by other images, it's probably less. So let's say four seconds, which is not a lot of time to get a story across. You can't explain everything, so whatever you show must be obvious. No, it must be *more* than obvious! Make it so that even a mentally challenged monkey looking the other way could get it in four seconds, and you might have a slightly better chance of getting noticed.

EMPHASIZING YOUR STORY

Okay, great. You've got your story down. You know exactly what needs to be shown and what can be left out. Now it's time to think about what elements you can add to increase the drama, movement, humor, or whatever you want to show in your image. This is a very important step because it is basically where you try to move the camera around in your head to look for the perfect angle of the scene. There are some things to keep in mind though when you're staring into oblivion, trying to figure out where to put the camera:

SOME BASICS

Kick force perspective, low horizon: Increases the size of the character, adding a threatening effect; makes the user small and the subject big; great for your giant and dragon illustrations (**Fig.02**).

Eye level on main subject, horizon in the middle: Size of main interest is approx. the same size as the viewer (**Fig.03**).

Bird's eye view on main subject, horizon at the top: Subject of interest is smaller and/or lower than viewer; subject is dominated or the "underdog" (**Fig.04**).

These are the 3 most basic options. Of course, you can apply them in subtlety or exaggerate

them however you want. You can use one of them, or combine them. It just comes down to the question: what works best for your purpose? There is always going to be much more that you can do and play with!

ADDITIONAL SUPPORTING ELEMENTS

Composition Disclaimer

Now the following section is a bit of a dilemma. I want to talk about supporting elements like foreground elements, the direction of lines, and the space around a subject to create a certain sense of motion, but those elements will only work if your basic composition allows it. Yes, here we are again: composition. But to fully dive into the realm of composition is quite a task, and as mentioned before it would probably require 10,100 magazine pages filled with information written by – not me. I am far from a formal composition master or teacher. So what to do?

I'm going to slap composition in the face by stuffing it into a few basic boxes for this tutorial's sake. Now, don't kill me over this, I also have to go outside sometimes and get some fresh air, as well as eat. Talking too much about this subject will strip me of any form of what (very, very, very little) social life I (pretend to) have.

Ok, so let's get back to it. In general there are two types of composition: Static and Dynamic.

Static Composition is where the overall balance of an image feels solid (I am sure there is a much better way of describing this in one sentence, I just can't think how), and there is no obvious sign of motion. It often uses horizontal and vertical lines in a central orientated layout, using a triangular, round or square composition (this is really putting it into a small box!).

Dynamic Composition is where the image suggests movement, almost like a frame capture from a movie. It often uses curved and

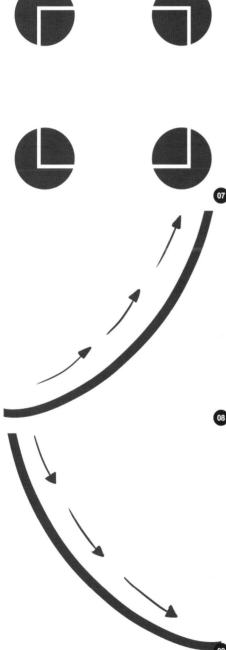

diagonal lines in an off-center layout, and often shows an element that suggests that it's going in a certain direction – your brain automatically finishes the movement. Now, if you want to know more about this, please don't email me. Read a book or take some lessons. If you want to complain about my composition blasphemy, you have all the right to, I guess.

LET'S FOCUS ON DYNAMIC COMPOSITION

So you have your important elements clear. You know that you want to show it either big or small, depending on the purpose of your story. Now how do we get this baby moving?

Well first of all: don't put your focus point in the center; don't put it in the horizontal center; and don't put it in the vertical center (**Fig.05**). No center!

Disclaimer: there is no absolute rule in a lot of compositional rules. And, of course, you *could* put it in the center and still make it look dynamic, but you have to know exactly what you're doing (and I'm betting that the chance is really high that you're not reading this tutorial if you do).

Good, so you put it out of the center. Why does this work? Well it breaks the perfect balance of the whole composition, but also it suggests movement. To put it simply: balance = static; off balance = dynamic. If there is room in front of the character, for example, it suggests an area where the person can move to. If you show a large area behind the character it suggests the character is coming from that direction (putting

a big empty space behind a character can also – depending on your context of course – suggest an element of danger) (**Fig.06**).

Secondly, you want to have more than one focus point: let the eye of the viewer wander around the image; let the viewer explore the image; allow eyes to follow lines and areas of contrast – the more the eyes move the more dynamic the image seems. Don't make 100 focus points – that won't work! That will just frustrate you *and* your viewer. Keep it simple. Just trust me for now.

LINES

Diagonal lines work great for a dynamic composition! Why? Because your eye automatically follows lines, and lines have a direction (a line does not have to be an actual drawn line, it can also be a suggested line by light, dark, colored or other elements as seen in **Fig.07**).

A quick note on lines: I was always a big fan of flipping my image in Photoshop. It's great because it makes you look at your image from a new perspective. The old Masters used to hold their images or paintings upside-down in front of a mirror to check for mistakes. But lucky us, we have an option called "Flip"! I've always wanted to make sure an image works in either direction – flipped one way or the other. Later, when I was researching some things about visual storytelling, I came across some information that explained that a line curved upwards from left to right is perceived as going up (**Fig.08**). But if you flip it, it is perceived as going down (**Fig.09**).

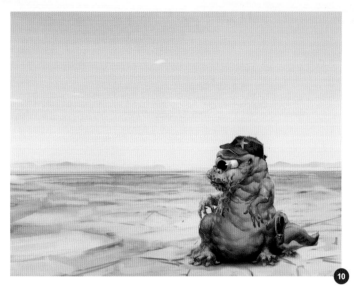

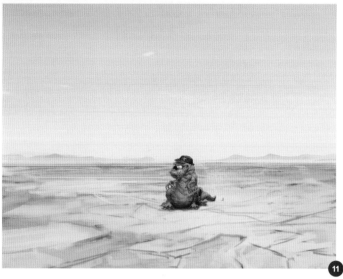

So an image doesn't have to work both ways, because you read the image completely differently either way. It's got something to do with the reading direction. We are used to reading from left to right, which is why we also "read" an image from left to right. This has even more implications than just a line going up and down: things on the right side of the vision have a tendency to be perceived as more threatening (in general); things coming from the right side – let's say a train, for example – are also perceived as going faster than when the train with the same speed is coming from the left side. These are small, unconscious things, and all really dependent upon context and so on. But they are fun to play around with!

DEPTH PLACEMENT

There is the option of putting the subject anywhere in the distance. So why should you choose one or the other? Well, the safest way is to put your main element in the middle ground, add some foreground and background elements, and you're done. But this is boring and far too easy!

Putting your character in the middle of anything destroys the potential movement it can have towards any direction. It makes it balanced. Putting your character in the foreground suggests importance of the background, and an involvement of the background with your character.

For example, an empty, dried-out plane or desert stretching towards the horizon is much more threatening if your character is in the foreground element (**Fig.10**). This way the plane becomes much bigger, and it suggests that your character has to cross it or at least has some business with the unpleasantly big and empty space.

If you place your character half way along the plane, it also suggests isolation, but the plane becomes much less impressively big (**Fig.11**).

By putting your character in the background of the same plane suggests even more solitude, and hints at a traveled distance (**Fig.12**).

So to sum up, placement in depth can be considered in the same way as placement on the horizontal or vertical axes.

CAMERA ROTATION

The simplest way of creating a dynamic composition is to rotate the camera. All naturally static horizontal and vertical lines – the horizon, trees, etc. – become diagonals, and it suggests that the camera or viewer is participating in the scene in a more active way (**Fig.13**).

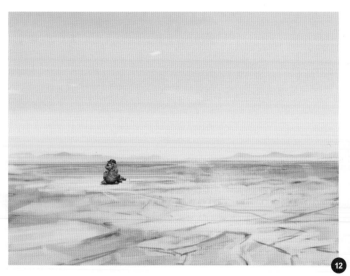

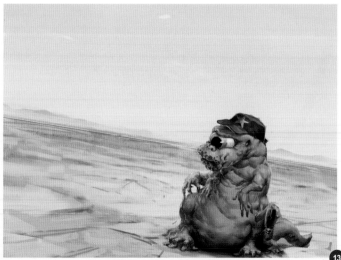

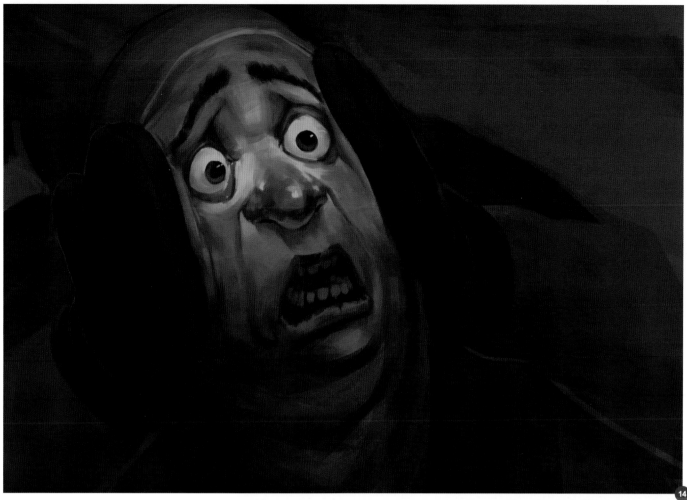

14

OVERLAY ELEMENTS

Suggestion works great for dynamic scenes! Showing a little will make the viewer finish the rest in his or her brain. If you have a character that looks scared at the camera, it works, and it makes people guess a bit about what is happening (**Fig.14**).

If you show exactly why he or she is scared, it still works a bit, but it's less exciting (**Fig.15**).

If you place an extreme foreground element, like an arm, hand, leg (or whatever) over the camera, it suggests involvement with something more, and the viewer is right in the middle of it (**Fig.16**).

Quick Tip : A great way to learn about these compositional tricks is to analyze movie shots – old black and white movies in particular, like *Macbeth, Citizen Cane*, etc. (they're worth watching anyway, even if you're not studying them).

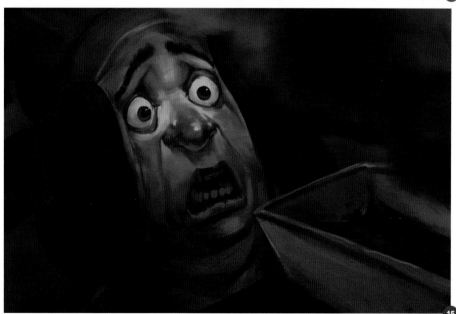

15

FORESHORTENING AND LEAVING THE FRAME

Another great trick to suggest more is to have a certain line or element leave the frame – a leg, for example. This draws the eye of the viewer in towards the place where you want it. But it also suggests a world outside of the frame. It makes the frame more like the current view of the onlooker and suggests the potential of something else happening. You have to be

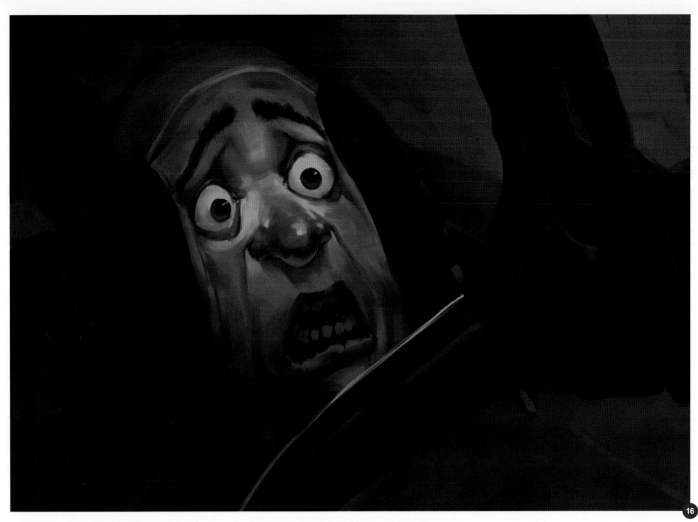

16

careful with this, though, because it can also make the eyes of a viewer leave the image if not treated right. Remember the direction of lines! If a line is followed by the eye and it goes towards the edge of the canvas, and there is nothing to stop it and pull it back in again, the eyes will leave the canvas.

PARTICLES, WIND, DUST AND SUPERHERO CAPES

A great way to enhance the dynamic feeling of your scene is to add elements that we know move, like wind, dust, small particles, falling leaves, and so on. It's a sure shot way to making it dynamic (or at least moving). If we go to the empty desert again, with nothing in there except a character, we can see that it's quite a static, non-moving scene. Why? Because it's a dry, empty plane – nothing is happening (**Fig.17**).

Now, if we would add some suggestion of really strong wind by adding some sand blowing

up from a little ridge, and some particles all going in the same direction (we'll go with right to left, because it's perceived to be a faster movement in this direction) all of a sudden the whole static desert becomes a moving – and even more threatening – plane. You can feel the sand gushing past your face and through your legs; you know you have to move through it but you can see there's nothing to find shelter in (**Fig.18**).

If you have a character with a nice cape, dress, or other fabric elements that will show wind,

you should make use of it! If your character doesn't have it: What's wrong with you? Have you wrapped your character up in Latex? It better not be a guy! Just give it something that moves. If you avoid it hanging straight down as though made out of lead, it instantly suggests wind and movement. Such an easy trick, and yet it always works (**Fig.19**).

GUIDELINES

Remember that all these are guidelines. It's much more important to figure out what you want to say and think about how to do it, rather

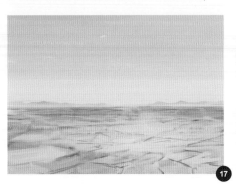

17

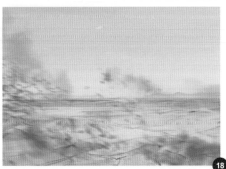

18

than follow standard rules. Get familiar with the tricks and get to know why they work. And what they exactly enhance, but don't become a slave to them, or to any trick for that matter. Try to keep an open mind and keep thinking on what you could do to improve what you are doing.

Okay so you figured out your story, you've established your primary and secondary elements. Now let's look at the limitations or possibilities of your frame.

FRAMING

Alright! Framing: the package in which you wrap up your little story! The borders for your brilliance; your own little frame of infinite possibilities; the edges that border your deep, intellectual thoughts; your own piece of ... Yeah, OK, I think you get it!

Framing is as versatile as the composition you put in it, and actually, it is an important part of the composition itself. The frame is the first thing you see; it's the work area and it depicts a lot of the suggestion of the scene even before the image is shown. Do you want your viewer to have an endless visual journey from left to right over a magnificent widescreen landscape? Or do you want to show them a deep and interesting vertical image? What about leaving the traditional frames for what they are, and pushing the limits a bit? What does a round frame do? How about a squared frame with an element leaving it?

FIXED FRAME

Framing offers lots of possibilities – that's if you have the freedom to pick a frame anyway. Often in the commercial world there are certain limitations to the frame you can use. If, for example, you have to create a cover illustration for a book then you'll have to work within the limitations of the format. This can make things a lot harder. When you need to display a lot of information about a landscape, for example, and a very wide horizontal frame would be perfect but the book is standard vertical size ... well, this is where you want to have a good understanding of composition, but more importantly about the most important elements that you need to show in your image. It is in

these kinds of illustrations that you often have to sacrifice important things; the trick is to sacrifice the least important one.

Sketching, thumbnailing and having a camera floating around in your head looking for the best possible angle are vital techniques to employ in these kinds of illustrations. However these kinds of frames are boring, or they're boring to talk about at least because they are set, fixed, and there is nothing you can do about it. You just have to find a way to make it work.

FREE FRAME

So I want to dive a bit further into the world of free frames; the place where you have endless possibilities – choice all over! The question is of course: Is more choice better? Choice is great if you can choose (now that makes sense, doesn't it?). Sometimes having no choice is great in the way that it forces you to think about a less than standard solution. It pushes you outside of your own little safe world where everything is great, beautiful and boring. It forces you to get frustrated and start thinking again.

I find that people often choose a frame because, well, just because it's always like that: landscape = wide; portrait = vertical. Of course it works; it always works. There is not necessarily something wrong with it, providing you know *why* you chose it.

So here we are: we have all the freedom in the world to choose a frame for our dynamic composition. What are the options? Well, infinite actually, but that would make this tutorial extremely long (or extremely short if I just keep it at the word, "infinite"). So let's break it down into a few forced boxes again (I like that: pushing things or people into boxes where they don't quite fit, but with enough force, or at the right angle, they will awkwardly look like they sort of do).

BASIC FRAMES

The non-special, what-you-see-all-day-long frames:

Horizontal: Your basic screen layout. Comfortable to look at, fits in the view of a person. It's a solid balanced shape. It's great for showing things that require some width, or for images that you plan for people to use

as backgrounds. It's often a good choice for something that you want to feel like it has some sense of space, or if the space around an object is important. If you don't know what to choose, go for this one: easy, simple, straight forward (**Fig.20**).

Vertical: Again, quite a basic layout (but then I have put them in the basic category, so it does make sense). It has a familiar shape which is great for showing things that are a bit higher than they are wide, such as people. This shape also often shows a bit more depth, since a many elements tend to be overlapping or have foreshortening going on to make them fit in the frame (**Fig.21**). Now, I also find this shape a bit more dynamic. I'm not 100% sure why, but it might be because it's less grounded then a horizontal shape. Maybe it's because your eyes often can't fully see the whole image at once and they have to travel up and down, left to right? Or maybe I just like it? Not sure!

Squared: I really don't know what to say about this one (**Fig.22**). It's good for a CD cover, but that's about it in my opinion. I use it sometimes, but that's mainly because I crop the vertical or horizontal image because of a mess up somewhere and then it eventually ends up squared. Squared is boring; it's too solid, too rigid, too … well, it's just boring. Anyway, since this is not science I am not obligated by objective facts, I can be as subjective as I want to be. And I will be! I think squared sucks! It's just not fun! And there you have it. I don't think anyone will look me up after reading this and punch me in the face because he (or she – I prefer she) is a squared frame fundamentalist.

I just love to tell the whole world something sucks. It's just great! Somehow it's more rewarding than saying you like something. No, you really, truly think something sucks and the whole world can know about it – awesome! Of course, my opinion on things tends to change, so there is a good possibility that in the next year or so I may become an absolute squared frame fundamentalist!

Anyway, enough off-topic nonsense! We are here for information so let's move onto something a bit more interesting.

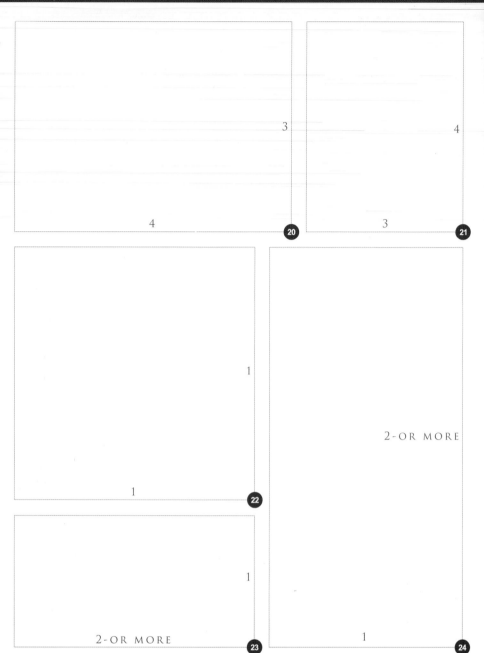

EXTREME FRAMES

Extreme frames! This is basically the same as the basic frames, but exaggerated. Now there should be a note to the usage of extreme and unconventional frames: by using a choice of frame like this, you have got to have a reason. It will stand out if you don't, just because it is such an unconventional frame choice. That means that people expect it to make sense. You have to explain your choice of frame to the viewers. Now, if you choose an extreme widescreen frame for example, and you put a character in there (vertically), that means that the space around the character is given significant importance. The placement of your

character in such a frame requires much more thought than in a regular frame. It can work out brilliantly – only if you place it right and there is a reason to place it there.

Extreme Widescreen: This one is awesome for über epic landscapes, or to show off exactly how long your hero's cape is (**Fig.23**).

Extreme Vertical: This is a great choice for things that are extremely long, or deep. It's a good choice if you want to have a wide angle camera lens and you want to show how big, or deep something is. It's also a good choice for a 3-point perspective (**Fig.24**).

UNCONVENTIONAL FRAMES

"Unconventional" is pretty much anything that hasn't fit into the previous headings. I rarely use them. Why? Well, because I don't often have a reason to use them. They also take a lot of pre-thought since all applications and paper are pretty much always bound to have four 90-degree angles, making them any variation of a square. So, if you want to do something different, you have to plan it, and you have to have a good idea why something like that would be a good idea. And I'm not too good at that – I tend not to plan.

But then, saying that I don't plan would completely discredit the previous text that I wrote before this. I do plan! I don't really like it, but sometimes you just have to. But, if I have a choice – as it is with free choice of frame – I choose not to plan too far ahead.

Still following me? Good. The thing is that there should be a reason for your choices. Are you in an online art competition and you want your space marine to stand out next to all the other squared space marine images? Well then, yes, go to the forum, press Print Screen, get the background color and "fake" the unconventional frame. Give your space marine his gun outside of the frame. Cool!

Ok, so a few conventional variations on unconventional frames. When people use unconventional things to be "original" they tend to choose the most common of uncommon things. Please don't use it for that; use it because it fits the image. If you want to be original like that then go out and paint a bicycle

with pizzas. Otherwise, just make an original story and choose a frame that fits it.

Round: This is a bit like squared, don't you think? It's solid, but it's better than squared. I wouldn't use it though unless I had to. It's good for an avatar/portrait, I guess, but I'm not sure what else I would do with it. An epic landscape doesn't really work in this one (**Fig.25**).

Outside the Box: This one is fun (if you can use it properly, that is)! It's a great way to attract attention to your image. It's very good for creating a sense of depth. Have your warlord step out of the image; it really works wonders if well applied. Be careful with it, though, because if you make a digital image, the image is always squared, so you actually have to select the background color in order to fake the effect. This makes it only good for that one specific forum. Of course, it's a bit easier if you make a comic, since you know the background and it's always the same (**Fig.26**).

Fuzzy Edge: This one is quite interesting, too, and it's great when combined with one of the above! Again, be careful because the image will only work with certain backgrounds (unless you make the background a specific color and you create a new frame in your big frame). It's hard to say what it is specifically good for since it depends so much on the image. It can also be nice to combine this with a normal sharp edge to create a surrealistic effect (**Fig.27**).

CREATING THE FINAL IMAGE

So you've got your story ready and you've decided on your choice of frame. Now you just have to put it together and make an image. It's that simple!

The main trick here is to know what you want to make. Try out different setups; try out a vertical frame or a horizontal one. Try adding an Overlay layer to the foreground, or perhaps even a big, empty space in the background. Try, try, try; sketch, sketch, sketch. Never go for the first one.

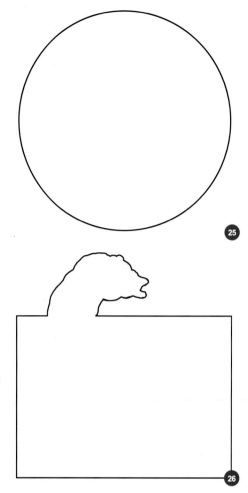

I could go into detail here on how to make an image exactly and setup your whole composition, but that would be ridiculous. Just try it out for yourself and use some of the elements described previously. I don't want to make a 1, 2, 3 step tutorial on how to create the "perfect" image. I don't want to hand out a sheet with tricks. Just use this as a guide to help you understand composition, camera placement, framing and the dynamics of an image better. Sorry for all those who were expecting a super trick to the solution of life, the universe, and everything under it, including eternal internet fame! It's not here; I'm not your man. If you want to know that, go and read *The Hitchhikers Guide to the Galaxy* (the answer is 42, by the way). But I do hope you've enjoyed reading this as much as I have writing it …

Not that I was drunk while writing this (well, at least not the whole time anyway).

Painting a Jungle Monster
By Matt Dixon

Software Used: Photoshop

Conceptualization

There are many different ways to approach monster design. It's good to be familiar with as many different methods as possible, not only does this allow for greater versatility when selecting the appropriate solution for a particular design challenge, but employing a range of techniques helps to keep ideas fresh and the process fun.

Other than a jungle habitat nothing about this monster is predetermined. While the idea of having free reign with the design is appealing, such an open brief comes with one very significant challenge: where to begin? To solve this little problem, we'll look at a technique that will spark the imagination and quickly provide a variety of different options to explore.

Quick Tip: Before picking up a pen, spend a little time getting into the mood. Refer to appropriate reference material and inspirational sources such as art, photography or even evocative music while you think your design over. Wait until ideas begin to flow before reaching for your pen. Filling your head with ideas before you begin to draw will really help start the creative process and should mean your imagination is already whirring away when the pen hits the paper.

Now the drawing can begin. Sketch out lots of quick doodles, keeping the lines as fast and free as possible. Details are not important at this stage, only basic shapes and proportions.

Concentrate on the overall form of each creature as you draw. We want these drawings to be deliberately loose and spontaneous. This approach is similar to the 'automatic drawing' employed by the surrealists, where the drawing hand is allowed to move across the surface of the paper in a random fashion in an effort to tap into the subconscious mind. The human eye instinctively seeks to make sense out of chaotic shapes. The idea here is that encouraging random and accidental lines onto the canvas will help to suggest ideas that may not have been drawn deliberately. You can take this technique as far as you wish; completely random doodling can produce very interesting results and is a fun way to try and break a creative block, but a more structured approach inviting some chaos into deliberate sketching is likely to yield more usable ideas. However if it is employed, this is a very effective way to prompt new and unusual designs. Go crazy (**Fig.01a – b**)!

Stop once you find ideas repeating and review your doodles. Set your imagination to work on each in turn, considering how they might look with different patterns, colors and materials applied to them. Try to make sense of any chaotic lines – are they feathers, horns, tentacles, a trunk or something else? Which are most appealing visually? Do any suggest a story or particular behaviour? One or two will usually stand out right away - though they may not necessarily be the best or most rewarding choice - take time to explore each drawing thoroughly.

Try to justify the final decision. Just liking the way it looks is reason enough, but thinking through the reasons for making the choice will help give direction to the next stage of development – what appeals to you about your choice? How will you communicate that to your audience?

I chose the creature in the top right (**Fig.01a**). I liked the idea of a monster with cute proportions – balancing that juxtaposition should be a satisfying challenge as the design

02

progresses. The mixture of rounded and sharp shapes in this sketch also appealed to me and suggested a small, tree dwelling beastie which seems a practical choice for a jungle environment.

DEVELOPMENT

The next step is to develop the creature doodle into a full concept design. A neutral symmetrical stance allows you to concentrate on making the anatomy work without having to solve any problems that may be caused by a difficult pose. Begin by loosely defining the proportions of the creature then gradually begin to make sense of the shapes in the doodle. Make use of scale, rotate and distort tools to quickly experiment with different proportions (**Fig.02**).

With basic anatomy and proportions decided, add details. Again working against a neutral pose makes this easier. Use layers to quickly compare different ideas. Keeping shapes consistent within the design gives rhythm. Remember why you chose this doodle as the starting point for your jungle monster, trying to retain and develop what appealed to you at that stage.

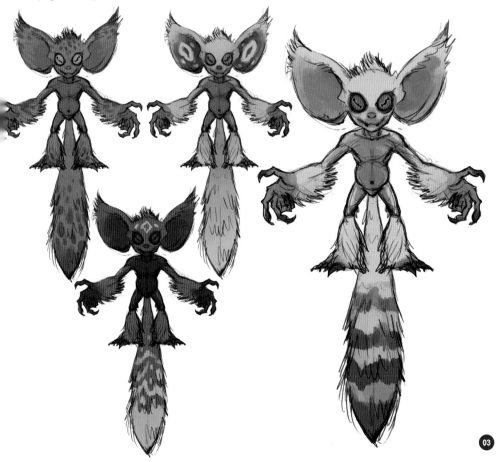

03

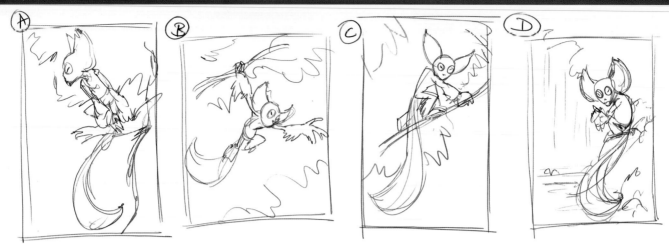

I focused on the cute proportions which first drew me to this creature, the large eyes, head and ears. A long, thick tail exaggerates these proportions further. Spiky details – fangs, claws, tufts of fur – hint at a nasty side to the monster while also helping to tie all the shapes in the design together. The eyes will be a focal point of the design and are traditionally seen as windows to the soul, so it's here that I need to concentrate the marriage of cute and cruel that I want to show in my jungle monster (**Fig.03**).

Now consider the colors, patterns and textures of your monster. Again, layers can make changes and experimentation easier – set your sketch to Multiply mode and apply color to a layer beneath it. Use color adjustment tools to quickly see variations on your ideas. Try to make your development deliberate, ask yourself why your monster would have a particular color or pattern. Is your design led by evolution – color for camouflage, courtship, or deception – or to satisfy criteria in your design – eyes as a focal point, contrast with background color – the choice is yours. Remember what justified your design choice - does that give reasons which influence your decision on color?

With a chosen color, your design is complete. Look back at your original doodle to see how it has developed. Have you built on the qualities that attracted you to the sketch?

For my creature design to work as I intend, it's important to get across aspects of both cute and nasty in my monster. I have chosen colors which I think will support this. To establish the eyes as a strong focal point, I have selected a

saturated orange/red here – this is traditionally a color associated with danger or warning which should project the nasty side of my creation, and will work well against green hues in a jungle setting. A neutral body color will give additional contrast to the eyes, and choosing a bright tone for the fur ensures good contrast with the background which will help to show off the cute body proportions. Accents on the tail add interest and help to maintain a consistent color theme within the design."

PRESENTATION

How will this freshly-designed monster be used? This will determine how best to present your creation. What you have at this point, perhaps with additional viewpoints and annotations may well be sufficient for a pure concept piece, but the design is only half the fun. Your jungle monster will be far more engaging, more alive, if you show it in a scene.

COMPOSITION

The first step is to decide on a pose and setting for your creature. Pose can communicate a great deal of your creature's behaviour or personality. A background may not strictly be necessary when presenting a creature design, but the setting can be a powerful tool in establishing the mood of the final piece.

The development process should mean you're now well acquainted with your creation – imagine the kind of things it would do and try to choose a pose which will tell the viewer something about your monster. Think about how it moves, what it eats and where it spends it's time. Try getting into the character of your creature and act out movements. Though this

may be amusing for any nearby spectators, it can be a very useful way to explore different poses quickly if you keep a large mirror where you work.

Consider a setting which supports a suitable mood for your creature. Hopefully this is something that was considered back in the sketching stage. Jungle environments are rich and diverse; decide if a predictable background of green broad leaves or something more unusual suits your jungle monster best. Try to show scale by including objects or cues which will be familiar to the viewer (**Fig.04**).

Explore different ideas with loose thumbnail sketches. As in the doodle stage, keep things fast and free – not only will this repeat the possibility of accidental marks sparking new ideas, but loose sketches capture movement and energy very effectively.

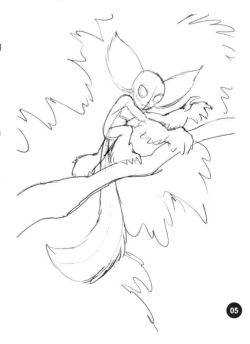

I have referred back to my original doodle for inspiration on the pose for my creature. It looks almost as if it's been disturbed or startled which I think adds to his character and suggests that it's engaged in some sinister behaviour which suits the mood I want to project. I intend to keep the background as simple as possible to show off the creature most effectively. The bough along which it creeps together with some surrounding foliage should give a good impression of the scale of my monster (**Fig.05**).

To begin, build on your compositional thumbnail. Simply establish the basic pose and proportions of your creature along with any background elements. Lay everything out to make sure the arrangement of shapes in your composition is correct. If it works in this simple form, you can be confident that you have a solid foundation to build upon (**Fig.06**).

Now add details to your layout sketch. How far you take this depends on your coloring and painting technique and the complexity of your monster design, but it's important to have all the significant elements in place before you proceed to the next stage.

Thumbnail C (**Fig.04**) was my choice for the final painting. This was closest to my original doodle, though I modified the pose to make

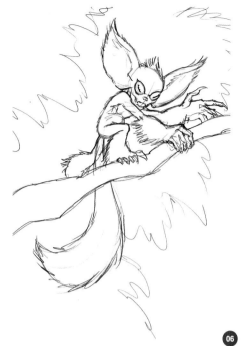

the creature appear more confident, less like it has been startled and more like it is about to pounce!

VALUE

Next, establish values. Defining the values in your painting before working with color allows you to control the contrast in your image more effectively and to consider form and the basic behaviour of light more simply. Place your sketch on a separate layer set to Multiply

mode, and lay in values on a layer below (**Fig.07**).

Begin with basic layout of flat values. Establishing the basic arrangement of value is the only goal here, so keep things very simple (**Fig.08**).

Add variation to the basic arrangement. Strengthen the contrast where dark and light values meet, and place any significant details. Try to keep forms flat at this stage. Decide where the darkest and lightest values in your image will be placed – be aware that these points will often establish the areas of highest contrast which will become a natural focal point (**Fig.09**).

Begin to add form to the shapes in your painting, and place any final details. Pay particular attention to edges at this point – soft surfaces should have soft edges, hard surfaces hard. Try to ensure all lines are removed in preparation for painting.

My values are very simple. I designed my creature's bright fur to contrast against the background, so I placed it against a shadowed area of foliage to make the most of this. The highest and lowest values are deliberately placed in my monster's head to draw a strong focus to this area.

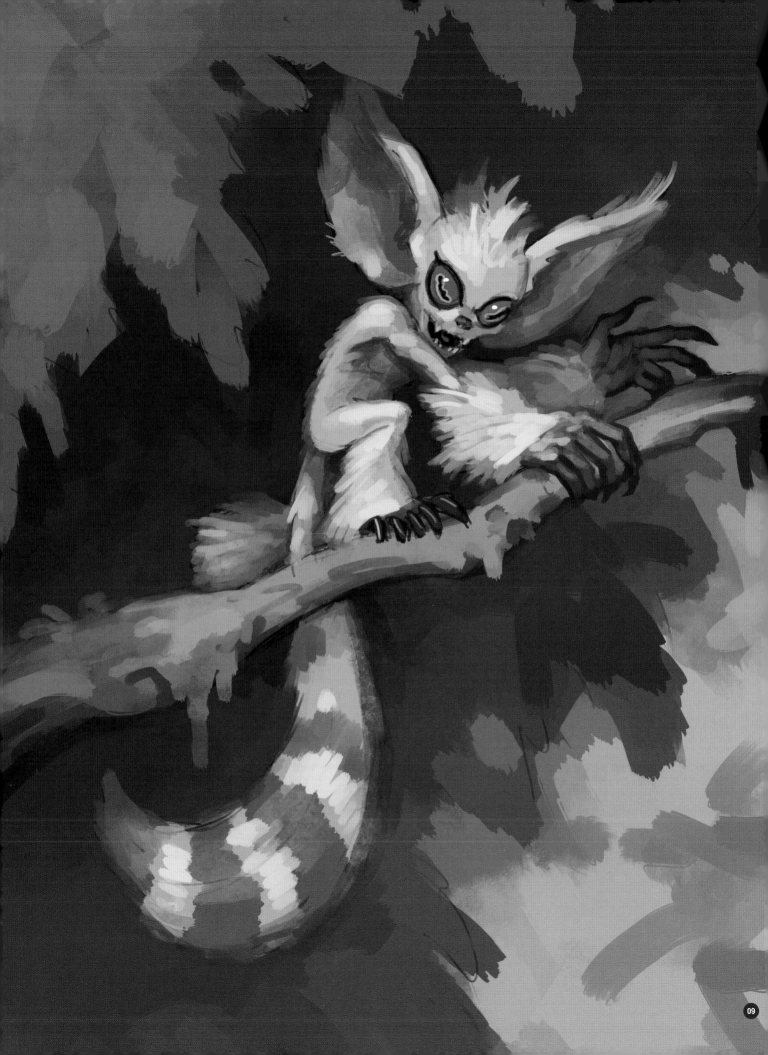

COLOR

Flatten the final value treatment, then copy it onto a new layer and again set to Multiply mode. Lay in basic colors on a layer below. It's always best to work with a simple scheme, at least to begin with. No more than three or four main colors as a starting point. Begin by establishing the basic colors of your jungle monster as these are already decided, then choose complimentary colors to use in the background. Using a soft brush here will encourage colors to mix which can produce interesting results that you can carry through into your final painting. Different colors may be added on separate layers so that adjustments can be made more easily if necessary (**Fig.10**).

The Opacity of your value sketch layer may need to be reduced a little, especially if your values are strong, in order for the colors beneath to show through effectively. This is fine as the relative values remain consistent. A positive side-effect of this is to reduce the strength of the very darkest and lightest values, which may then be re-established during rendering.

A good impression of the final image should be seen at this point. All the significant elements have been put in place and all that remains is to refine what is already there. This is a good opportunity to take stock before final painting begins. Note areas which could be problematic during the painting process or which don't work as you intend and try to address them before you progress to the next stage. Similarly, take note of any areas which are particularly successful and make sure you don't spoil them! I've chosen a basic color palette. A green

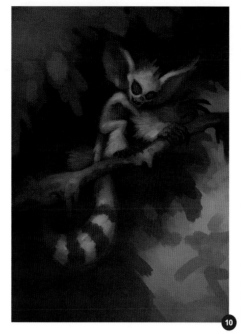
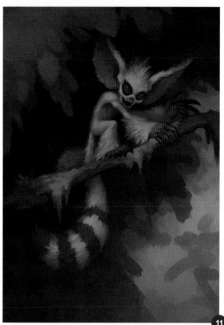
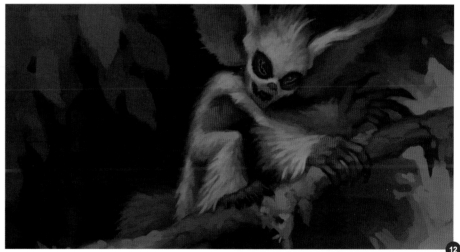

background is a strong compliment to the saturated hues in my jungle monster and I've used a blue shadow to add interest to the scheme. The blue shadow and green foliage colors mix to create a bright teal hue where they mix. I like how this ties the colors together and I will aim to maintain that in the final painting.

RENDER

Now the fun can really begin! Flatten the image and build on the colored value sketch. At all times try and develop the image as a whole, rather than concentrating on small sections. Use the biggest brushes you feel comfortable with - this will force you to make bold marks and encourages the idea that each mark should be deliberate (**Fig.11**).

At each stage of the render, try to build on what has gone before. In the previous section the colors were placed, use the color picker to choose colors from the existing image and begin to refine your painting. Resist the temptation to add new colors at this point. Tidy any loose or messy areas and pay particular attention to edges and texture (**Fig.12**).

Continue working across the image, making sure to balance the background elements with the foreground.

Here I'm really feeling out the background of my painting. I want it to look like foliage, but I don't want it to draw attention away from my monster. My solution to this is to take an almost abstract approach to the background, defining

rough shapes of leaves and plants without placing any details. The goal is to give the impression of what's in the background without having to show anything too specific (**Fig.13a – b**).

Now is a good time to flip and rotate your painting, this gives a fresh viewpoint on your image and can draw attention to problem areas. Fix any issues you can see. Continue to refine your work, strengthening values and adding detail as required (**Fig.14**).

As the rendering process draws to a close, add any remaining details making sure to keep the tightest detail in and around focal areas.

FINISHING TOUCHES

The rendering is complete. The final step is to add a few finishing touches. Pick out significant details with highlights, strengthen values to give the image plenty of contrast punch, make any final adjustments to the texture of surfaces. Image adjustment tools can be very powerful at this stage, but try to avoid getting bogged down with tweaks and frills. If you've followed these steps correctly, you will have made deliberate, positive decisions about your creature design and presentation throughout the process and major adjustments at this stage should be unnecessary (**Fig.15**).

Your jungle monster is complete!

In the final stage, I pushed some darker tones into the shadow area behind my creature and added further bright values to the fur. This really boosted the contrast around the creature and gives the image a satisfying 'pop'. I drew further attention to the eyes by adding some subtle reflections which, along with hard, bright highlights make this area a very strong focal point. I also added some small details such as the skin texture in the ears, and some floating pollen in the background.

CRITIQUE AND CONCLUSION

Acknowledging that there will always be some aspect of your work that can be improved means that each piece you produce can be viewed as an opportunity to grow and refine your skills. Take a little time to look back at your work with a critical eye to see what may have been done differently and to review anything you feel you have learned from the piece. This is best done at least a few days after completing the work to give a better chance of casting an objective eye over the image. For a concept piece such as this, pay particular attention to the development of your ideas. Compare your first sketches against your final image. Does your finished creation remain true to your original concept? Does it successfully answer any design brief? Was the process smooth and deliberate? Do you like the end result?

13b

I'm generally pleased with my jungle monster. It's good to look back at the very first doodle which inspired this creature and see a direct connection with the final design. I think the design criteria, a quirky mix of cute and nasty, which I set myself is successfully met along with the intention of having the monster's eyes as a strong focal point. Perhaps the design could have been more original or unusual. Though presenting a creature with some similarity to familiar animals (in this case a small primate such as a lemur or capuchin) can help the viewer to accept the design as plausible. The finished painting works as I hoped, I like how having small parts of the creature obscured behind the foliage and bough helps to give the impression of a secretive, skulking nature to the beast. Some elements, particularly the monster's hands, could maybe stand out a little better but that might interfere with the strong focus on the eyes so I'm happy that there's a good balance to the picture overall.

Designing monsters is always fun. Hopefully the techniques that we have looked at in this example will have been interesting to explore and will prove useful in the future. Introducing an element of 'automatic drawing' into the early sketches is not always easy, especially if an artist has been trained to produce neat and tidy drawings, but it's an approach worth persevering with even if it does not feel natural at first. Few other methods have the potential to produce such varied concept ideas as quickly as this, and remember that your unused ideas can be saved for possible future use! If you've enjoyed the process, why not go back to your concept doodles and develop other monsters?

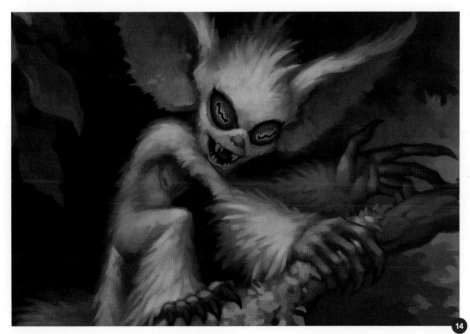

14

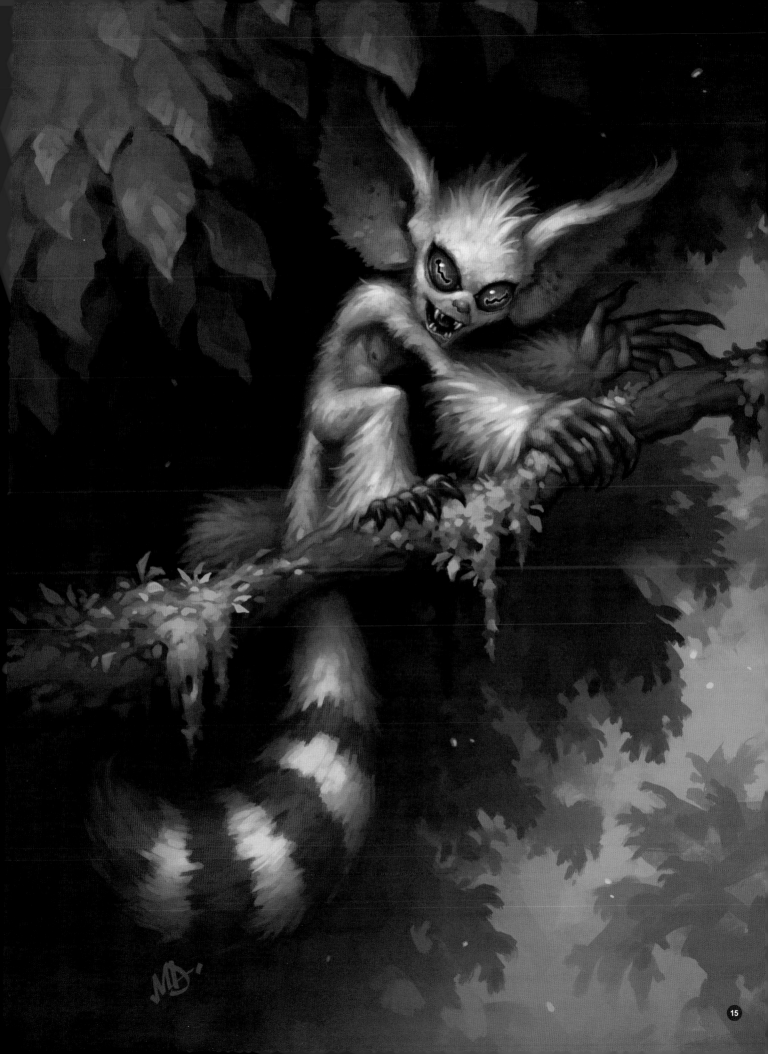

PAINTING A VAMPIRE
BY RICHARD TILBURY

SOFTWARE USED: PHOTOSHOP

INTRODUCTION

Before beginning any sort of project I usually begin by doing a bit of research into the subject and gathering some reference material. In this case I searched Google for images relating to vampires and the numerous incarnations that have appeared over the years. When you look into the topic of vampires you'll realize how many different interpretations exist, from the early vision of Count Orlok in the film *Nosferatu* through to the classic character portrayed by the ubiquitous Christopher Lee. Then at the opposite end of the spectrum are the more modern takes that are evident in the *Blade* and *Underworld* series'. Suffice to say there is no single and consistent concept that springs to mind when you think of a vampire.

This poses an initial problem as I can't decide in my mind what the character should look like, and what type of aura I want him to convey. Should he be a sickly, cowering type that hides from human contact, or have a more powerful and charming persona exuding status and sophistication? These issues led to decisions over the costume design and posture, and with so many question marks it was necessary to start with some thumbnail sketches to try and resolve the problem.

THUMBNAIL SKETCHES

It's very good practice to make a series of small and swift sketches before starting a final design as it will help clarify things and also suggest artistic directions that you may not have previously considered. In this instance I begin with a few silhouettes to try out some poses (**Fig.01**).

You can see here that a simple silhouette can convey much about a character (1 – 3), providing an insight into their proportions and clothing, for example.

I decided to make a few head studies to explore the type of qualities and look he should have, and to try and decide on his demeanor (**Fig.02**). Should he look imposing and more human-like or perhaps be eerie with exaggerated features that resemble more of a sub-human or monster?

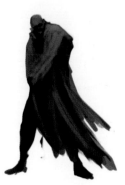
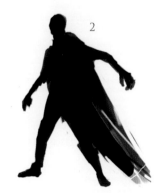
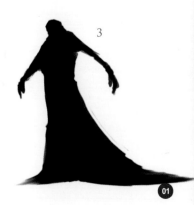

1

2

3

You can see that the top left sketch resembles Nosferatu (1) and has a very different feel to the version seen middle-right (4). The bottom-left character (5) looks more like a monster, whereas the top-right sketch (2) looks more modern and contemporary in context. Each has a different quality, and by making a series of sketches such as these we can begin to formulate an idea and turn a vague notion into a clearer vision.

Usually there is not one single sketch that looks right over and above everything else, but rather there are aspects that prove to be likeable in each. In this instance I like the more charismatic quality to number 4 compared to the left-hand column, but I also think that the long hair in number 2 adds a certain feminine quality which contrasts well with the notion of a physically powerful being, lending him a certain dynamic. I also like the robe/cape shown in number 6 which adds a classic look, as well as providing a lyricism through the flowing lines of the fabric.

By making these quick sketches I have already been able to decide on a few components that I would like to include in my design, so I can now go back to the pose. The one that strikes me the most is number 1 (see **Fig.01**). It doesn't feel as domineering as 2 or 3, but with the extended arm it seems a little creepy and mysterious, without being too obvious.

Favoring this posture I begin on some variations (**Fig.03**). I have made the decision to give the character a robe and long hair, but if the robe envelops his body there will be little room for detail; I don't want the majority of the concept to be made up entirely of this element! To add some interest I open the front in order to include some anatomy which will contrast well with the dark clothing (1). Version 2 looks

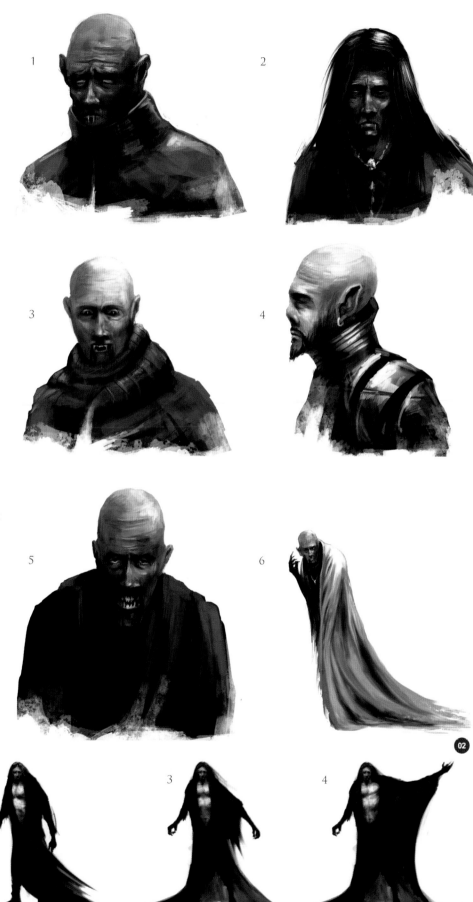

1

2

3

4

5

6

02

1

2

3

4

03

CHAPTER 1

somewhat surprised, as though he's been disturbed and has looked around to face the viewer. This combined with his more hunched shoulders gives him a creepy quality, which I like but is not in keeping with a powerful presence.

I've decided to add another arm to version 1 for thumbnails 3 – 4, but version 3 is the one that seems to work best, as 4 appears to be too gestural and makes too strong a statement.

BLOCKING IN

The first step is to add a neutral background, which I generally do by filling the entire canvas with a tertiary gray of some kind, and then paint random strokes over it using a textured brush of some description. On a separate layer I then begin by blocking in the character in rough, bold strokes, focusing on the main volumes and areas of color (**Fig.04**).

I have used a custom brush to add the textured effect, which was modified from a photo of broken glass, of all things (see inset). Much of the other blocking in is done using the standard Hard Round Airbrushes and Chalk brushes that Photoshop provides.

I always keep the background as a separate layer as it makes it easy to change the color scheme and lighting, as we will see later in this tutorial. In fact, I think it would be interesting to have the bottom of the image a touch darker and have the character almost emerge out of this darkness. To do this, I select a gray/green

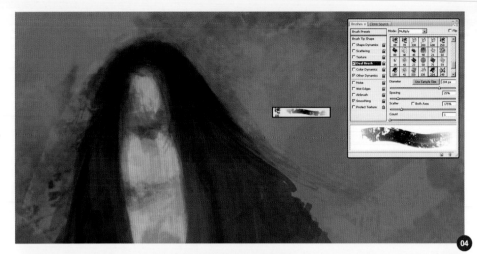

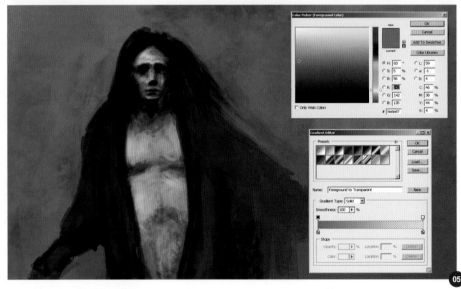

color (**Fig.05** – see inset) and on a new layer I add a Gradient (Foreground to Transparent), and then set the layer blending mode to Multiply.

You can also see that I have now started to block in the main shadow areas across the face and torso, and have better defined the head.

The character at this point appears to be looking slightly to his left, whilst the thumbnail sketch confronts the viewer directly. So I change this here, as well as tidy up the hair shape which looks a little windswept (**Fig.06**). The other issue was that his robe was open very low on his torso, which was looking a little risqué, so I amended this and started to paint in some fabric folds.

So far the Photoshop file has been divided into three layers: the background, the gradient and the character himself. Continuing on the character layer I start to use a grayscale palette to work on the skin. This is so I can focus on the tonal range, but I also want him

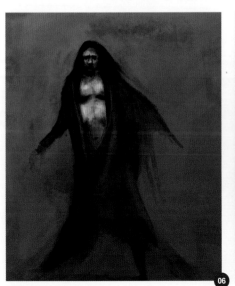

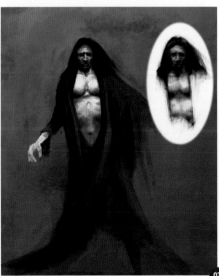

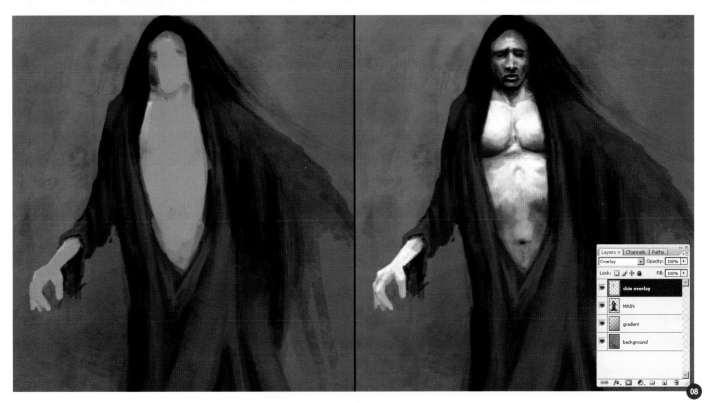

to have very pale and lifeless flesh to create a ghostly, non-human appearance and a suggestion of the undead (**Fig.07**). Although pure coincidence, I really like the expression in the thumbnail (see inset). It suggests to me a look of sorrow, or some forlorn hope which I really want to capture.

Part of the reason I've painted the skin in black and white is that I can overlay a color, retaining the tonal values but with the option of making hue changes at any point during the process. In **Fig.08** you can see a dull ochre color on the left, set to Normal mode, but when changed to Overlay (see right inset) it adds a certain glow, whilst maintaining the ghostly quality.

In compliance with the 3rd thumbnail in **Fig.03**, I've added the character's left arm (**Fig.09**). You can also see at this point the layer structure on the right-hand side palette, with the separate color overlay for the skin.

I notice here that the figure looks a little wobbly on his feet, so I rotate him slightly to make him more upright (**Fig.10**). I also add some fancy brocade around the sleeve and torso to add some interest, and start to form some of the folds in the robe, all of which is done on the character layer.

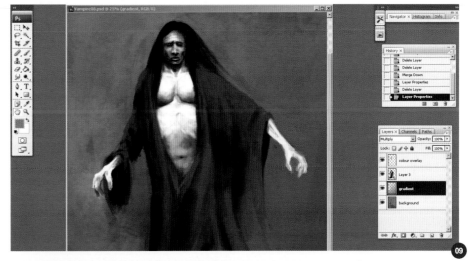

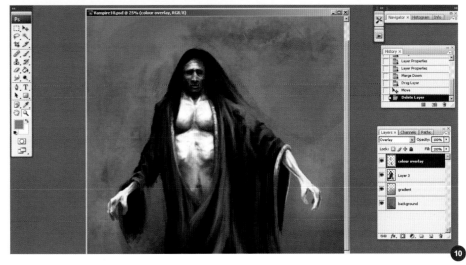

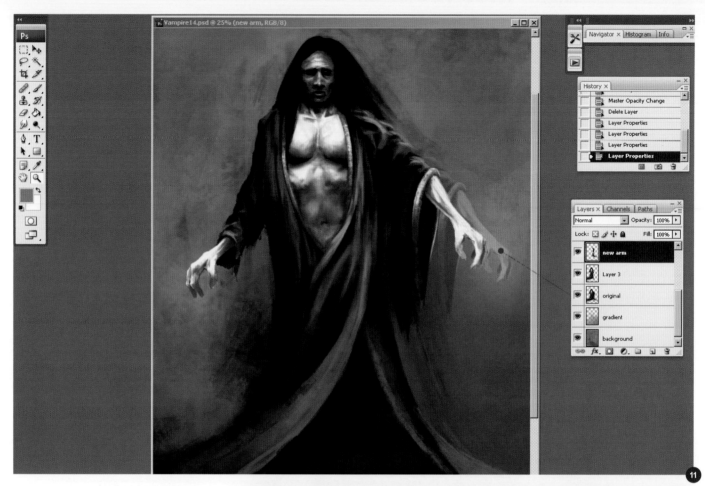

BUILDING THE DETAIL

At this point I am starting to realize that because I have used my thumbnail as a starting point, which was obviously done quickly and not accurately, I have transferred many of the problems across to my final version; namely the proportioning. Not only does the character look very tall, but the rib cage looks too low down, and his left arm is also too long. Sometimes having these exaggerations can help a design, and in this case the small head and long arm does somehow lend our vampire a creepier presence. In fact, a smaller head is often a good device to make a character seem more heroic and portray a sense of power!

However, I have decided to squash everything up a little, which I do using the Edit > Transform > Scale tool. I duplicate the right arm, and on a new layer move it to a better position, using the Eraser tool to blend it in with the original layer before merging the two together. In **Fig.11** you can see the original position highlighted in red and how it has been altered.

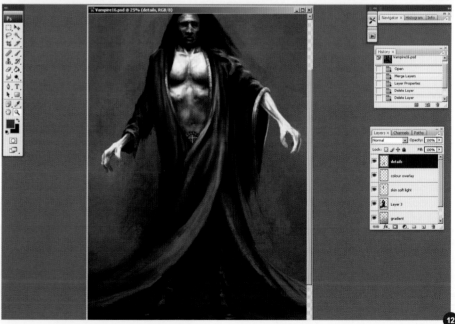

With the anatomical proportions improved I start to work on some more detailing, namely fixing him on the ground. I consider the idea of having the robe hide his legs, or making the bottom part of the painting dark to create the impression of him floating, but I settle on some

boots, along with a small decorative element to his robe (**Fig.12**). I add another gradient to make the bottom part of the painting darker, which also emphasizes his skin color.

I've been moving the robe detail around but it never really seems to work until I place it at

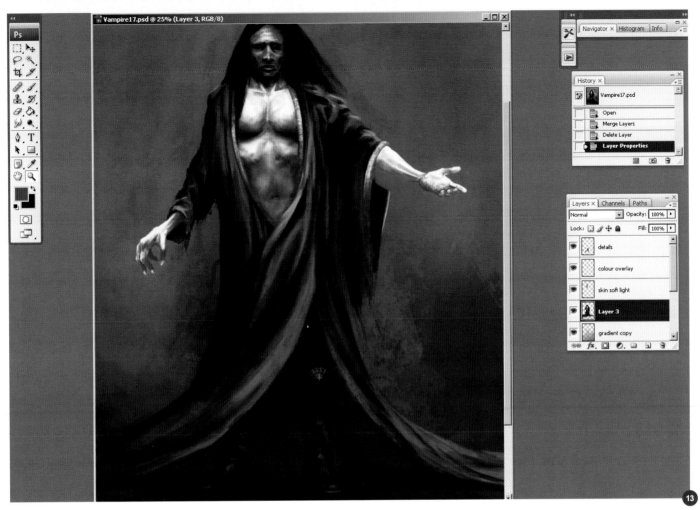

the top of his left boot, which immediately feels right. I've also added another small focal point to the bottom section of the picture.

One other part of the design which has been causing me some problems is the hands, which look rather too symmetrical – as though he is sitting on a throne. I've thought about the nature of vampires and their reputation of being able to charm and seduce their victims, and so I've decided to change his left hand to a more beckoning gesture (**Fig.13**).

It's always good to have a distinct lack of symmetry in your characters to make them more believable, but in **Fig.14** you can see that the naval is far from being central to the torso and head, and looks awkward as a result.

REFINING

I alter the shape of the hair, making it less bouffant, and I add some length and highlights on a different layer, just in case I want to reverse it or leave it short (**Fig.15**). You can

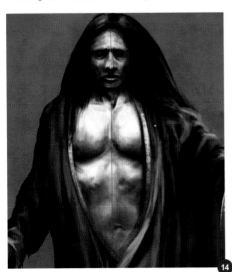

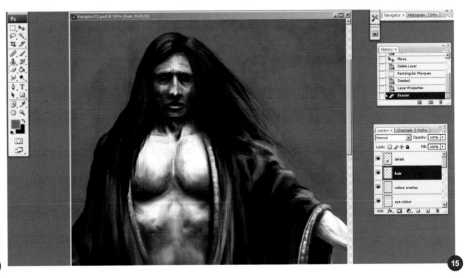

also see that I have created a new layer called "eye color", which is set to Overlay and shows the red tint around the eyes.

You will have noticed that the background color has changed throughout this tutorial, which is the advantage of keeping it separate to the character. You may wish to change the tonal values etc. – or in this instance add some textural detail in the form of a blood spatter (**Fig.16**). I created this custom brush a while ago and thought, with some subtle use, it could prove appropriate to this particular painting. I added a new layer for this effect.

The painting is almost complete now, but after having altered the right arm and hand it has since seemed inconsistent with the other one. The thin wrist and angle of the forearm does not feel right and again mimics the thumbnail too closely. After using a mirror and some careful posing, I decide on a different gesture, the result of which can be seen in **Fig.17**.

CONCLUSION

This has been a fun project as I have never painted a vampire before and more particularly because I did not have a clear idea about how he would look before starting out.

It's interesting to see how an idea or feeling evolves during the painting process, and you will have noticed how the character has transformed during this tutorial. There are aspects which perhaps do not follow strict rules, such as how the robe fits around the body (I am sure some fashion experts could point out some of the problems to me!), but from an artistic perspective I like the flow and rhythm it has created.

The boot design and hand gestures have certainly been improvised along the way, and the fact that one sleeve is torn and ragged compared to the other was also unintentional. However, part of the fascination with anything creative is the fact that it can suggest its own direction and surprise you on the way!

Here is the final version (**Fig.18**).

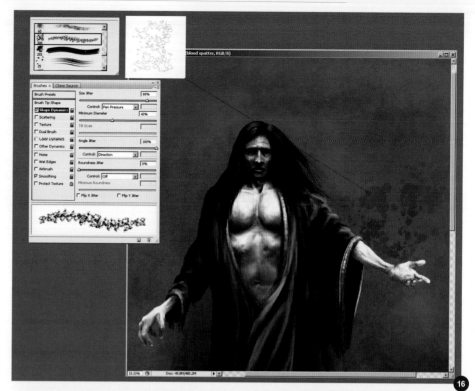

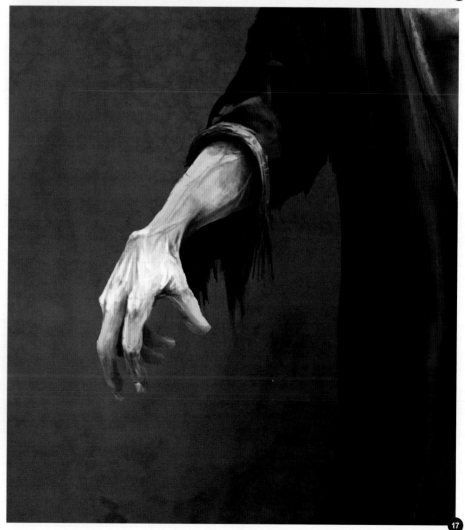

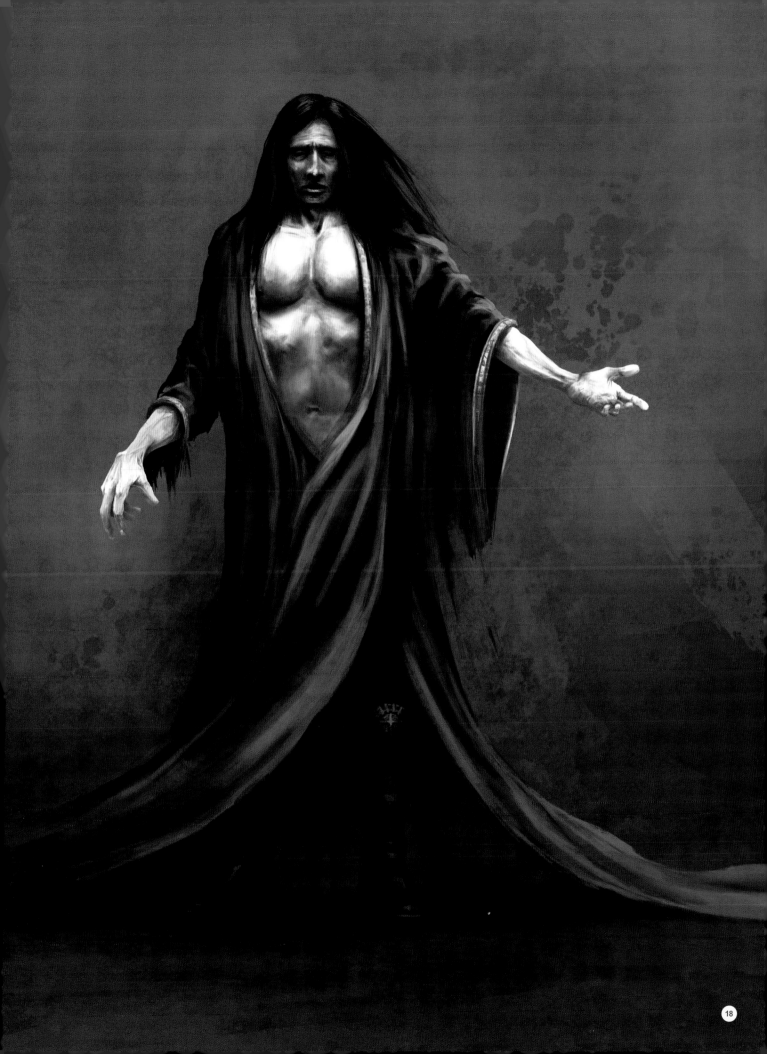

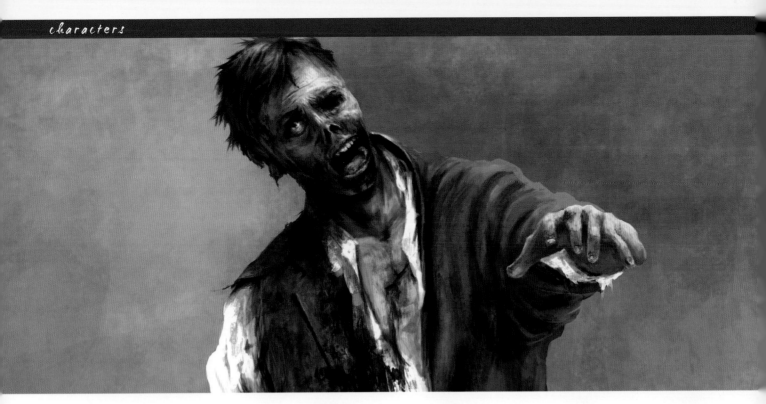

PAINTING A ZOMBIE
BY RICHARD TILBURY
SOFTWARE USED: PHOTOSHOP

INTRODUCTION

The zombie in many people's eyes has probably been epitomised by the films of George A. Romero but it has been modified over time into a variety of guises. The word zombie refers to a 'mindless' human being or someone who has been reanimated or brought back to life without speech or free will. There are different incarnations and some appear as slow lumbering creatures that wander around groaning whilst we have also seen in recent years a hybrid form that which is quick, more aggressive and predatory in films such as *28 Days Later*.

As with all characters once you start to research the subject, you find a great number of interpretations but the one contemporary common thread is that all are human with a need to attack other human beings by way of biting and thus spread their disease. This aspect has become part of the modern myth and popular culture and is somewhat removed from the original meaning of the word and its roots but is nevertheless a widely accepted convention within the modern entertainment industry today.

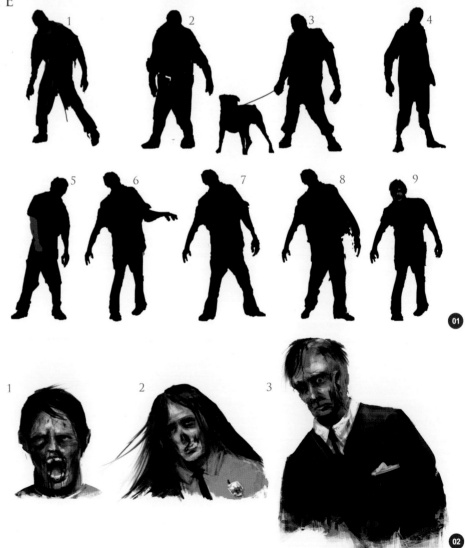

I decided that my zombie would be your average office worker that did not look unusual in any way and would be the slow, lumbering type as this quality felt strangely familiar from my days commuting in London in the mornings and being turfed out of pubs at closing time in the evenings! Over the years I have had plenty of inspiration for this subject from living in cities, believe me.

THUMBNAIL SKETCHES

What was very important in this image was the posture, as this would carry much of the personality and characteristics and suggest how he would move. Vampires and werewolves have no distinct movement compared to the somewhat erratic gesticulations of the classically sluggish zombie and so it was important to come up with a pose that reflected this.

This type of problem is perfect for silhouette thumbnails and so this is where I began (**Fig.01**).

Having an unbalanced posture with limbs being awkwardly positioned would help show an unstable walk and aspects such as a tilted head and misaligned shoulders also lend a suitable quality. The first four sketches incorporated hunched shoulders and tilted heads and I even considered including a zombie dog but none of these felt right. Sketch 6 was the first thumbnail that seemed ok and looked as though the character was having trouble walking and keeping his head upright. I liked his leg positions and left arm but his right arm did not look great and so I made three variations (7 – 9).

I decided that pose 6 would be the best starting point for the final design even though I was unhappy about the right arm but thought this could be resolved during the painting process where I could try out a few options.

With a solid idea about the pose I then decided to make a few portrait sketches to explore the type of expression and degree of disfigurement he would display (**Fig.02**). Having his mouth agape as in sketch 1 looked more threatening but made him seem a bit too angry. It did

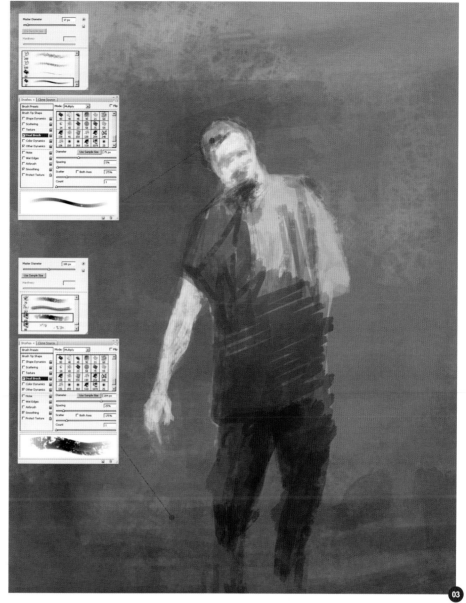

suggest that his bite is used as a primary attack form but the expression was not right. I liked the notion of showing the teeth however so for sketch 2, I removed some of the flesh from around his mouth as well as the front part of the nose. I maintained the rolled back eyes from sketch 1 which suggested a dysfunctional brain or semi conscious state. The third sketch shows a well dressed man but with a different level of mutilation. One of his eyes is missing which I thought made him look scary as though he had been viscously attacked. I also transferred the left eye from sketch 1 which gave him an intense stare which I liked.

I decided that the final version would be an amalgamation of all three as you will

eventually see. The main reason for making these sketches is to try and give form to what are rather shapeless ideas in one's head. I do not think it necessary to fully resolve all of the creative issues at this point but if you can formulate a general direction then a number of the lesser decisions can be made along the route.

BLOCKING IN

With a reasonable idea in mind I began the final version of the painting (**Fig.03**). I decided not to stick to a grayscale version with an Overlay but instead used a color palette. I have taken pose 6 from **Fig.01** but left out the problematic right arm for the time being.

I could have chosen to have his right arm missing but thought this would be a cheap solution so decided to try having him reach out towards the viewer in a classic zombie posture which looked quite creepy (**Fig.04**).

With the right arm in place I made a start on some of the gory details. I started to add some features to the head as well as use my custom blood brush for some stains and spatters (**Fig.05**).

At this point the head looked far from satisfactory, not least because the angle was wrong. I made a rough selection around the head and neck and then rotated it to the left after which I filled in the gaps and adjusted the features (**Fig.06**).

The head and features looked much more convincing after the alterations but his outfit resembled that of a surgeon more than a city worker – time for a change of clothes!

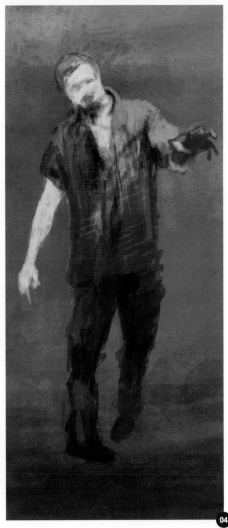

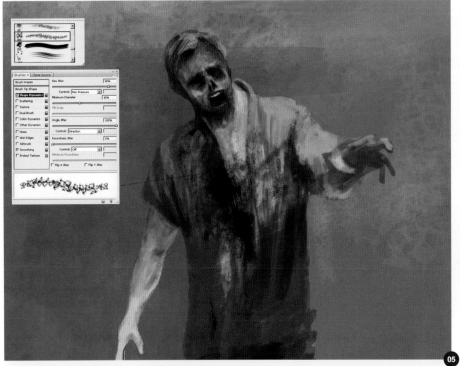

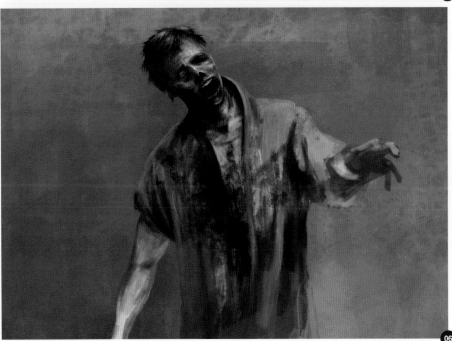

I was painting this on a single layer, so in order to change the color of his suit I made a general selection area around everything except his skin using the Lasso tool and then selected the Quick Mask mode (highlighted in green in **Fig.07**). You can then use a brush to either add to the mask (using black) or subtract from it (using white) enabling you to precisely mask an area which is tinted red. With this done I then clicked on the Quick Mask button once again to return to standard Selection mode and went to Image – Adjustments – Desaturate and turned his suit to a grey color.

Now the main problem with doing this, and why using separate layers for different components can be useful, is that by doing so it will also desaturate the blood which is not what I want. Therefore to avoid this I first used the Magic Wand tool and selected the main areas of blood which were then copied and pasted onto a new layer before changing his clothing.

I now had the opportunity to alter the blending mode of the blood which actually looked much better as Overlay as it appeared less opaque and paint like and was now affected by the clothing beneath (**Fig.08**).

Having learnt from my mistake I added some extra blood but this time on a new layer (**Fig.09**). It is important to add some variation in the blood to show that it is very reflective when wet but also that it congeals and dries quickly. There are two dark spots on the shirt which are browner in color and suggest it is thicker here as well as a pale area on the left lapel which looks as though it has caught some light and has yet to fully dry (blue circle).

BUILDING THE DETAIL

The zombie by this stage has been fully blocked in along with a reasonable amount of detail but the face still lacked character. I liked the rolled back eyes in the thumbnail sketches in **Fig.02** and the intensity of the right eye in sketch 3 so decided to combine the two (**Fig.10**).

I have also brought the jaw forward from the neck in the shadowed section and painted in some lighter highlights to help the eye socket look more menacing and recede more. You

will also notice I have tried a new background color as part of the ongoing process which is something worth experimenting with as your color scheme and tonal range changes.

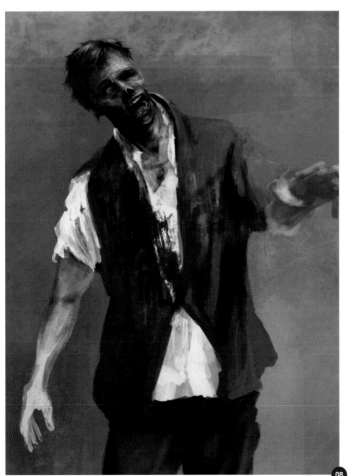

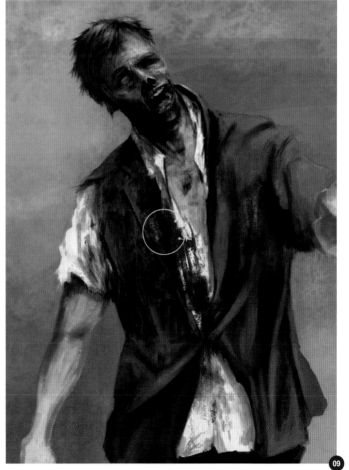

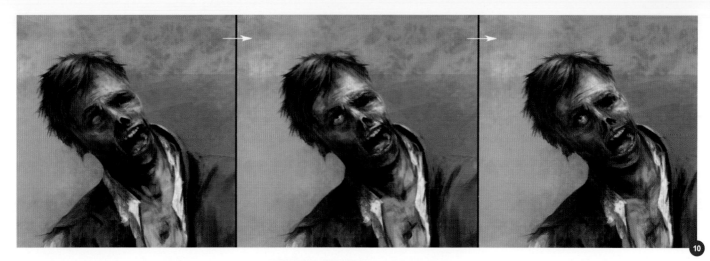

I felt at this point that the character was developing nicely but in order to help emphasize the blood and make him look a little more like someone who had actually died he needed a different skin color. He looked a little too pink which would suit someone who had just died but I wanted to make him look more gruesome. I duplicated the character

layer and then went to Image – Adjustments – Color Balance and moved the slider towards yellow (inset 1 in **Fig.11**). I then used the Eraser tool to delete around most of the skin so as to leave the hair, parts of the face, suit and shirt unaltered. I could as an alternative have applied a New Layer Adjustment but this method was quite quick and easy ultimately. It

proved useful to have a separate blood layer (see top of layers palette) as this can remain unaffected. The two insets show the before (2) and after (1) effects with the result in the main picture.

In the layers palette you will notice that I have added a shadow layer and a Gradient to

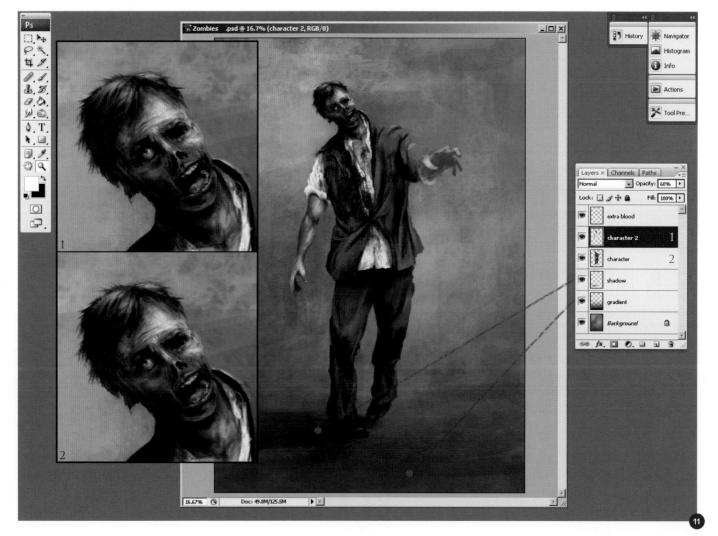

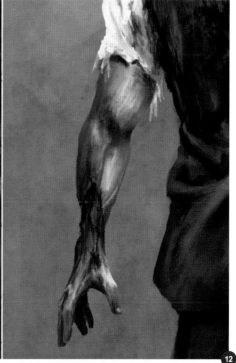

12

darken the ground section. It was time to fix that right arm which was the main area lacking any definition. I decided to raise the arm to make him look more contorted and suggest he was more desperate to reach out to something or someone (**Fig.12**)!

I felt his new arm position added extra tension to the pose but when flipping the canvas horizontally he did seem to be leaning too far to the right overall as though he was about to fall. To rectify this I went to, Edit – Transform – Warp and adjusted his legs. You can see from the red guidelines how the posture has been modified which includes the angle of the left arm. Some smaller details which have also been added are the torn bottom of the shirt and sleeve as well as some further refinements to the suit.

With the second arm resolved, the painting was nearing completion but I felt he needed some more interest on his exposed and rather clean arm. I opted for a wound which was created on a new layer in case I changed my mind (**Fig.13**). I thought the wrist needed an adjustment and so drew a selection area around the hand and went to, Edit – Transform – Rotate. Once done I "stitched" it back onto the arm by painting over the tears and making sure there were no gaps.

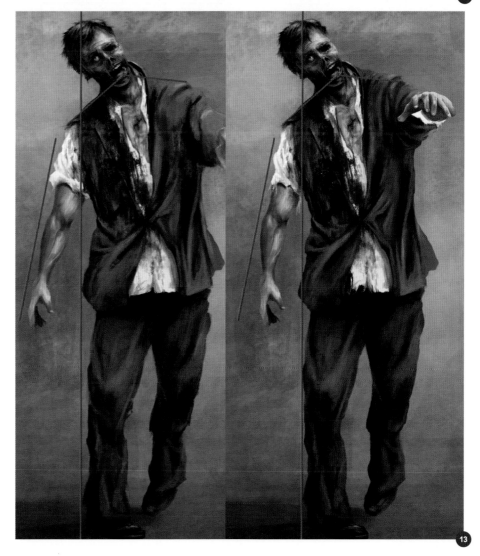

13

CHAPTER 1

FINAL ADJUSTMENTS

Whilst reducing the size of my canvas I noticed that he did not stand out clearly from the background as much as I should like and so used, Image – Adjustments – Curves to increase the contrast of the character. To complement this I modified the background by playing off light against dark i.e. where the light hits the right side of the face the background is made darker and the section behind his left arm is lightened to bring the arm forward (**Fig.14**).

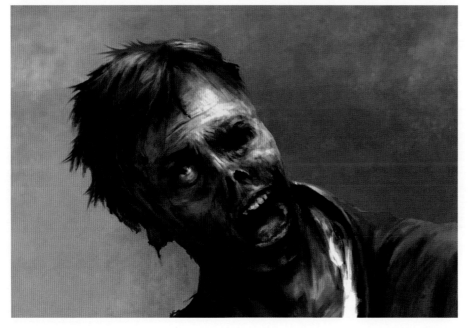

When you feel you have added all the details and flattened the image it is sometimes worth applying an adjustment layer of some kind to experiment with the color scheme and mood as this can always be undone. I find Curves and Color Balance are particularly useful and once applied there is always the option of painting into the mask to control the areas affected without destroying any of the final painting.

One final stage which I often incorporate, particularly if the image is large scale, is Filter – Sharpen which essentially increases the contrast between pixels, making the image look clearer. You can see the final version of the image in **Fig.15**.

CONCLUSION

The process of exploring ideas through thumbnails is a crucial part of the creative process and concepts nearly always require approval before embarking on a final design. However it is always worth having a little room to improvise if possible, without necessarily straying too far from the original design.

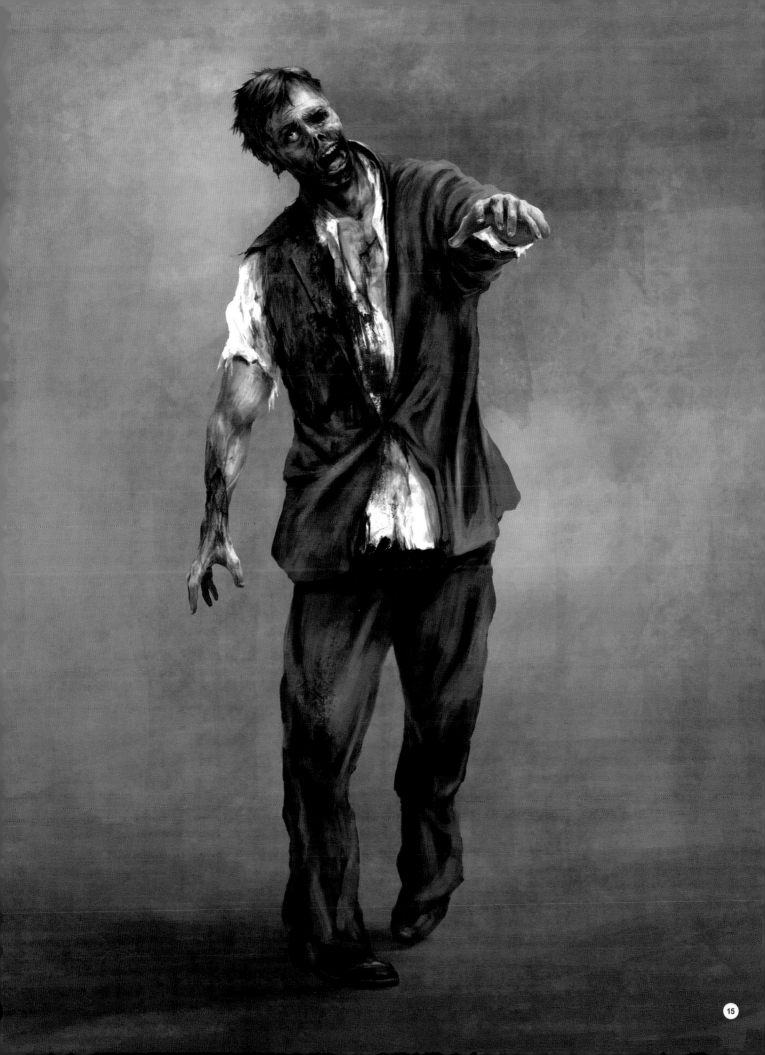

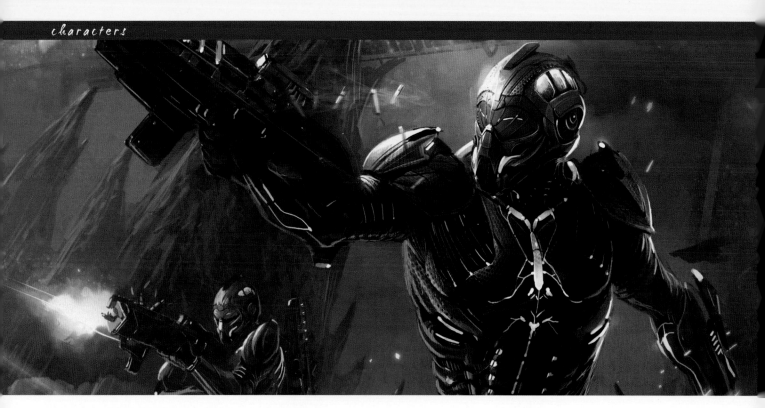

FUTURISTIC MARINES
BY IGNACIO BAZÁN LAZCANO

SOFTWARE USED: PHOTOSHOP

INTRODUCTION

Hundreds of games have been published in which the main character is a soldier from the future. These games are known as FPS or First Person Shooter. Currently a lot of progress is being made concerning the way games look. New technology and 3D engines make games look as if they are real and contain very detailed images. For this reason, when it comes to making art, you have to show

a lot of detail. Although detail and design disappear when playing the game, the truth is that you have to first sell the game. This is the reason why detail and a cool design make the difference.

THE TUTORIAL

The idea of this tutorial was to design a marine who has a suit that could withstand extreme heat on fire planets. For the last two weeks I've been drawing volcanic lava backgrounds for the company I work for. I had to do a lot of research and look for various images related to volcanoes and natural landforms. This was very useful as I can use this research for my tutorial.

THE SKETCH

To start, it is necessary to do several sketches to help you select the best idea. The first idea that came to me was to draw the character standing in front of a background, holding a gun in his arms. This is the classic way of showing a character, and it is useful to begin with it (**Fig.01**). Later in the process I realized that this idea would be a bit boring, and decided to do something less static always thinking about the commercial effect. I decided it would be best to show the character in a dramatic situation, full of action, as if it were the marketing poster for a game (**Fig.02a – b**).

I made two quick sketches and selected option 2. I thought this was the one that had more potential to be developed.

STYLE AND REFERENCES

To be up to date and know what is fashionable, it is necessary to sit down and look for good references. What is very useful when thinking about action scenes, is to see films related to the subject, or to play games full of action. *Crysis*, *Dead Space*, *Section 8*, *Halo*, *Appleseed ex machina*, all provided me with inspiration for my image and all of them are excellent games and films in my opinion.

To decide what to draw and which aesthetic or creative path to take, it is necessary to think about all the references that we researched earlier in the process. On this occasion I look for human body pictures to use them as reference for the marine's suit. I also look for

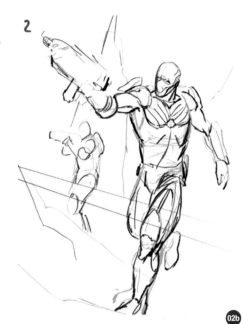

02b

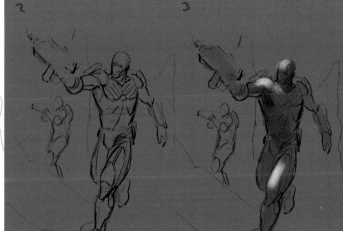

03

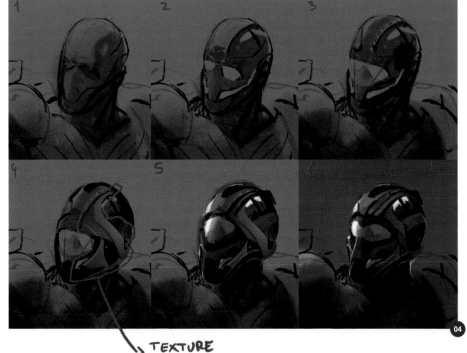

TEXTURE

04

photographs of volcanic lava, volcanoes, and stones for the background.

As I always say, the first and most important thing to do is to research before you start to draw. This is the way most videogames companies work.

THE PICTURE

My aim, if possible, is to show you in a simple and fast way how to create a more professional and realistic drawing. I will focus on techniques concerning realism, final finish, texturing and special effects.

To begin with I will show you step by step the following figures in grayscale. Afterwards, I'll stop to explain to you how to work on the more advanced stages (**Fig.03**).

REALISM AND FINAL FINISH TECHNIQUES

To get an idea for the whole design I begin by drawing the soldier's helmet. Once that is finished, it will help inspire me to draw the rest of the body. In the first three pictures I used Photoshop's Classic brush. In the following images I used part of a helmet from a photograph to give it a real texture and from then onwards I used this texture, drawing on it with a normal brush (**Fig.04**).

To select the area of the photograph I am interested in I use the Loop tool. Then I mark out the area I want (CTRL+C, CTRL+V). Once I have got the piece of the photograph I want in my drawing I use CTRL+T and click the Warp option in the top bar to adapt the photo to the soldier's head shape. The last step is to transform the photo's colors into the same gray tones of the drawing. Afterwards, I'll press CTRL+U and select the proper light tone on the lightness progress line (**Fig.05**).

This technique can be used to make things we draw seem real.

The following picture shows in four steps how I designed the torso. Almost everything is done with the brush and for strategic areas photographic support can be used (**Fig.06**).

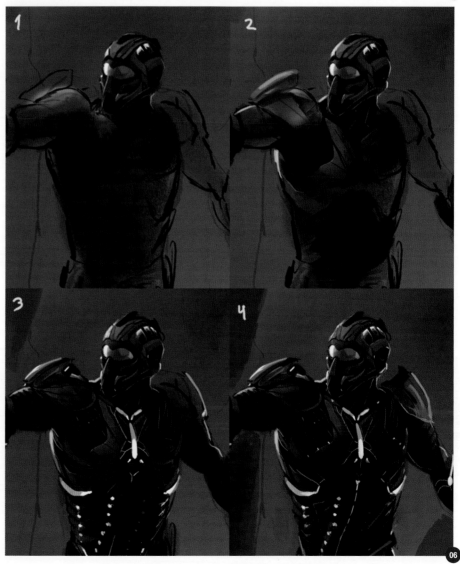

This is another example using the same technique, but this time selecting the front part of a modern car (**Fig.07**).

TEXTURES

When it comes to texturing, the most recommended method is to first draw the shape and afterwards cover it with a particular texture. This time I'll show you how to make the stones that are in the background.

First draw a rock with any brush you want. Then look for a photo that has the desired rock texture, and then select the area you are interested in (Loop tool + CTRL C+CTRL V), and put it on the drawing using Overlay. Once you have the texture on the drawing, open up a new layer and paint the texture with a brush to give it the final finish. It is an easy and fast way to obtain realistic results (**Fig.08**).

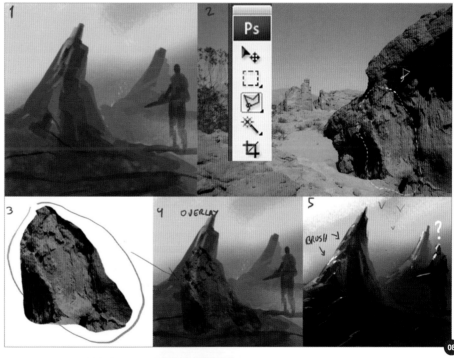

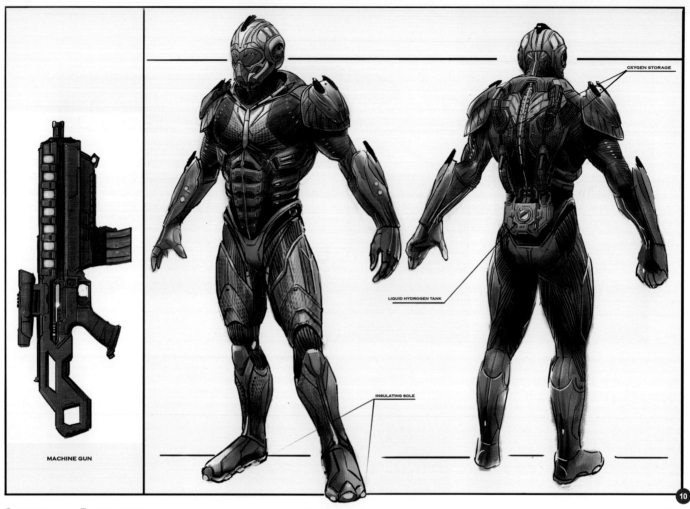

OXYGEN STORAGE

LIQUID HYDROGEN TANK

INSULATING SOLE

MACHINE GUN

SPECIAL EFFECTS

When the drawing looks like it is nearly finished it is time to think about the last step, which I call "to put popcorns to the subject". That is to say, special effects: sparks, lights, fires, etc. This step is defining, because it will give our drawing the final punch to be marketable. To make the sparks draw yellow color points -almost white- on each and every area poured with lava and the use one of Photoshop's effects. Go to FX + Outer Glow and then modify levels to obtain the desired effect. It's very easy and it looks wonderful (**Fig.09**)!

BONUS TRACK!

I designed for the final presentation a schematic. This image helps 3D artists to shape the final character to be included in the game (**Fig.10**).

CONCLUSION

It's very difficult to develop in one tutorial a drawing like this completely because of its

complexity. I've tried to teach you the key points to get the best quality possible. You can use the tips more than once in the same drawing but don't make ill use of them.

Remember that this is only a technique useful to improve your work. The most important thing is the ability to create original things.
I hope you have enjoyed it!

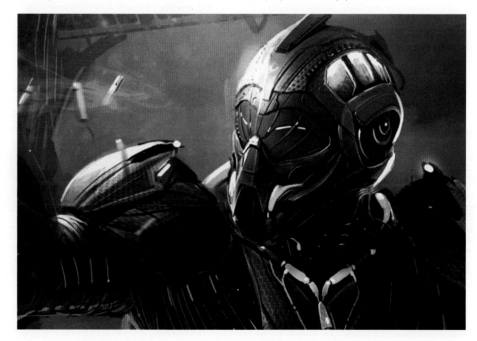

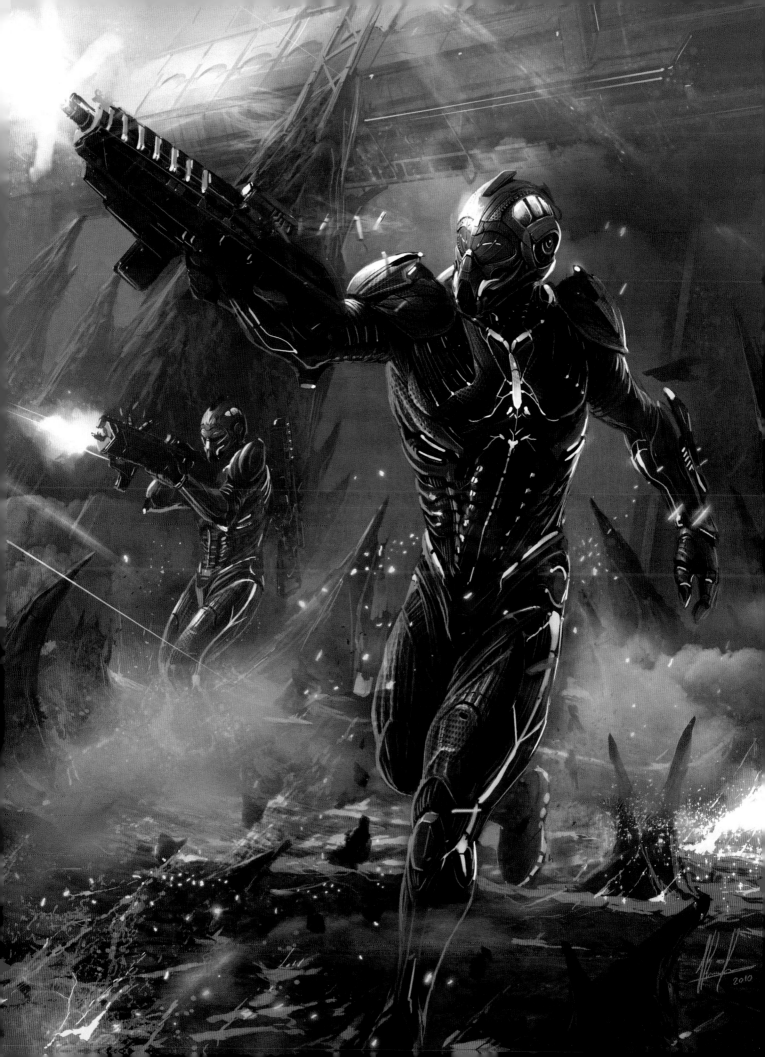

CARICATURES
BY JASON SEILER
SOFTWARE USED: PHOTOSHOP

INTRODUCTION

I have done many tutorials and step by step guides on creating and painting caricatures, and each time I share a different technique of how this is done. This may frustrate some, but I do not have a set way or formula that I stick with. The same things are important each time, like shape, likeness, and values, but the approach may differ. In the end what matters is the final piece.

THE PAINTING

As a subject for this tutorial I chose my friend Ben, who is the owner of Deluxe Tattoo in Chicago. He has a great face and I thought he would be perfect for this demonstration. When I start a caricature of someone, one of the first things I do is make sure that I have more than just one reference picture to work from. I went to Ben's shop and took about fifteen or so pictures of him, from various views and angles. This gives me a solid idea of what his head looks like in 3D. I also have a few skulls that hang out with me in my studio. My favorite skull to sketch with is a small skull that fits comfortably in my left hand as I draw. I bought it at AnatomyTools.com for those of you interested. I don't always draw caricatures

or portraits while holding a skull, but every once in a while it really comes in handy. It is important when sketching a caricature that you understand the structure and foundation of what lies beneath the skin and muscles. So having a small skull that you can hold and tilt with one hand while you sketch is a real advantage.

When starting this piece, I first thought I would do a finished line sketch similar to the style and look of a sketch I recently did of my friend Brian (**Fig.01**). But as I began sketching I felt it would be more interesting to show how I draw and paint caricatures under the tight deadlines that I have to deal with on a weekly basis.

To get warmed up, I decided to draw a few quick thumbnail sketches as seen in **Fig.02**. These sketches were done in two to five minutes each, with the exception of the sketch on the far right. The purpose for these quick doodles is to familiarize myself with my subject. Sometimes it is a challenge to put down the exaggerations and shapes that I see in my head with a drawing or sketch done only with line, as was the case with this caricature. When under a quick deadline I don't usually spend much time sketching the accuracy of the features. Instead I put down a basic shape, and merely suggest where the features will go. Then I begin to block in the shapes with broad brush strokes. I cover ground much faster this way and can easily make adjustments whilst I paint.

But before I get into that, let me explain what I look for when starting a caricature. First ask yourself, what is the shape of your subjects head? For example, Ben's head seems to have the shape of an upside down egg. Next I'll ask myself, where is the weight on Ben's face? Meaning, does he have a higher forehead which would mean that the weight is his forehead? Or does he have a smaller forehead and a larger chin? In this case, I decided that the weight on Ben's face is in his forehead. In fact, he doesn't have much of a chin at all. If you look at **Fig.03**, you will see that I created a rectangle which goes around Ben's head. I then put in a few horizontal lines, first starting with the top of his head, then with one going through his eyes, another just beneath his nose, one through his mouth, another under his mouth, and the last under his chin. This diagram shows the head divided in a way that will help you make your choice of exaggeration a little bit easier, and help distinguish the relationships between the features. This isn't something that I normally do, eventually exaggerating and caricaturing will become natural and you will begin to draw and exaggerate with feeling. If you look at **Fig.03** you will see that Ben has quite a big forehead, mostly due to the fact that he has a receding hairline. Notice how there isn't a big distance between the nose and the mouth, but the space where the nose lies is quite long. Also, if you look at the space from the bottom of his lip to the bottom of his chin, you will see that he doesn't have much of a chin at all. For another

example of this I took a picture of myself and did a ten minute sketch, see **Fig.04**. Notice that similar to Ben, I too have quite a big forehead. But you will also notice a few differences, such as a shorter nose, and the space between my nose and mouth is slightly less than that of Ben's. The space from my bottom lip to chin is greater than the space between Ben's lip and chin. Understanding these relationships will give you a good place to exaggerate from.

Going back to **Fig.03**, after establishing where to put the weight and placement of features, I now question the shape and size of the features in relation to one another. For example, how close are the eyes, are they

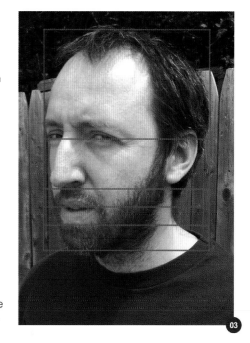

CHAPTER 1

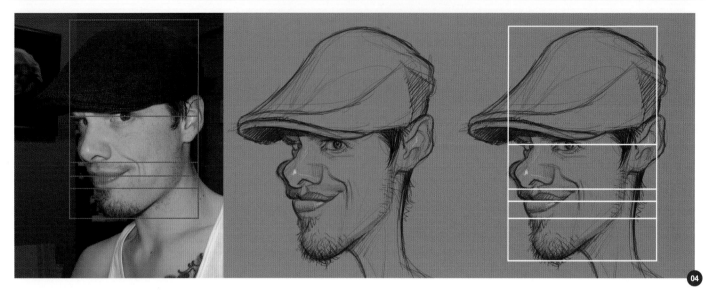

small, sunken, or are they large? What shape are the eyes, what shape is the nose? Are the nostrils large or small, do they have large or small wings? Does the subject have creases or wrinkles on their face, and if so what kind of shapes are they creating? Don't forget about the ears, how big are the ears in relation to the nose and the rest of the face? What shape are the ears? Take a look at Ben's ear in comparison to my own. You can see just how different ears are from one person to the next.

Quick Tip : I believe there are three things that are the most important to get right in order to create a strong and accurate likeness. Head shape, eyes, and the mouth. If any of these are wrong, the caricature's likeness will no doubt suffer greatly. I mainly focus on the eyes and mouth. If you get the eyes wrong you can kiss your likeness goodbye, and the mouth is just as important. Think about it like this. When you talk with a friend or watch someone on T.V., where do you look? I know that I look at the person's eyes quite a bit and when they talk I watch their mouth. What is fun though with both the eyes and the mouth is that they both can be used to enhance expression and character. By accurately exaggerating the eyes and mouth you achieve greater likeness as well as the humor that is necessary in a caricature. After all, caricaturing is exaggerating the truth, or understanding the truth of what you are seeing in your subject and then pushing it further.

Back to creating my caricature of Ben, if you take a look at **Fig.05 – 06** you will see the gradual steps that I saved while blocking in with a round paintbrush. After sketching the thumbnails, I realized that I wasn't capturing what I was seeing in my head, so I decided to move things along by painting in shade and values rather than spending more time drawing with line. I use this time to establish my values, using black, white, and a couple lighter grays that fall in between. I set my brush to 90% flow and 90% to 100% Opacity. At this stage I am only using a round brush, and only

painting with larger brushes. There is no need to use smaller brushes or to zoom in for that matter, don't get caught up with details until later on. As I have decided to draw with large paint strokes rather than thin lines, it means I can capture both drawing and values all at the same time which saves time. At this point I am still painting all in one layer. I usually create a new layer for a small palette of values that I select from while painting. Once I have enough values painted into my painting I won't need the palette, and I delete the layer. To select my values from this point on I use ones that

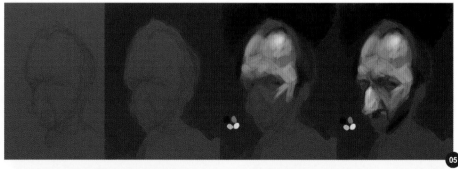

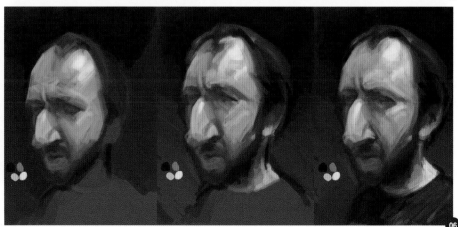

already exist within my painting, and if I have to make any adjustments I make them in the color picker.

If you look at the progression of my value painting in **Fig.05 – 06**, you will notice that I made a lot of changes to structure as well as the placement of Ben's features. My first feeling was to give Ben a much larger forehead, but as I painted I began to realize that I was neglecting the size and unique qualities of his nose, to fix that I quickly paint the eyes higher on the head and extend the length of the nose. It's not that Ben's forehead isn't important, but as I developed the shapes I realized that it was his nose that needed more attention. You may find it helpful to create a list showing the order of importance. In Ben's case the list would be as follows, larger nose that takes up most the face, large forehead, small mouth, and basically, no chin. Once you have the main idea of how your subjects face works, you can then decide how far you would like to push the exaggeration. For this demonstration my purpose wasn't to make fun of Ben, but instead capture his essence. So I decided to exaggerate less. For further options of exaggeration, I did a three minute doodle of a more exaggerated Ben (**Fig.07**).

Values are the lightness or darkness of a color, rather than the actual color itself, and at this stage of the painting I am preparing a foundation of values to build off of once I begin using color. When blocking in my values I slightly close my eyes, blurring my sight so that the detail of what I am looking at is softer. I look

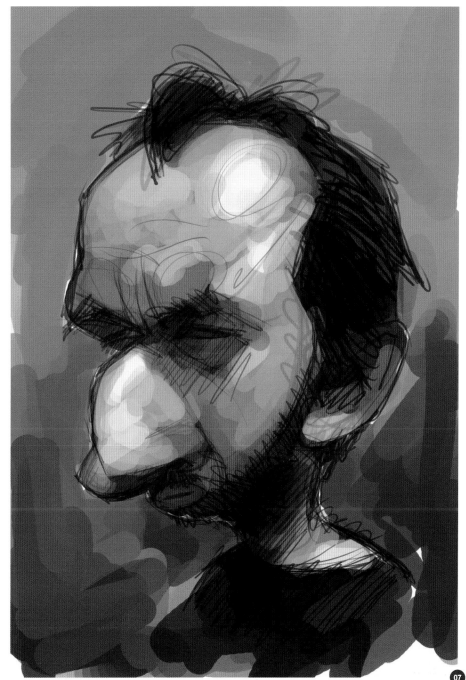

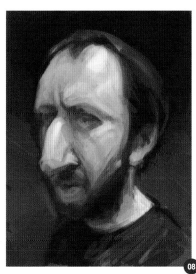

for the darkest darks and the lightest lights. Once I have those established, I block in a few mid tones. You can see that my last version of Ben in **Fig.06** is still very basic there are no real details, only suggested detail. The face and values are close enough to move onto the next stage, painting and finishing in color. The time that I have spent so far on these first steps is about thirty minutes.

By this stage (**Fig.08**) I have prepared a rough black and white value painting, with enough values and structure to move on to the color.

To begin painting in color I create a new layer above my value painting, and fill it with an orange-like brown, specifically 20% cyan, 66% magenta, 67% yellow, and 1% black. I choose this color randomly, depending on how I'm feeling at the time. My reference pictures felt a little cool in temperature and I wanted a warmer painting. Next, I change that layer mode from Normal to Color. Now the orange-like brown is transparent, changing my black and white image into a monochromatic block-in. Next, I extended the left side of my painting, to create a palette and area to mix and create

my colors. A lot of what I do is by feeling, and I know that the most important thing to get right is the values. It's been said that if the values are right, you can pretty much paint with any colors that you want. To create my palette I select the flesh-like colors that were created by layering the orange-like brown over my value painting. Next I select a few more colors that I feel I will need for the painting, like reds and greens as well as black. It is important that the colors I choose harmonize with one another. For example, I won't choose a bright red, instead I'll pick a red that shares the same values and tones as are seen in Fig.08, and likewise with any other color I choose.

Next I create a new layer (**Fig.09**) and fill it with 75% gray. I then go into my filters and select Add Noise. After this I select blur more and I set the layer to Soft Light and bring the Opacity down to 26%. There is no set way of doing this, you will have to mess with these settings to get the look you desire. The reason I do this is to give my digital painting a slight texture that helps it feel less digital and more traditional as this is the look that I prefer to achieve. Without this Noise layer the painting would still look nice, but it would look too slick for my taste. This isn't something that I do on all of my paintings, but I would say that I do it on most of them, some with more noise, and others with just a touch. After this I create another layer that is placed above the orange-like brown layer and under the Noise layer.

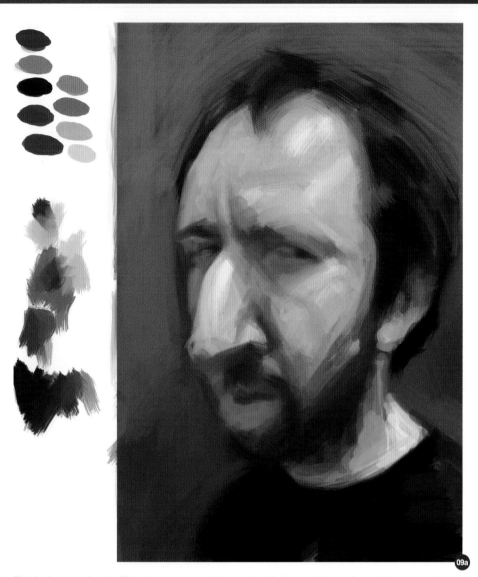

09a

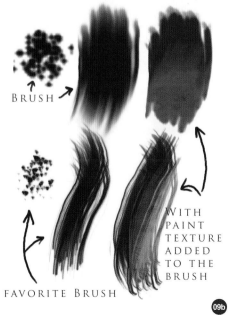

BRUSH

WITH
PAINT
TEXTURE
ADDED
TO THE
BRUSH

FAVORITE BRUSH

09b

This is the layer that I will begin to paint on. Up to this point I have been using a round brush, but at this stage of the painting, I begin to use brush #24 which is a standard Photoshop brush. Years ago my friend Bobby Chiu at Imaginism Studios created a really nice texture that can be used with any brush that has the same texture as real paint. I don't know how to create brushes, so Bobby was nice enough to share this texture with me. So occasionally I will add this texture to brush #24 to give my digital painting a texture like that of a traditional painting. I adjust the levels of opacity to my liking. Sometimes I want a lot more texture, other times, just hints of it (**Fig.09a**). I also use another brush quite a bit, and to tell you the truth, I don't even know where this brush came from. It is similar to brush #24, but a bit more brush like, I call this brush "my favorite brush". You can see in **Fig.09b** that I have begun to

block in the painting quite a bit in comparison to **Fig.08,** mostly using my favorite brush with a bit of paint texture added.

At this stage I am still squinting my eyes quite a bit and focusing on the values, but I am also concentrating on color temperature. I prefer to keep it simple, so I quickly block in a cooler gray-like green into the background. As I do this I purposely let some of the red from the background show through here and there, this helps the painting feel more traditional than digital. My colors at this stage are basic, mostly browns and flesh-like colors to cool and warm where it is needed. At this time I also start to define the features and structure of his face. I locate important areas of the skull to keep in mind as I paint, such as the Superciliary crest (or brow ridge), Temporal line, Zygomatic process of the frontal bone, the Zygomatic

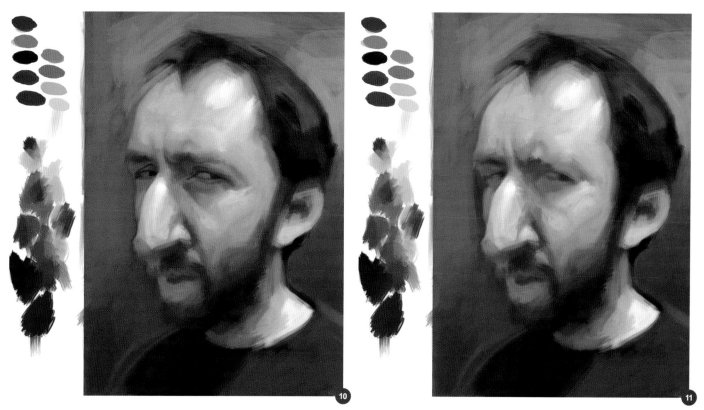

bone, the Orbits, and of course, the Nasal bone. If you don't understand what I am talking about, I suggest you invest in a few human anatomy books, because I find it very important to understand what it is that you are Painting.

I continue the same process of adjusting the face in **Fig.10 – 11**, adding more layers of paint, and making adjustments where they are needed. You can see by comparing **Fig.10** to **Fig.11** that I began to mess around with his

shoulders, and in **Fig.11** I have now started to work on his eyes using a smaller brush. It is important to note that I have not yet zoomed in to detail the eyes they are still more of a suggestion than anything else.

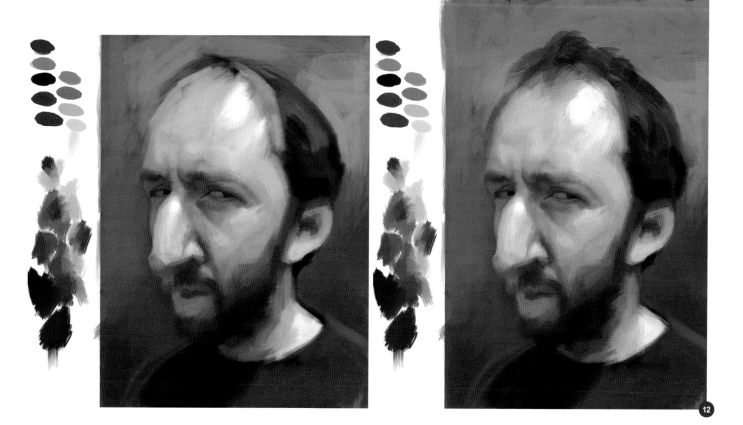

CHAPTER 1

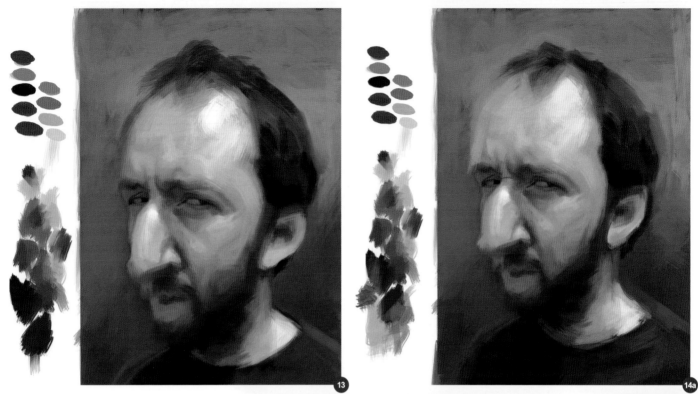
13
14a

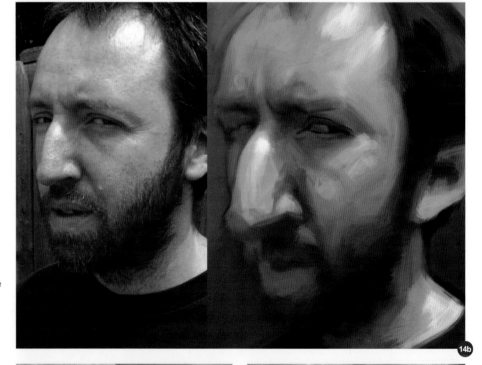
14b

In **Fig.12** I decided to increase the size of the canvas size and add more space around Ben's head, adjusting the composition as well. I also felt that Ben's forehead could use a bit more work as well. This brings us to **Fig.13 – 14**. There are not many things that change between these images, but you can see that I continue to draw and adjust the structure and likeness while trying to mix accurate values and color. Also in **Fig.14** I start to detail and develop Ben's eyes (**Fig.14a – c**). Up to this point I have only used large brushes and have painted from a distance. To paint the eyes I zoom in and begin to use smaller brushes, but my technique hasn't changed at all, the only difference is that I have to now slow things down a bit in order to focus on the details of the eyes. This is the part of the painting where you need to be patient. I can easily spend a couple hours just painting eyes, but for this painting I wasn't interested in a photo realistic look, instead I wanted to end up with an image that looks realistic yet painterly. I enjoy brush work and work hard to create brush strokes that are pleasing to the eye. You may notice that there are all sorts of soft edges, and a lot of subtle changes in color and value? In the photo reference in **Fig.14b**, you can see that there is a variety of colors. Don't let this overwhelm you. To simplify I again squint my eyes and

14c

14d

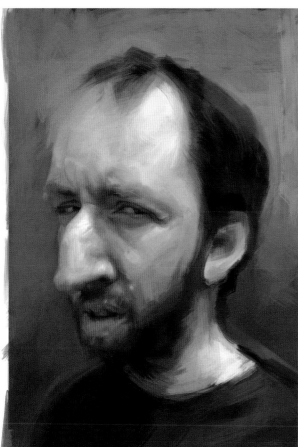

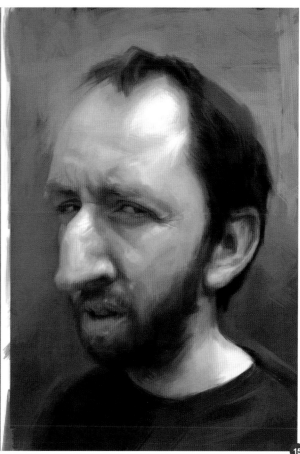

15

as the photo blurs, the colors unify and pull together. Those are the colors and values that I focus on.

Continuing on to **Fig.15**, you will notice that I develop the areas around the eyes a bit more but also begin to work on the nose, mouth, and ear. I don't stay in one particular area for more than a few minutes or so. Rather than just finishing one of the features, such as the nose or mouth, I prefer to move back and forth between the features. This way I can see how the painting is coming together as a whole. This is important as you don't want to overwork one area over another.

Moving on to **Fig.16a**, I no longer have a need for the palette of colors that I created on the left side of the painting. From this point on, I will use the Eye Drop tool and eye drop colors that already exist within the painting, and adjust the values by going to the color picker. You will notice that I have begun to add details such as pores in Ben's nose (**Fig.16b**). For this I switch back to a soft round brush. Remember, my intention isn't to create a photo

realistic painting, but instead a painting that feels and looks more like a traditional painting. So instead of getting in there and painting every single pore and crease, I merely make suggestions.

This is the fun step, painting hair. I love painting hair, there is always an opportunity to add humor and character just in how you paint the hair. For the majority of the steps, you will notice that the hair and facial hair were solid shapes of color. I always wait until the end of a painting to add details such as pores and little hairs. I start detailing only when I am happy with my colors and the values, and when the eyes, nose, mouth and ears are finished. To paint the hair, I created a new layer above my main layer and switch to a soft round brush. I make sure that Shape Dynamics is clicked on giving my brush a point. After selecting the colors that I want to use for the hair, I begin painting in small hairs on top of what I have already blocked in. After I put a layer of this down, I select the Blur tool and set it to about 20% and then lightly pass it over the layer of hairs. I then select the Eraser tool and turn the

Opacity to at least 50%, and make a light pass over the hairs. What this does is soften the hairs slightly and push them back a bit into the painting. Repeat this process a few times to create depth (**Fig.17a – b**).

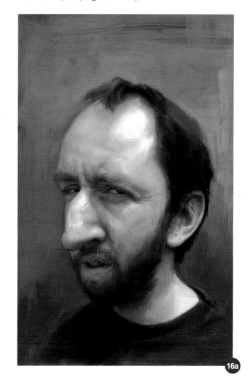

16a

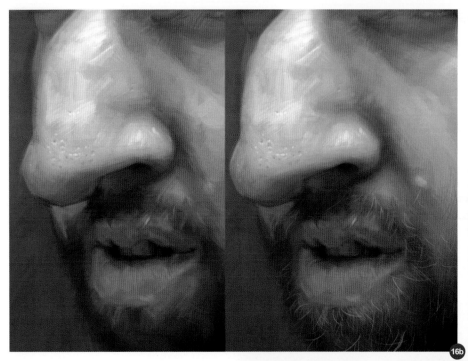

16b

17a

To bring my painting of Ben to a close, I make a new layer and set it to Multiply (**Fig.18**). I continue to use a soft round brush, but click off the Shape Dynamics option. To create freckles, I eye drop the color of skin that I will paint the freckles on, and then randomly paint in freckles of all sizes and shapes. Once I am finished, I select the Eraser tool and lightly pass it over the freckles until they are softened into the skin. I felt that his hair still needed a little more work, so I created another layer for hair and repeated the steps I mentioned for **Fig.17**, adding more hair to the back of his neck as well as to his beard and neck. Once the painting is to a place where I feel it is finished, I like to zoom out so that I can see the painting from a distance and see how it looks at a smaller size. I will also flip the painting horizontally as well as vertically to see if anything strange catches my eye. After my approval, I sign the painting and call it a day.

I am so honored to have been asked to do this step by step. I do not consider myself to be a master of anything, instead i think of myself as a student for life. I will continue to work hard and to push myself to learn new and better ways to create my art. It has been a passion of mine ever since I can remember, and I hope that what I have shared here will inspire and re-fuel your passion for art, whether you are interested in caricature or not.

17b

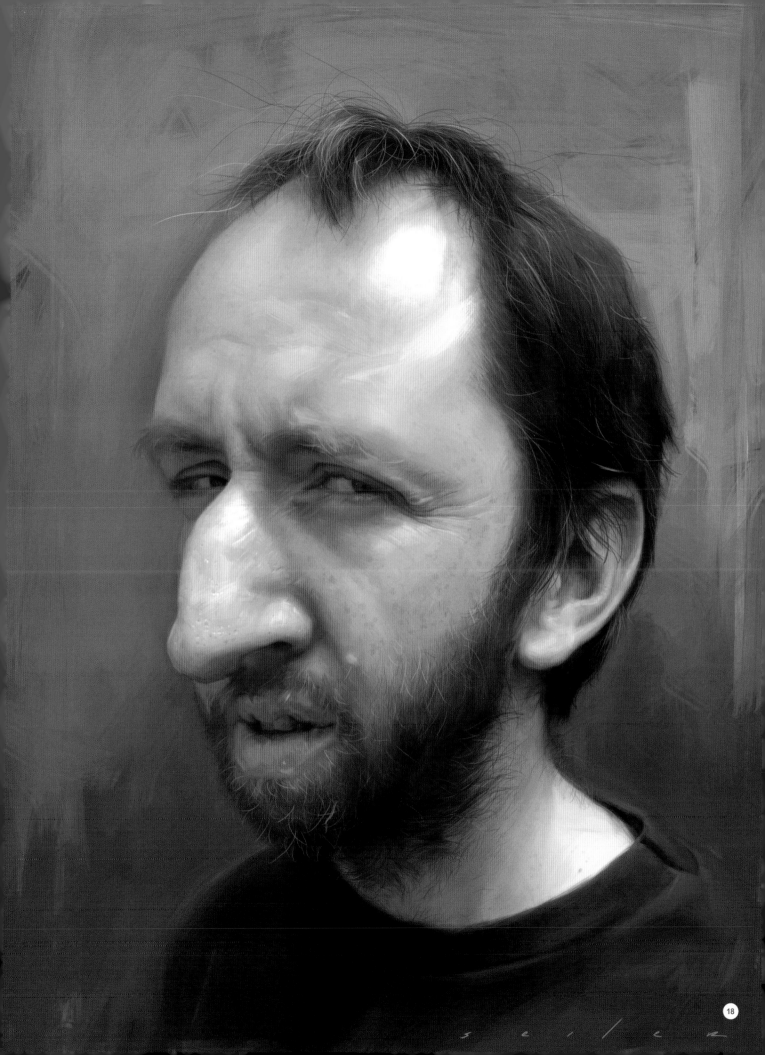

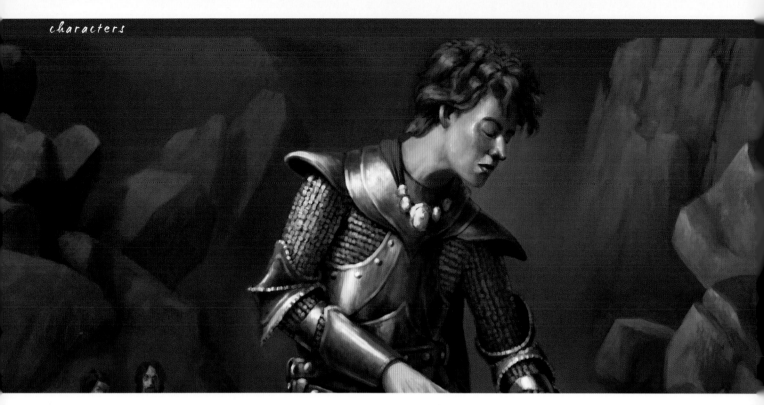

KING ARTHUR AND EXCALIBUR
BY SIMON DOMINIC

SOFTWARE USED: ARTRAGE, PAINTER

INTRODUCTION

For this medieval tutorial I've chosen to depict a scene from one of the Arthurian legends. I wanted to show Arthur about to withdraw the great sword Excalibur from the boulder, and demonstrating his worthiness as king.

A couple of years ago I might have been tempted to tackle this piece in a more dynamic way, showing Arthur in the act of hefting the sword, chunks of rock flying in all directions and onlookers staggering around

in amazement. Since then I've learned that sometimes a less direct approach works best, so here I've recreated the scene immediately before the act. We see Arthur quietly confident reaching out to grasp Excalibur, whilst in the background an audience made up of failed challengers lounge contemptuously, scornful of the idea that this upstart can accomplish such a momentous task. In this way the anticipation of the viewer should provoke a stronger reaction than would a portrayal of simple dynamism. That's my theory anyway, and I'm

sticking by it. The piece is created digitally, starting in ArtRage 3 Studio Pro and moving on to Painter 11.

SET UP THE CANVAS

In ArtRage I set up a new canvas. I start small – 826 x 1141, which is 1/3 the final size – although soon I'll be upsizing in order to add detail. I create the canvas with a fairly rough texture so that my initial pencil sketches will more resemble traditional media. I also set the background to a light buff color because I find pure white too overpowering (**Fig.01**).

MAIN CHARACTER OUTLINE

Arthur is very much the focus for this piece so I draw him big and bold in the foreground. I use only a few lines at this stage because I want to get the overall outline sorted before I start sketching detail. I show him as young and somewhat on the weedy side, reinforcing the idea that nobody could reasonably expect him to succeed in his task. In the background I include the outlines of the three watching knights. Again, no real detail here but I'm careful to make their stances look natural, projecting the knights' mood clearly even though they are minor characters. One knight is muttering to the other, "Why is he wasting his time?" whilst the third one can't even be bothered to get up and watch what's going on, preferring to simply sit and smirk (**Fig.02**).

SKETCH THE ENVIRONMENT

With quick, bold strokes I outline the mountains and surrounding rocks and, most importantly, Excalibur itself, embedded in stone (**Fig.03**).

UPSIZE

Having outlined all the desired elements I upsize the image to its final resolution of 2480 x 3425 (**Fig.04**).

SKETCH DETAIL

Here I use a few references I found on the web in order to make the characters' garments

believable. My primary reference is the 1903 painting "King Arthur" by Charles Ernest Butler. It's important to remember that referencing should not mean straight copying. In this instance I use Butler's painting mainly as a clothing reference and not a base for the pose or composition. I sketch the detail onto a separate layer. That way, when I'm done, I can erase the initial rough sketch. Not essential but I find it quick and tidy (**Fig.05**).

TONAL UNDER-PAINTING

Tonal under-painting is basically just shading the values – the lights and darks – to better define the composition and solidity of the image. This can be done using the Pencil tool or, as I've done in this case, a dry brush. I paint onto the canvas underneath the sketch so that the sketch is still visible. When I'm done I drop the outline layer onto the canvas ready for painting (**Fig.06**).

SET UP THE PALETTES

I find it very useful to do most of my work from a set palette. Moving to Painter I dab my desired colors onto the Mixer Palette. When I'm happy with those colors as a base I'll create a Color Set Palette using the Create Color Set from Mixer Palette option. This takes care of about 80% of my color usage. For the rest I'll just add colors to the Mixer Palette as required during the course of my painting. I will be staying in Painter from this point on. I like to

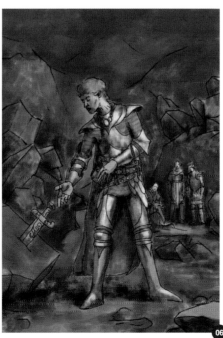

CHAPTER 1

alternate, on a piece-by-piece basis, between ArtRage and Painter for color work because both have their strengths. I find ArtRage is by far the most authentic tool for emulating natural oil media whereas Painter is quicker and more forgiving for oil work, and allows greater control over small detail (**Fig.07**).

BEGIN WITH THE MAIN FOCUS

You can start coloring anywhere but I usually begin with the primary focus, which in this case is Arthur's face and upper body. I use the

Artists Oils brush set to about 10 pixels. Guided by the tonal under-painting I concentrate on getting the lighting looking believable and consistent. At this stage I don't concern myself with smoothing or fine detail (**Fig.08**).

PAINTING METAL

Using Butler's painting as a partial reference I make Arthur's armor sleek and slightly golden-looking. When painting reflective metal like this bear in mind not just the direction of the main light source but also the lesser reflections from the environment. These needn't be especially

accurate but if they are not included the metal tends to look dull, like stone. Arthur's armor is unmarked in order to reinforce the idea of a young, inexperienced character (**Fig.09**).

CHAIN MAIL

Chain mail, viewed at mid-distance, is easy to paint. First, paint the area in a uniform dark color. Then, pepper the area with a series of dots, aligned across the chest and down the arms. In the same way as the metal armor reflects the light, each of these dots must be lit according to how much light it reflects. However, rather than picking a new color for every dot, I go over the same area several times, each time with a brighter color and each time covering less of the area. At this stage you'll note I flip the image horizontally. There's no particular reason for this, I just prefer it this way around (**Fig.10**).

REINFORCING AREAS OF INTEREST

Renowned oil painter James Gurney refers to this as 'counterchange' and it's basically the way in which key elements of a painting area can be tonally contrasted with their background. For example, the left side of Arthur's face is in shadow so I've lightened the local background in order that his features stand out. If you look at his hands, which are brightly lit, you can see that in both cases their immediate background is dark, therefore enhancing the hands' appearance and making them 'pop' (**Fig.11**).

SECONDARY CHARACTERS

Despite these characters being in the background they are still very important in setting the scene. We don't want to make them stand out too much but at the same time we don't want them to get lost in the environment. Therefore I use the minimum amount of detail I can get away with in order to convey their mood and appearance. Also, I ensure that they are partially in shadows and that the sunlight that does fall on them is weaker than the sunlight that falls on Arthur (**Fig.12**).

ATMOSPHERIC DEPTH

In order to stop the image looking flat we need to give it some depth. I do this by decreasing the contrast for distant objects and lowering their saturation so that they appear to have a bluey/greeny tint. In addition I paint the background more loosely, saving the intricate detail for the foreground and areas of interest. When painting the landscape, and indeed any part of a picture, a good tip is to use the largest brush you can get away with. So, whilst I may use a 10 pixel or less brush for Arthur's facial features, I use a 100 pixel brush for much of the misty, mountainous backdrop (**Fig.13**).

THE SWORD

This image needs careful handling because it has more than one area of interest, or focus. The main focus as we've seen is Arthur himself, specifically his head and upper torso. The secondary focus is comprised of the watching knights but we also have another secondary focus, that of Arthur's reaching hand and the sword Excalibur. For this reason I paint

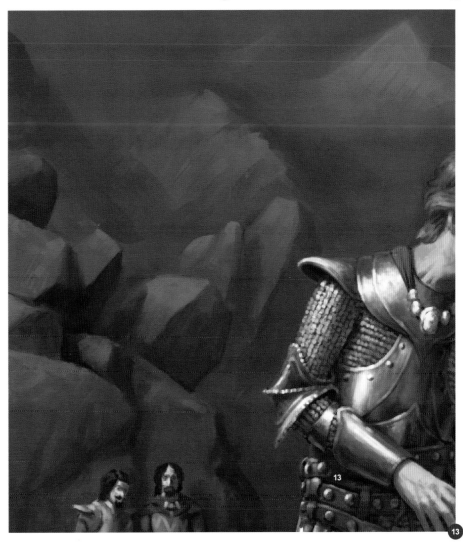

CHAPTER 1

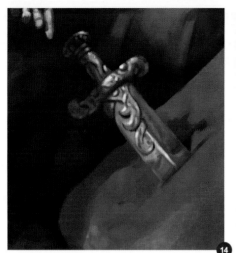

the sword boldly, although not too boldly as we don't want to overwhelm the main focus and therefore confuse the image. I also add a shadow to the rock and the sword handle. This helps place the sword in relation to Arthur, reinforcing the idea that he's just about to grasp it. Whilst I'm happy with the metallic look of the sword it's looking a bit bland so later I'll come back and jazz it up (**Fig.14**).

ENVIRONMENT

At this stage most of the detail is complete so I move on to the environment. Using stronger, more saturated colors for the foreground I use a medium-sized brush to define the rocks and earth. I also add a bit of water between Arthur

and the knights. Note that the water uses the same colors as are present in the landscape, on account of water being mostly colorless and taking its color from reflected elements of the environment, e.g. rocks, sky and in this case the lower portions of the three knights (**Fig.15**).

CLOSE-UP DETAIL

For the rocks closest to the viewer I add detail using a smaller brush. Selecting relatively bright hues I apply only a small amount of pressure so that a rocky texture is suggested. Again, I'm always mindful of the location of my primary light source so that consistency of lighting is maintained (**Fig.16**).

BACK TO THE SWORD

I decide to make the sword's handle look like it's forged from gold, with emerald inserts. A very unwise choice for a sword handle, being about as appropriate as clay or balsa wood, but as this is fantasy we're allowed a little leeway (**Fig.17**).

THE FINISHING TOUCHES

Using very light pressure on one of the default blenders I dab at the rough areas around Arthur's face and hands, so that the skin looks soft rather than scaly. I then move around the whole of the image and tidy up any loose ends I find (**Fig.18**). And that concludes the tutorial - hope you've found it to be some use!

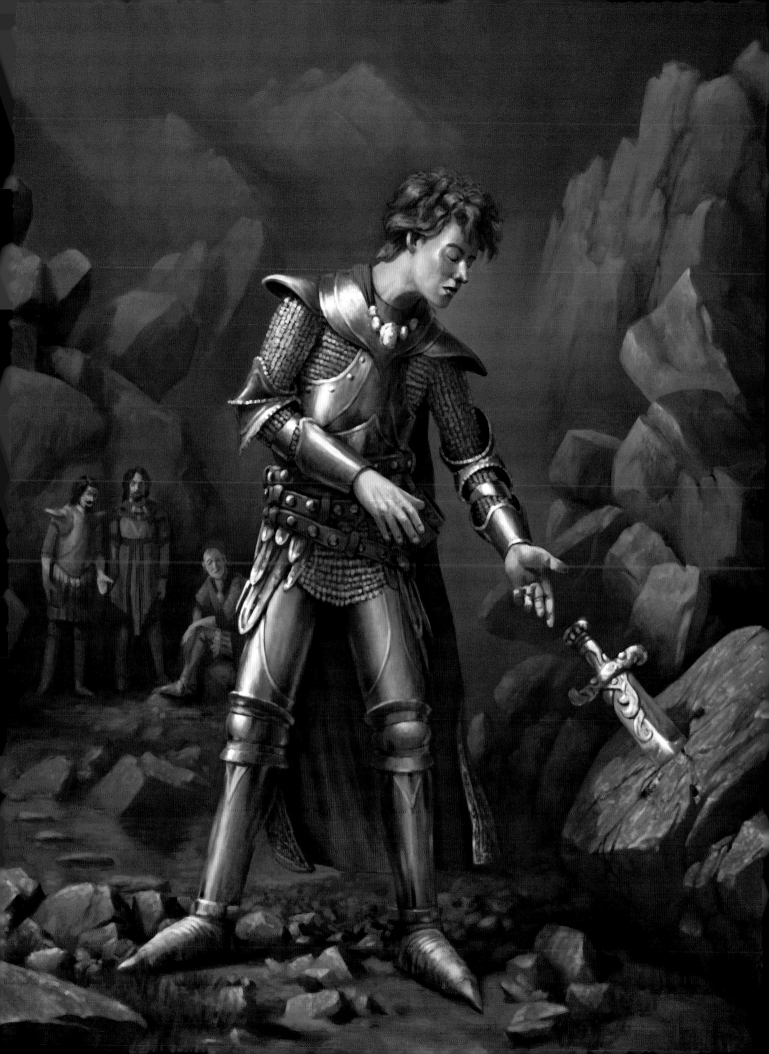

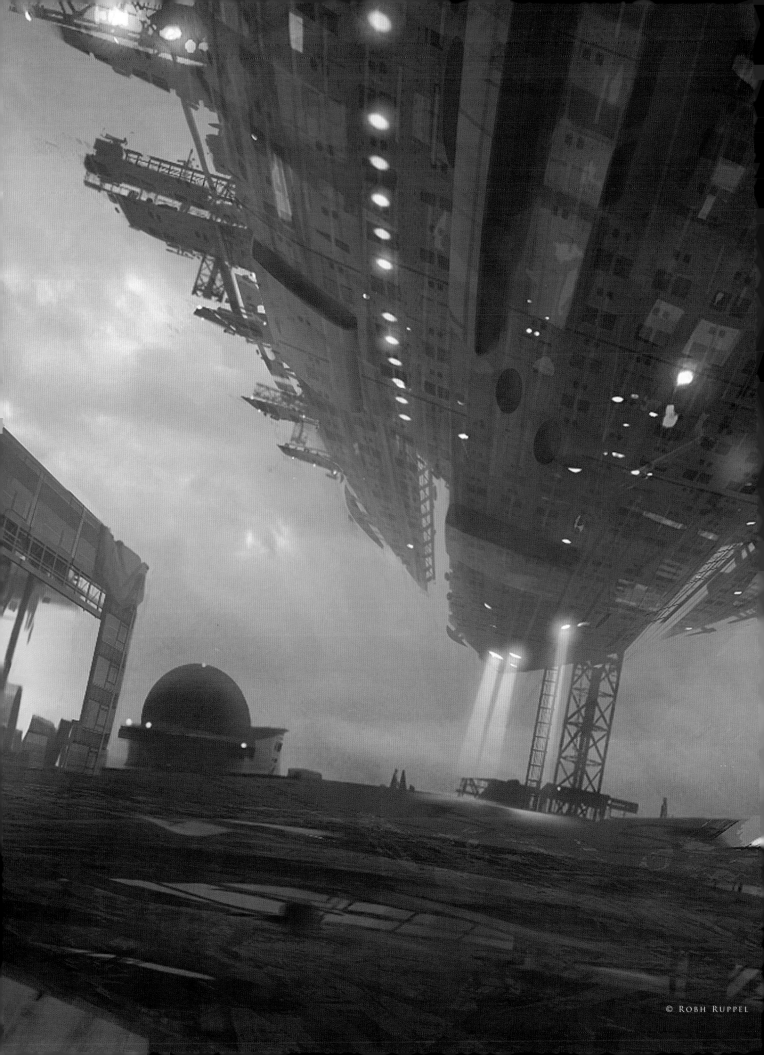

© Robh Ruppel

science fiction

Sci-fi is one of my favorite genres, probably because it leaves a lot of room for invention. It has to look real, and still follow the same laws of light interaction and good design, but the sky is the limit, no pun intended. Good sci-fi is really just good design. Patterns, rhythms and proportion still matter but the forms can take on a new and never before seen appearance that is familiar, yet different.

The digital tools today's artist has to work with are amazing in their breadth and scope, BUT as Syd Mead is fond of saying, "idea trumps technique". Meaning all the custom brushes in the world won't paint the picture for you. It still takes an artist with a unique idea to catch the world's attention.

ROBH RUPPEL
robhrr@yahoo.com
http://www.robhruppel.com

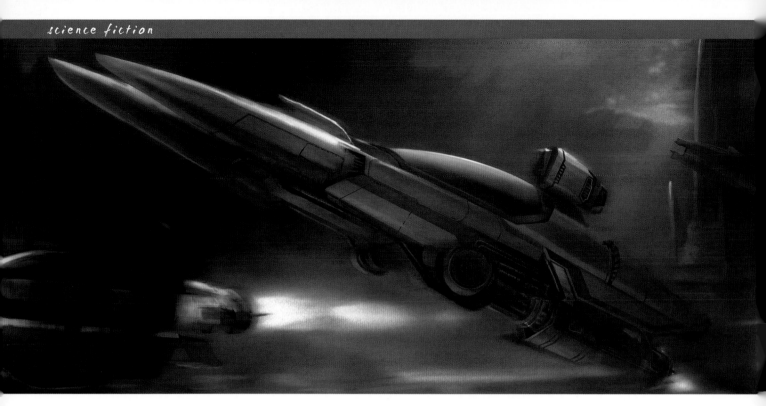

SCI-FI VEHICLES – SPACESHIPS
BY CHEE MING WONG
SOFTWARE USED: PHOTOSHOP

INTRODUCTION

In each segment of this tutorial we will consider simple traditional techniques and discuss design and function first and foremost. Effective design is being able to fully translate your ideas in an accurate and inspiring manner towards the recipient, be it a 3D modeller, game designer, art director or a member of the public (**Fig.01**).

FORM & FUNCTION

Space transport comes in all forms and can generally be split into the following:

- Geometric
- Industrial and angular (functional)
- Organic and xenomorphic

The other aspect to consider is whether the overall shape is symmetrical or asymmetrical. Therein lays the challenge: to produce a convincing design in whatever shape, form or symmetry.

For the purposes of this tutorial, let's consider a functional and partially geometric function.

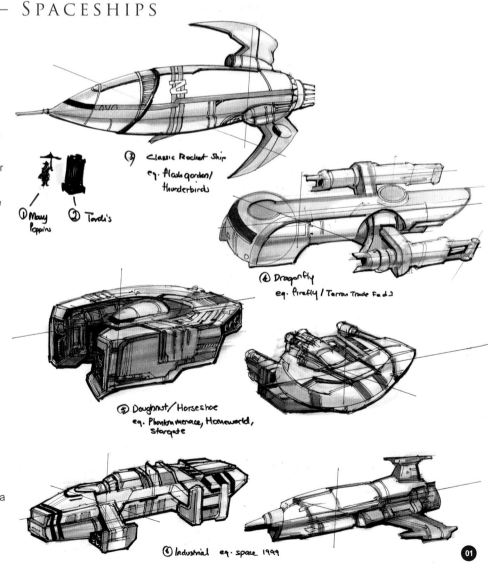

① Mary Poppins
② Tardis
③ Classic Rocket Ship eg. Flash gordon / thunderbirds
④ Dragonfly eg. firefly / Terran Trade Fed 2
⑤ Doughnut / Horseshoe eg. Phantom menace, Homeworld, Stargate
⑥ Industrial eg. space 1999

01

Fig.01 illustrates various classical and retro spaceship designs currently known in popular culture.

- **Mary Poppins** (1) – Yes, I consider her to be an android in disguise as a super nanny (how else can one explain her anti-gravity vertical takeoff and landing capabilities, via an umbrella?)
- **Tardis** (2) – An unconventionally shaped spaceship of the time lords (where the insides are larger than the exterior due to non Newtonian 4-dimensional capabilities)
- **Classical Space Rocket Ship** (3) – e.g. Flash Gordon
- **Dragonfly/Animal shape** (4) – e.g. Firefly/ Terran Trade Federation
- **Doughnut/Horseshoe** (5) – e.g. Phantom Menace/Homeworld/Stargate
- **Industrial** (6) – e.g. Space: 1999/Aliens/ Pitch Black
- **UFO/Saucer** – e.g. Independence Day
- **Cigar-shaped/Jet fighter-shaped** – e.g. Buck Rogers/Battlestar Galactica/Star Wars/Thunderbirds

Let's next consider a fictional spaceship manufacturer, Azora Dynamics, who will be designing and producing a multipurpose and modular space transport. This can be used for civilian purposes, law enforcement or even deep space racing and must carry one to two passengers, and can be used for atmospheric re-entry. In terms of technology, gravity has a minimal effect on this space transport, but during atmospheric flight, tiny aerodynamic adjustments may provide small advantages, crucial for racing.

PROTOTYPING

Traditional Tools Required: Biro/pencil/ink gel pen, paper (any kind) and imagination (as standard).

First of all, let's consider various forms for our single/twin seater transport (**Fig.02**). You can explore these designs in a side view or as shown in 3/4 perspective view.

These images were rendered with a mixture of a cheap 37p biro and thick 0.7 gel ink pens. I find it particularly effective to use stripes and

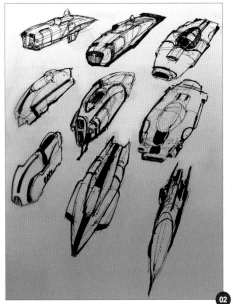

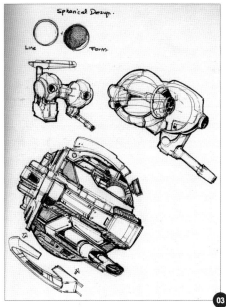

marks across a vehicle, or along its frontal/ posterior axis, to suggest form (**Fig.03**).

In the designs shown in **Fig.03**, various cockpit configurations and some degree of asymmetry are included within the designs. Once the initial form is considered, it's sometimes useful to consider the internal mechanics underneath the external cowling armour plating (as shown in the singular sphere design in **Fig.03**).

DESIGNING THE PROTOTYPE XA-332

Having decided upon the overall form to be a cigar-shaped shell, reminiscent of the historic

1950 Grand Prix Formula One front engine racing cars, let's attempt to spruce it up towards a probable function and purpose for space based racing.

In the exploded schematic (**Fig.04**), a finalised view of the fictitious XA-332 is rendered using digital markers and marker paper.

USING MARKERS: A SIMPLIFIED INDUSTRIAL DESIGN APPROACH

Traditional Tools Required: Cool gray markers 20%, 30% and 50%, Pilot G-Tec-C4 0.25 and 0.4, Pilot G-2 0.7

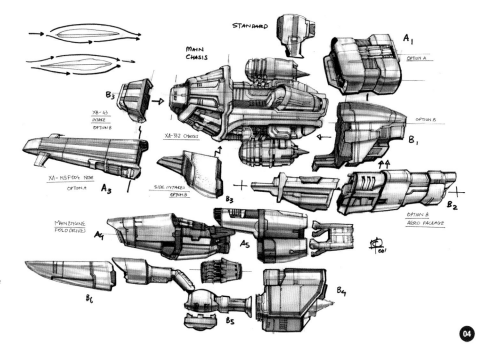

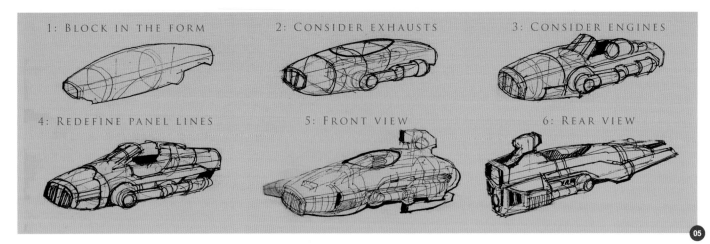

1: BLOCK IN THE FORM

2: CONSIDER EXHAUSTS

3: CONSIDER ENGINES

4: REDEFINE PANEL LINES

5: FRONT VIEW

6: REAR VIEW

05

Recommended Paper: Any high quality bleed proof marker pad, e.g. Letraset.

The trick here is in the wetness of the mark! Working with markers, one has to work quickly and rapidly, whilst the mark is still wet. This allows you to graduate your various tones (normally I use a gray tone of 20%, 30% and 50%, primarily) repeatedly over one to two passes, and then lock the design down in ink (I prefer using Pilot 0.4 Hi-Tec-C/G-Tec-C4 pens). Shadows and stripes on the other hand are best done with gray 70%, produced in one single pass.

For inspiration and reference, one can refer to the great concept art markers rendered by Doug Chiang and Feng Zhu. From various experiments, I find it easiest to do as follows:

• **Basic form and perspective** – Loosely mark down the overall form using a 10-20% cool gray marker. Take note to plan your vertical and main axis. Don't worry about leaving residual marks or unsightly construction lines; the whole idea is to communicate your overall form using the values established by your marker pens.
• **Tonal values** – Next, whilst the markers are still moist, proceed to lay down your tones using 30% and 50% cool gray markers. You need to ensure you have a relatively good idea of your light source to enable you to show reflectivity. Some simple observation of how light forms bands on a cylinder or a shiny parked car can provide immediate and simple reference.
• **Overall form** – You want to outline your

design now with your smallest ink pen available. If available, use a fine tip 0.25 pen to ghost the various outlines.
• **Accentuate your lines** – You can further accentuate this with a 0.4 diameter pen, ensuring that you start blocking in further details, panel lines and considering how various parts may interlink to form logical but functional shapes.
• **Research and Knowledge** – These designs do not require a Master's degree in engineering, but some rudimentary knowledge of how transport is put together, and can be front, rear or mid-engined, will be helpful.

BASIC DESIGN

Traditional Tools Required: Biro, pen or pencil.

Let's now look at how we can approach the design of a semi-elliptical and cylindrical object (**Fig.05**).

1. **Blocking in the Form** – Ensure the main axes are drawn first, to suggest a horizontal and vertical axis relative to the perspective plane you intend to use. Then roughly outline how you would like the overall form to appear. This ensures that a modeller can understand how the form is lathed on both sides, and whether the form is symmetrical or asymmetrical.

2. **Consider Exhausts** – Next, try to consider if there are any external ports, engine exhausts or thrusters. These will suggest how the transport will be propelled.

3. **Consider Engines** – Most of the time the engines will not be obviously shown externally, and it may seem strange to consider it at this point. However, if you consider very simply if it will be located in the front, mid or back, then this allows you to determine where aspects such as seating, cockpits and avionics, electronic equipment and countermeasures can be located.

4. **Redefine Parallel Lines** – This last step means to add panel lines in parallel to the main axis, and also to add smaller details such as access hatches, further panelling and plated areas.

ENGINES

Engines form a distinctive character towards any form of transport, in particular aerospace related vehicles. There are a whole host of engine types that can be categorized into two types: funnel-shaped and needle-shaped. Both may incorporate small adjustable fins to better control and direct thrust. In addition, engines tend to feature smaller sets of piping and tubes that regulate fuel, an oxygen/fuel mixture and combustion, as well as multiple pressure valve controlled feedback loops.

Within our designs, we'll stick primarily to circular exhausts, although they may be housed in different shaped external housing – as both an aesthetic/aerodynamic consideration.

XA-332 SUNRED PROTOTYPE

Let's take a look at some shapes and designs for the XA-332:

- **Fig.06** – Three part process illustration of the working mechanics of the XA-332 from inwards to out.
- **Fig.07** – Shows the low shot view of the XA-332 side.

If your design is going to be considered for production or initial 3D prototyping, then it's useful to consider breaking the design up into three parts (**Fig.06**), as follows:

- Internal engine and mechanics
- External frame/exoskeleton
- Full armor plating and final external form

Much like dissecting is required to understand the anatomy of a species, of bone, muscle, organs and flesh, we can use a similar analogy to understand transport design, such as:

- **Organs** – Are analogous to the combustion engine.
- **Fuel** – Is analogous to the blood.
- **Bones** – The underlying main skeleton that holds the frame of the machine together.
- **Flesh** – Analogous to the overall rigid skin of a machine.

From the inside working our way out we have as follows:

- **Bare bones** – Depicts the internal working mechanics, engine and basic cockpit.
- **Cowling** – Depicts the internal frame that shelters the mechanics above and provides basic protection.
- **Full frame** – Shows the full external view

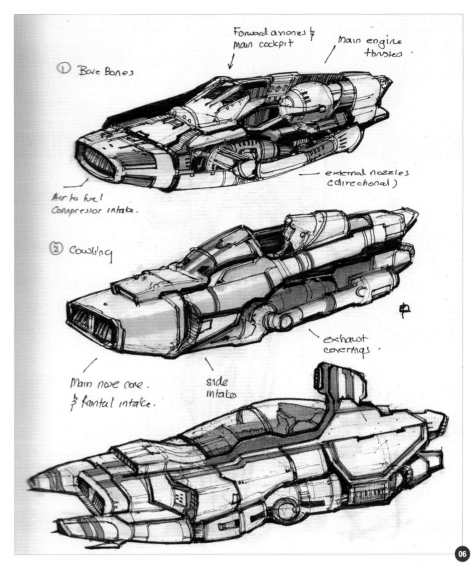

that is hardened and built to withstand the various extremities of the environment.

PRODUCTION READY
Once the final key designs are accomplished, it's time to produce the finalized marker

designs (**Fig.08**). A frontal and rear 3/4 perspective view are chosen to illustrate the XA-332. All the basic steps are employed, only this time we wait for the markers to dry out before adding in further details, and give it a second pass of markers and inks.

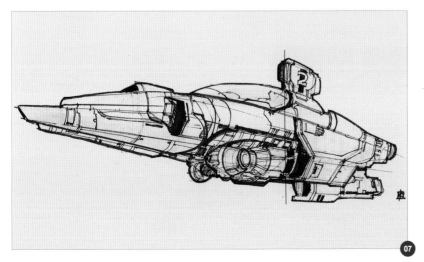

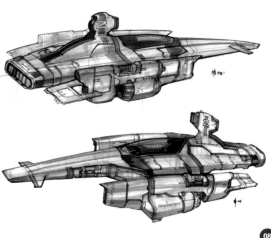

To finish up, included are three additional variant designs that explore different engine designs or placements and accentuate the overall feel (**Fig.09**). In this instance, the best designs are still the earliest designs for both the XA-332 and Sunred transport.

To finish off, you can scan in all your marker designs and present them in a logical and clean fashion (**Fig.10**).

STORYBOARD 101

We're two-thirds through our workshop and the end is in sight. Well ... almost! Before

we present our designs to the head chief of engineering for consideration of use for a production model, it would help if we could imagine this transport being used. As such, we can rely again on simple basic techniques: storyboarding (**Fig.11**).

In **Fig.11** there are five different views of a space race taking place on the surface of a planet/moon. With each panel, try to use one to two keywords to describe the scene. In fact, because it is so minimalist, the headline words can accentuate the story with great impact. For

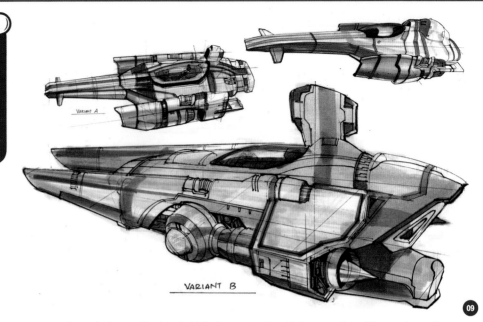

VARIANT A

VARIANT B

09

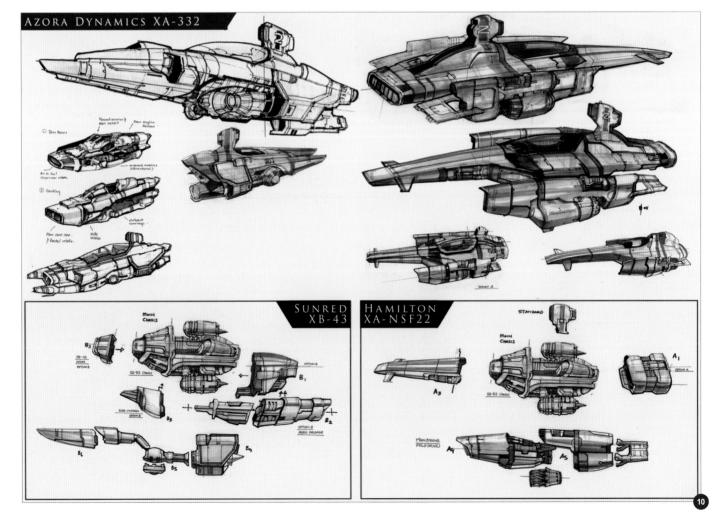

AZORA DYNAMICS XA-332

SUNRED XB-43

HAMILTON XA-NSF22

10

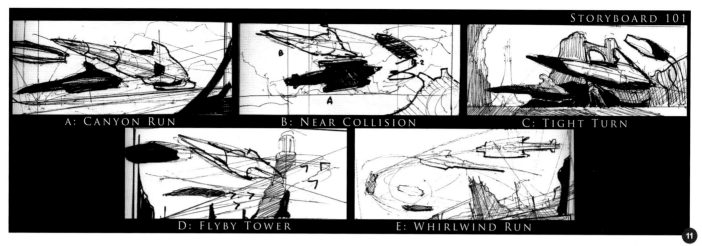

STORYBOARD 101

A: CANYON RUN B: NEAR COLLISION C: TIGHT TURN

D: FLYBY TOWER E: WHIRLWIND RUN

our illustration, I would like to go for a mixture of A (Canyon Run) and C (Tight Turn) set on a desert surface of a moon.

SPACE CANYON RACE ILLUSTRATION

Great, so now that we have spent all this time preparing for our final illustration and all the steps are in place, ensure that all the key transports are scanned in and cleaned – it is the clean crispness of the edges that determine how successful the final image is.

In addition, be prepared to lose some of the original lines for a more logical layout.

- **Perspective and Layout** – Using the established designs and storyboards, lay out the composition grid and align vehicles accordingly (**Fig.12**). Save these grids on a new separate layer, which you can turn on/ off at will.
- **Establish Horizon Line and Perspective** Add vehicle drawings on new layer set to Multiply. Clean the edges and make clean selections of the overall form to save as an Alpha Mask (**Fig.13**). Next, establish the background plane using flat washes.

I have taken the liberty of ensuring that there is both a diffuse light source pooling down the centre, and a vague shape of an observation tower (far right) and large looming structure in the far distance (far left).

Bring your vehicles into the image (on a separate layer), and do check again that their outlines are saved onto an Alpha Mask/

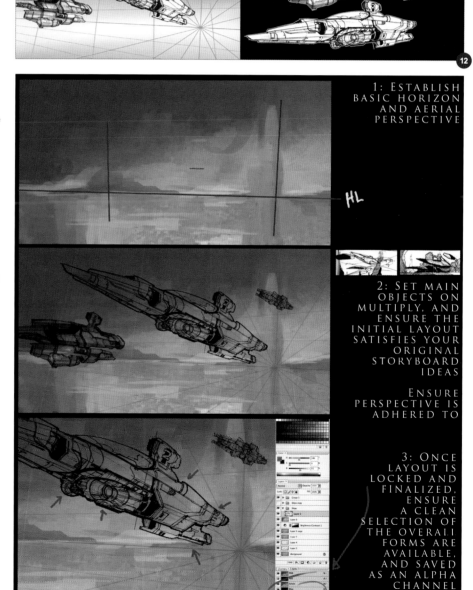

1: ESTABLISH BASIC HORIZON AND AERIAL PERSPECTIVE

HL

2: SET MAIN OBJECTS ON MULTIPLY, AND ENSURE THE INITIAL LAYOUT SATISFIES YOUR ORIGINAL STORYBOARD IDEAS

ENSURE PERSPECTIVE IS ADHERED TO

3: ONCE LAYOUT IS LOCKED AND FINALIZED, ENSURE A CLEAN SELECTION OF THE OVERALL FORMS ARE AVAILABLE, AND SAVED AS AN ALPHA CHANNEL

CHAPTER 2

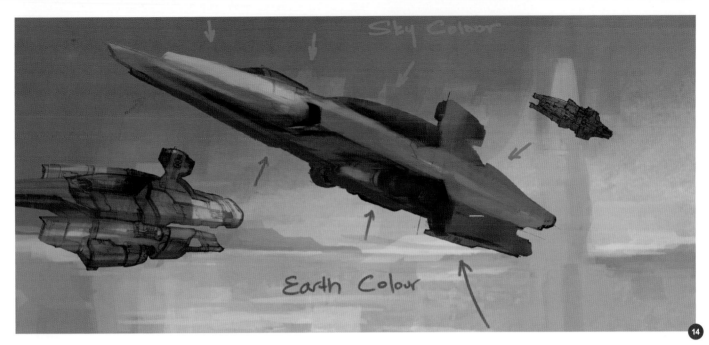

Channel, as you will be constantly reusing this throughout the whole illustration.

COLOR TONE: EARTH & SKY COLOR

Once the vehicles are included, you need to consider how to color and light them. Observe images of Formula 1 cars, for example, and then consider how the light reflects off shiny surfaces. (**Fig.14 – 15**):

• **Block in** – Select your main transport and provide a flat wash of tone. This is painted directly on a new layer above your lined art, and this is where Form and Line are in transition.

• **Warm and cold** – Once the general shapes are blocked in, you can give light and shadow to your objects (**Fig.14**). In general, a shiny metallic surface reflects a sky tone (whatever color the direct

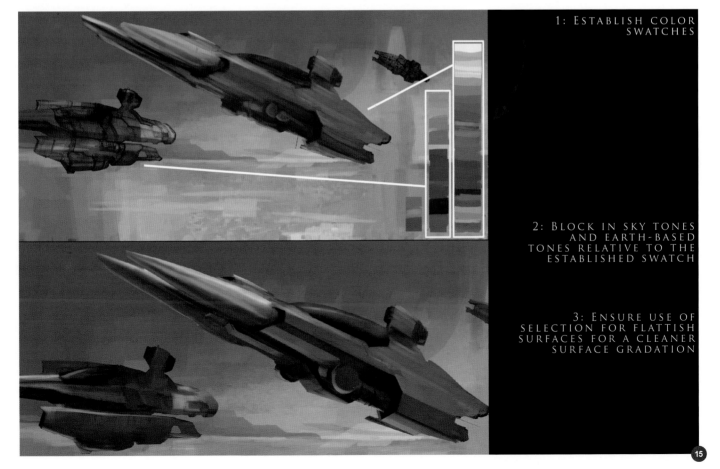

1: ESTABLISH COLOR SWATCHES

2: BLOCK IN SKY TONES AND EARTH-BASED TONES RELATIVE TO THE ESTABLISHED SWATCH

3: ENSURE USE OF SELECTION FOR FLATTISH SURFACES FOR A CLEANER SURFACE GRADATION

ambient light is above), and similarly the underbelly/underside reflects an earth tone. Sometimes the reflected or bounced light for the earth tone can even be as bright as the direct light.

- **Establish a swatch/palette** – Once the basic forms are blocked in, it can be useful to establish a color palette for use (**Fig.15**). This is like an immediate color guide (paint by numbers) to apply from areas above and below. Once you have worked out the color tones, it saves a lot of additional guesswork and can lead to very methodical workflows.

BRINGING IT ALL TOGETHER

In **Fig16** are some of the key stages in bringing everything together:

Background Environment

- **Instant Contrast** – By rapidly copying the whole layer onto a new layer (set to Multiply), you can subsequently erase out areas that are too dark to produce a quick fire environment.
- **Block it out** – Use the largest brush size you can tolerate, and quickly work out some general shapes in block form. We want to keep it loose but also realistic (our brain fills in all the missing details from its established database of forms and shapes).
- **Focal lighting** – We darken the whole image (on a new layer) to allow for more focal lighting.
- **Rim lights and tightening up**
- **Bounced ambient light**

ALMOST THERE!

The overall image is almost complete now, and it's just a matter of taking that extra step of ensuring details are correctly in place.

1. Add jet wash – I choose to use some diamond-shaped thrusts based on existing research by XCOR/JPL/NASA using methane rocket engines.

2. Add motion blur – Using the Motion Blur filter, copy the whole image onto a new layer by selecting the whole canvas (Ctrl + A). Copy all

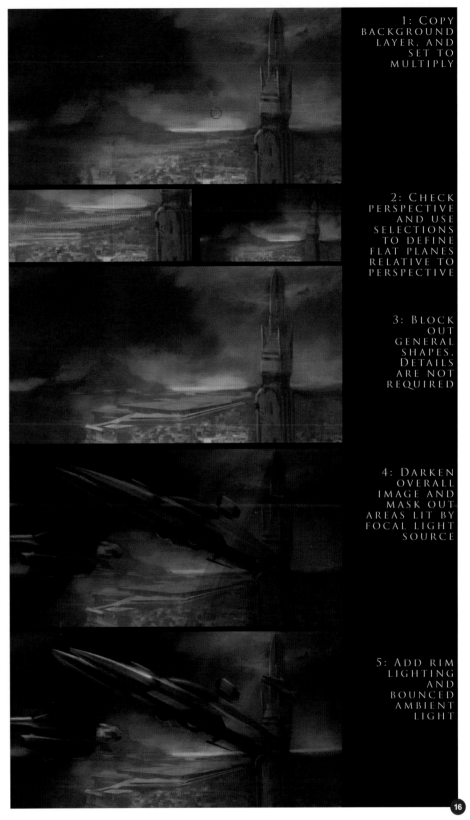

1: COPY BACKGROUND LAYER, AND SET TO MULTIPLY

2: CHECK PERSPECTIVE AND USE SELECTIONS TO DEFINE FLAT PLANES RELATIVE TO PERSPECTIVE

3: BLOCK OUT GENERAL SHAPES. DETAILS ARE NOT REQUIRED

4: DARKEN OVERALL IMAGE AND MASK OUT AREAS LIT BY FOCAL LIGHT SOURCE

5: ADD RIM LIGHTING AND BOUNCED AMBIENT LIGHT

16

the layers (Ctrl + Shift + C) and subsequently paste as normal (Ctrl + V).

3. Smudge leading edges – For the final touches, ensure you smudge lightly various

edges and try to blend the vehicle and environment together well. The use of some atmospheric perspective (dust) may help. Here is the final version (**Fig.17**).

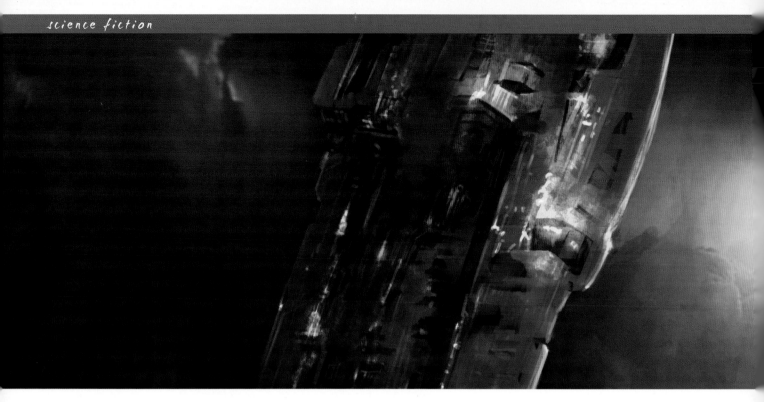

SCI-FI TRANSPORT – CAPITAL SHIPS
BY CHEE MING WONG

SOFTWARE USED: PHOTOSHOP 7

INTRODUCTION

I have grouped together the large collection of ships able to carry groups and large amounts of inhabitants as "Capital Ships". In our current naval equivalent these are termed (from small to large) as *Frigates, Destroyers, Deep Space Sensor Arrays, Mass Troop Transports, Battleships, Massed Array Destroyers, Multi-Assault Super Destroyers, Carriers, Fleet Carriers* and *Leviathan-Classed Battleships*. These terms roughly describe the range of militaristic space capital ships.

GRAND DESIGN: CONSTRUCTION OF A SUPERSTRUCTURE

To start the construction of something that is relatively large, we have to scale it down significantly. Large or small objects, when they are all scaled to the size of a thumbprint, leave very few discerning details. The main thing to therefore observe is its overall form and shape. It is with this issue in mind that I often want to label the design of spaceships as "sexy bricks" (**Fig.01**).

DESIGN – SEXY BRICKS

When you consider the look, feel and design of

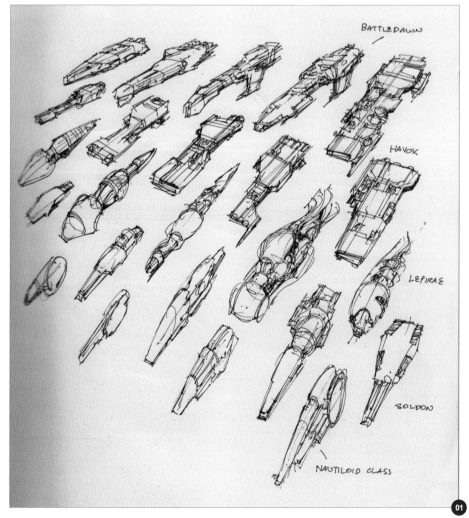

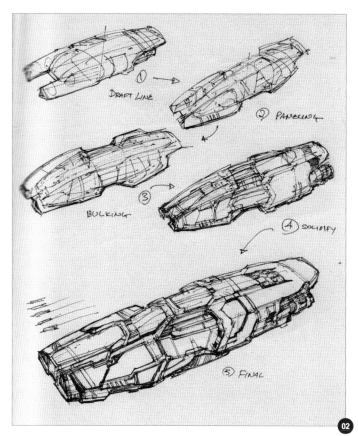

02

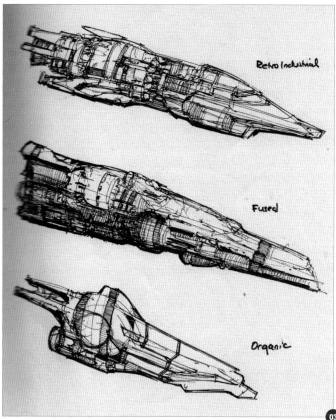

Retro Industrial

Fused

Organic

03

a very large spaceship there are a few useful everyday considerations that can help convey a sense of realism and aesthetic beauty. You could in essence look at capital ships as a hybrid of U-boat, battle tank, naval warship and bullet train, all mixed to different extents. The thing about space is: there is no real need to consider atmospheric aerodynamics, in general.

CAPITAL SHIPS: HOW TO

In general, you can take any cylindrical or relatively rectangular object and these would serve as a very good base to make a spaceship. The way I would like to approach the construction and design of a capital ship is to assume that I could produce the same functional design given the right technological level, to perfectly build a spaceship.

The closest production method would be to take a leaf from both the building of naval ship construction and the car manufacturing process. In this methodology, a combination of semi schematic and loose sketch allows both the designer and viewer (modeller/architect/director) to appreciate how the forms cross from one side to the next, and also present

to the designer (and their subconscious) additional data on how to refine, and improve on the design process (**Fig.02**).

In the illustration (**Fig.02**) is a five step approach towards this aim.

1. Draft – In the draft form, keep the lines loose and ensure they cross from one side to another.

2. Panelling – Start to divide and construct separate sections for your spaceship, e.g. forward bulkhead, engine section, living quarters, observation deck – all of these get considered here.

3. Bulking – Additional plating and armature are added towards the overall exoskeleton

4. Solidifaction – This represents the pre-prototype before you complete your initial design. The whole ship should look solid, well built and capable of performing its intended role.

5. Final – The design is considered finalized when all the additional details such as

markings, panels, piping, engines, hangars and such are drafted and considered in the final plans.

CAPITAL SHIP TYPES

The next few steps to consider are the individualistic styles your design may have. Often, the style of the ship may be considered initially, or alternatively you can consider how it may look once a suitable selection of ship shapes and designs have been drafted.

Determining how a ship should look is akin to determining the type of fabric, weave and pattern that goes into a finely embroidered rug. In gaming terms, it could be representative of which guild or faction a particular make belongs to; and functionally, the type of look can lend credence to how your current ship line has been built, and how its lineage can be represented for designs originating from this ship genealogy.

In the illustration (**Fig.03**) a range of three representative styles are displayed:

• **Retro-Industrial** – This represents a more industrialized feel, where many elements

such as tubing, pipes, engines and overall superstructure is exposed. If you desire to look at truly futuristic design, look to the past; it's probably one of the few reasons why ships of old look so good.

- **Fused** – This represents a fusion of industrial and angular shapes, combined with slight elements of a smoother and more organic shape. Our current modern-day design aesthetic is roughly within this sphere of design sensibility.
- **Organic** – Smooth flowing lines, hidden pin-point engines and seamless joints all suggest a more exotic origin of space design language (for reference, look up Luigi Colani).

CAPITAL SHIP: SUPERSTRUCTURE

As a general workflow, I tend to:

- **Start the design** – With pen and paper, on any paper/sketchbook available and explore various shapes, forms and aesthetics

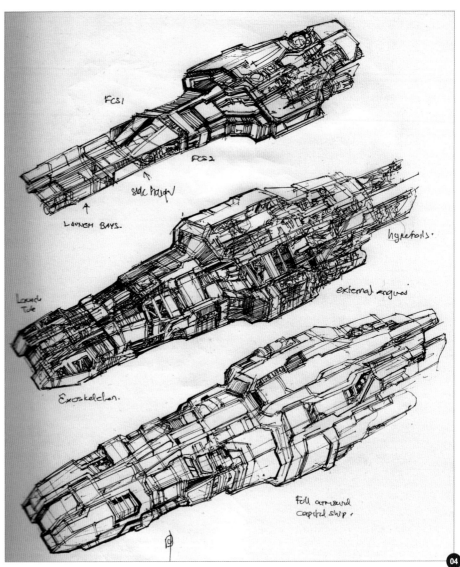

- **Refine the design** – Utilise the design language and reference to establish a ship line, and narrow the selection process into two or three designs that show promise
- **Finalize the design** – Using markers and pens to depict 3/4 perspective views of the space vessel front-to-rear and rear-to-front views

In **Fig.04** the design is taken further. Using the same process, more care and deliberation is used and the overall draft is produced on A4 moleskin paper. The finer lines are produced using a brown Pilot 0.4 G-TEC-C4 pen.

SPACE FLEET SCENE

In part two of this workshop, let's take you through some basics of how to produce a space fleet scene. The thing is, trying to showcase your latest ship designs in formation can often be a large undertaking that falls flat for one primary reason: reality.

In reality, these ships in deep space will no more reflect light than appear as a multitude of blobs. As for the flotilla of ships: nothing, just dark outlines of nothing … against a sea of dark.

Perhaps a small smattering of local lights may help define its form better against the backlight of … nothing? And there we have the appeal for artistic license.

Problems arise in depicting relative scale and atmosphere. There are no visibility issues in reality, you either see a ship or you do not, and scale of a large ship vs. a small ship by the naked eye is impossible to discern.

The proponents of artistic license will happily use:

- A backdrop of ships going through a nebulous region (often the density of nebulas are so heavy all forms of organic, structural and latest state-of-the-art ships crumple into nothing, or are fried into space dust from the intense radiation)
- A group of ships running through space gas and clouds (runs again into the nebulae issue)

FLEET SHOT – THE DRAWING BIT

Gray Layout

In **Fig.05** a bunch of capital ships are depicted in grayscale. On the far left, rough outlines of the basic geometry have been employed. And on the far right, the ships are depicted using rough and large paint strokes.

The argument for depicting a deep space scene in grayscale is that it allows you to concentrate on design and composition. The difficulty that arises is the transition to color.

The transition from grayscale to monochromatic color is not difficult, but looks very unimpressive. In fact, it looks very gray. The transition to happy impressionistic artistic license Technicolor is a whole new kettle of starfish altogether. Color will imply saturated colors. And desaturated highlights ... well, you will see it is challenging to look just normal, much less make it decent.

In space, all forms of orientation of up, down, left or right are nonexistent. For artistic purposes, it would be convenient to use a one or two point perspective but all notions of including a horizon are often nonexistent.

06

Background

With reference to **Fig.06**, we now make the transition to color. In this instance, it is just as if you are painting desaturated clouds in space.

Sometimes it does not pay to zoom in on every nut and bolt. Focal detail is the mark of a quality illustrator, and it is towards this goal that every artist seeks to attain and spend a lifetime polishing and refining.

CAPITAL SHIP DESIGN

Paradoxically, I stop the painting process to take time out to design the capital ships. What I like about the rough forms of the initial grayscale is translated in essence onto markers and pens (**Fig.07**).

I use this opportunity to take the design as far as I dare. And it is at this juncture I would like to briefly talk about scale and panels:

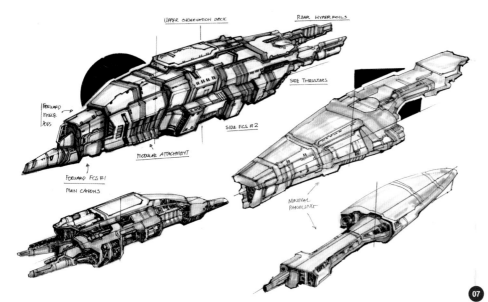

07

08

Scale – In space, the size of a space vessel may be hard to gauge. And thus, care should be taken to block out segments. Generally, a large vessel has more segmented shapes than a solid singular small space transport. However, when an object is so large, its multiple segments can often blur into panels.

Panels – The size and variety of panels can be both a stylistic and relative scale to compare a large ship to a small one.

Panels with windows, vents and lighting are therefore very useful for this purpose. In **Fig.07**, the warship on the left is depicted with multiple panels and detail. In comparison, the warship on the far right is minimally detailed and panelled. Yet, the object on the far right can be perceived to be bigger, even though the warship on the left is intended to be the larger and more powerful warship.

In summary, it can be generally said that the object with large panels and lesser details can be seen to be bigger than a similarly sized object with details and panels throughout.

THE SHIPS

The ships are brought back into the colored background and a few issues are immediately apparent (**Fig.08**).

Firstly, the values and lighting are different from the original grayscale background. So, to remedy this you can use the following steps.

1. Put the ships on a separate layer, and set it to Luminosity

2. Make a duplicate copy and set it to Multiply above

3. Masked out the overall forms, and save to Alpha Channels

4. Select the forms and use the Lasso tools to cut out various panels and selections relative to each plane (for example, the top surface of the

main warship), then apply faint washes of gray in perspective.

FINAL DETAILS

To bring it all together, the overall image is flattened and each respective ship has the following applied to it (**Fig.09**):

- The panels near to the bright objects have been cut-out.
- The upper edges reflect the red/orange highlights of the nearby galaxy

09

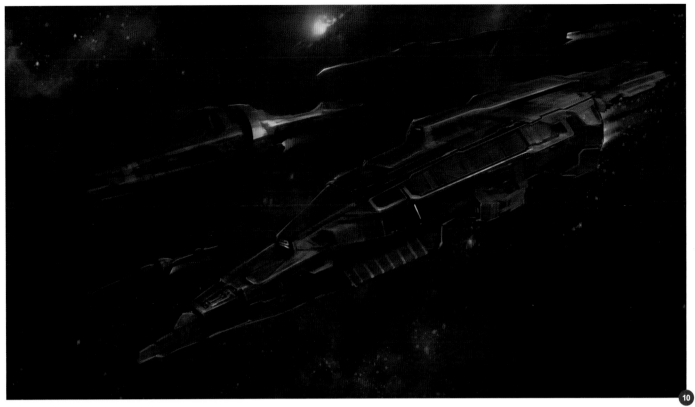

- Bounced light is applied to the lower edges or across flat surfaces.
- The overall color has been determined by the color of its ambient surroundings
- Engine washes have been applied faintly towards the rear of each ship
- Atmospheric perspective – I judiciously added a faint hint of dust and pushed objects into the distance. In reality, this effect would not be evident, and the nearby and far objects would be equally lit and provide comparable luminosity.

FINAL IMAGE

In the final image, the vibrancy of green and blues are more saturated. The far right warship is edited out of the final image, as its overall shape is decidedly poor and distracting (**Fig.10**).

IMPRESSIONISTIC BURNING SHIP

To conclude the third and final section of this tutorial, we will tackle a more colorful and impressionistic approach towards painting

space capital ships, and give a small nod towards John Berkey, famed granddaddy of sci-fi and space art.

PAINTING INSPIRED-BY BERKEY

The key to one of Berkey's images is being loose and impressionistic, coupled with big fat strokes to suggest form, color and lighting (**Fig.11**).

FORM AND PALETTE

In **Fig.11** a basic color palette is determined beforehand. In this instance, I choose to use a greenish/yellow background.

- **Primary** – typical cream white for the ship's main color
- **Cool** – reflected ambient color, greens and blues
- **Warm** – Reds and purples

DIRECTIONAL LIGHTING

Subsequently, the canvas is expanded to incorporate a more traditional portrait view (**Fig.12**).

On the far left are some small thumbnail cutaways.

FOREGROUND
—PALLETTE
BACKGROUND
—PALLETTE

LIGHTING
THE SCENE

CHAPTER 2

1. Top left – small thumbnail to assess overall form and composition.

2. The bottom and mid-left thumb – to depict the lighting issues; ideally, the space yacht would have a sharper rim light as depicted by the small thumbnail, but it is at this juncture that I am still undecided as to how close/far the light source should be.

COLOR & MOOD

The next thing to consider is the color and mood. The original green color is very interesting, although I really prefer the warmer orange based palette (**Fig.13**).

DO NOT PASS WITHOUT CHECKING!

This stage is all about checking (**Fig.14**). Ensuring that:

- The values allow the forms to read well.
- There is appropriate use of color as a compositional tool.
- The image is relatively balanced (with regards to adjustment levels).
- Bounced light and ambient light allow the form to have soft edges and suggest how light turns around the forms.

PYROMANIACS

The last aspect of the illustration is to add the fire and destruction, debris and explosions.

Here is the final composition as it stands, burning with wreckage being strewn everywhere. Careful study of explosions and fires would show that there is far more smoke and glowing deep embers for any burnt up object travelling at velocity. As such, the image depicts it accordingly (**Fig.15**).

13

14

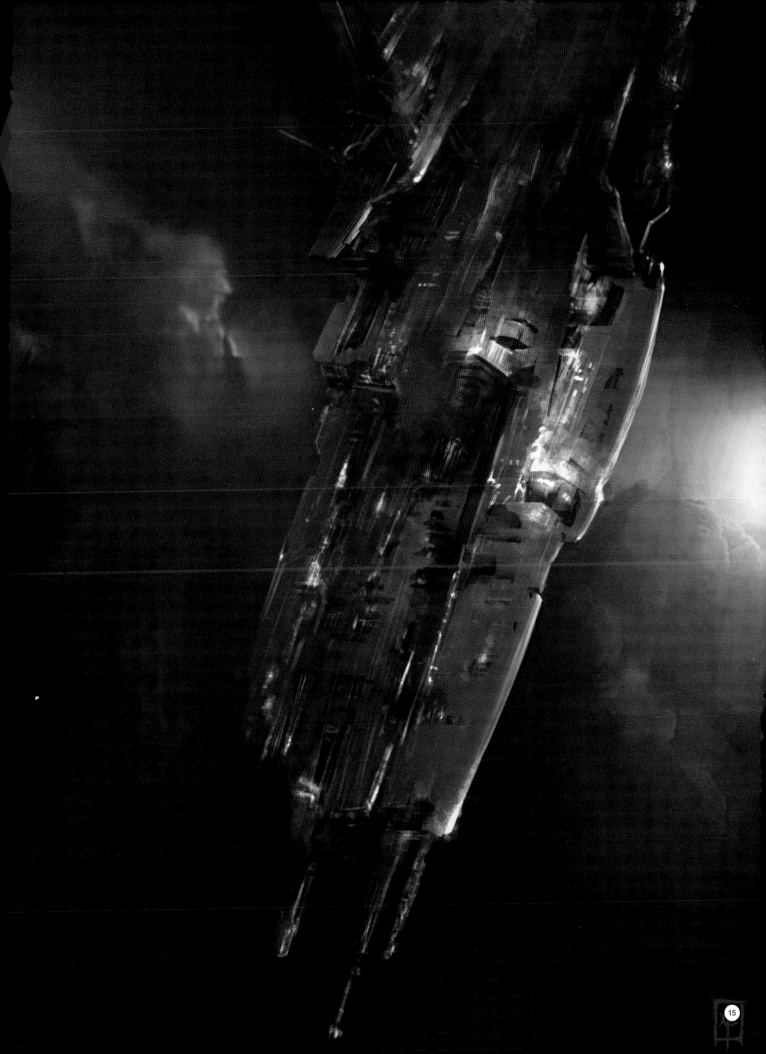

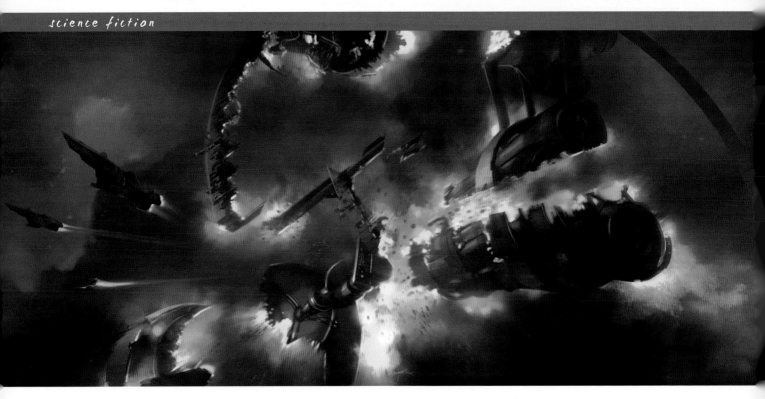

SCI-FI TRANSPORT – SPACE STATIONS
BY CHEE MING WONG
SOFTWARE USED: PHOTOSHOP 7

INTRODUCTION

When given a typical brief to design a space station for either illustrative or production design, there is a certain limitation to how radical the design forms can be. The design of such large installations should be based on existing technological limitations and designs, and extrapolated around 20-30% into the future and the imagination.

Another consideration to keep in mind for large structures larger than 100 feet in height and width is panel lines. The larger an object becomes, the less discernible these become, and imperceptibly may appear as almost featureless, flattish positive and negative shapes and surfaces. This is not to suggest there are no divisive lines; however panel lines on objects such as space stations may truly be

a giant canal or a great grouping of massive tubular structures.

SHAPES

In **Fig.01** is an assortment of various semi-detailed thumbnails that are starting to outline a general form, and will later be worked on. Essentially, you can explore space technology as thus:

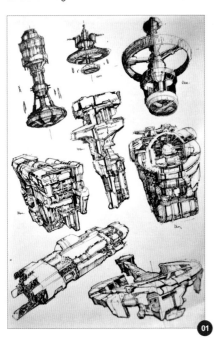

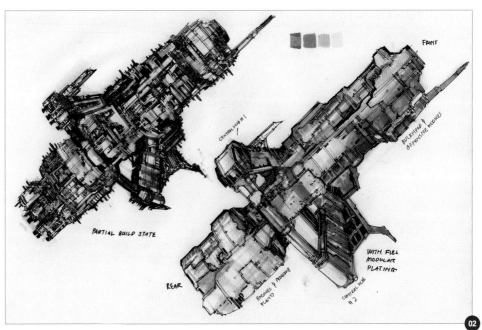

- **Conventional** – Cylindrical, modular, semi industrial, almost pin-point LED lighting and symmetrical.
- **Advanced** – More streamline or grandiose forms with less joins, piping and streamed lighting.
- **Exotic/Alien-esque** – Forms are more organic and smooth in nature: asymmetrical and fantastical shapes may be employed. They generally appear highly advanced or non-manmade.

Battle Space Station Design: Construction States

When creating space stations it may be useful to envisage how it is built, and possibly how it would look partially built, fully built and in a fully ruinous state.

In **Fig.02**, we see a more militaristic space station in two states, one is partially built and the other is well armored.

1. APPLY BROAD STROKES
03a

Using gray markers and marker paper you can make the structure look loosely based upon a cylindrical structure, with its values utilising 4 core values of gray: 10%, 30%, 50% and neutral gray 50%.

With regards to the partially built station design (left), a state of construction can be accomplished by imagining the entire form bristling with partially connected tubes and extruded layered forms. In contrast, when considering a fully armored station design the main idea is to convey a sense of interconnected plates and joins that fit together logically and with purpose.

ILLUSTRATING GALAXY SPACE STATION X

Setting up a Galaxy

For this illustration, the shot is produced without any preliminary study or definite design worked out. All that I know is that it will involve a typical widescreen/landscape aspect ratio.

1. A greenish blue hue is the intended color palette (**Fig.03a – b**). The canvas is partitioned into thirds and a brighter light source is established early on. I've chosen to provide an extra "bleed" area reminiscent of how one may paint on a traditional canvas/watercolor canvas.

2. The next step is to expand this canvas more to include a counterbalance such as saturated clouds of ochre and neutral blues. Broad strokes are best used for this initial stage to provide a rich gas cloud style in space.

3. Once a general palette is established, areas of contrast are defined. It's sometimes nice to leave some remnant strokes to help build up a random textural feel towards the background.

2. BLEND YOUR VALUES ACCORDINGLY
03b

CHAPTER 2

04a

4. The next aspect is to establish the light source and values as a compositional tool (**Fig.04a – b**) as the eye is drawn to areas of light and high contrast. Once done it is time to establish the star systems and brighter stars.

SPACE STATION

The next step is to incorporate a typical space station design within the environment.

Painting with Light and Form

1. Using primitive shapes of just cylinders, toroids and various flat panels, the initial design is blocked out (**Fig.05**). Using the color and light sources established in the background, we can add color and light to the surface of the space station.

04b

05

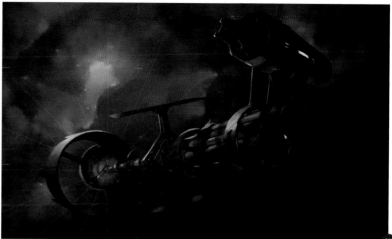

2. The next aspect is to make the level of detail and form more discernible to the viewer. The front segment of the space station has appealing shapes that suggest a cluster of cylinders grouped together, and surrounded by a large toroid (**Fig.06**).

3. Finer subtle details such as rim lighting and graduated edges are to be painstakingly added

next, using a mixture of selections and simple painting techniques to blend various direct and ambient lighting sources. These include adding tiny banks of lit windows, access panels and hatches that are probably not seen immediately.

4. Lastly, it can be useful to check that all the proportions are in place and fit accordingly

(**Fig.07**). Areas to probably correct are the large toroidal shape housed towards the rear and the area situated furthest from the viewer.

Getting Your Space Station Up & Running
To finish your space station illustration, you can make it more interesting by adding more objects.

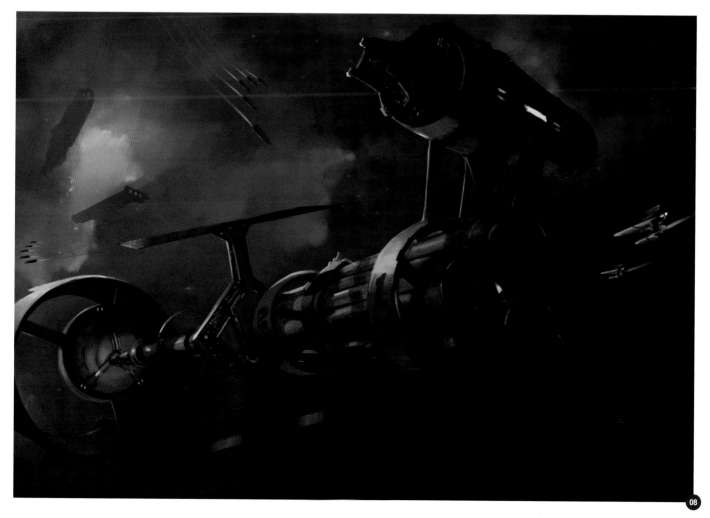

CHAPTER 2

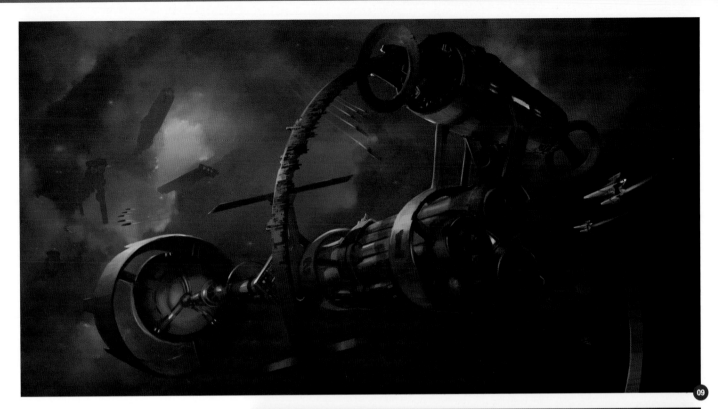

09

To achieve this, various capital ship shapes are added in the distance to help provide some scale and relativity (**Fig.08**). In the foreground a basic tri-pronged cylindrical object is painted in to denote larger space ships and the core structure of the larger outer ring is finally installed.

To finish up I address various perspective issues, including the upper flat solar panels and the large spherical engine quarters (far left end), and there you have it – a fully working space station (**Fig.09**).

BLOWING IT UP

In the second element of this workshop, we plan to blow up the space station. Yes, we're going to blow it up to explore how light and large explosions can be depicted whilst still using only simple forms, to cast light and shadow and minimal detail.

1. The first step is to break the whole station up (**Fig.10**). The trick is not to scatter the various parts too far from its point of origin. This is so you can depict the station as part-drifting part-exploding/burning in space.

2. Next, on a layer below, a base color of orange is applied on areas which may contain

10

11a

reservoirs of oxygen (**Fig.11a – b**). Again, one may argue that such explosions will tend to burn blue primarily, but choosing a more realistic option tends to clash with the ambient color chosen. It is advisable to keep this "effect glow" on a totally separate layer so that you may change its hue, color and saturation with ease in the future.

3. Now that you have tackled depicting the glows behind the space station, repeat the same principles in front of the station onto a new layer (**Fig.12**).

4. In the bottom right the whole illustration is applied with a Blur > Radial Blur set to zoom at 10%. Ensure that the whole image is duplicated beforehand. Apply a Layer Mask on the whole image, as if the whole effect has not occurred, before repainting the blurred elements onto any peripheral edge of the explosion and objects.

5. The next step is to add some small degree of remnant debris depicted by tinier fragments exploding from the central explosion.

6. Lastly, you can depict various vessels escaping the blast by producing various shots of large vessels heading out from the centre of the field of focus (**Fig.13**).

7. To really finish it all off, add some subtle contrails and glows to suggest engine washes.

And there you have it – a fully blown up space station (**Fig.14**).

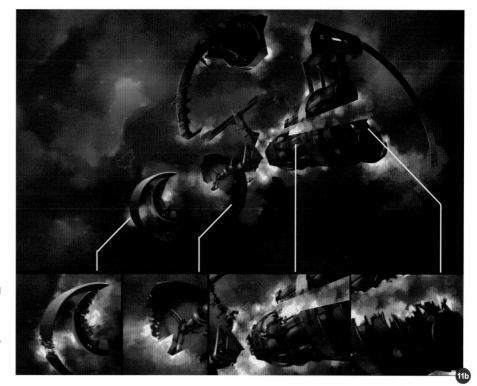

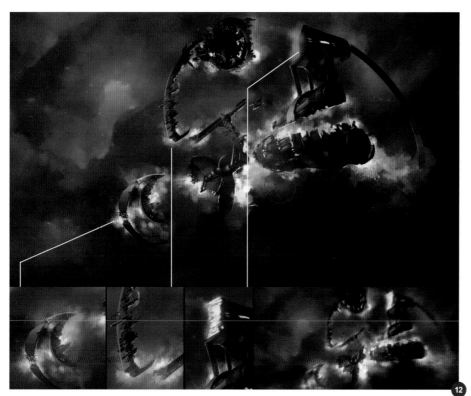

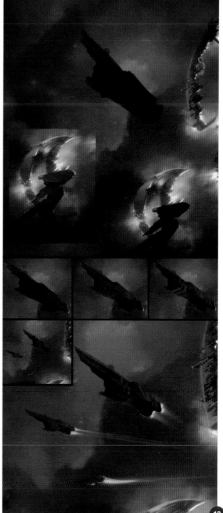

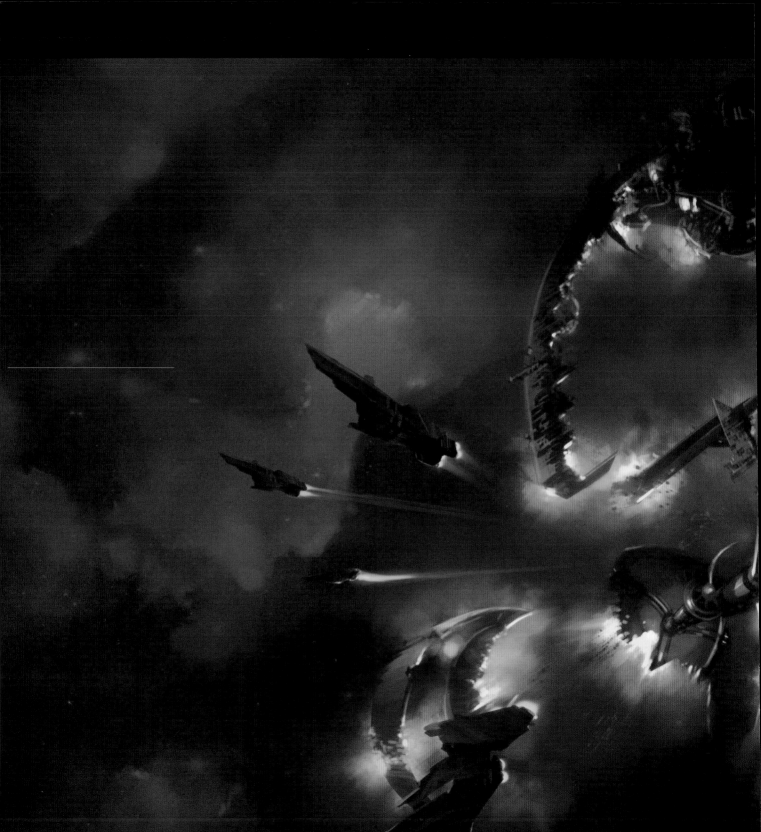

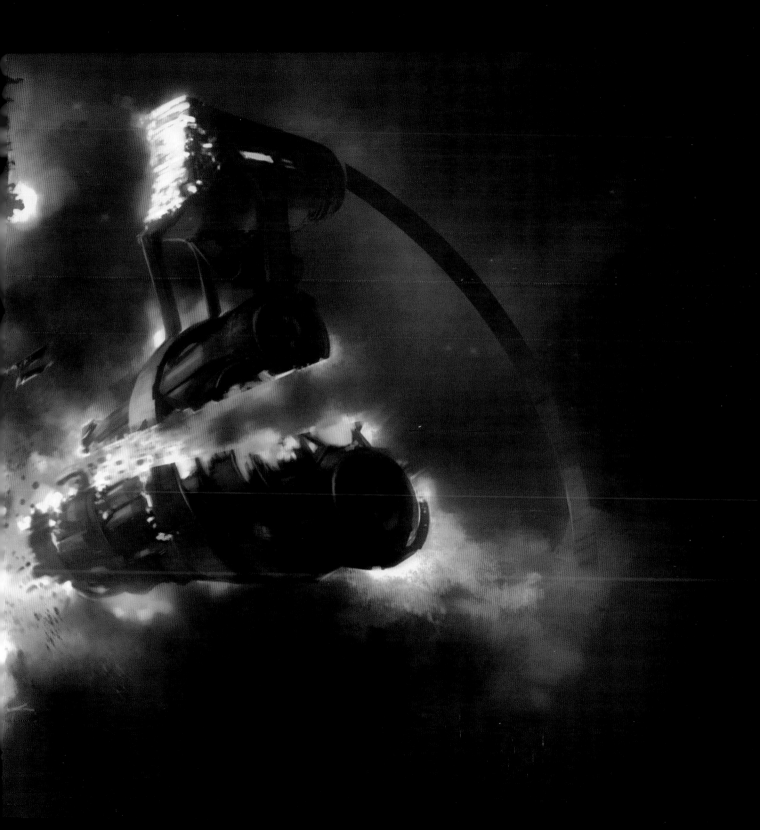

SCI-FI ENVIRONMENT – COLONIZED PLANETS
BY CHEE MING WONG

SOFTWARE USED: PHOTOSHOP 7

INTRODUCTION

During this tutorial we will discuss the challenges of illustrating an image through to its finality. Inevitably, there comes a point where even an image cannot be saved, and you have to make a key decision as to how to persevere or adapt it into something more fitting.

SPACE ELEVATOR

Let's explore the concept of a space elevator as a vital mode of mass transport between a

planet side and near planet side/low orbit. The key features of producing a space elevator are:

- A fixed point in space
- A lightweight cable system
- An appropriate counterweight

If we consider the current day challenges of building a space elevator on Earth, we firstly need to determine a fixed point in space, known as a "geostationary point" above a

planet. It is at the geostationary point that the force of gravity is sufficiently weak, thus allowing an object, such as a satellite, to orbit in an exact fixed point in space.

Now that you have a fixed point it seems a simple matter of hooking a long rope from the ground to the geostationary object. For the purposes of this tutorial, we will assume that this technological barrier and such limitations are easily achievable. I start by doing various

sketches exploring different architectural styles to house a space elevator (**Fig.01 – 02**).

SKYSCRAPERS OF THE RETRO FUTURE

For references you could look at the architectural genius of Hugh Ferriss (1889-1962), a master of shadow and light. His works show a technical brilliance of contrasts and towers of epic proportions. Another inspirational source is the artist, Erich Kettelhut (1893-1979).

PAINTING AN ARCOLOGY

For the remainder of this workshop I will take you through the design, composition and challenges of building an arcology and space elevator into our final illustration. But first of all, I'll explain a bit about an arcology:

Arcology is Paolo Soleri's concept of cities which embody the fusion of architecture with ecology. The complexification and miniaturisation of the city enables radical conservation of land, energy and resources.

So in essence, we are attempting to both integrate the housing of a giant space elevator with a central compact living environment.

Initial Composition & Layout

For our own arcology/space elevator design, I imagined an angular white faceted style for all the buildings, cities and towers. In the initial composition, a simple one-point perspective is used, with the focus primarily on the central tower in the middle (**Fig.03**). To showcase a bit more of the overall city, a slight tilt is used in combination with a central composition. I imagined the foreground to incorporate a large flattish leisure area/park with verdant hanging gardens replete with fountains and pools.

Building in Some Structure & Design

To bulk out the initial design further, I duplicate the central features and set these to Multiply. Using the Eraser tool, various features and facets can be etched out to create and suggest buildings, roads, towers and parallel lines.

For the foreground elements, the Lasso tool is employed to provide clean selection edges, to provide a sharper crisp and defined edge.

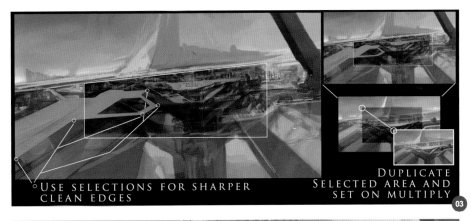

USE SELECTIONS FOR SHARPER CLEAN EDGES

DUPLICATE SELECTED AREA AND SET ON MULTIPLY

03

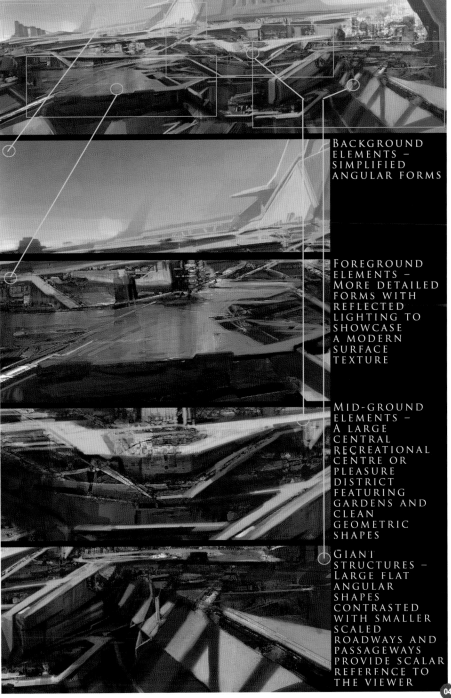

BACKGROUND ELEMENTS – SIMPLIFIED ANGULAR FORMS

FOREGROUND ELEMENTS – MORE DETAILED FORMS WITH REFLECTED LIGHTING TO SHOWCASE A MODERN SURFACE TEXTURE

MID-GROUND ELEMENTS – A LARGE CENTRAL RECREATIONAL CENTRE OR PLEASURE DISTRICT FEATURING GARDENS AND CLEAN GEOMETRIC SHAPES

GIANT STRUCTURES – LARGE FLAT ANGULAR SHAPES CONTRASTED WITH SMALLER SCALED ROADWAYS AND PASSAGEWAYS PROVIDE SCALAR REFERENCE TO THE VIEWER

04

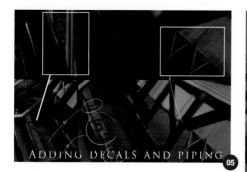

ADDING DECALS AND PIPING 05

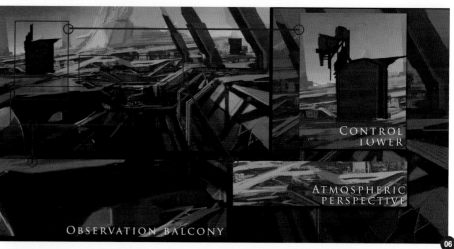

OBSERVATION BALCONY

CONTROL TOWER

ATMOSPHERIC PERSPECTIVE

06

Bulking Out

Having laid-out our base, the next steps are to (**Fig.04**):

- Block out simplified angular forms
- Provide contrast and relief for the foreground elements
- Maintain clean geometric shapes throughout (keeping it consistent with the established design of angular and geometric design)
- Large parallel structures that lead the eye towards the central tower

Quick Tip : It is worth sticking in grayscale to establish the forms, lighting and composition. At this stage the basic values and key design issues can be scribbled in or painted out easily, with less loss in overall time management.

The next thing is to add further details to the various foreground elements and forms, such as decals and piping along our large sewer like structures (**Fig.05**).

Other issues to consider are the elements of atmospheric perspective. Blocking in the background and mid-ground elements with a lighter gray can be used to suggest distance.

Elements in the background merely require basic forms blocked out to read well (**Fig.06**). A few new additions to the foreground include a control tower and observation balcony. On the top right, repeating shapes of diagonally placed tower blocks are added purely as focal interest which I imagine could serve to remind the inhabitants of the grandeur of the central tower/elevator.

Rapid Vessel Prototyping

For this workshop, I would like to share a rapid

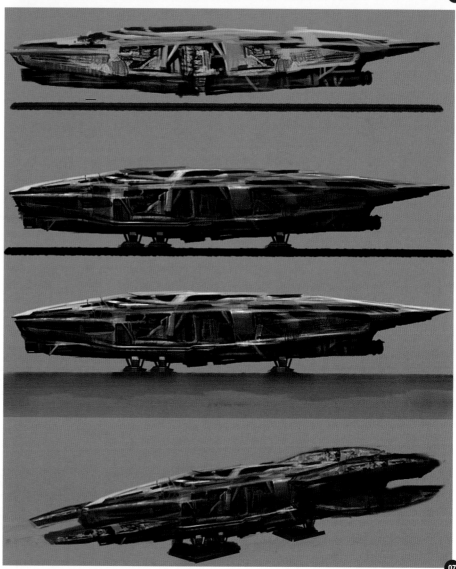

07

way of prototyping transport vessels. The transport depicted in **Fig.07** is a basic civilian vessel being constructed. As such, various elements of underlying skeletal structure and foundations are shown. By initially designing

a vessel in the side view, it is possible to generate many designs rapidly and quickly. Simple top-down lighting will help depict the transport's form, and once the general form is determined a small transformational shift (Ctrl

+ T) will be sufficient to suggest the transport's overall shape in perspective.

I still prefer designing with a simple biro and paper; fewer complications and gimmicks – just ideas. If one can translate these ideas, even with crude sketches, then a well-executed end product is all that matters.

COLORING & RENDERING

In theory, if the original grayscale composition is well defined, then transferring the imagination into color should be relatively straightforward.

In **Fig.08**, a basic monochromatic ochre-yellow based color pass is applied via the Hue/ Saturation layer option (set to Colorize).

To make the typical blue sky/yellow haze look is a matter of determining the primary color and the ambient color. The trick is to add each color pass layer by layer, to create a homogenized feel (or mess). Ultimately, it is a subtle mixture of color blends, some elements of repainting, and luck.

Color Choice: Yellow Haze
We will next look at three different times of the planetary cycle: daytime, dusk and twilight. We'll start with the golden hazy approach (**Fig.09**). The overall image is warm, inviting

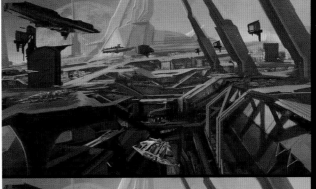

1. MONOCHROMATIC YELLOW COLOR PASS

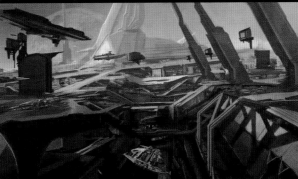

2. COMPLEMENTARY DESATURATED BLUE TO INDICATE SKY AND ATMOSPHERE

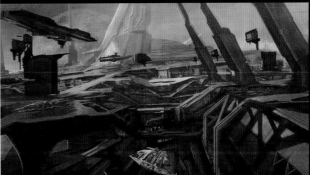

3. MID-RANGE SATURATED GREEN TINGES ON FOREGROUND ELEMENTS

08

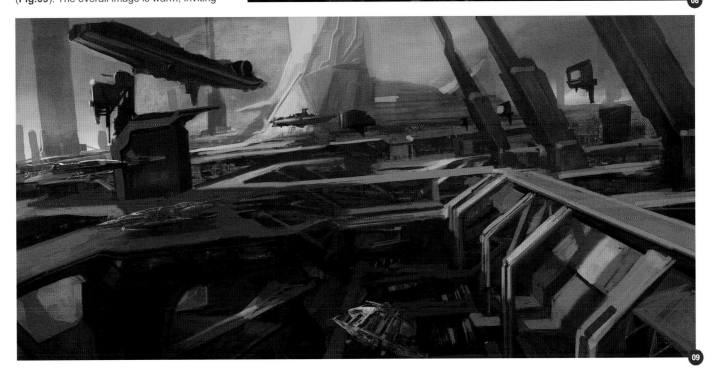

09

CHAPTER 2

and golden tinged. For this color choice, bluish complementary colors, such as engine washes or blue tinged lighting, can bring out a good sci-fi feel.

Some degree of repainting is required to paint out the blacker elements and line work from the grayscale painting. Overall, as long as the range is narrow, the overall image will work monochromatically.

For the final image, a bluish/purple engine wash is added towards the central transport, and various elements of steam and smoke help to provide an industrialized city feel (**Fig.10**).

Color Choice: Blue Haze
Next, we try to tackle the same scene with a daylight styled color (**Fig.11**). For a daytime approach, tinges of green and some blue and orange are required, but in more subtle amounts. One thing a daytime approach is good at is suggesting atmospheric perspective.

I started to feel that the overall composition was too busy so the first step is to simplify the whole design (**Fig.12**). This means selecting out areas that are in the same plane; using the Lasso tool you can pick out the upper walkways and lower areas, one by one. Subsequently, save this selection as an Alpha Mask in your Channels layer, for quick access later. Using a new layer, block in the

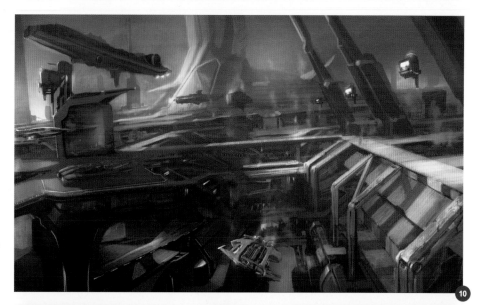

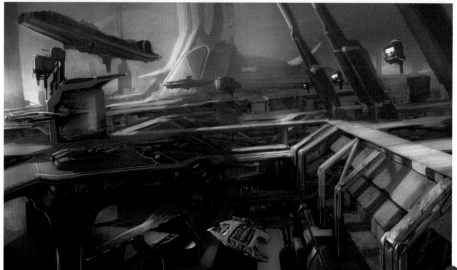

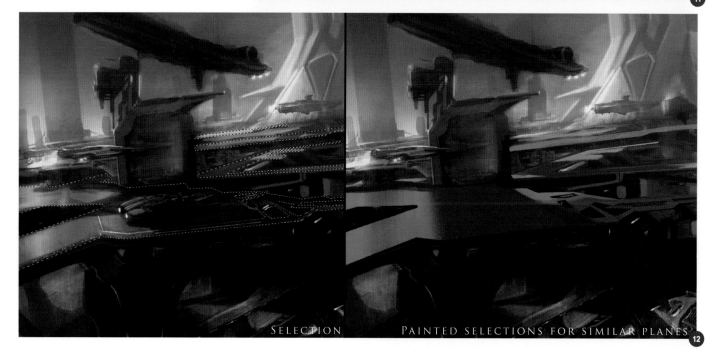

SELECTION PAINTED SELECTIONS FOR SIMILAR PLANES

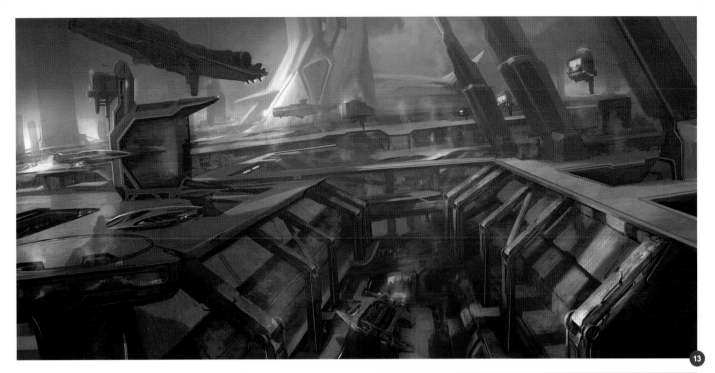

same color and value for any surface sharing the same plane/angle. Since there is a focal light source, these should all share the same directional light and ambient light source. Then block out the corresponding shadows.

Colored Details

Using the same process, we can now add further detail and wear and tear on various objects; texture overlays can help provide this feel (**Fig.13**). I have chosen to simply paint in various colors based on flaking rust and worn paint onto the large arches (bottom right). This is the final daylight image, and gone is the asymmetrical design in favour of a more parallel and central feeling. Care was taken to ensure that the opposing arches were in shadow and the landing pad area has been restructured to look logical and functional.

Color Final: Twilight

For the final alternative we will repaint the scene within a night/twilight mood (**Fig.14**).

For this scene, I apply a saturated blue/green feel. The main premise is to use the arches now as glow-lit supports heading into the centre with the horizon painted as a thin wedge of bluish twilight.

For the final touches, elements of the central tower are restructured and relit with beams of

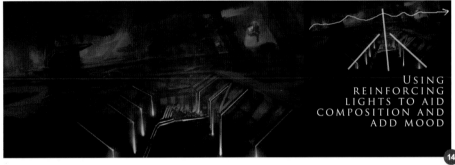

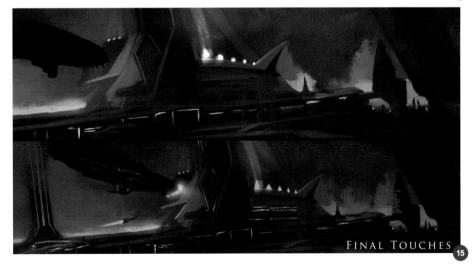

searchlights and bands of horizontal lights to suggest scale and focal interest (**Fig.15**).

SUMMARY

Overall, we have looked at various ways to work a production painting from various angles and troubleshoot various design elements in both grayscale and color. I hope this has both been an informative insight into tracking a sci-fi theme, that invariably crops up in one's line of freelance or professional work, or even for one's own leisurely paintings (**Fig.16**).

CHAPTER 2

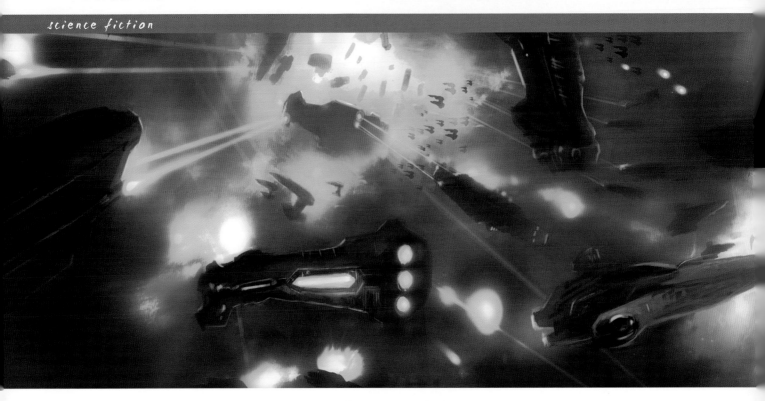

SCI-FI ENVIRONMENT – SPACE BATTLE
BY CHEE MING WONG

SOFTWARE USED: PHOTOSHOP 7

ASSEMBLING THE PROPS

For this scene, our main purpose is to produce the set of a key battle moment from an epic space fleet battle, followed by a composite shot to show how a singular key battle moment may be illustrated as the "money shot".

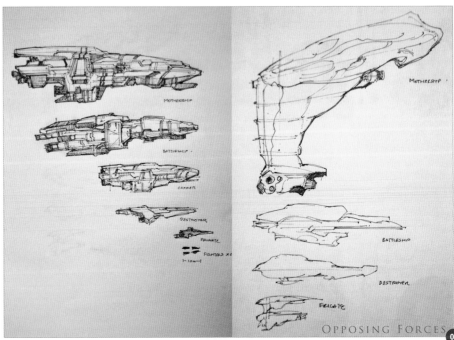

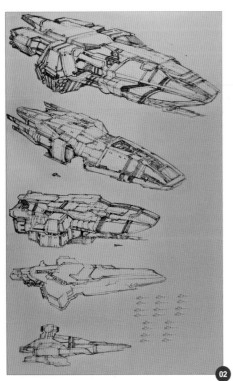

OPPOSING FORCES – LINE UP

A good starting point would be to line up the various capital ship profiles side by side, to determine and visualize the core silhouettes of both forces (see **Fig.01**). On the far left, Team Alpha is defined by a symmetrical, semi-industrialised, angular look that is characterized by chunky and elongated forms along the longitudinal axis. In contrast, the far right Team Zeta is defined by a more organic geometric shape, coupled with elements of an asymmetrical nature, borrowing from elements of a trident, scythe, and a two-to-three pronged fork.

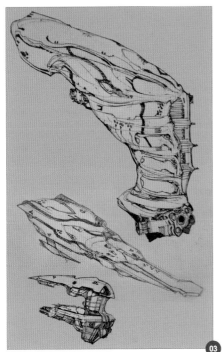

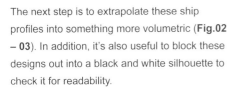

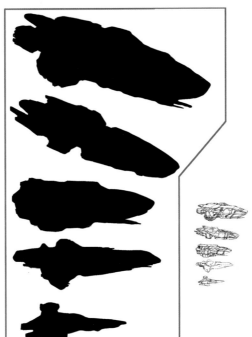

The next step is to extrapolate these ship profiles into something more volumetric (**Fig.02 – 03**). In addition, it's also useful to block these designs out into a black and white silhouette to check it for readability.

One thing that may be surprising is be that after adding details and panelling, the overall forms might not work out as well as you might have expected. In **Fig.04** team Zeta has very defined shapes, in particular the Mother Ship (top right) and Frigate (bottom right). In comparison, Team Alpha has very similar shapes. In fact, if there was no relative comparison of size; one would be hard pressed to distinguish these as a battleship from a normal pea shooter. Does it mean the design is flawed? Does it mean the ships require more definition or defining characteristics? Or does it mean the ships require a return to the drawing board?

All of these issues, or variants, are important issues to consider for the would-be concept designer of futuristic designed space ships in the entertainment industry.

OPPOSING FORCES – TEAM ALPHA

For Team Alpha, we will gather a range of capital ships and a single personal fighter (see **Fig.02**). In the three-quarter view, the designs that seem to work well are the second (from

the top) capital ship and the last two shapes at the bottom. What is really surprising is that the fourth (from the top) ship works quite well as a distinctive shape, but it has the least panel lines or design, whereas the top two ships have the most design, thought and functionality instilled into them, but then their outlines may not work as well (see **Fig.04**).

OPPOSING FORCES – TEAM ZETA

In comparison, the requirements for Team Zeta (see **Fig.04**) meant producing a more distinctive (i.e. visually different) design. Partially organic and smooth in comparison (this sometimes translates to an alien look), it

was a matter of lines and functionality working well (luck), from the first draft (that did not require too many further developments).

Any design language deviating radically from known historical or current day objects/ transport/functions may appear incredulous and perceived as "alien looking" in nature. Even when a distinctive design becomes iconic and enters popular culture, it may be that until the general public is able to see, interact and physically use the new device, abode or transport, that anything too radically different will appear alien looking. For example, if you were to rewind the clock back 100 years and tell folk that one day every household would be

able to have a small receiver device to show full moving pictures on a screen, or that there would be small personalized communicative wireless devices to talk to one another, that even played back movies, you would be rightly scoffed at and laughed at as being delusional. Go back 500-600 years and the world view would be so radically different that such current day appliances would have had most folk hanged or burnt as a demonic heretic for even entertaining such thoughts! To conclude, what this slightly more academic discussion means to simply state is this: 70:30. By that I mean that if you want to keep the designs within the realms of believable and accepted world view, try to keep your design 70 percent rooted on known existing design, and leave 30 percent to the realms of creative imagination.

KEY SCENE MOMENTS

The next crucial step is the process of idea generation. From my own experimentation, I gather all the approved design forms and line them up in one corner of the digital canvas – similar to generating a paper cut-out of various approved designs and forms, you literally scatter it across your canvas (**Fig.05**).

DRAWING A LINE IN THE SAND

The next aspect is to generate a backdrop. In this instance, I have reused elements of previously painted backdrops. Next we make the choice of an arbitrary horizon and perspective (see **Fig.05**).

ESTABLISHING SHOTS

Using this basic canvas, I would recommend producing a grid of six to eight panels of equal aspect ratio. In this instance, we use the

widescreen aspect ratio to conform to modern film conventions. Try to work loose and fairly rapidly, working in the general forms and approximate shapes, and focusing primarily on mood, lighting and readability. My ideas can be seen in (**Fig.06**).

Ultimately, I prefer the first shot as our ultimate key visual scene. The thing is, sometimes your first concept or first stab may be the best; however, it is not until you have worked out other alternative shots that you can adequately make an informed decision.

INITIAL COMPOSITING

Using the key visual thumb in Shot 1 (see **Fig.06**), the next task is to assemble all the various props into one chaotic mess (**Fig.07**). Shot 1, in critical analysis, is quite orderly and this ultimately translates into a very sedate, almost calm scene. Aim to thrust the viewer right into the action. This can normally be achieved by having a camera viewpoint set up just behind or over the shoulder of any transport your camera is focusing on. So that's it, Shot 1 must go, unfortunately.

With reference to **Fig.08**, we take all the best elements of the six panels (noted by the various areas selected in red), and consolidate them into one miraculous, organized, chaotic mess. This involves some degree of overlay

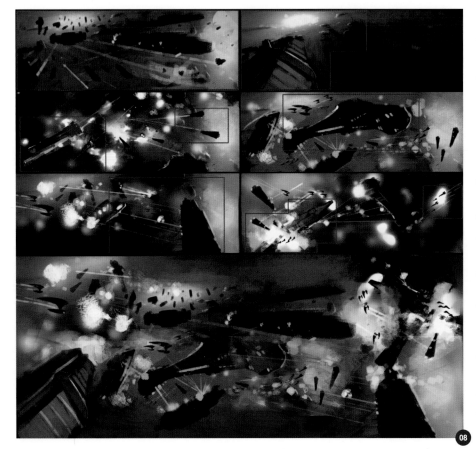

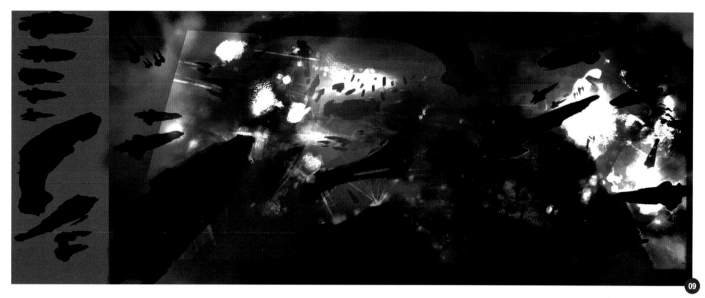

painting and repainting to produce some sort of coherent mess. Notice that Shot 1 provides the main backbone towards a more complicated battle scene.

THE MONEY SHOT

Now the process of idea generation has been relatively explored, one can get down to the nitty-gritty of producing the "money shot".

PROOF OF CONCEPT

The entertainment industry works roughly like this: a production director, game team or writer has a great idea for the next great big movie, animation or game product. The thing that gets the product a green light is producing, a) Proof of Concept, and b) Key Scene Visuals. If you're successful at passing through the first hurdle, the next few stages are roughly the elements of production.

THE COMPOSITE SHOT

With reference to **Fig.09**, the amalgamated grayscale shot incorporates all the various elements, shapes and forms. It all looks relatively confusing and is without any visual focus. The explosions are all relatively of the same luminosity and all the forms are of the same black silhouetted placeholder ships.

GRAYSCALE TO COLOR

Now begins the trickier bit: converting a grayscale value image into full Technicolor. The fact is it's both hard and challenging to make a grayscale image look good in color, but not impossible.

So let's have a look at some different methods of successful conversion:

- Overlay an old photo/texture painted image on a low Opacity (3-5%)
- Photoshop > Select > Color Range method (feel free to do some self exploration to achieve this method)
- Establishing a monochromatic color (e.g. Hue/Saturation set on Colorize) and add thin washes of complementary or adjacent color
- Straightforward over-painting

In this workshop we will opt for the last option: the simple, straightforward, purist method (**Fig.10**). On a new layer (100% Opacity, Normal) you can simply paint and establish various colors and complementaries to generate a vague and pleasant-looking set of hard-edged (colored) clouds. These can represent various nebulas or slightly colored gas clouds.

The next step is to slowly reintroduce the cut-out shapes of various groups of ships that recede into the distance, and to ensure that readability is achieved. Following this comes the trickier bit, and that is to introduce all the mid-ground to background explosions and elements. A simple method is to set your image on Luminosity and lower the Opacity (**Fig.11**).

The painting reaches the ugly stage which again is a natural process and is simply a matter of ordering chaos out of all these elements. In addition, explosions in the distance are further blended into the background and toned darker to achieve a more homogenized background.

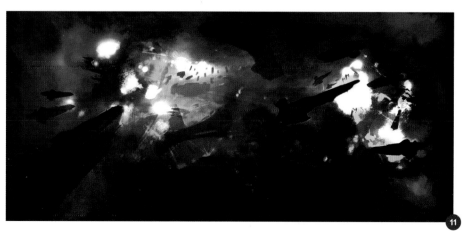

CORRECTION & DETAILING

From this point on it is now a matter of starting to add some rudimentary details to our foreground objects (**Fig.12**). Panel lines and sheets of metal can achieve an even sheen by painting parallel strokes according to their relative planes. In the top-right segment there is a feeling of empty, useless space. The explosions are thus rapidly converted into various ships coming out of hyperspace and being attacked and/or surrounded. Some even display the first signs of an explosive shockwave of contained gasses, debris and hot plasma.

LEVEL 2

I break the coloring and detailing of the image into Level 1 (30%) and Level 2 (70%). To create a very high quality visual, this may even necessitate further effort, texturing and

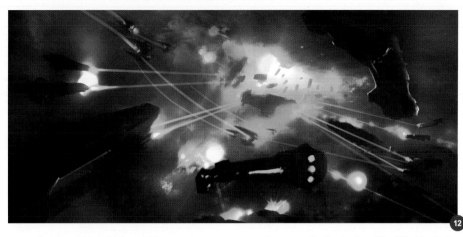

super-fine tweaking which would amount to Level 3 (90% complete). So, befitting the purpose of this workshop, we are only interested in achieving a Level 2 finish. This is mainly because of relative real world time constraints; you often do not have more than one-to-two days maximum to work on a large, complex piece. So let's have a look at the

overall composite illustration (**Fig.13**). Most of the placeholder objects now have their shapes defined by relative rim lights, based on the ambient and direct lighting.

Some further close-ups now show us the rough details of the use of local directional lighting to colorize the foreground elements (**Fig.14**). In the top segment, the Alpha fighter utilises a warmer color on its lower aspect, whilst the upper portions are cast in relative relief, thus producing an under-lit finish. Whereas the main Zeta Mother Ship uses a more muted and narrow band of values that are close to the mid-to-background colors. These will help to seat the object into the mid-ground.

Finally, the subtle use of volumetric-cast shadows can just add that additional element of realism. We finish off with a few additional corrections and blend it all into one final giant (organized) chaotic clash of light, color and space vessels attacking and counter-attacking one another, with various groups having their own personal dog fights (**Fig.15**).

Alas, we have not yet finished. This is because we have forgotten to tell the basic story behind our image!

A STORY WITHOUT WORDS

The final aspects of a Level 2 detail (going into Level 3) would be what I liken to post-processing. This means the majority of the painting in this image is complete, and from here on it's a matter of fiddling and fudging with various cropping angles, filters, contrasts, and color/lighting adjustments.

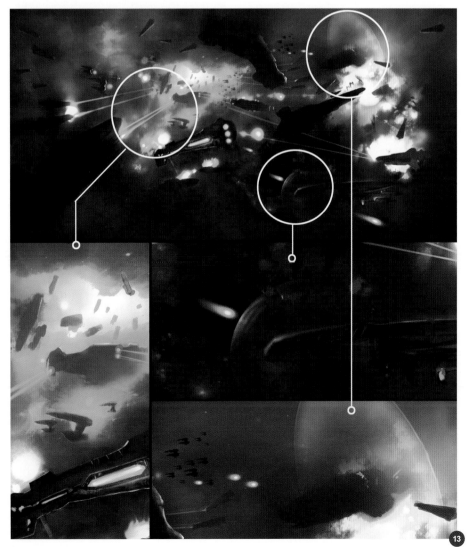

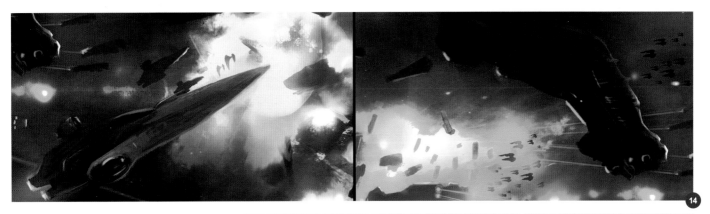

Now, there are various ways of setting up a good composition. Utilising your basic Selection tool, or Crop tool in Photoshop, rotate your selection and take virtual snapshots of compositions you desire. Sounds like common sense, and that is the beauty of it: it's simple and underused. You can take various selections and generate a simple storyboard out of these selections at will.

Have a look at **Fig.16** as a basic storyboard. In essence, it should tell a basic story of a space battle. The really clever thing is the simple and effective use of motion blur and radial zoom (blur). By making duplicates of your selections you can replicate fast shots by tracking your focal object (thus the background is blurred in the direction of your camera's relative speed and velocity) or by panning out further to take a

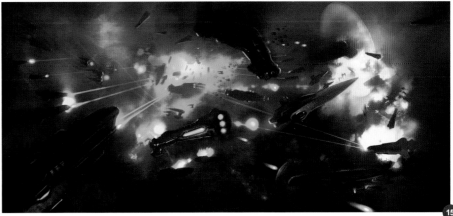

wide shot. Take care to erase/paint-out blurred areas to bring back various objects of visual interest into focus.

Personally, my ideal shot would be embodied by the panel in **Fig.17**, which has echoes of

the Shot 1 thumb (see **Fig.07**) but now with elements of motion and blur of the respective elements. Do note that motion blur should not be a crutch to a decent understanding of the basics, but it's certainly useful to help sell the idea of action.

CONCLUSION

This workshop hopefully demonstrates one methodology that you can experiment with in your day-to-day workflow. Thinking cross-laterally, you can also apply similar optimization and thought generation workflows in other related genres, e.g. character and creature design, landscape and cinematic set pieces, and so on.

In conclusion, the main things to get out of this short article are:

- Find the right shot.
- Ensure the forms read.
- Apply sufficient visual contrast.
- Be prepared to apply judicious artistic license versus your own core values, if the scene warrants it.
- Optimize your workflow for a more productive ideation.

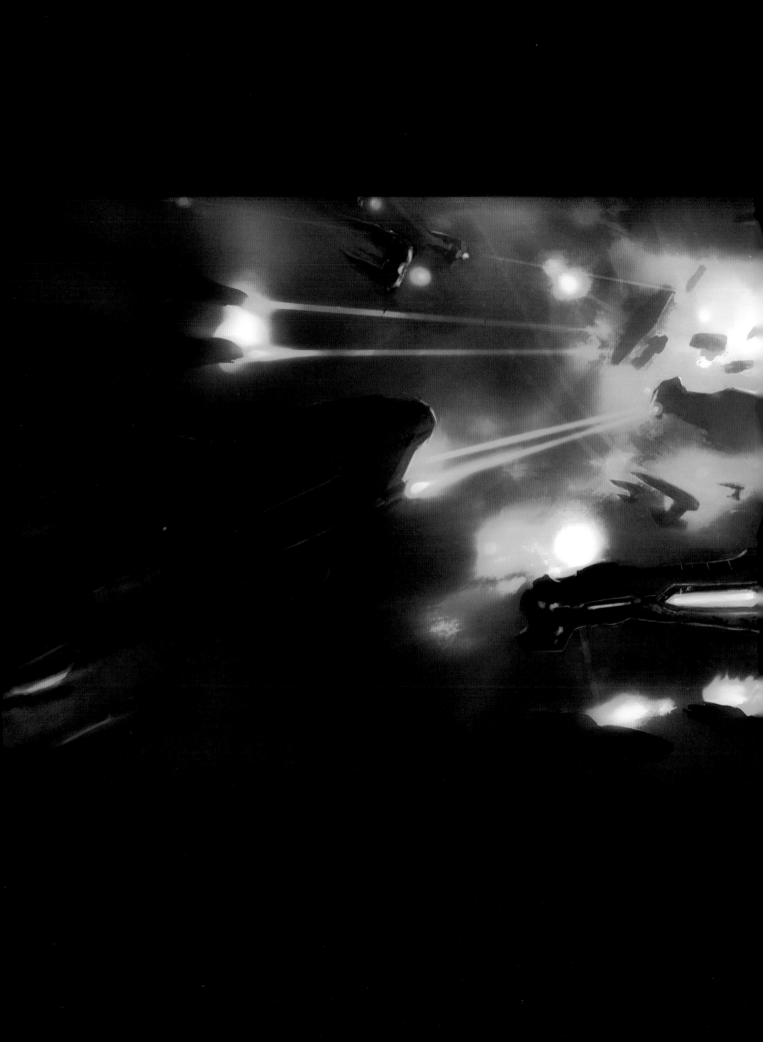

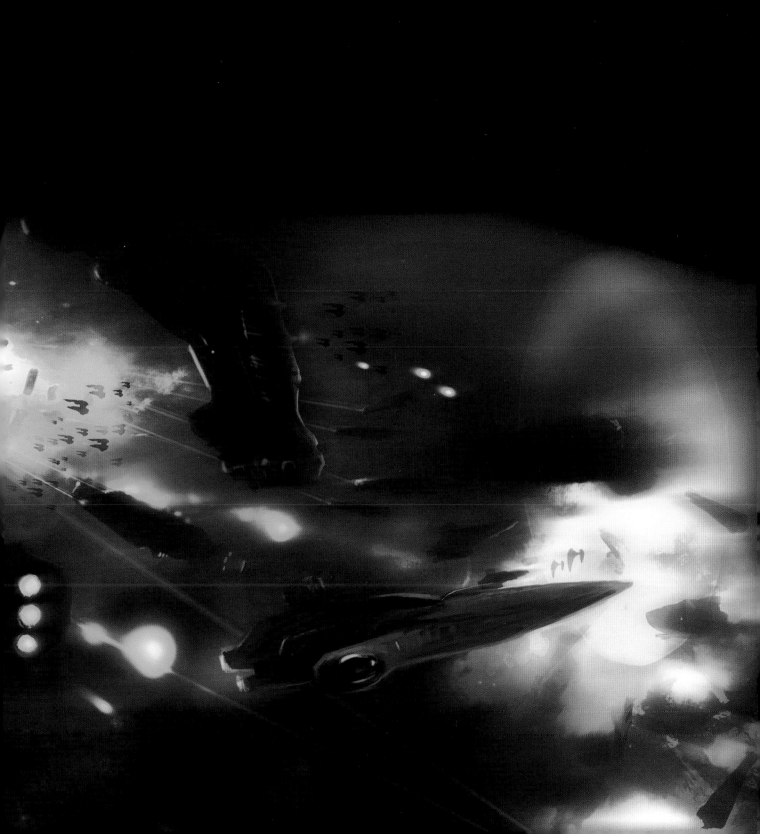

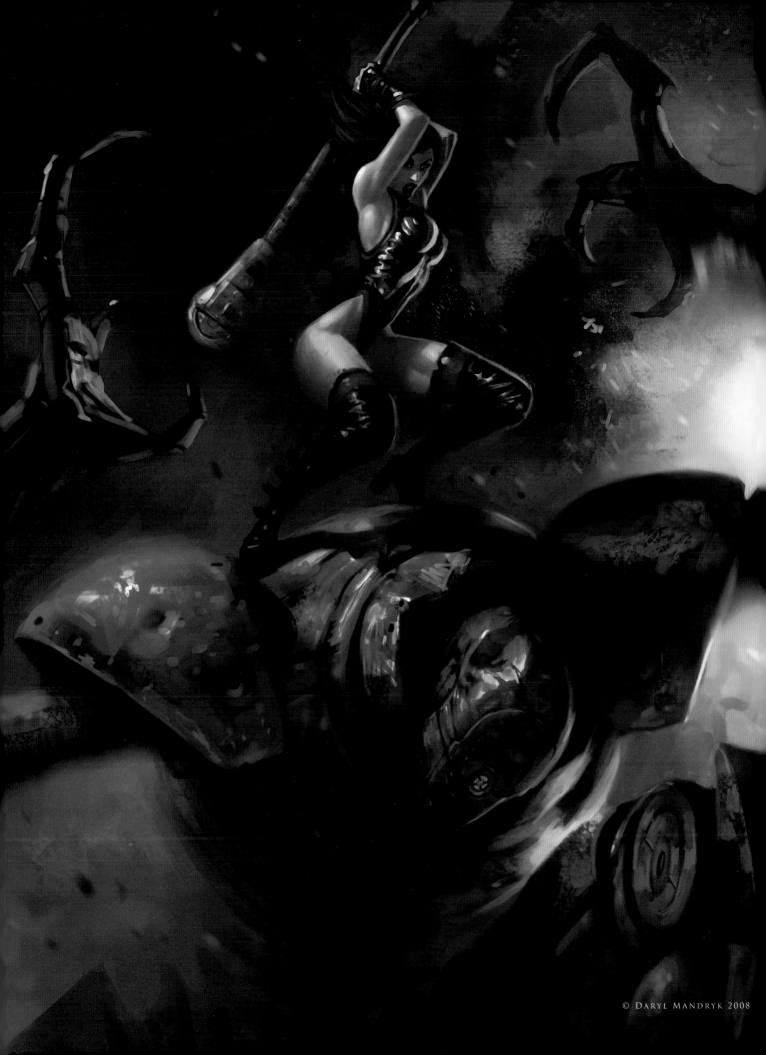

fantasy

The importance of fantasy art is that it provides an outlet for anyone who has ever felt that their life was a bit mundane, and that somewhere out there – adventure awaited. With fantasy art, there is always another world to explore, another story to experience, another fantastic design to entice you. The page becomes your doorway to the artist's imagination, and we become explorers without ever leaving the comfort of our own homes. It's this emotional response in the viewer that every fantasy artist tries to capture, and you'll see for yousefl in the next few pages just what I mean by this. Enjoy these amazing images!

DARYL MANDRYK

blackarts@shaw.ca

http://www.mandrykart.com

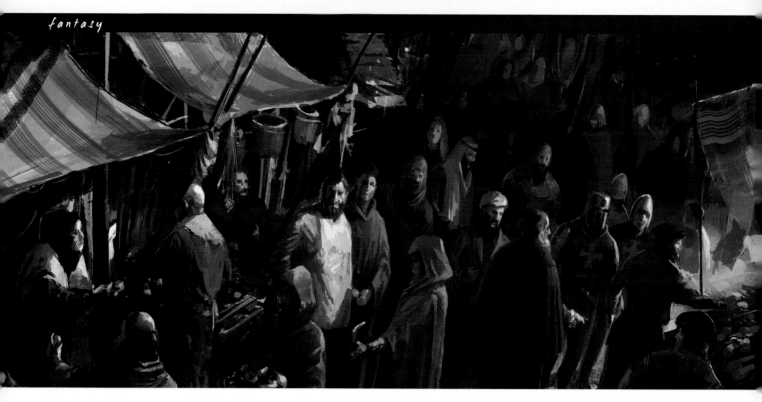

MEDIEVAL MARKET
BY IGNACIO BAZÁN LAZCANO

SOFTWARE USED: PHOTOSHOP

INTRODUCTION

Today I'm taking on the task of drawing a medieval marketplace. The first thing I imagine when thinking about this type of setting, is a place full of people from different social classes: knights, noblemen and merchants are all together in a place filled with texture and color, where there is smoke and several tents of different sizes and shapes. Perhaps it's even surrounded by stone walls and narrow roads or streets. I understand markets to be essentially social places where people gather for exchanging either things or ideas.

THE PAINTING

If you're drawing a marketplace, you can choose any viewpoint or approach; you can either draw in the foreground two people bartering or trading, or perhaps a child stealing some fruit from a stall – there are many potential stories to be told. The picture, or your point of view, will change depending on what choice you make here. If we think about it, the possibilities are truly endless! My choice is possibly the most complicated one: I'm choosing to show what happens in a marketplace as if we're looking at it from an aerial perspective.

01

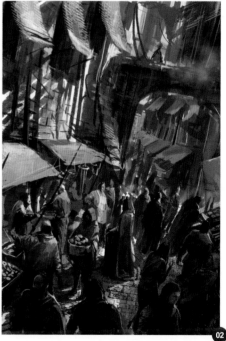

02

To start working on something like this, you need to use quick strokes to get the idea down, defining it step by step as you go. Measuring perspectives is necessary for making adequate structures. In this first instance, it really works to make quick sketches, without thinking too much about the anatomy of your painting (**Fig.01**).

Once you have an idea established, with regards to the objects and the location of the people in your scene, you can start defining and specifying your work more accurately. Amongst many things, digital art allows you to gloss very easily over any black-and-white drawing that has been done. Another alternative is to color your work from the very

beginning. This is the most traditional way of doing things, but you have to be very sure about the palette you are going to use when taking this approach. I'm going to do something in-between: define the objects and people in gray until I get what I'm searching for, and afterwards I'll gloss over in color (**Fig.02**).

The starting point will be a quite defined drawing to which you have put the first layer of color. Blue is the selected one for me, which I apply to the base layer using the Ctrl + U command. Tick the Colorize option in the new window that has already opened up (**Fig.03**).

Look for the blue tone you want in the slider bar called "Hue", and with other options you will be able to adjust the color even more. You should now have a completely blue colored drawing which is ready to have the real color for each element applied over it (**Fig.04 – 05**).

To color over the blue, let's create a new layer (Shift + Ctrl + N). Tick the Colorize option over the layers bar, and from now on you can paint with the colors you like (**Fig.06**).

Blue will be the background color. I'm going to use it to shade all the elements included in the

picture. My sketch is full of people and objects, so I'll try to use as many colors as I can to achieve variety in my composition. There are many characters that are becoming gradually defined: to the right there is a man that carries fruit in a basket; in the middle is a mysterious figure covered with a red cloak; above and below the picture you can see people from different social classes, moving upwards and downwards (**Fig.07**).

The second stage consists of giving basic color to each element and, at the same time, to go forth, tracing and polishing characters.

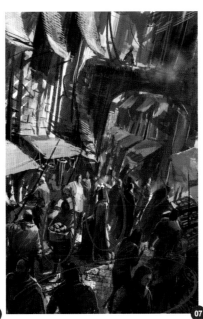

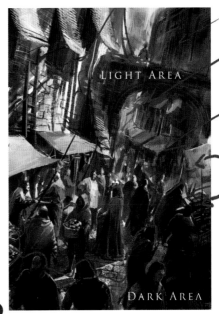

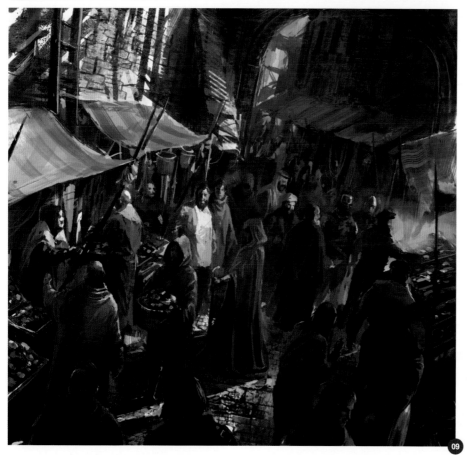

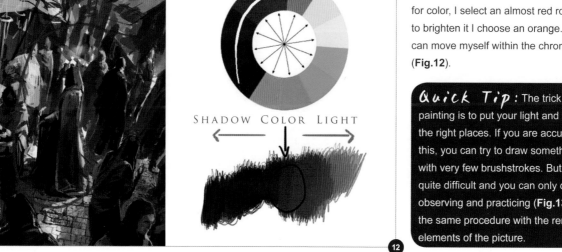

The following one is to define contrasts better. There are different ways of getting it: marking the place where light comes from very well; and, at the same time, where dark and shade zones are placed; using warm and cold colors to separate elements (**Fig.08**).

The drawing is becoming even clearer now (**Fig.09**). At this stage you must control the situation; that is to say, you have to adjust the whole picture at every moment. The control is yours!

The following is without any doubt the stage of adjustment and precision. Let's use the magnifier for details now, to make elements become clearer still. I usually use the Paintbrush at 78% Opacity for this. This gives me a certain degree of sensitivity and, at the same time, strong lines to define it better (**Fig.10**).

To explain what I'm saying, I'll now show you, from the very beginning, how I have colored the character who is dressed in a cloak and holding a cane (**Fig.11**).

What I want to get is the feeling that his cloak is made of pure velvet, something very luxurious. For the shadowed areas I use a basic blue; for color, I select an almost red rose color; and to brighten it I choose an orange. This way, I can move myself within the chromatic scale (**Fig.12**).

Quick Tip: The trick with painting is to put your light and shade in the right places. If you are accurate with this, you can try to draw something realistic with very few brushstrokes. But this is quite difficult and you can only do it after observing and practicing (**Fig.13**). I use the same procedure with the remaining elements of the picture.

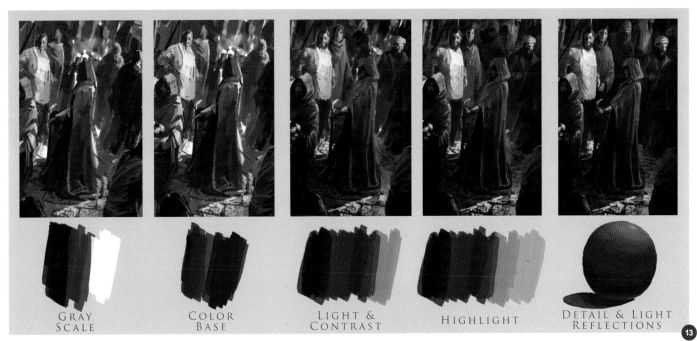

GRAY SCALE COLOR BASE LIGHT & CONTRAST HIGHLIGHT DETAIL & LIGHT REFLECTIONS

With the painting done throughout the scene, and with all these details hanging around, it is fairly easy for us to imagine what kind of custom brushes we might need to make work easier for ourselves when it comes to finishing up with the detailing work. When I think about a marketplace I generally see stone, fabric textures, weave, ornaments, and so on.

So to make any kind of medieval scene you might imagine, I'm now going to take you through the process of creating four custom brushes to aid you on your way – they're all very easy to design and make (**Fig.14**).

CUSTOM BRUSH NO. 1

Select a default Photoshop Paintbrush and draw a line with different degrees of intensity to get an interesting texture (**Fig.15**).

Select this line with the Lasso tool and then turn it into a paintbrush by going to Define Brush Preset and naming it. Now we've got a new paintbrush with interesting weft (**Fig.16**).

The following step is to retouch it to get the final paintbrush. Go to the Brushes menu. We're going to modify each brushstroke's distance, giving it 140% Spacing. From this, we'll get a staggered effect (**Fig.17**).

Next, tick the Texture option and scale it up to 1000%, selecting Overlay mode (**Fig.18**).

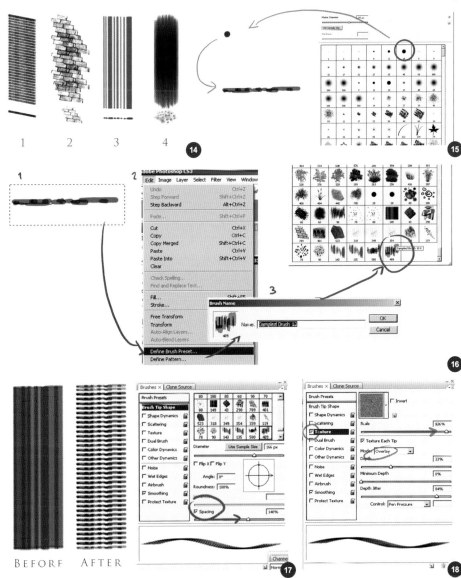

BEFORE AFTER

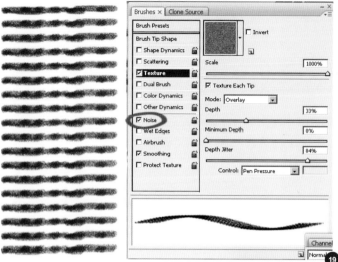

Finally, to give it a dirty texture, tick the Noise option (**Fig.19**).

Let's now see an example of how we can use this paintbrush in our painting (**Fig.20**).

CUSTOM BRUSH NO. 2

First of all, look for some photos where you can see bricks or stone. The idea is to create a paintbrush that will let us overlay the entire painting where stone, walls, and floors (etc.) can be found (**Fig.21**).

Go to the tool bar and select the Lasso tool. Choose any form that allows you to get a tile, something that fits well when using it over and

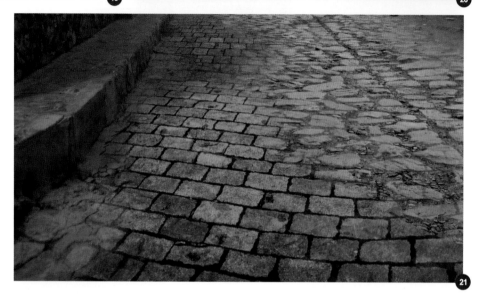

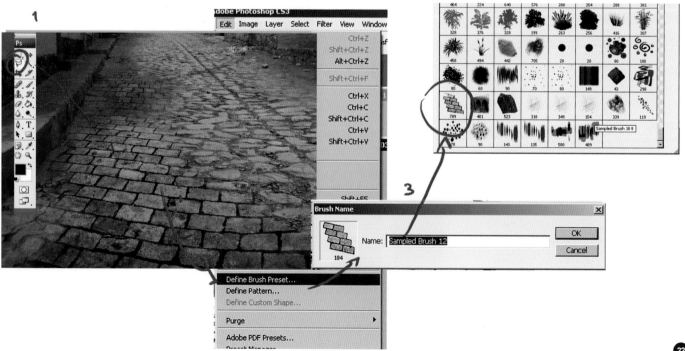

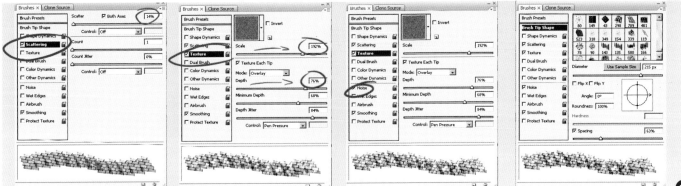

over on your canvas. Then define your brush (**Fig.22**) from the Brushes menu, and tick the Scattering option, setting it to 14%. This will let us repeat the texture several times within an adequate distance. The scattering can be regulated to keep the distance you wish.

Select the Texture option: set 192% for Scale and 76% for Depth; tick the Noise option. Finally, select the Brush Tip Shape option and set Spacing to 63% (**Fig.23**).

You now should have an excellent paintbrush to decorate the walls and floors of your painting in a quick and easy fashion (**Fig.24**)!

CUSTOM BRUSH NO. 3

Like in any medieval marketplace, we'd expect to find tents with fabrics and awnings. For this, it's therefore useful to design a paintbrush for weft.

Select a default Photoshop paintbrush and then draw a dotted line with different degrees of intensity in the stroke (**Fig.25**).

Select this line with the Lasso tool to turn it into a paintbrush (don't forget to define your brush: **Fig.26**).

Go to the Brushes menu, select Other Dynamics and tick the Noise option to make it smooth at the ends. At the same time, give it a dirty texture (**Fig.27**).

Trying the paintbrush out vertically on your canvas should help you to appreciate the effect of this brush (**Fig.28**).

CUSTOM BRUSH NO. 4

Finally, we'll design a paintbrush to emulate

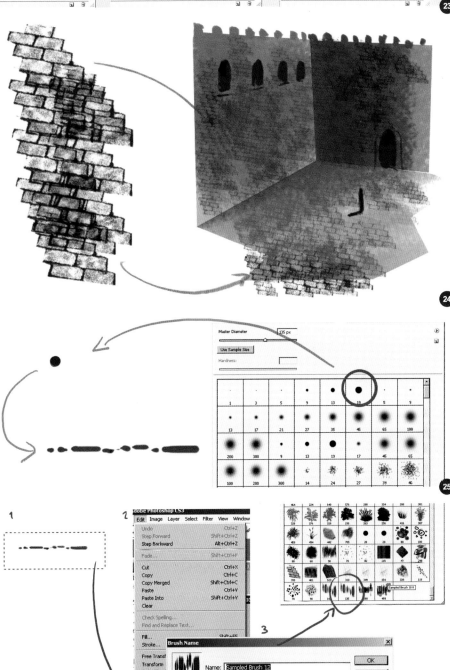

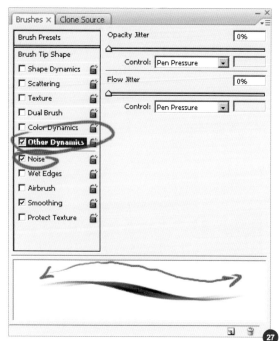

a real one! Select a default Photoshop paintbrush, and with small dots try to make what would be the bristles of a real paintbrush when pressed against paper. To create variations or different strokes, make larger and smaller dots, each one separated from the other. With a suitable shape defined, use the Lasso tool to turn it into a brush and define your brush preset as "normal" (**Fig.29**).

Once we have the paintbrush defined and stored inside our Brushes palette, tick the Other Dynamics option in your Brushes

menu to get a beautiful horsehair type brush, ready to use. This paintbrush is useful for everything: people, backgrounds … but, best of all, it makes you feel as if you're painting the traditional way (**Fig.30**)!

Although brushes are nothing but tools, they are funny and simple to make and use. They help us to get good quality results in a short time, because digital art simplifies the creation process. But I think that brushes must only be used when they are absolutely necessary, because otherwise they can cause you to lose

the challenge of art creation, and drawing becomes only a digital image with several textures applied.

Finally, to give your drawing a traditional painterly look, you can use a filter over it (Filter > Sharpen). And here we have the final painting (**Fig.31**). You could keep going and working your image to achieve a photographic representation of a city marketplace scene, but each of us knows when our work is done, and mine is now.

You can download some custom brushes (ABR) files to accompany this tutorial from: **www.3dtotal.com/dptresources**. These brushes have been created using Photoshop CS3.

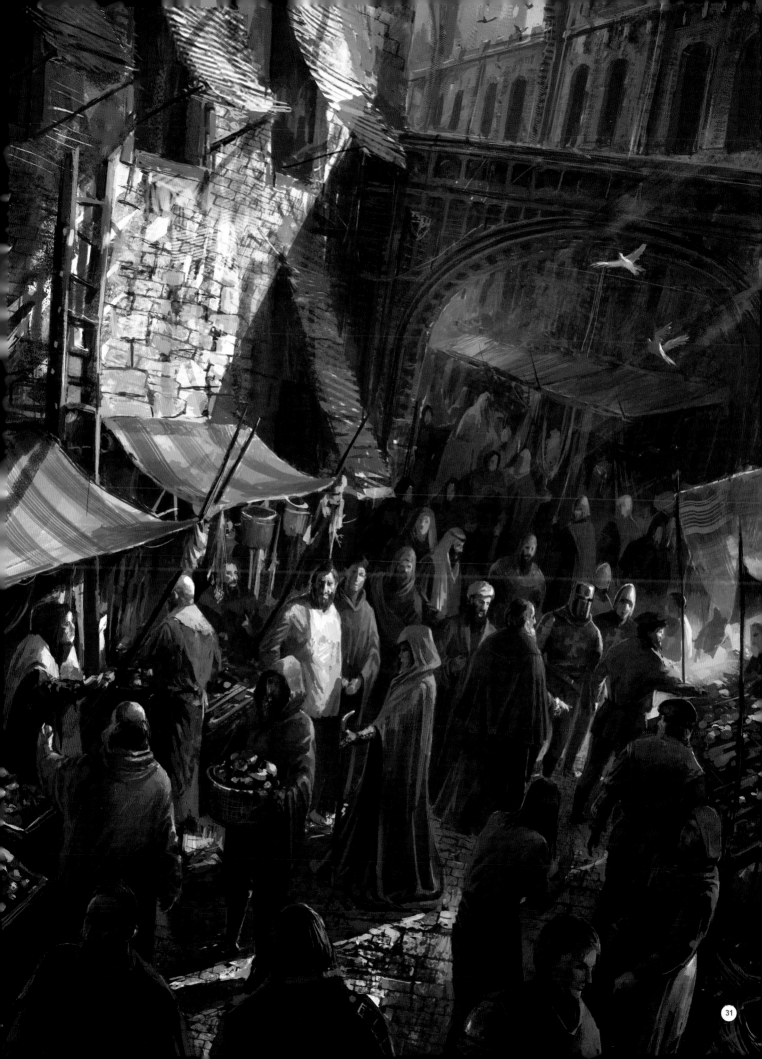

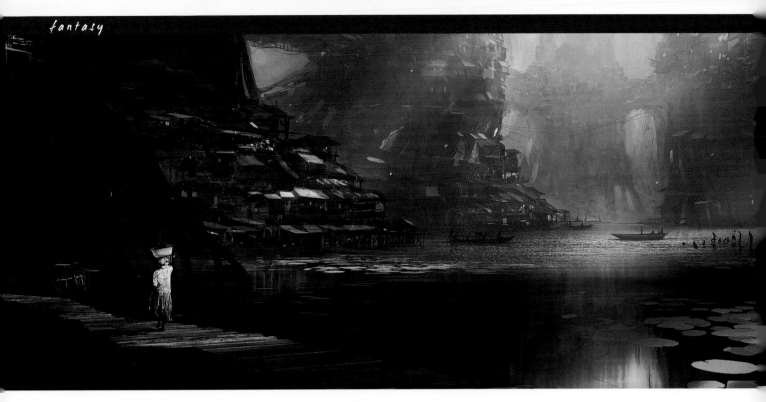

FANTASY CITY ON STILTS
BY JESSE VAN DIJK

SOFTWARE USED: PHOTOSHOP

INTRODUCTION

In the following tutorial I'll document some of the decisions I made during the process of creating this image. Initially all I started off with in terms of an idea was to create a 'city on stilts'.

THE PAINTING

When the time schedules allow for it, I like to take a bit of time to create my first rough sketches. I prefer to work in various, very short (15 min) sketch sessions to put some ideas on paper, making sure I don't start detailing anything and just get down the essence of an idea I might have. Also, I prefer to do these both digitally and analogue - again, when time allows for it. I usually find that doing analogue sketches provides me with different solutions than sketching in Photoshop. Not necessarily better ones, just different ones. It's partly because I can't do line drawings in Photoshop very well. When I sketch on the PC I use shades of gray and surfaces mostly, but with pen and paper I primarily draw.

This process can take a long time, sometimes even weeks or longer. During such a period I just do a quick series of thumbnails and

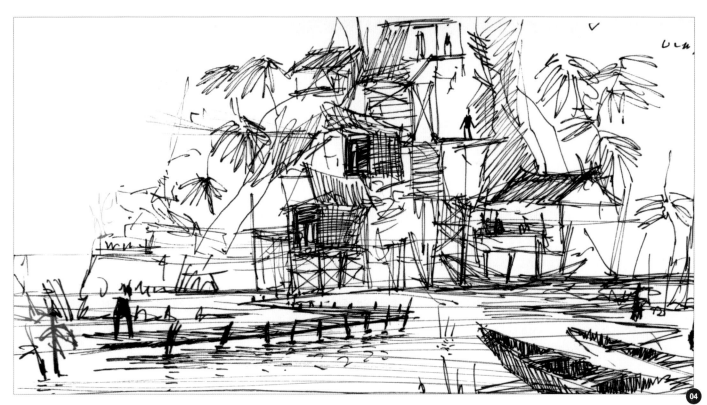

sketches for 15 minutes before I proceed with the rest of the paintings I'm doing that day. The combination of sketching for one theme/image and then detailing another is one I find particularly comfortable.

Shown below is a collection of images I did during my sketch phase for the 'city on stilts' painting (**Fig.01 – 07**).

I very soon discover that I've got some conflicting requirements for my final image. These usually result in compromises and subtleties, and therefore I want to avoid them. In my paintings, subtleties are badly solved problems 99% of the time.

In the case of this image, I wanted the scene to show an extensive part of the environment, which on the whole should feel huge and epic, but I also wanted it to suggest some sort of 'homeliness' – if that's the word – even a bit of coziness. My first ideas for solutions for these two aspects were each other's direct opposites – for the first I would use a very large scale, but for the other a much smaller scale would be better. And there were other conflicts like that as well. I wanted the scene to be in daylight, but I also wanted to show light behind windows.

CHAPTER 3

Back to my collection of sketches: So far, these aren't really blueprints of what my final image should look like – but I've gathered some interesting ideas through them. Particularly I feel the combination of up-scaled vegetation with the concept of a city on stilts works very well. I end up choosing a very rough thumbnail to go ahead with (**Fig.08**). I know beforehand that what I'll end up with will bear very little similarities to what I've just started with, but I'm not too bothered by it. I consider this sketch primarily to be a means to get the process started – I'm not really fussed about changing things around 180 degrees if needed. I find there's an upside to this approach, but also a downside; it allows you to really hone an idea, but it also takes quite long.

The first thing I do once I've selected my line art thumbnail is to put some value in there. This is done very simply by making sure the sketch layer doesn't have any gray areas any more, setting it to Multiply and then I paint underneath it (**Fig.09**).

In **Fig.10** I try to get some idea of scale by suggestion of some human activity. I want the place to feel populated, not deserted. The scale of the world can use some attention too; I stretch the image vertically to increase the height of the trees.

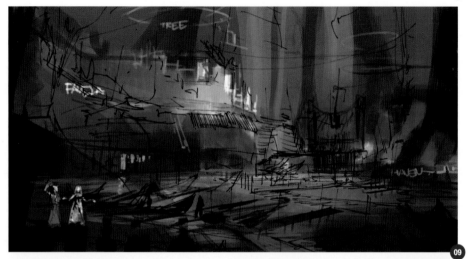

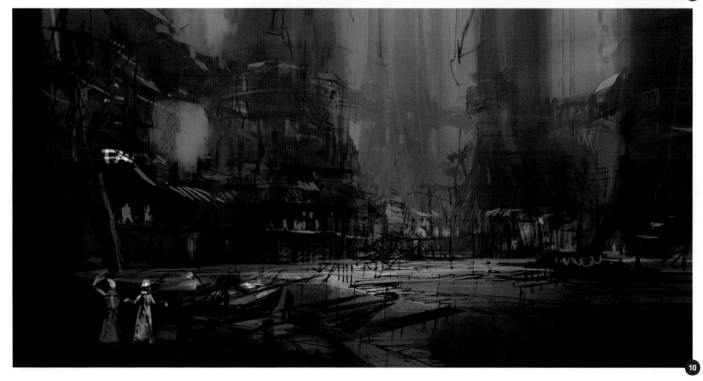

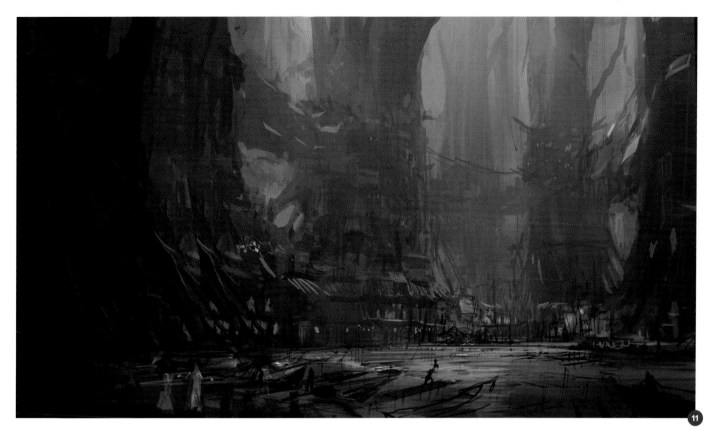

Before I worry about color, I tweak my environment one last time to give the trees even more height (**Fig.11**), I also make a more elaborate suggestion of some prominent tree roots on the left. During this process I also cut and paste bits of my sketch here and there - all I care about at this point is macro composition.

I can sense that I'm not absolutely certain about which aspect of this scene I intend to highlight - and I will come to regret that later on.

The first implementation of some color (**Fig.12**) features a prominently blue/greenish haze.

Light is shining on the canopy, but is also emitted by artificial light sources from the population.

This is a point where I really have to wrestle with the image (**Fig.13**). The values are affected by my rather brute force color

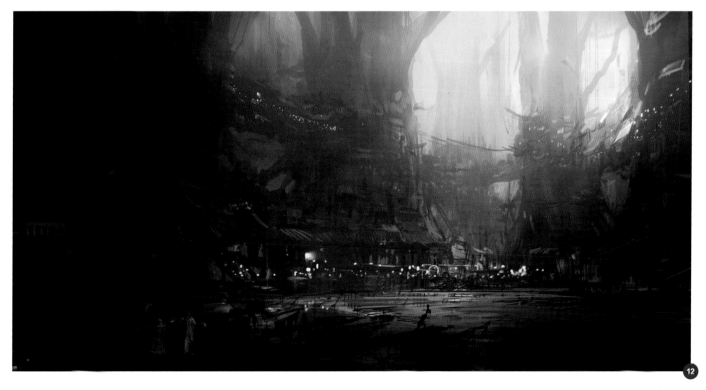

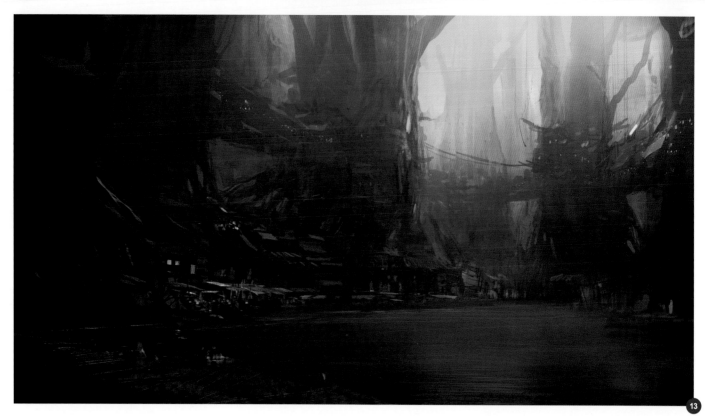

13

implementation (overlay layers and color balance adjustments) and I just can't read the image properly.

I try a lot of different things, and in the end I resort to a rather generic but failsafe method - structure the image by means of atmospheric perspective (**Fig.14**). It works to a degree - I

can now finally tell what is supposed to go where - but the lighting has become incredibly boring. I decide to build on this base - flattening the image. I do that a lot during my process, at (mostly) sensible points. However, things like the borders of the tree bases, (or actually, the shape of their silhouettes) are typically things that are useful to keep in saved Selections

or Channels. For example, should you want to paint fog behind a tree, having the shape Selection stored can save you a lot of time.

Here we are nearly at the point where I'm going to have to call it done (**Fig.15**). I provide some light from above on the rooftops, and add birds to liven up the scene. Particles are used to

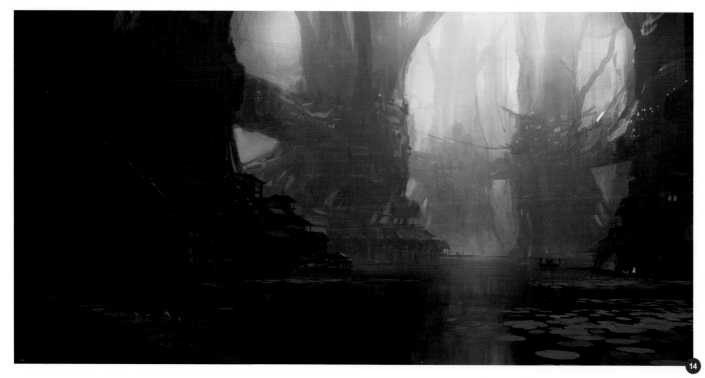

14

much the same effect. Also, quite a good bit of detail is inserted in the scene once more - and stuff painted at this stage is typically a task that 90% of your audience will overlook - so be aware of that. If things aren't working now, detail isn't going to save you. It's amazing how easy it is to write this, but how hard it is to implement it while painting!

At this point though I am still not quite satisfied! For my final pass (**Fig.16**), I beef up the lighting once more, possibly overdoing it now, but again, I don't really do subtleties very well.

Having now done my final pass, I look back at my process critically, and I can't help but feel I've thrown too much at the image from **Fig.12 – 13**. My final image suffers from conflicting interest points - something I often struggle with.

That is not to say I didn't have a good time painting it. It's just not the end of this design - I'll revisit this world at a later time to set things straight. Stay tuned.

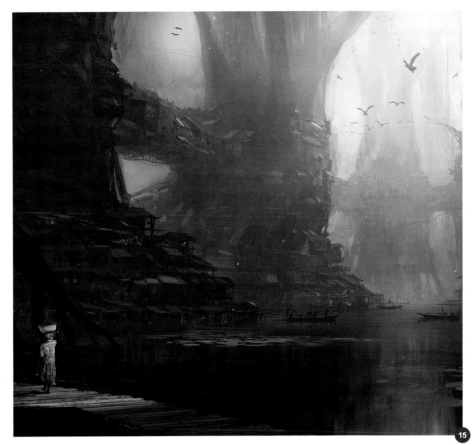

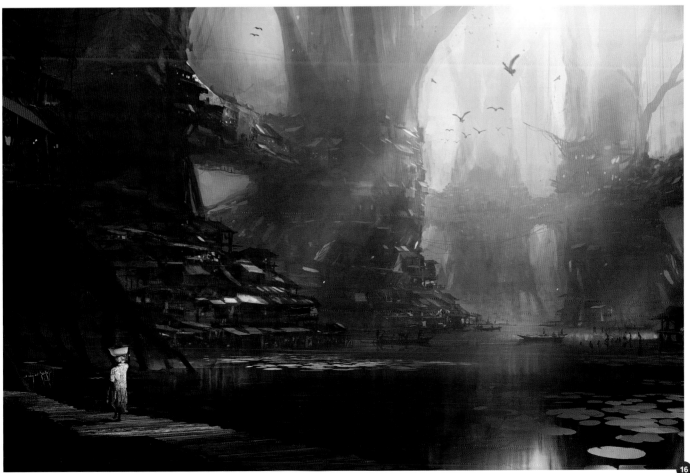

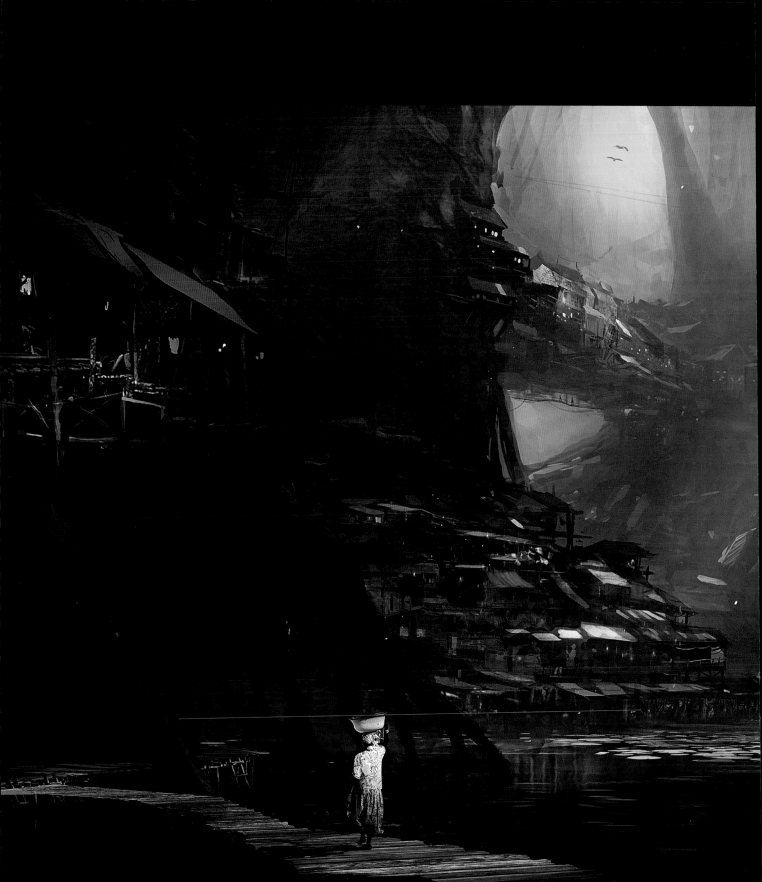

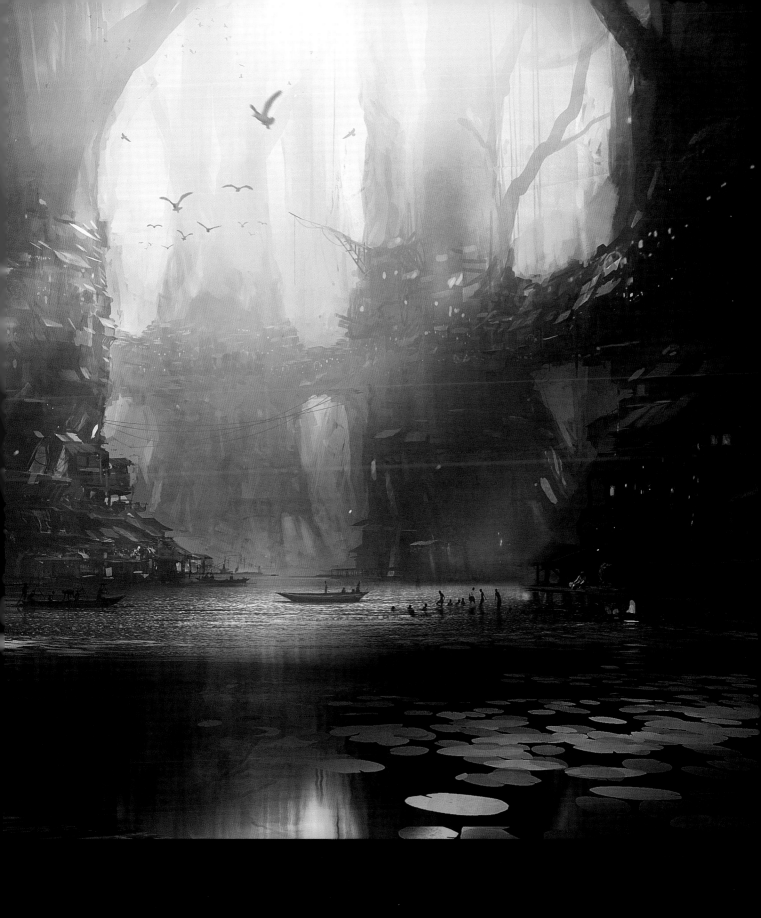

MEDIEVAL SLUMS
BY RICHARD TILBURY
SOFTWARE USED: PHOTOSHOP

INTRODUCTION

This particular task required the creation of a medieval scene that could fit within the Fantasy genre and also had to represent a slum area of a city. I searched the internet for some reference material initially, looking for scenes of old streets and alleys and anything that related to the medieval era. The type of architecture that seemed appropriate was anything asymmetrical and with some feel of chaos to its structure as this felt more indicative of a slum district. I also knew that I would keep the palette muted to convey a dirtier environment.

I decided to set the scene at street level, in a narrow alley shaded by the tall buildings that would create an almost tunnel like atmosphere. I hoped that this would convey a more claustrophobic quality and suit the theme.

BLOCKING IN

Once I had decided on the rough composition and eyelevel I began blocking in some of the key forms along with the main areas of light and dark (**Fig.01**).

I started with a tonal layer just using black and white and then using this as a guide I added

some color. Often I work in a grayscale to determine the light and dark areas and then add color on a separate layer but in this case I added the color onto the same layer, straight over the tonal sketch to establish my base layer.

I painted in an arch spanning the narrow street and liked the notion that this may be partly

used to prop up the overhanging buildings. This made quite a good structural device and also a useful way of creating perspective.

I repeated this shape along the street as seen in **Fig.02** keeping the warm tones along the left side. At this point I was laying down numerous colors on a newly created layer set to Overlay and experimenting with the quality of light.

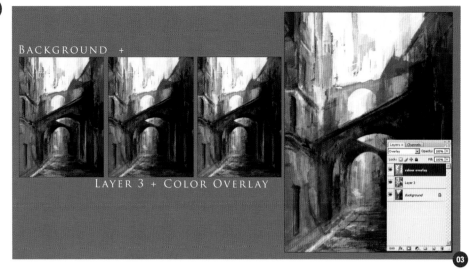

BACKGROUND +

LAYER 3 + COLOR OVERLAY

I use this technique intermittently throughout the painting process and once I am satisfied with the result I usually flatten the image and then continue the process. This way I can minimize the size of the file and keep things from getting too complicated.

This is precisely what I did in **Fig.03**. I flattened the image at the stage seen in the previous illustration and then added two new layers, one set to Soft Light and the other to Overlay. On the far left is the initial background layer with the other two added in sequence culminating in the version seen on the far right.

BUILDING THE DETAILS

After reaching this stage I again flattened the image and started on a new layer which I used to add architectural features and begin building the detail (**Fig.04**).

I began painting in some of the windows and doorways as well as supporting beams and struts. The brush that I mainly used during this

project was a standard Chalk brush combined with various Dual Brushes during the process (**Fig.05**).

By enabling the Dual Brush function you can vary the brush marks and texture by changing the Sampled Tip (**Fig.06**).

I continued adding details such as the beams jutting out from the right rooftops. I painted

some sunlight filtering into the street in the mid-distance and also illuminating the buildings in the background on the left (**Fig.07**). I decided that the spire in the upper right was a little distracting and so removed this for the time being.

After taking out the spire I thought that maybe something should occupy the skyline to emphasize the heavily built up nature of the city

CHAPTER 1

and make the scene feel more claustrophobic. I added a large cylindrical tower on the right as shown in **Fig.08** and hence leaving less of the sky visible.

To emphasize this feeling I created a new layer set to Multiply at 60% that added a darker shadow in the foreground (upper left in **Fig.09**). A second layer set to Overlay at 100% comprised of some highlights on the street and paving (lower left).

Leaving the file intact with these four separate layers I altered the color balance adjustment layer by going to: Layer – New Adjustment Layer – Color Balance (**Fig.10**).

This adds a new layer above the one you currently have selected and allows you to modify the color and tone etc. This means that any alterations can be reversed if need be as everything is done on a separate layer and hence can be deleted. However an Adjustment

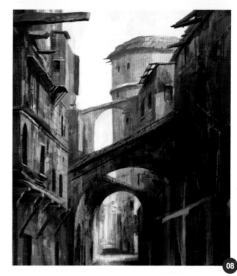

layer allows the option of using a mask to control the effect which means that it is non-destructible.

You can use black to reveal the initial layer or alternatively use white to show the adjustment layer. In **Fig.10** you can see the Color Balance Adjustment Layer in the Layers Palette and the mask thumbnail to the right.

Below are the Color Balance settings, these are used to add a warm tone across the picture with black being painted into the mask to reduce the area of effect.

Fig.11 shows the masked area in Quick Mask which shows exactly which parts have been left unaltered – this corresponds to the black and white areas in the thumbnail.

REFINING THE PICTURE AND ADDING TEXTURE

Once again I flattened the image at this stage and then added a new layer which was to represent the glare from the sun. To do this I used a Soft Round Airbrush and painted in a small white area top right above the tower roof. I then clicked on the Add Layer Style button at the base of the Layers Palette. This brought up a dialogue box similar to that seen in (**Fig.12**). It is here that you can add your desired effect, in this case an Outer Glow.

This creates a glow around whatever is apparent on the layer and enables you to control the Opacity, Color, Size and Blending mode. You will notice that the Size is at

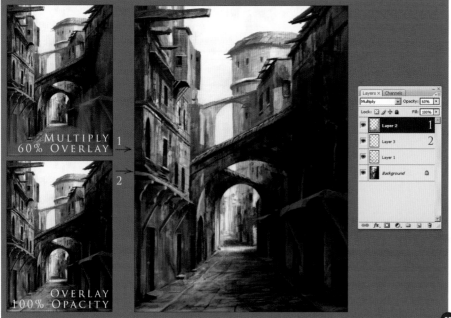

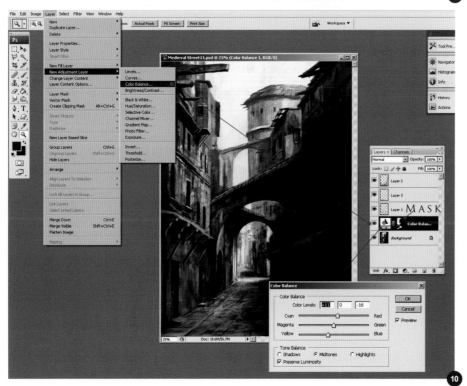

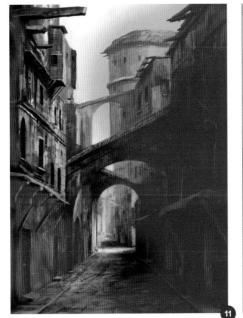

maximum and the Opacity is at 58%. Also notice the Opacity in the Layers Palette which is set to 56%, helping to keep the effect subtle. You can see how this bleaches the wooden beams and right side of the tower, creating a more intense light with a soft orange tint.

Fig.13 shows the effect at 100% opacity. The last stage in the process is something a lot of concept artists do when working digitally and that is to blend in some photographic references to add some realistic textures and details.

In **Fig.14** you can see some of the photo references that I have merged into the scene to add another level of detail. All of these images

were taken from the free library available at 3DTotal.com (**http://freetextures.3dtotal. com**). This is a great resource for artists and is perfect for this kind of project.

Almost every photo will require some form of color correction before it can work with the lighting and color scheme in your work and there are two key approaches I use to do this.

Once the copied section has been pasted in and scaled accordingly I either desaturate the image, setting it to Overlay or Soft Light and then adjust the Curves and Brightness/Contrast to match the scene. Alternatively I leave the Blending mode at Normal and go to Image – Adjustments – Color Balance and alter the

values and then use Curves etc. to blend it in. In **Fig.15** you can see an example of the first approach which I have used to add the rubbish lining the street. Sometimes even when the photo elements have been blended in it is necessary to use your brush to correct areas and help integrate things.

In **Fig.16** you can see a tower that has been added into the background but with some over-painting to ensure it fits into the image. I added some cobblestones on a near section of the street and some windows along the right foreground wall to balance the detail on the left hand side.

At this point I flattened the image to avoid the file getting too big. After reviewing it I decided that because this was meant to be a slum area it needed to be a bit darker and even more claustrophobic. I duplicated the scene and reduced the brightness as well as tinting it towards a blue and green by way of Image – Adjustments – Color Balance.

Once done I then used an Eraser to restrict the darker layer to the ground level (middle image in **Fig.17**). To add some drama I then created a layer set to Overlay and painted in some highlights along the upper left row terrace and facing side of the right hand building using a pale yellow (left image).

Because I had now added some sunlight I figured the areas catching the sun should be warmer to contrast with the street. I therefore created a Color Balance adjustment layer (Layer – New Adjustment Layer – Color Balance), using the settings shown in (**Fig.18**) and then painted into the mask to restrict the warmer values to the upper section of the street.

The scene was almost complete at this stage but I thought that it needed just one or two more elements to lend it a more slum like quality. I thought that the building on the right looked unstable due to the damaged wall and so painted in a haphazardly placed beam to brace it against the opposite side. I also added some precarious scaffold in the middle distance to help create a more chaotic and shanty quality to the district.

Last but by no means least I looked through the free reference library mentioned earlier in order to research some medieval costumes and add in some shady looking characters.

Here is the final version (**Fig.19**).

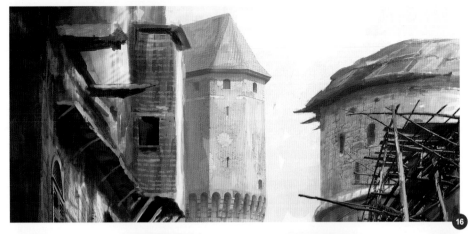

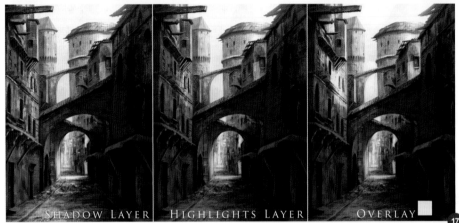

SHADOW LAYER HIGHLIGHTS LAYER OVERLAY

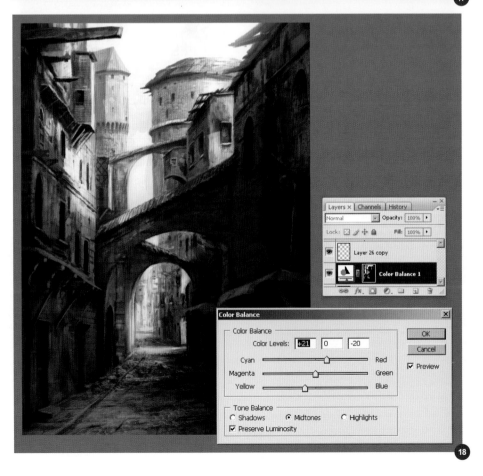

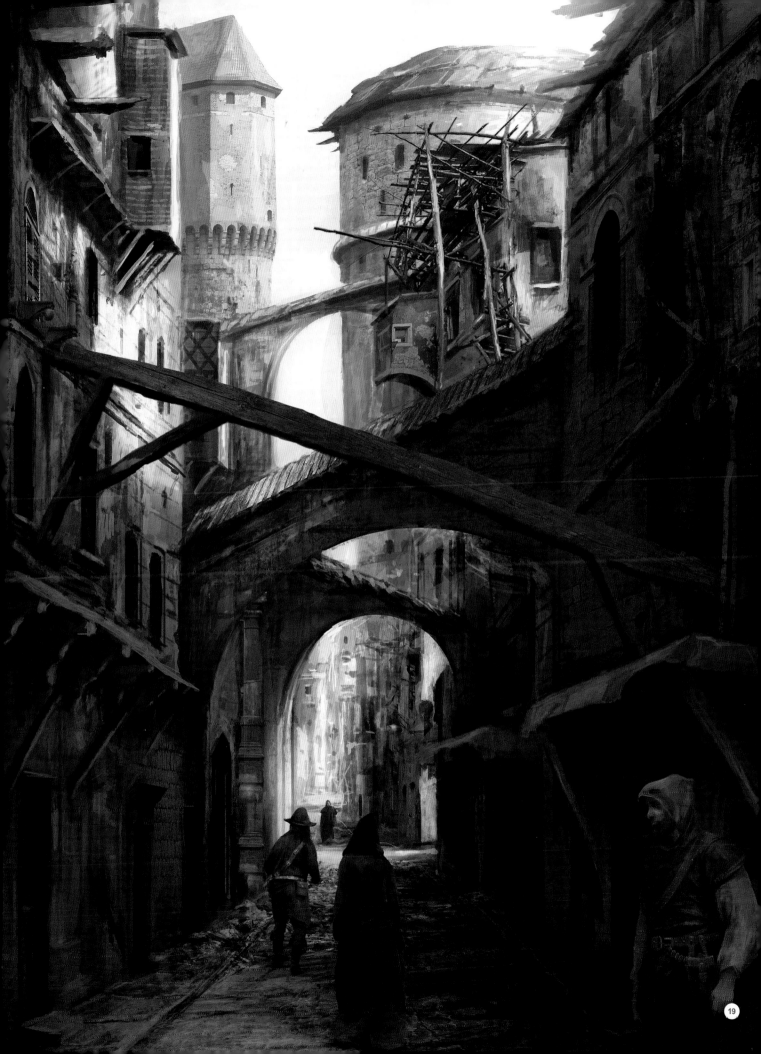

© Matt Allsopp

vehicles

Concept design and the prototype stages of development will range from Initial Concept through to Proof of Concept, which may take a further leap into becoming a fully realized 3D model or manufactured product.

My contribution to vehicle design begins by taking something real and commonplace, and pushing it towards something more unusual. Here an incredible creative process begins, where anything can happen from fully functional real-world automobiles, to organic alien star destroyers that are completely abstract. As a concept artist I love being versatile, as the range of design can be huge and the possibilities endless.

After all of the initial sketches it's great to exhibit the final design. As shown here one of my key favorite ideals is to really sell that vehicle, by displaying the craft in its 'natural' atmospheric environment.

MATT ALLSOPP
matt.allsopp@gmail.com

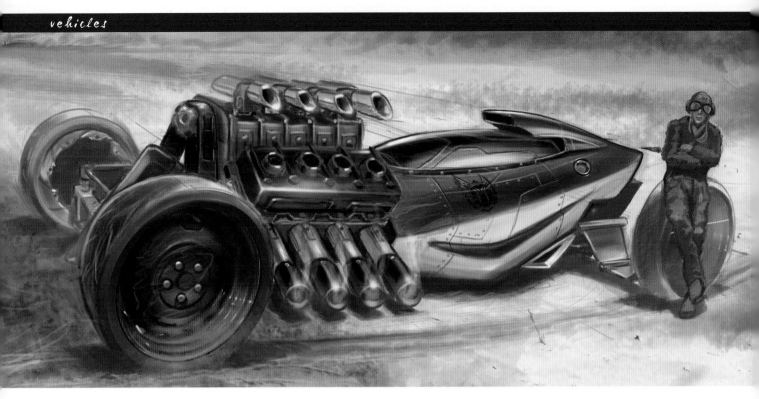

DESIGNING A CONCEPT RACING CAR
BY DWAYNE VANCE

SOFTWARE USED: PAINTER, ALCHEMY AND PHOTOSHOP

INTRODUCTION

My design brief for this project is to design a
sleek race car, so I'm instantly thinking of long
sleek shapes that are aerodynamic and fast
looking. My next thought is when the car will
be built: should it be from the future or from
the past? Since this is an open project I will
probably let my shapes dictate whether it is set
in the future or the past and I will draw forms
that represent both.

THE CONCEPT

In this tutorial I'll give a few different
approaches that I like to use to generate ideas
quickly. I use three different programs to start

01

my ideation: Alchemy, a freeware program, Painter and Photoshop.
At this point I just let my mind wander as I try to come up with unique
shapes and patterns. I treat this phase as if I'm looking at the clouds in
the sky and coming up with shapes and interesting forms; trying to be
unique but still achieving a really cool look.

At this stage you don't need to worry about being perfect; just draw and
let your hand flow. It really can be a lot of fun and takes the pressure
off you to create something perfect on your first try. I start with Painter
and make lots of scribbled drawings; I'm not trying to be precise with
these sketches, just letting my hand flow. The only thing I think about

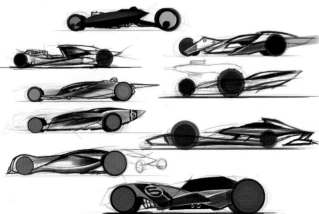

02

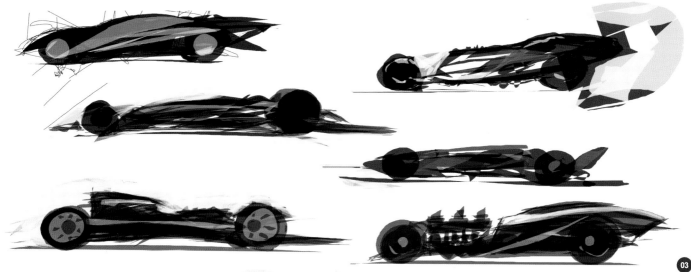

is that it needs to look fast, so my lines are long and aggressive. I will refine them as I go along. As you can see (**Fig.01**), I have several rough squiggles. I am keeping my lines quick and loose, trying not to draw what I already know; trying to come up with new lines and unexpected shapes.

I now start to go over my Painter sketches and fill them in a little, trying to keep the squiggles as my guidelines to create interesting shapes (**Fig.02**).

Now I try another program called Alchemy, where I draw random shapes and again try to keep it loose and see what kinds of combinations I can come up with. In Alchemy there are lots of settings you can choose from. There is no "Undo" in this program though, which can actually really help in your creation process as it forces you to work in an unfamiliar way (**Fig.03 – 04**).

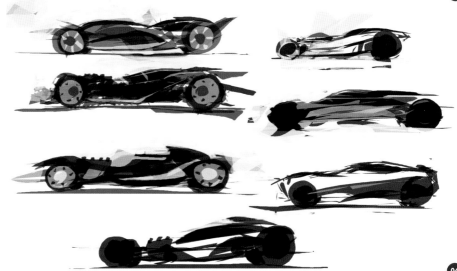

I feel at this stage like I'm drawing too many familiar car shapes from the side view, so I'm going to work from top views instead (**Fig.05**). There is a really cool mirror tool in Alchemy that creates symmetry – it makes some great "happy accidonts"!

I'm now trying one more method for creating random shapes, and I also create some custom brushes in Photoshop. The guys at Steambot came up with this method and it works great! So I create my own custom brushes in Photoshop and make them really aggressive-

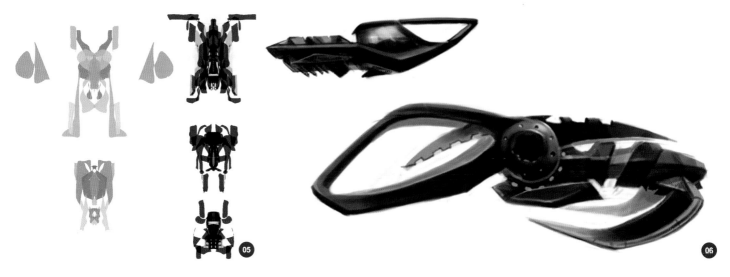

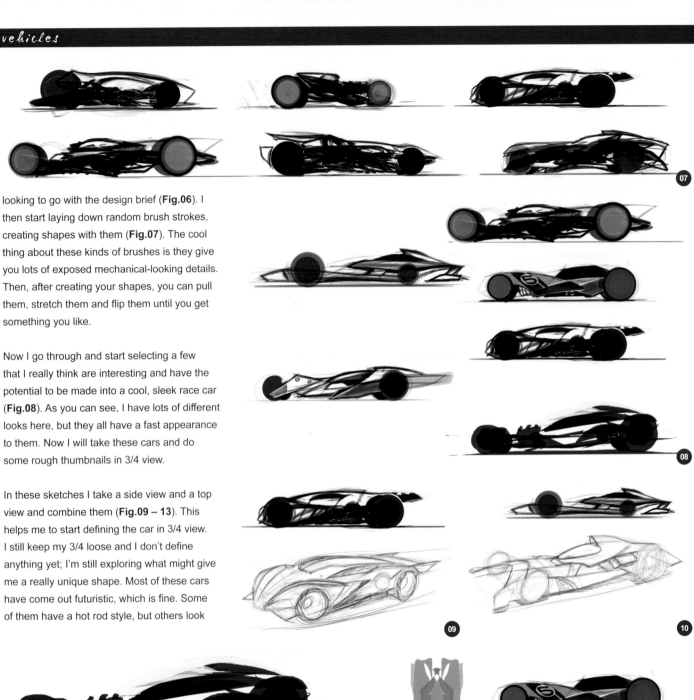

looking to go with the design brief (**Fig.06**). I then start laying down random brush strokes, creating shapes with them (**Fig.07**). The cool thing about these kinds of brushes is they give you lots of exposed mechanical-looking details. Then, after creating your shapes, you can pull them, stretch them and flip them until you get something you like.

Now I go through and start selecting a few that I really think are interesting and have the potential to be made into a cool, sleek race car (**Fig.08**). As you can see, I have lots of different looks here, but they all have a fast appearance to them. Now I will take these cars and do some rough thumbnails in 3/4 view.

In these sketches I take a side view and a top view and combine them (**Fig.09 – 13**). This helps me to start defining the car in 3/4 view. I still keep my 3/4 loose and I don't define anything yet; I'm still exploring what might give me a really unique shape. Most of these cars have come out futuristic, which is fine. Some of them have a hot rod style, but others look

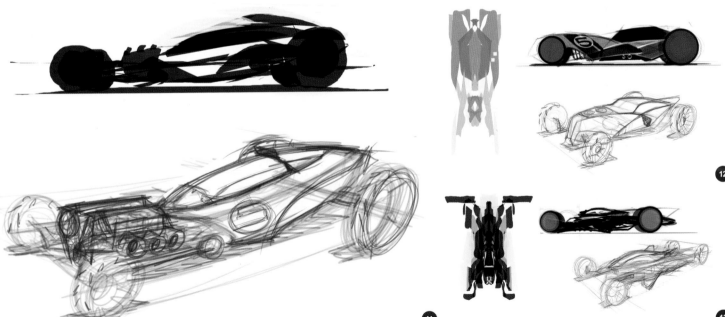

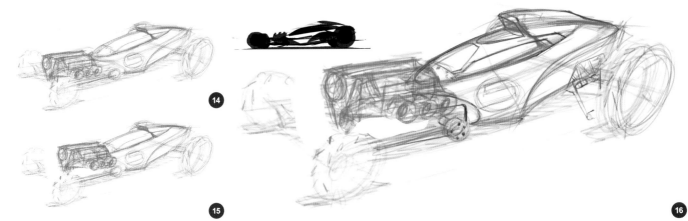

like flying ships with wheels. So I feel I have several good ones to choose from and I can still take each sketch and make them look different.

REFINING THE CONCEPT

This next stage is more of a thinking stage where I figure out what makes my rough ideation look good and what the design and proportions look like. So I take my roughs, which give me a decent idea of what the car might look like, and start to sketch over them. This is one stage that can be a lot faster if you are working digitally.

In my drawings, I cut stuff out, move them and scale them to get different proportions and such. The three final designs were sketched in the same way, using Painter 11, in which I made a non-photo blue pencil.

So in the first phase I take the ideation sketch and fade back the layer so it is lighter and

gives a good underlay (**Fig.14**). This way I can see my new line sketch as I lay it down.

I decide that the engine is too far forward and I want to make the car look longer, so I cut the engine out and move into a position where I think it looks better (**Fig.15**). I then start laying down some line work to start cleaning up the design (**Fig.16**).

I really figure that the engine will be the showcase piece on this vehicle – after all, the

bigger the engine, the faster it looks! So I go to my reference stash from all the previous hot rod shows I have attended (**Fig.17 – 18**), and pull up some engine references. Using references, I feel, is very important; it helps you put in details you might not have thought of when you were drawing entirely from your mind – especially if you've never drawn the subject before.

I don't stick to the exact design and I add some modern features to the engine, as if

it could be from the future or an alternate dimension (**Fig.19**). I also love things with lots of mechanical detail; it gives a sense of being engineered and that it could function if it had to. You may also notice I made the engine big, but I later shoved it back into the body more to really kick the wheels out in front!

I tighten up my wheels with some ellipse guides (**Fig.20**). One thing that I do manually is use my ellipse templates on my Wacom 21 UX. It takes too long to draw up a circle and stroke the path, so I just put my ellipse templates right on my monitor and draw as if I was using regular paper. This saves some time. I also add a small grill to the front to keep the engine cool. I know it still has the hot rod feel – what can I say? I love hot rods!

20

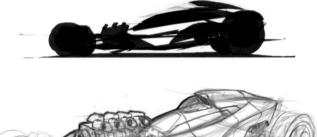

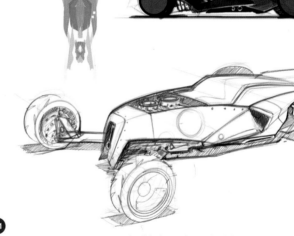

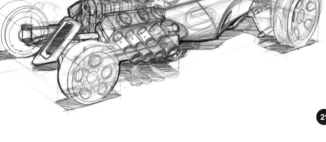

21

22

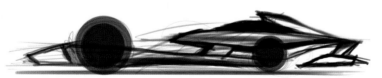

In this last phase I add a ground shadow to place it on the ground (**Fig.21**). When you add a simple shadow, it really helps make the object you just drew feel like a solid mass – even when you draw a spaceship hovering over the ground, you can place a shadow under the ship. Not only does it give mass to the object, but it also helps you determine the top view. I then went around and added a few shadows to darker areas to give detail and add mass.

The following sketches were also done in the same way (**Fig.22 – 23**).

As you can see, my final concept is still not a really tight drawing, but is much closer to a finished piece now. This phase is probably

23

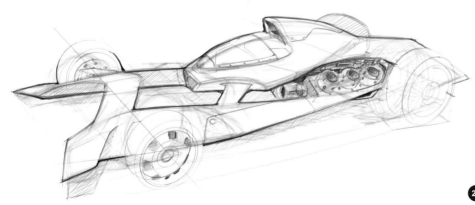

the hardest phase because you are figuring out the design and how things look with each other. This comes with practice and observing things in life, and then figuring out how you can manipulate that to look futuristic – or whatever the design brief may ask for.

THE FINAL DESGIN

Next I'm going to look at adding color and setting up the scene. I drew my car in perspective to understand the form and to give a general sense of what it looks like and now I want to draw it in a more dynamic way. I'm going to set it up in a scene as if it's racing or parked in a garage and I want the car to look more real, so I will draw it from a perspective that suggests I've taken a picture of it through a camera (**Fig.24**). When you draw things more from the top it can sometimes look like a toy, so I find drawing it at a lower angle is best, from more of a realistic point of view.

I take my rough line drawing and clean it up. I then take my cleaned line sketch and

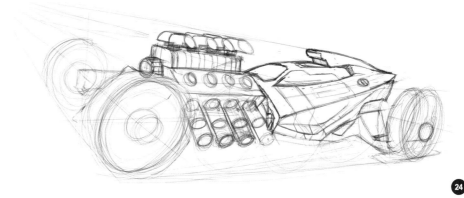

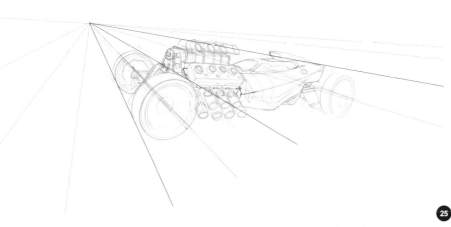

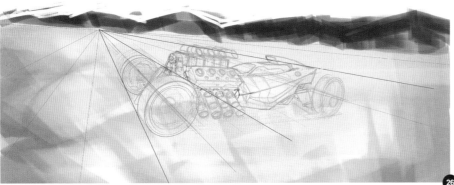

place some quick guide lines for perspective (**Fig.25**). I lay out my perspective guidelines to line up the background and make sure it is sitting on the right ground plane.

I decide to place my car in the desert, as if it's a Bonneville Salt Flat car. As you can see, I have refined the car a little more and modernized the body of it. So I make my canvas fairly big now and lay in some ground that looks like sand, and I include some mountains to the distance to add some additional interest (**Fig.26**). Now this piece is more about showing off the vehicle design and less about the scene, so I really make the vehicle the centre piece for the scene.

I decide to really crop the picture in at this point to focus more on the vehicle. I add some sky tones, clouds and some texture details to the ground. I try to keep this really quick because it is more about the vehicle and not the scene. I take the sketch and make it darker-toned so that I can see everything going on in the car (**Fig.27**). The blue just wasn't helping anymore.

I remove the perspective guidelines now and start to work in some color. I leave my sketch

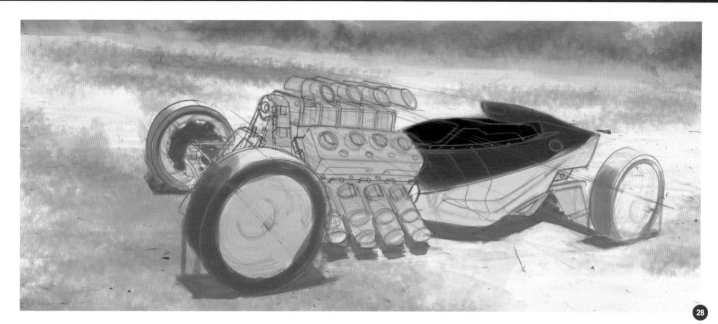

on one layer and start coloring under the
sketch to start. As I define more of the car I
will move on top of the sketch to pretty much
eliminate the line drawing. I decide to go with
the green color because it is kind of inspired by
WWII aircrafts. I also start with a gray for the
engine area, just to lay in some tone (**Fig.28**).

I start to define the cockpit area more here
and put the horizon line and sky tones on the
top (**Fig.29**). One trick when you're rending a
vehicle in a scene is to match the color of the
ground with the tires. Just go slightly darker to
define the difference between the object and
material. It will look like it is part of the scene
pretty quickly. It wouldn't look right if I went in
and colored the tires solid black against the
sand color. They would look too clean, as if the
car has been dropped into the scene rather
than having been driven there through all the
dirt.

So here I start to lay down some other colors
for the engine (**Fig.30**). It would be very dull
and boring if I made the whole thing metal. You
can have various kinds of metal as well; shiny
chrome, dull flat metal, brushed metal etc. So
you can use these to break up the engine so it
doesn't look like one solid chunk of metal. The
top intake area I decide to make shiny chrome,
so I lay in some sky tones and a ground plane
(**Fig.31**).

I add quite a bit to the engine area and break
it up into different colors and materials to

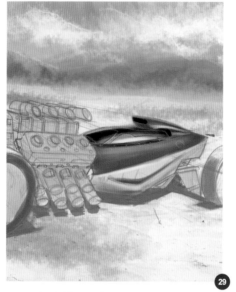

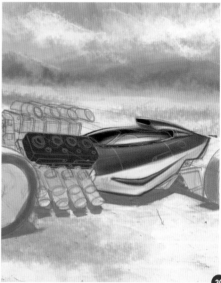

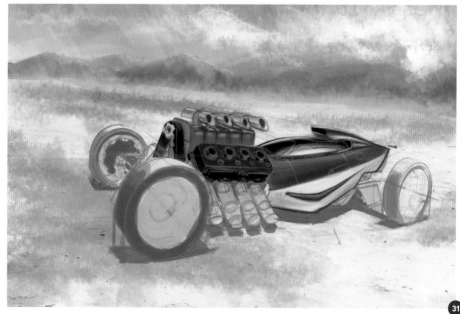

give it interest (**Fig.32**). I still use my engine references while rendering the engine, just so I can see what details I need to have there to make it look believable (**Fig.33 – 34**). I modernize the engine a bit to push it out into the future. I also keep working on the body of the car to keep refining it. I put the lighter color on the bottom because it is reflecting the color of the sand up into the body. Then I make the top darker because it is reflecting the blues of the sky.

In **Fig.35** you can see a rendering material example and the similarities and differences between each material. Chrome always reflects its surrounding environment, just like a mirror. The green shiny paint is similar to the chrome but it is using all green hues. Then if you render dull metal, the sky, horizon and ground all blend a little. Just compare the shiny chrome to the dull metal. The rubber material of the tire can also be seen. It's not shiny because the sky, horizon and ground all blend together, just giving enough indication of where they all are. I use cylinders to render because most car shapes are complicated cylinders. They will have your sky tone on top, your horizon in the middle and your ground tone below. Then you just take your horizon and bend it around the curves and different surfaces of your automobile or vehicle.

I am still focusing on the engine area of the car and adding details and small material break-ups (**Fig.36**). I am starting to show a process called "vignetting" (vin-yet-ing). This is when

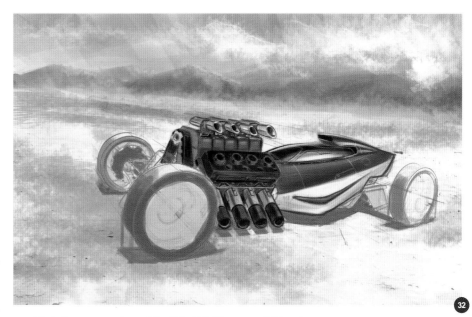

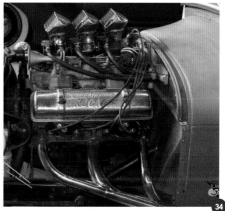

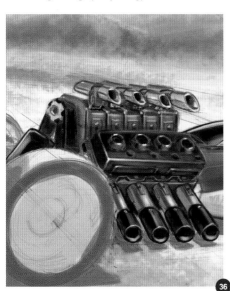

1

BRUSHED OR NON
SHINY METAL

2

RENDERING CHROME

3

SKY TONES

HORIZON

GROUND

TYRE

4

SKY TONES

HORIZON

GROUND

GREEN PAINT

you make things fade out from the closest object to you. The front wheel and engine is the part of the car that is closest to you, so I focus my detailing and color saturation on those areas. Everything from there fades out. This really helps the eye to flow over the vehicle and saves time when rendering. It also helps keep your vehicle from looking flat or "pasted" into the scene. You don't need to render every single detail to get your point across!

At this stage I pull some photo scraps from one of my hot rod photos and place them

onto my car. I just take an existing wheel and modify it. I do this to save time and it gives me a very precise and defined wheel instantly (**Fig.37 – 38**). One thing on a vehicle that is very important is the wheels. If they are not very defined wheels, or not drawn correctly, it can quickly ruin a cool vehicle. I just take a wheel that is close to the perspective I need, and skew it into the right perspective using the Transform tools in Photoshop.

I finish up the detailing on the wheel and go through and start adding a few more details to the car. I also add some smoke to the exhaust and some paneling details to the body (**Fig.39**).

The wheel in the back was taken from the same photo (see **Fig.37**), but I used the back wheel of the car instead of the front. I don't spend too much time on the back wheel because I want the front wheel to have most of the detail. I then detail up the back suspension to make it look more complete. I use a soft brush to go over the back wheel as well, to make it look dustier and to push the wheel back further (**Fig.40**).

The car looks a little strange just sitting there on its own and so I add a driver sitting on the rear wheel (**Fig.41**). Again, I'm still leaving the focus on the vehicle and so I place the character in a position where he is not the main focal point. I am also working on the far front wheel, just adding enough detail to give some indication of parts and a possible brake system

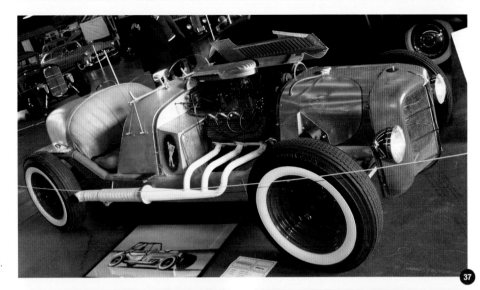

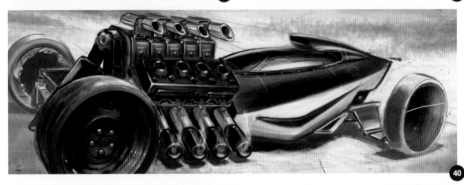

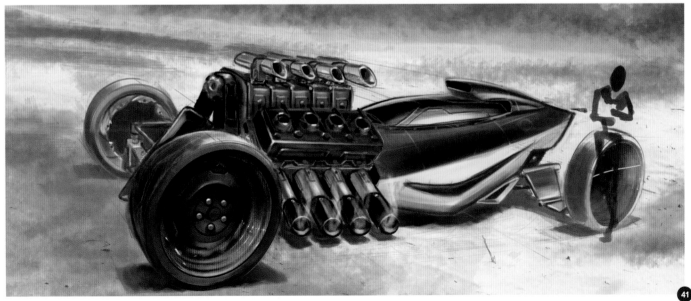

like a street bike. Again, I'm not putting a lot of focus on that area – just enough to suggest that something is there.

I work on the driver a little more here, giving him a type of vintage suit and goggles, almost as if he's a fighter pilot that drives this car (**Fig.42**).

I decide here to put a logo from my book, Masters of Chicken Scratch, on the side of the vehicle. It has a kind of vintage feel and is a logo you might see on a WWII aircraft (**Fig.43**). I also lay down some dust over the driver so he becomes part of the scene. I then adjust the background a little and turn up the contrast a touch; I felt it was a little too muted.

The logo is skewed and placed on the side of the vehicle. I also use the Warp tool in Photoshop to give it the curvature to match the body. I continue to add details to the body, like rivets, and refine the areas around the cockpit (**Fig.44**).

I add some more detail and contrast to the ground around the car here (**Fig.45**), just to lead the eye through the whole piece. I start adding a car in the background that is racing through the desert. When cars race out there they very rarely race alone; they all have to have buddies. It adds more action and interest to the piece. I also add some tire tracks to the sand so it looks like the car just rolled up there and parked. It adds realism to the piece and helps to make the car feel like it hasn't just been dropped there. I then decide the shadow looks a little dead and I could add some color in this area. When you have warm light from above, the shadow will be a cool color, so I add some purple in there.

This is the final piece (**Fig.46**). I decide to crop it down a little more because I don't need all that background. I like the long, narrow look when working on a car piece. Like I said before, it's all about the vehicle and not so much about the background.

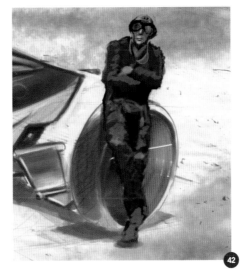

42

43

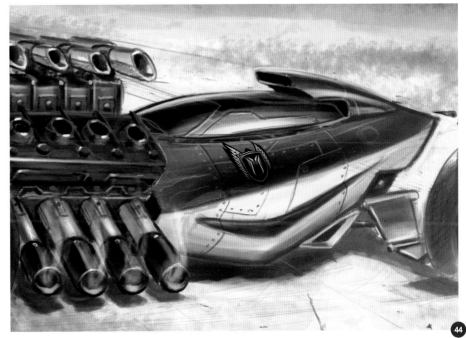

44

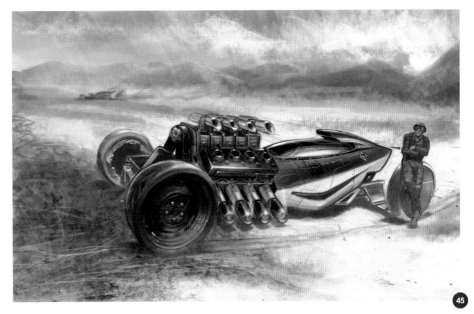

45

CHAPTER 4

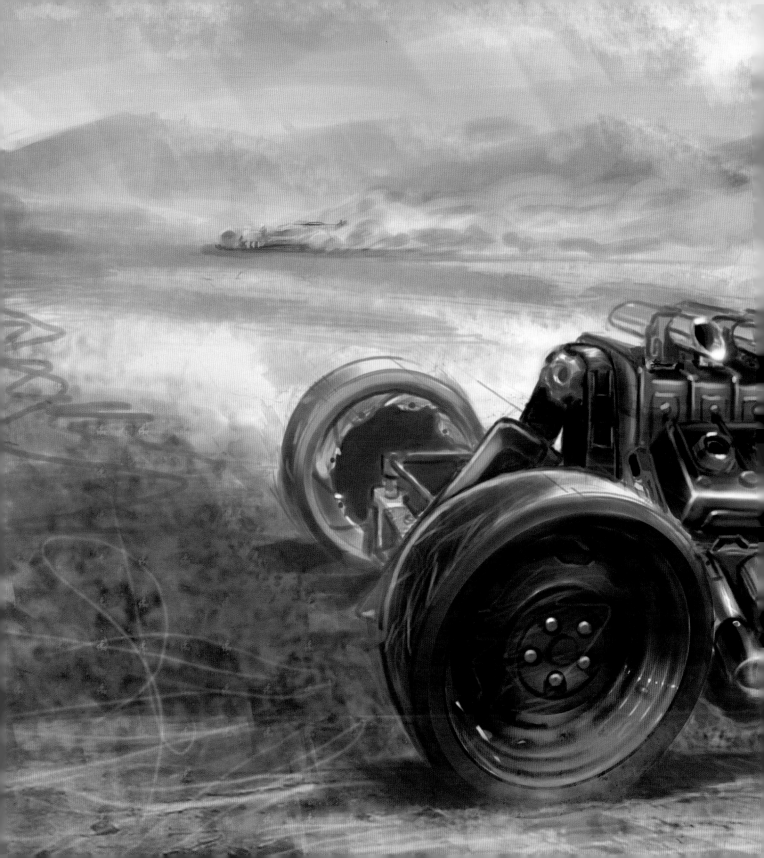

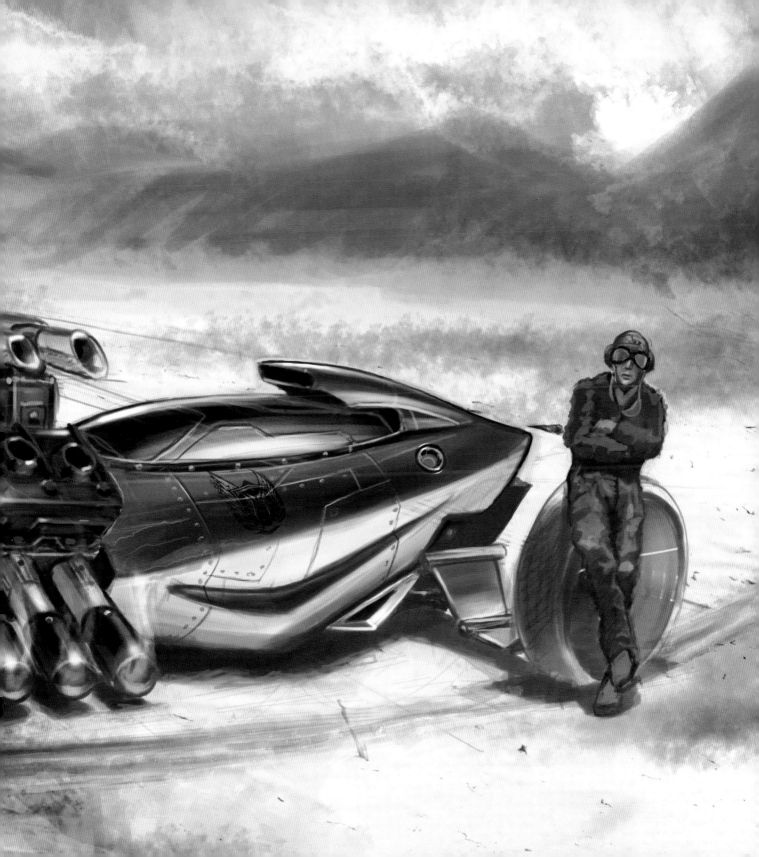

DESIGNING AN INDUSTRIAL VEHICLE
BY HOI MUN THAM

SOFTWARE USED: PHOTOSHOP

Tools Used: ARTLINE 200 0.4 fine point pen (similar to a Super Fine Sharpie) and Prismacolor medium cool gray 30 & 50% markers.

EARLY CONCEPTS & IDEATIONS

In this tutorial we're going to be designing a futuristic construction vehicle. Since we're going to be designing it for entertainment purposes, we have to be constantly aware of how people are reacting to our designs. Whether the audience finds it nice or ugly, cool or not-so-cool; every design decision made should always support the context, story or purpose.

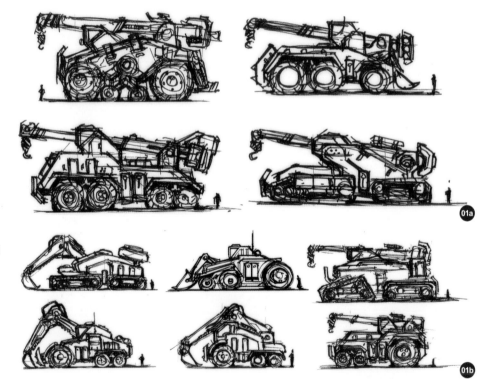

01a

01b

01c

When designing vehicles, the second most important thing – apart from cool visuals – is functionality. All good designs are followed by practical and believable functions. Most of the time concept art is meant to provide a better understanding for the next person down the pipeline, so it's important not to create any sort of confusion in your designs.

I start off by creating a huge set of thumbnails and then make some rather small, rough concepts, experimenting with shapes and silhouettes. Depending on your personal preferences, you could just start by creating different silhouettes before getting into too much detail or form, but, I work differently depending on the length of a project. In this

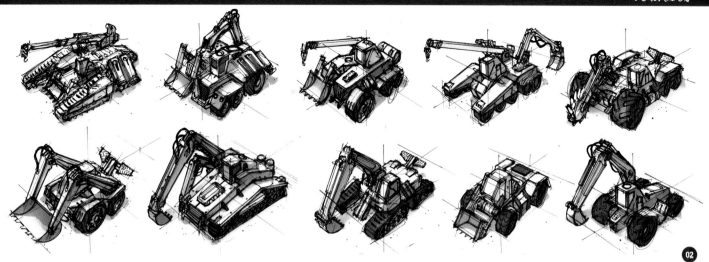

case I draw them rather detailed and small so that I can get more stuff figured out at once. Again, it depends on what works best for an artist and it should not be something that is either right or wrong (**Fig.01a – c**).

I spend about 10-15 minutes on each thumbnail. Try not to worry about your pace at the beginning if you're new to all this, just try to work out lots of good designs at this stage, because your pace and speed will catch up eventually once you've done this for quite some time. Practice, practice, practice, because there are no shortcuts!

When designing, I usually give myself a set of guidelines to work with (just to keep in mind). For example, in this case, I want to make the design cool, tough, balanced, practical, logical and heavy. With these key points, I'm able to flesh out all the thumbnails. But of course, before this I go through a bunch of references. It's very important to know how things work, particularly when there is a lot of machinery involved.

As you can see here, some of the vehicles I'm working on have wheels and others have tank tracks; some designs are excavators and some are crane-like – some are all in one! I'm still keeping my options open in terms of shape and

size. When designing these thumbs I start off by laying down a two-point perspective guide to help me out and then I start sketching with a felt-tip pen. Start from the biggest shape to the smallest, general to specific, and you'll be able to control the overall volume much better (**Fig.02**).

Lastly, put all of your thumbnails together and evaluate your designs. Refer back to the guidelines you set yourself earlier and see which fit the best. Slash out the ones that aren't working, even if they look good. Again, if there's a story for you to refer to then it should be the one that fits and supports the story.

From my thumbnails, I choose a design to be developed further into a final presentation piece. The goal of this tutorial is to illustrate a vehicle design, and so I'm not trying to make my concept design look too dynamic or exaggerated in terms of angle and position. What I'm trying to do is to find the best possible angle in order to present the design without experiencing any difficulty or hidden parts. I quickly draft out four thumbnails of different compositions to see which will be most suitable to present the vehicle (**Fig.03**):

- **Image #1** has a rather dynamic camera angle which provides an interesting and

engaging feel, but at this angle many parts are hidden and overlapped, so it will be difficult for viewers to read parts of the vehicle. This isn't wrong – it's just not the right choice for this illustration.

- **Image #2** is the most comfortable angle to see most of the vehicle. The level of distortion in terms of perspective is lower, so shapes are more readable. I also like this angle because the vehicle front is facing to the left, and the human eye has been trained to read things from left to right, so it's a nice thing to have your vehicle's front being read first and followed by the rest of it.

- **Image #3** has an average human eye level perspective. It's a better choice than #1, but not #2. At this angle, many details on the top part of the vehicle are hidden.

- **Image #4** is at another angle – similar to **#2**, but at the other side of the vehicle this time. Although the angle is right, a huge part of the vehicle is blocked by the big arm and so it's not such a good idea to go with this one either.

LINE ART DRAFTING

After a process of elimination, I decide to go for composition #2. I usually work with 3D software these days to construct a rough proxy shape of my vehicles, simply because it saves a lot

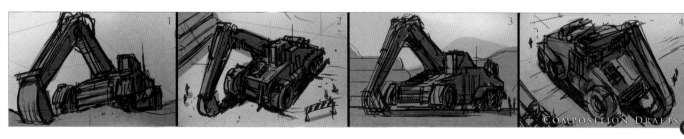

COMPOSITION DRAFTS

CHAPTER 4

of time and is a lot more accurate, but in this tutorial I would like to share with you guys how I work with a design starting from a line art, all the way to the final render. I'm going to be working entirely in Photoshop from here on.

Firstly, referring to the composition draft selected, I lay down some perspective guidelines. They are not 100% accurate, but should be good enough. I then take the thumbnail and distort it according to the perspective guides, making it look like a flat image in the centre of the space as a design guide (**Fig.04**). From there I start blocking in primitive shapes that create the foundation for the vehicle (**Fig.05**). I always work from general to specific because it's much easier for me to judge an overall shape before committing too much time to one particular part if the rest is not working.

Once I'm happy with the basic shape of the vehicle, I remove the guidelines and start to refine the shapes with more sub-shapes and details (**Fig.06 – 07**). This part is really fun because with details you can determine the character of a certain shape. For detailing mechanical designs, I always follow this rule: balance. What do I mean by that? Well, I

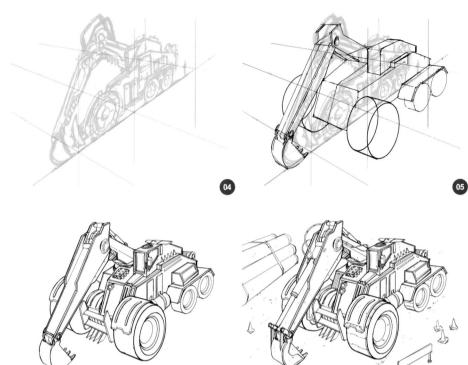

would always try to create parts with intricate designs and parts that are huge and plain so that, in the end, there's a balance between the two. I will never do one more than the other unless there's a need to, but usually I have big shapes working with much smaller shapes

to create some contrast. Detailing requires a lot of referencing, especially mechanical designs because parts and pieces have to look believable in terms of function and logic. Details are not just filling up a space with unnecessary shapes; they have to mean something. For example, this area of detail must have something that looks like part of the engine, or this part should have details that suggest a power source. If you accomplish that, it will take a design much further into believability and realism.

Once I'm happy with the line art, I can start setting up the light source. Here I use natural light and cast it from the left of the image (**Fig.08**). I make the cockpit area brightest because I want to direct viewers to that area instantly, and with natural light I can have shadows with no distortion. Artificial lights are usually close to the subject, therefore creating long, distorted shadows which are too dramatic for this piece. Light is the other element that plays a very important role in making a design more believable, because things like cast-shadows will help ground the shapes into the space. When a picture looks like it's floating, usually it has something to do with the light and shadow being inaccurate. Also: don't forget the

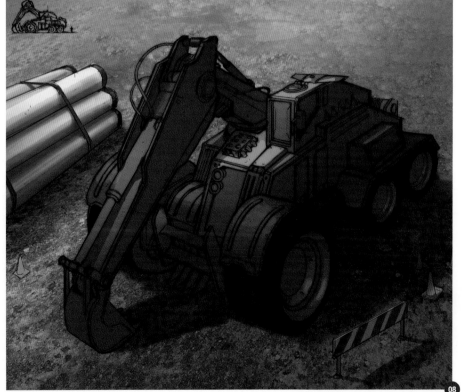

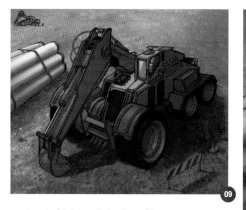

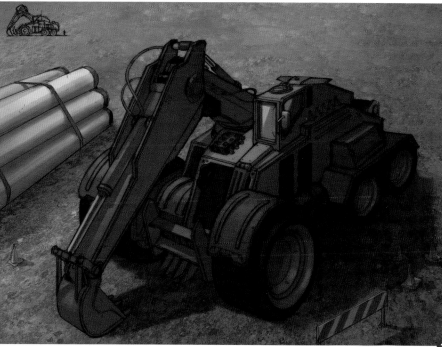

contrast of light and shadow. Shapes nearer to the camera should have higher contrast compared to shapes further away, unless you're trying to achieve otherwise.

So here I block in the local colors of each part, with lighting and shadows cast (**Fig.09**). If there's any weathering or damage to the material I usually do that towards the end of the piece – again, working from general to specific. Right now I'm just trying to get my light and colors as accurate as possible (**Fig.10**).

I've been laying down the colors and light on a Multiply layer over the line art; I also do an overall color adjustment to the piece to make it look less saturated. Once this is done, I create

a new 100% Opacity layer on top of everything and start painting in the finer details and further enhance the light and shapes.

MATERIAL RENDERING

Here are the two materials that I'm using for the vehicle (**Fig.11**). The first one is a chrome metal, used on hydraulics. Being hydraulics,

the surface needs to be smooth and thus a polished chrome metal is the best choice – not a brushed one. The smooth, polished surface of chrome has a very high level of reflectivity and it could almost reflect everything around it like a mirror. Like the reflection of the sky that makes the ocean blue, the same goes for metal. It reflects whatever color or material is around it, so it's really like rendering the reflected colors more than rendering a specific color for the metal. This metal also has a very high specular/hotspot, so the tonal changes are more obvious – like having a really dark line right next to the brightest part of the metal. This contrast will instantly create a very polished, smooth surface, as opposed to a soft blend of tonal values like the yellow material.

The yellow material I made is a painted metal sort of material. It is yellow gloss paint over brushed metal. Even though it still has traces of the metal, the elements have been softened because of a layer of glossy paint. The reflection and specular are much lower in contrast, but not in value. The hotspot could still get very bright but it won't be next to the darkest area because the paint has softened the tonal values of the metal.

The diagram on the right of **Fig.11** shows the grains of the two different metals. The first one is the polished metal which has finer grains and

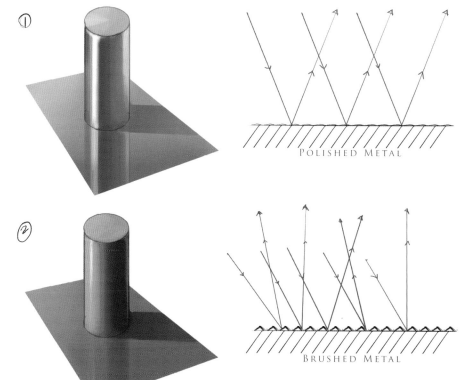

POLISHED METAL

BRUSHED METAL

MATERIAL RENDERING

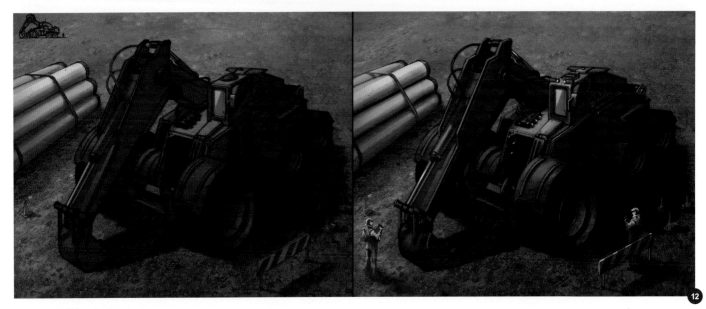

thus provides a more stable surface for light to reflect in a parallel order, eventually creating a sharper reflection. Whereas the brushed metal has rougher grains, so light is reflecting in different angles and thus creating a softer blend of reflections and tonal values.

It's now time to move onto a new layer in Photoshop, where I will paint what I like to call a "paint-over" layer. This layer will be painted similar to how a traditional, non-transparent

painting would be done – for example an acrylic or oil painting.

So on this opaque layer, I further refine and enhance the shapes and volume of the already established lighting. As you can see from **Fig.12**, you can see how the image looked before and after I painted on the opaque layer. If it has already been well established, the lighting of the image should not change much at this stage. So it's very important to get the

lighting correct before we start building up the layers – from general to specific.

ADDING DETAILS (SIGNAL LIGHTS & SPOT LIGHTS)

Here's a short walkthrough showing how I add extra parts, which were not created during the line art stage, onto the vehicle (**Fig.13a – d**). I want to add some small details on the vehicle's cockpit and after some research I decide to add

13c

13d

Signal and Spot lights. These are details which I think are practical and sell the believability much more. So what I do is start a new layer – Layer 11 – and draw a simple line art of the lights. Once I'm happy I proceed into coloring by starting another new layer above the line art layer (a Normal layer will do; a Multiply layer does not work well above colored areas). I paint in the values and colors of the lights – they are not highly detailed because they're rather small when you look at the painting as a whole, so simple shades can suggest the shape and read well without having to render photorealistic lighting.

In this tutorial I am 100% using the default round brush found in every Photoshop package – just a round brush tip and an eraser.

Here I try to keep in mind the different materials I'm painting (**Fig.14**); for example, having the very polished metal against the painted yellow metal creates a nice contrast for the viewer. There are not as many cables compared to real, existing excavation vehicles because I want it to look a little more streamlined and advanced compared to the ones we have in our own time. When I design a vehicle which is set in the future, I try not to go too crazy and fancy with the concept (unless the brief says otherwise); I like to keep it real and

believable so that it feels like it could actually be true. Some parts of technology advance faster than others, so not every single part of a vehicle needs to be modified when designing something for the future. Some details/ functions are already good enough for what they need to do, like the arm mechanism, and so doesn't really need to be changed.

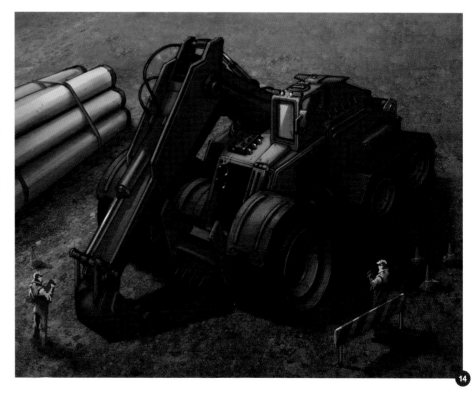

14

Once I'm done and settled with the overall paint-over on the opaque layer, things are pretty much done. So here is where I start adding textures, dents, weathering and scratches. Not every vehicle requires this sort of treatment, but a construction vehicle would not be complete without any of these characteristics, especially when the vehicle is in an outdoor setting. Sometimes wear and

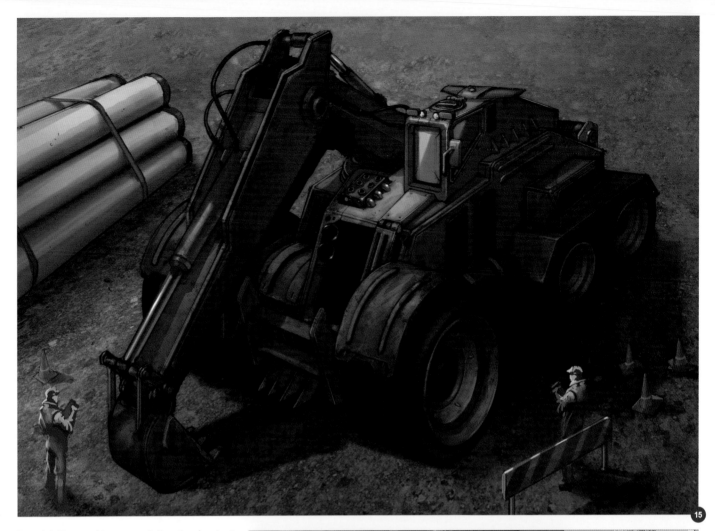

tear detailing could even push the story/context of a vehicle further, like where it has been, what it has been doing, and what its purpose is. So here I overlay a Multiply layer of rusty paint, and on the edges I add some painted scratches as well (**Fig.15**).

Take note that even though I have applied a rusty texture to almost the whole vehicle, I haven't forgotten that some parts/materials would not rust, like the hydraulics. This material in particular should always remain smooth and polished, so that it functions well.

TEXTURING UP CLOSE

Here's a rough step-by-step walkthrough showing how I apply the textures:

- First of all, I find a texture that I would like to apply to the vehicle; I have gone for a rusty paint texture which I found online (free texture websites like CGTextures.com are a good place to start) (**Fig.16a**).

- Secondly, I need the texture to be bigger so I tile the texture by flipping it and then place the two next to one another (**Fig.16b**).
- I keep repeating the tiling process until I get the size I want (**Fig.16c**).
- Here I adjust the contrast and color of the texture so that the pattern on the texture stands out more from its background (**Fig.16d**).
- Now I use my arrow and right-click on the image to open a sub menu, and from that I select Distort and then I distort the texture according to the rough perspective of the vehicle/scene (**Fig.16e**).
- Lastly, I select the Multiply blending mode for the texture layer and set it on top of the vehicle. Using a standard round Eraser I erase some of the areas I don't want to texture, like the glass, polished metals and the ground (**Fig.16f**).

So once the texturing is done, everything else from here on in is just extra tweaking, but still serves a purpose. With this image I add a layer of glow which I painted in with a soft round brush to show the reaction towards light on these materials. For example, the polished pipes and mirror would have a small amount of glow reflected, and this will help suggest the material better (**Fig.17**). The glow shouldn't be too much because we don't want that to distract the viewers' eyes from the main subject, which in this case is the whole vehicle.

DECALS UP CLOSE

I have a library of vehicle decals and aftermarket stickers. I like these because they somehow give the audience a hint of what the vehicle is about and where it comes from, but

in this tutorial I have decided to create a decal for 3DTotal. The decal is currently black on a white background, but I plan to invert it to white so that there are multiple ways of applying it to the vehicle (**Fig.18a**).

Since the decal is on a separate layer from the white background (Layer 1), I just hold down Ctrl and press I, and it inverts the color to white for me. Once that's done I want to transform the shape so that the decal fits well on the perspective of the vehicle. I use the arrow, right-click on the decal, and select the Distort transformation tool. This allows me to manipulate all four corners of the image separately (**Fig.18b**).

So once it's placed on the vehicle, I just blend the solid, white decal to the vehicle's tone. Since it's on the darker side of the vehicle, I simply decrease the Opacity down to about 28% (Layer 11). Then I just make it look more believable by using the eraser to add weathering and scratches on the decal, and it's done (**Fig.18c**).

Last but not least, I add some other decals to the vehicle to help create a little bit more context, such as where it was manufactured (**Fig.19**). I also add some small traffic cones and humans to suggest scale. I love creating layouts for my designs because I always believe in the good presentation of a concept.

It helps to improve readability and creates a better finish. Details of the artist, date, and title of the piece will provide better understanding to viewers, so they know what they are looking at.

FINAL THOUGHTS

We are visual communicators. We communicate through our designs. A visual communicator's job does not end with the

artwork. The final product of a certain design goes beyond our jurisdiction because it will be handed down to other people further down the pipeline, so therefore a good, readable, believable design is essential.

We are also known as commercial artists because in our line of work we don't work in the way that fine artists do. Our time and budget

is always limited. We don't have the luxury of waiting for inspiration to hit us and taking two years to finish a painting. I think many students need to understand that clearly if they choose to pursue a career in this industry. It's not always glamorous and good money, so it really boils down to how much you love the craft and how doable the individual is. Competition is really high so be prepared and be clear on your goals and objectives.

Think about it: if concept art is really what you want to be doing then you should know that nothing is going to stop you, and you will strive through no matter what life throws at you. Be strong, and work hard and smart. "The last person to give up is the first one to win."

Good luck and thank you all so much for taking your time to read this.

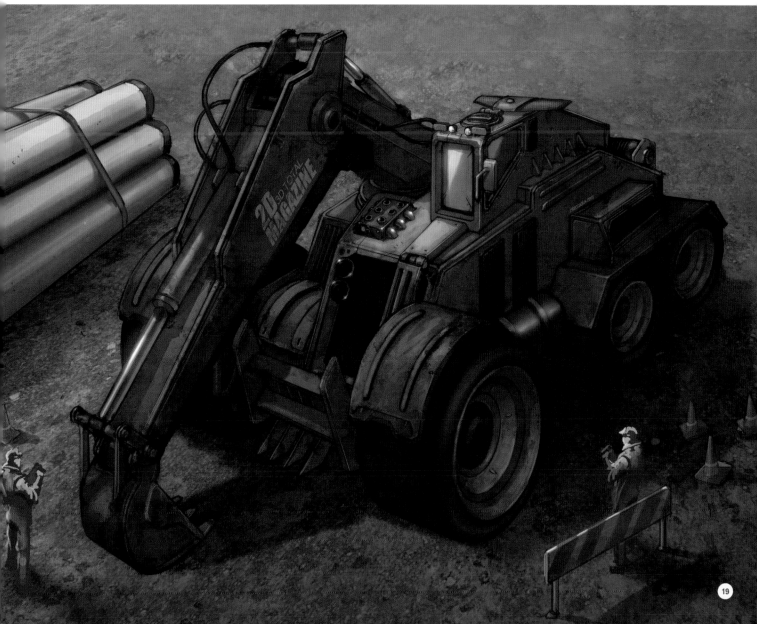

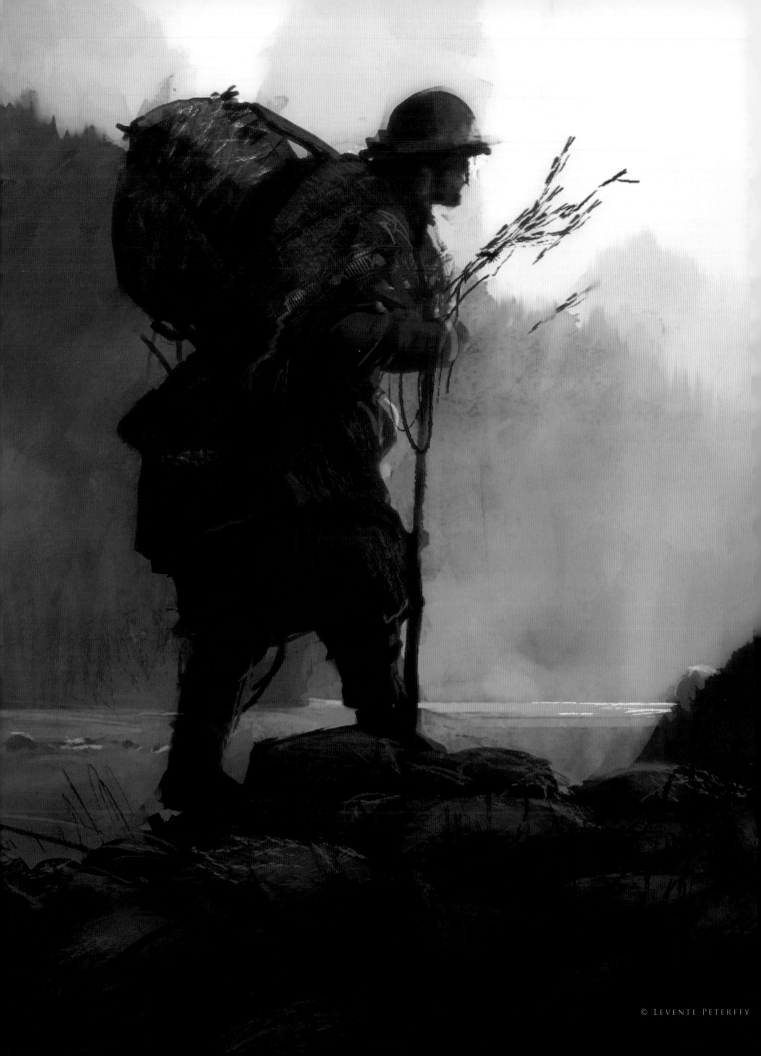

speed painting

Speed painting is a method of painting where all the essential parts of an image are laid down in a single painting session without detailing the image. The result is a crude sketch representing an image that has composition, color, light, shape and texture that has an impressionistic feel to it. In terms of practice I find this method crucial for an artist's development as it forces you to tackle all aspects of an image. It also makes you see that images need little detail to make sense, and that detail only needs to be used in certain areas. The method is not only a great practice tool but also a way to put down a solid base for a longer and more ambitious painting. Even though the method refers to the term "speed" it is important to not be stressed by this while painting. The image needs to feel complete in the end and that is the goal.

LEVENTE PETERFFY
levii@me.com
http://www.leventep.com

THE SLEEPY VILLAGE NEVER SAW THE HORROR APPROACHING

BY NATHANIEL WEST

SOFTWARE USED: PHOTOSHOP

INTRODUCTION

For this exercise, I've chosen to do a relatively calm setting, and to have the horrific area be more of a second read. It's a promise of impending doom to come, instead of doom that has already arrived. This sketch will be more about colors, values, and overall composition, rather than details. This allows me to work out an idea that can then be reworked with additional details in order to make it a finished piece.

STEP 1

I first start by laying in a wash of color onto the canvas. I want this background color to act as my initial Midtone, where I will develop both lights and darks from it. Any color will do, but

something orange or red is always popular, so I've gone with that option (**Fig.01**).

STEP 2

Next, I begin to lay in a lighter and cooler color for the sky. You can barely make out some roof top shapes in the negative space of the

sky color. This doesn't need to be exact at the moment, as I'm simply getting a feel for how I'm going to organize my values into large shapes that are easy for the eye to read.

I then decide to add in a scribbling of a darker mass, which will end up being a fountain in the

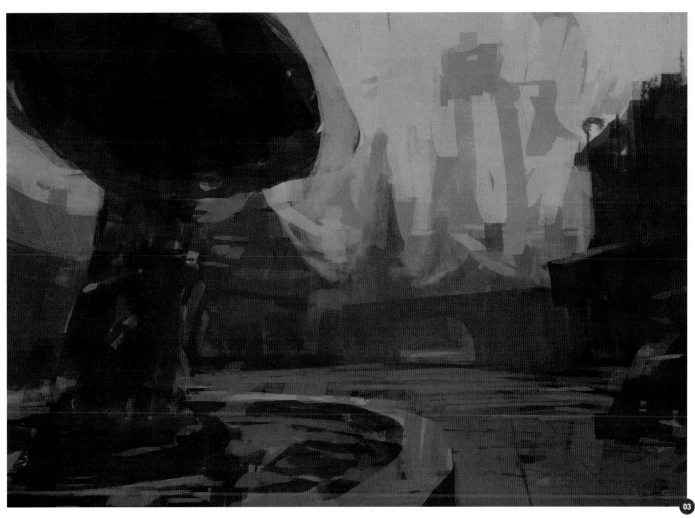

centre of the village. For the water, I pick up some of the sky color, which also helps to tie the upper and lower portions of the painting together nicely. At this point I'm already starting to get a feel for the composition and the overall lighting direction (**Fig.02**).

STEP 3

Next I continue by working out the perspective of the scene, and I block in more defined shapes. I'm staying very loose and sketchy with things, as I don't want to get too specific. For contrast and visual interest, I decide to add a slightly green complement to the palette to represent some lily pads in the fountain. This contrast will also help to make the fountain a focal point to the scene, and the horror part will be a secondary read for the viewer (**Fig.03**).

STEP 4

I continue to refine the forms further, adding in a suggestion of figures holding up the fountain basin, and putting loose details on the

buildings. In the background I roughly indicate some sort of multi-headed serpent creature way off in the distance. I decided to help pull out the fountain from the buildings behind it

by adding in a splash of red from the under-painting. It helps to draw the eye towards that area once again. A few more dots and dashes on the village buildings to suggest beams,

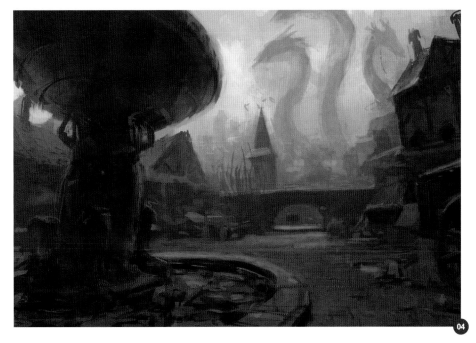

167 CHAPTER 5

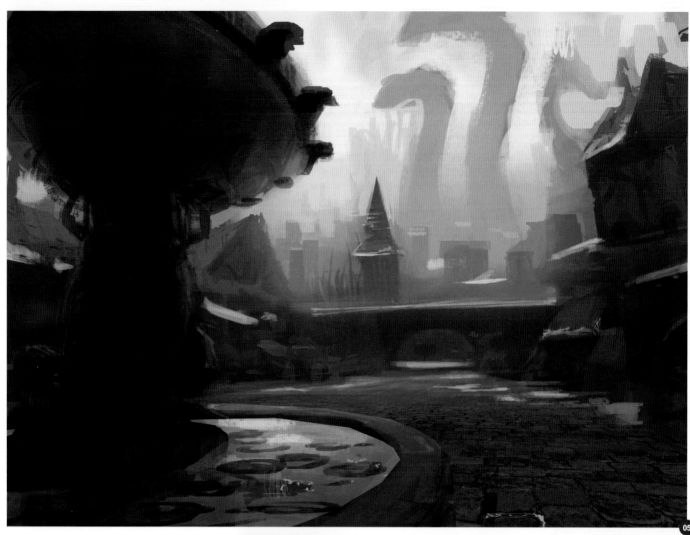

05

awnings, and street decoration are some of the
vital pieces of information I need in front of me,
and I can now begin to detail and refine this
piece (**Fig.04**).

STEP 5

I've decided to make the scene appear cooler.
The image is too red and warm for my eye. I
overlay some photos that have cooler palettes,
which quickly changes the mood of the scene.
One of the photos has some remnants of snow
in it, and so I decide to add some indications of
snow throughout. I also lay in a photo of stones
onto the ground in order to get the idea across
in a timely manner without painting in every
stone (**Fig.05**).

STEP 6

I feel that the right side of the painting needs a
bit more room, so I extend the canvas out a bit
and then detail out the building. The process I
use for this area is to find a photo that inspires

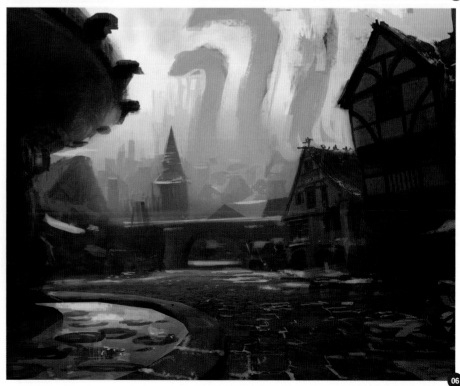

06

me, and then I lay it over the painting and adjust it to fit the perspective. I then paint over it to loosen it up a bit and to keep it sketchy. Once again, this process allows me to quickly get the idea across, rather than painting the whole building from scratch. I also continue to add in more traces of snow throughout (**Fig.06**).

STEP 7

I repeat the same photo manipulation process with the buildings on the left, and then spend some time indicating the monster in the background and adding in some more detail to the buildings in the distance (**Fig.07**).

STEP 8

Next, I focus my attention to the fountain, where I've decided to add in some icicles to break up the dark shape of the basin. At this point I feel the sketch is just about complete, so I wrap things up by adding a few more indications and highlights throughout the painting.

And we're done (**Fig.08**)!

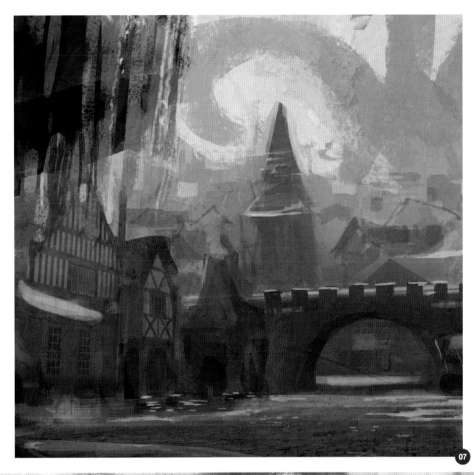

07

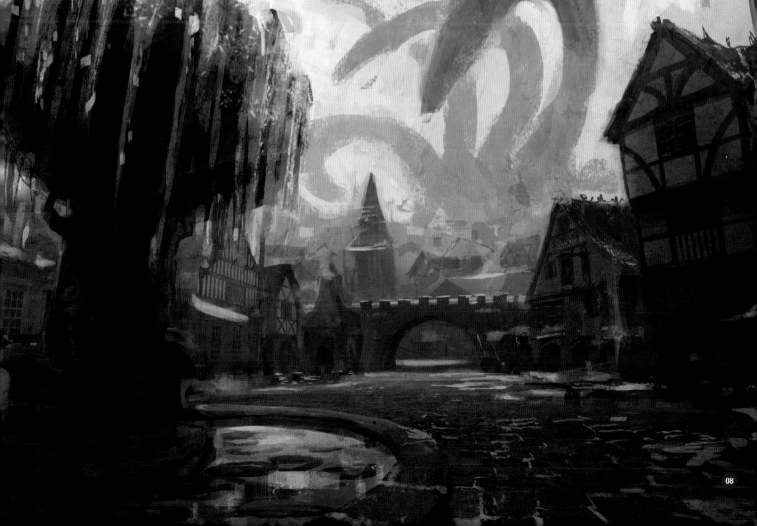

08

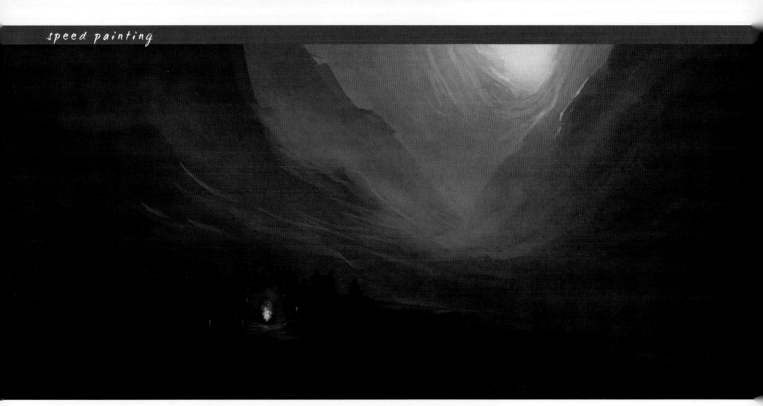

AS NIGHT FELL, THE DARKNESS CAME ALIVE
BY EHSAN DABBAGHI

SOFTWARE USED: PHOTOSHOP

CONCEPT

With this kind of task, first of all we must think about what we want to paint. I personally thought about the topic for a couple of days and then got my thoughts down visually by painting three sketches in black and white. From those sketches, I could work out exactly what I wanted to achieve with my painting: to depict a story about a group who want to stay in a camp all night long, but where no one knows what will happen once the sun goes down and darkness reigns.

STEP 1

So, with the story in place, I can now get to work. I start by making a new blank canvas in Photoshop at 4000 x 2000 pixels. I use some shaped brushes and just play around with the black and white paint, getting a feel for shape and tone (**Fig.01**). I think it's important to always try to work at about 50% or 25% zoom at this stage; that way you can see the whole image easily and think about the composition whilst you're working on it.

STEP 2

Okay, this is where I have to refine the design, so I make a brush that will be useful for this

task (**Fig.02a**). You can see the options selected for this brush in the palette (**Fig.02b**). In Other Dynamics I set both options to Pen Pressure. These brushes can give very interesting random lines and shapes that I personally find are really great to work with, especially when you select an area with the Lasso tool and then paint.

At this stage I add a foreground to the painting, as you can see (**Fig.03**). I believe that light is the most important thing to keep in mind when painting. I heard somewhere that you shouldn't think about light at first; that you should use color to get the light established very slowly, and then with just one or two touches of your brush you can achieve the light. Well, I'm not sure whether that's right or not, but it certainly sounds like a nice concept! I will test the theory out in my next painting. Getting back to work, I now add some light gray where I want my light source to be coming from.

STEP 3

I wanted to make a connection between the foreground and background in that previous stage, and I have achieved what I want: a feeling of depth. The light in the mountains seems to be working, and so now I need to start thinking about the shapes of the rocks as they will form a very important part of the scene (**Fig.04**).

STEP 4

Here I add in the poor guys who are going to be facing the darkness of the night in this scene, and possibly also dealing with the fear of their own deaths (**Fig.05**).

STEP 5

I use an airbrush at this point to add some haze to the background and to help achieve a better feeling of depth. I also make the foreground darker – which isn't too important at this stage as you can always do this towards the end of the painting (**Fig.06**).

STEP 6

At last, I finally reach the color stage! I start by creating a new layer in Color mode. I like the contrast between orange and blue, and so this is the color scheme I choose for the base work of this particular scene. It also works well with the story of the sundown (**Fig.07**).

STEP 7

I create a Color Balance layer here and add some blue to the shadows. I also add more red and yellow to the highlights (**Fig.08**).

STEP 8

Now it's time to add textures. Using the color of textures can prove useful; they can work very well when you get into thinking about color in your painting. For the textures in this piece I use a Soft Light layer, from the layer palette. I have three texture layers in total; you can use textures to distort or even to add more perspective to your painting. I use this trick on the mountains (**Fig.09**).

STEP 9

I use an Overlay layer here, which is great for creating nice color effects – kind of like a glaze does with oil paint. Here I further detail the mountain area (**Fig.10**).

STEP 10

I continue to add story and mood to the scene by creating a fire in the centre of the huddled guys in the middle ground, and painting the reflection from the fire onto the men. All of this helps to focus the viewer's attention on the people on the scene and assists with the story of the camp at dusk (**Fig.11**).

STEP 11

Adding some light to the foreground and middle ground area here is a good move – it

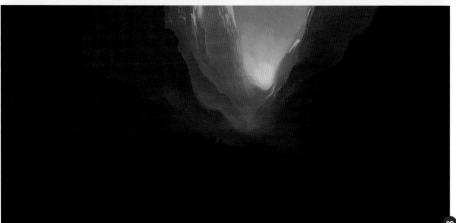

further helps with the connection between the foreground and background, as mentioned before (**Fig.12**).

STEP 12

This stage is all about helping to define the rocks and shapes, with some detailing brush work (**Fig.13**).

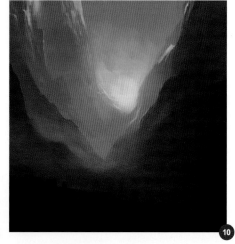

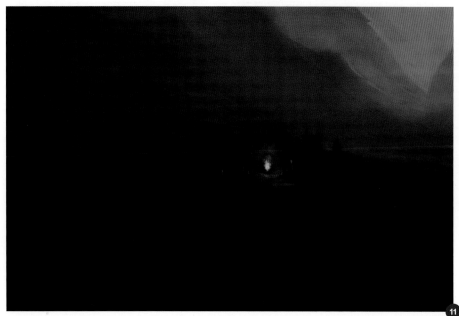

STEP 13

Using a Color layer is a really important trick to bring in at the end of a painting; you can create the color directly on the image, which is pretty exciting! I've never worked with oil paints before, but I do know a little about it and I think that if a digital painter can have an understanding of traditional oil and acrylic painting then it can help them to create a better digital painting. Understanding color is important, as is the affect of applying a glaze to a finished painting, which is what I'm currently

trying to develop an understanding of. With my Color layer here, I try to imitate the affect that a glaze might (I assume) create on a traditional painting of a similar subject (**Fig.14**).

STEP 14

Back lighting. I like it when there is light behind your camera; it seems to give more feeling to an image. To do this, I create a new layer in Normal mode and just paint with the color I want. Take a look at the mountain in the background (**Fig.15**); it's important to use colors for shapes. I'm very happy with how the red looks there, beside the shadow color – I really like this part of the image.

To finish up, I select all of the layers, drag and drop them into a new layer (using the function at the bottom of the layer palette to create the new layer), and then press Ctrl + E. I go to Sharpen > Unsharp Mask and set the options as required to make a nicely sharp image. To achieve more depth in your scene it can also be a good idea to erase some areas, if needs be. This also helps to create more of a feeling of focus.

As a final note, be sure to enjoy painting and be happy with your final outcome. Thanks for reading!

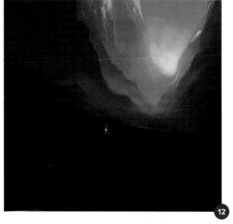

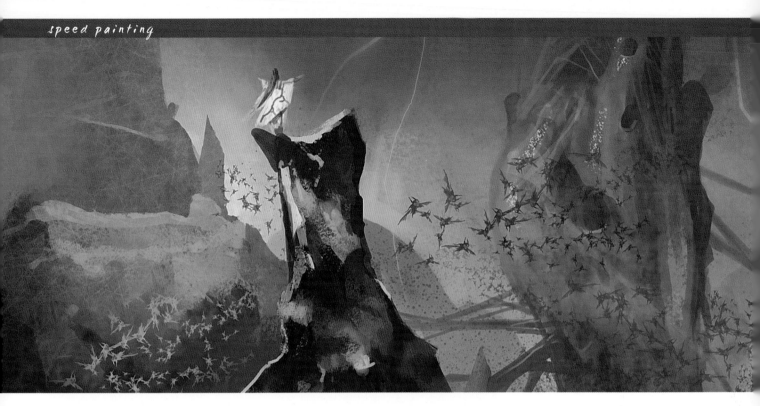

THE APPROACHING SWARM LOOKED BIBLICAL IN SCALE
BY JUSTIN ALBERS
SOFTWARE USED: PHOTOSHOP

INTRODUCTION

This was a very doom and gloom sounding piece, but had the potential to be epic. When I first read the caption I had two ideas – one was an Amazonian jungle setting populated by huge wasps or mosquitoes; the other was of a burning, orange Egyptian desert swarming with locusts or scarabs. I decided to go with the second, just because I like painting deserts!

STEP 1

I've opened up a portrait-style canvas because I'm thinking I'll want to have a lot of sky in there to show off the magnitude of the swarm. This is the part where I just experiment with colors and texture brushes until I find something I like. The palette here is pretty tame, and at this point I think I need to go much warmer (**Fig.01**).

STEP 2

I start to scribble in some shapes and define my composition. I know I want something in the foreground to denote scale. I also want some sort of ancient ruins or a sacred-looking building way in the back that's being threatened by this insect invasion, and then in the middle ground I want to show lots of sand. I toy around with the idea of having a huge Egyptian

monolithic structure in the background with sand pouring out of it, but while this seems pretty cool at first, it quickly starts to appear too busy. In addition, I begin to finalize the shape of the rocks in the foreground (**Fig.02**).

STEP 3

I decide to substitute the huge Egyptian structure for a smaller, more rectangular building that has some Middle Eastern influences in the architecture. I still want to

maintain a bit of a fantasy element to it, so I'm making stuff up as I go and reinforcing it with referenced details. I'm also defining the rock and sand in the middle ground (**Fig.03**).

STEP 4

I start to refine the composition, often checking in the Navigator window to be sure the piece is reading properly. I'm happy with the color palette; I like the blues with the oranges, browns and yellows. Now that I have these main elements in, it's time to add in the nightmarish swarm of insects (**Fig.04**).

STEP 5

Here I've painted in what I imagine one of these insects to look like, making a point to keep it fairly clean around the edges. I decide to make it a blue color to contrast with the surrounding oranges. I'm thinking these are about the size of a hawk… which is grossly big for an insect (**Fig.05**).

STEP 6

Once I have the scarab designed I make a brush out of it. To do this, I copy the layer with the bug on it and paste it into a new canvas so that it's by itself on a white background. Then I go to Edit > Define Brush Preset and name it "Scarab". I go into the Brushes tab and modify it; I check the Shape Dynamics and the Scattering tabs and adjust the sliders until

it looks somewhat like a natural swarm. I also alter the spacing in the Brush Tip Shape tab (**Fig.06**).

STEP 7

I'm trying out the new brush I made. It works great and makes an easy bug swarm. I make myself a few bug swarm layers and set the opacities at different percentages to make some appear further away. I combine these layers with the original bug that I painted and copy them a few times to create the swarm (**Fig.07**).

STEP 8

I'm happy with the swarm but it doesn't feel nightmarish or biblical enough! It feels like a

bright sunny day in the desert with a couple of annoying flies. To make the scene more exciting, I add more insects in the background so that the swarm starts to blot out the sky. I also add a scarab or two into the foreground and blur them out so that they appear close enough to be out of focus. I add an approaching sand/thunderstorm to the fray to help add to the chaos of the scene. My thinking is that this tower has been cursed and is being subjected to a plague of carnivorous scarabs, sand and lightning storms that will eventually destroy the tower and its inhabitants. Also, the figure in the foreground, who is a scout or a lookout, looks like he's just chillin' on the rocks with not a care in the world. So I add in some scarabs attacking him, forcing him to defend

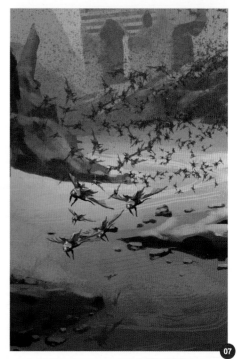

himself. I also add in the lightning, because lightning looks cool. I darken the foreground to really put emphasis on the swarm flying past and also lighten the area on the rocks by the scout to add focus to that little interest spot as well (**Fig.08**).

STEP 9

I make a few more adjustments to the piece after receiving some friendly critique. I make the foreground rock formation smaller and add in some ground details to open up the piece a little bit and make it feel less cluttered. Also, I ditch the building and add a huge insect hive; the image reads better fictionally to have the swarm pouring out from this thing and I turn the figure into some kind of warlock dude. I think adding in the giant, disgusting insect hive makes it feel more dangerous and nightmarish as the topic implies. I also add some gray to the middle and background to push those elements back into the painting (**Fig.09**).

As a speed painting this guy is pretty much done. I will probably go back and tighten up my edges by making a selection of each piece and painting inside it to make them precise. I will also tighten up the storm clouds and possibly add a few more scarabs.

And that's enough talk of man-eating bugs for one day!

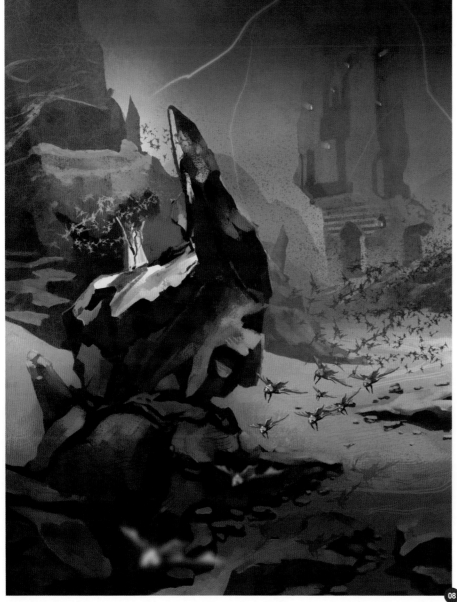

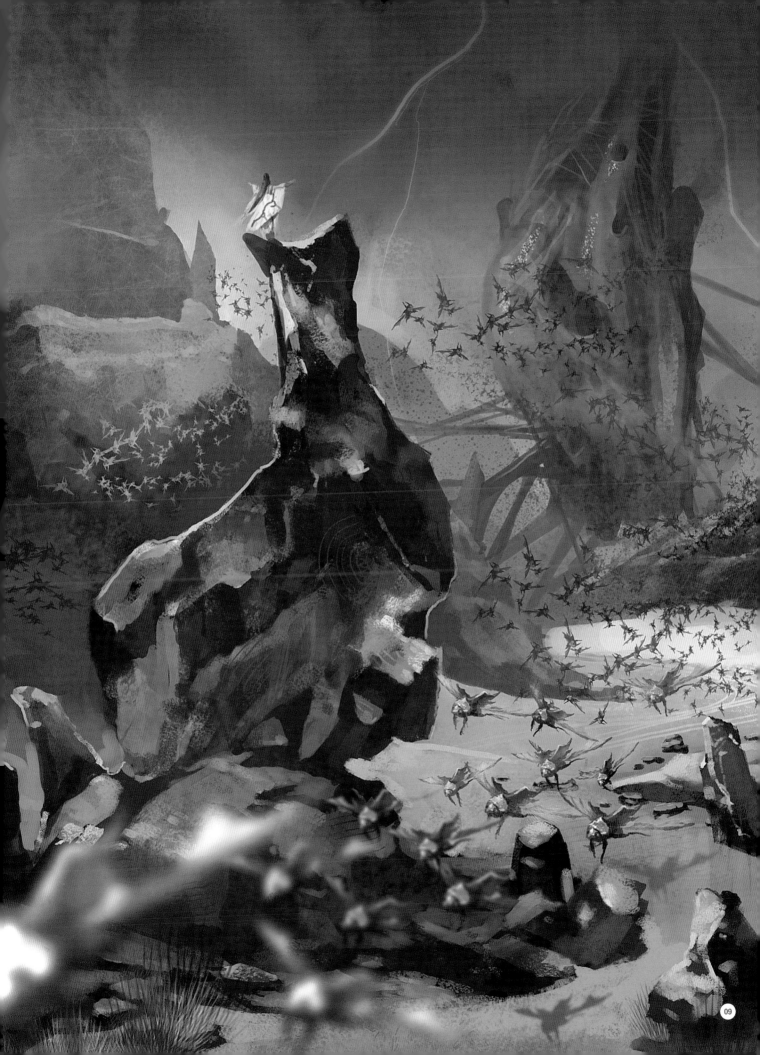

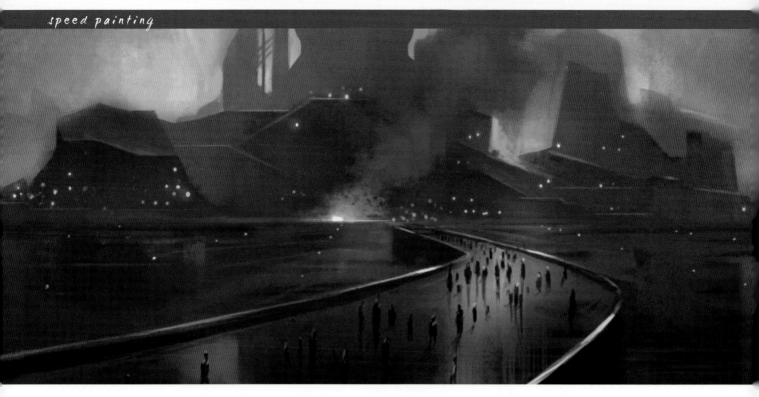

THE MACHINE WAS THEIR ONLY MEANS OF ESCAPE
BY EMRAH ELMASLI

SOFTWARE USED: PHOTOSHOP

INTRODUCTION

Hello everyone! First of all, I would like to let you know that this month's speed painting will be homage to English sci-fi painter, John Harris. When I first heard about the theme, the first thing that came to my mind was this scene, which is similar to one of John Harris's paintings. I thought it would really suit this theme so I decided to paint it. It will be very a simple and graphical composition with strong use of colour. So let's get started.

STEP 1

As usual, I'll be using Adobe Photoshop CS3 for this tutorial. It's going to be a vertical composition, so I'll create a new A4 canvas at 150 dpi. Firstly, I need to block the main shapes and colors in, so I'll choose a textured flat brush and start to paint. I won't be using any fancy brushes for this speedy, so that it's easier for you to replicate what I do (hopefully). Anyway, I'm trying to create a silhouette of a space ship with basic brush strokes; I'm trying to be really loose at this step of the painting (**Fig.01**). I also draw some perspective lines to create an illusion of depth to help me while I'm painting, and I'm using a very strong orange on the background because it's going to be a huge Sun!

STEP 2

I create another layer to mask the upper part of the Sun and give it a nice round curve (**Fig.02**). I also create an Overlay layer and paint on the Sun to give it a basic form. Now I can start to paint in the details. I start with blue smoke coming from the launch pad; blue creates a really good contrast with the orange at the back. For the foreground I paint in a wide road going towards the launch pad. Then I pay some more attention to the spaceship and paint in some more details on the launch pad. Small lights add an illusion of life to them.

01

02

STEP 3

For the next step I will just carry on detailing. I'll paint the prominent areas on the Sun and add detail to the chromosphere (the Sun's atmosphere) (**Fig.03**). I'm still not sure about the shape of the space ship, by the way; I'll probably try to define a good shape for it whilst I finish the painting. I thought a rectangular shape with sharp edges would look good, but it looks like a building instead of a ship, so I'll soften the edges in the future steps.

STEP 4

It's now time to paint the people walking on the road, who are all heading towards the space ship to embark and get the hell out of there, because the Sun is getting closer! That ship is their only chance to save them from extinction. As you can see, I soften the edges of the ship here – it looks more like a vehicle now. I won't give any form to it because I want to keep it like a silhouette (**Fig.04**).

FINAL

Almost done now! I always adjust colours while I'm painting, so here I open a new adjustment layer and tweak the colours a little; darkening the painting by adding some blue to it. This is the way I paint: adding contrast while I paint. As a final touch, I apply a texture to the Sun, using a picture of the Sun that I found on the internet, and just overlaying it on the painting. I erase out the parts I don't want and that's it – done (**Fig.05**)!

I hope you've enjoyed this painting process. Thanks for reading!

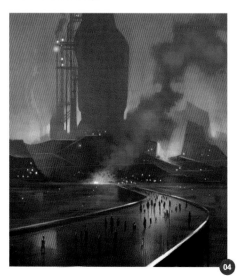

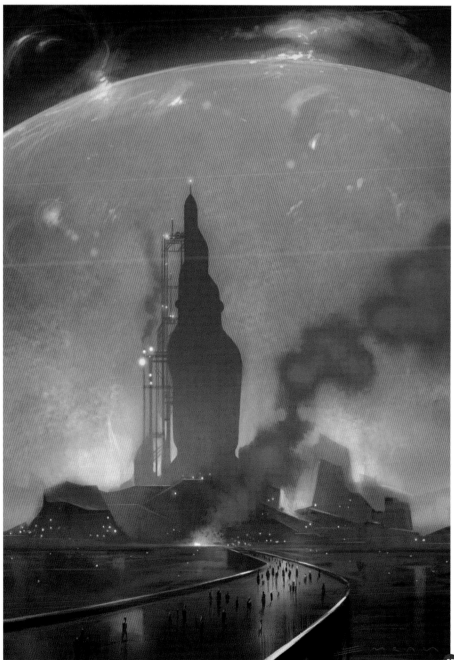

FEAR ENGULFED THEM AS THEY REALIZED THEY WERE ABOUT TO DIE
BY EMRAH ELMASLI

SOFTWARE USED: PHOTOSHOP

INTRODUCTION

The subject for this speed painting is quite interesting – I get to figure out how to draw a few people who are about to die! So after doing a few sketches in my sketchbook I decide to go with a simple but effective composition. I'm going to draw a giant coming out of a forest, walking towards a couple of humans, who are of course terrified because this giant is really mad! There's no place to escape and, well, anyway – you get the idea so let's get started!

STEP 1

My main software for speed painting is Adobe Photoshop. I'll be using CS3 for this piece. For the first step I start by creating a new file; it's going to be a vertical composition so an A4 canvas at 150 dpi will do. I need to block the main colors in, and I choose to go with a brownish and purplish palette. I use a textured "palette knife" kind of brush to block the colors in, trying to determine the places of rocks and trees very roughly. I also apply some very simple lighting into the scene. I guessed direct midday sunlight would do (**Fig.01**).

STEP 2

I create a new layer and start to paint the giant in, using the same block-in brush for this as well. Starting with a dark color I slowly paint some highlights and flesh-out this enormous creature. I use light purple for the highlights because I imagine that this guy is coming

out from the darkness. This also creates a mysterious atmosphere (**Fig.02**).

STEP 3

The next step is to start detailing. I don't do anything special just yet; I'm just painting straight away and trying to figure out the

gesture of the giant. I figure he's going to be holding a big club which he's carved from a tree trunk. Forming the background at the same time, I use green to create a feeling of fogginess. I want to use a kicker light for the giant to separate him from the background a bit, so I paint in a very slight yellow light hitting him from behind. At this point the image is starting to come together (**Fig.03a – b**).

STEP 4

Time to paint in the terrified humans! I use a very small brush because these guys are going

to be tiny in comparison to the giant. I start painting them in, trying to capture a "trapped" kind of gesture. When happy with the result I can start making the highlights glow a little. To do this I create a new layer and select Overlay from the layer options, then select a de-saturated yellow and start painting. This basically gives a glow effect and helps to enhance the mood of the piece (**Fig.04**).

FINAL

It's almost finished now; there are only a few details left. I continue adding the blood on the giant's club and mouth. It also fix his right hand, because it looks somewhat odd. Lastly, I create an Adjustment layer to adjust the colors slightly (Image > Adjustments > Color Balance) and I want some more blue in the piece so I increase the amount of blue and cyan until I'm happy with it. And I think that's about it (**Fig.05**)!

Hope you like it and thanks for reading!

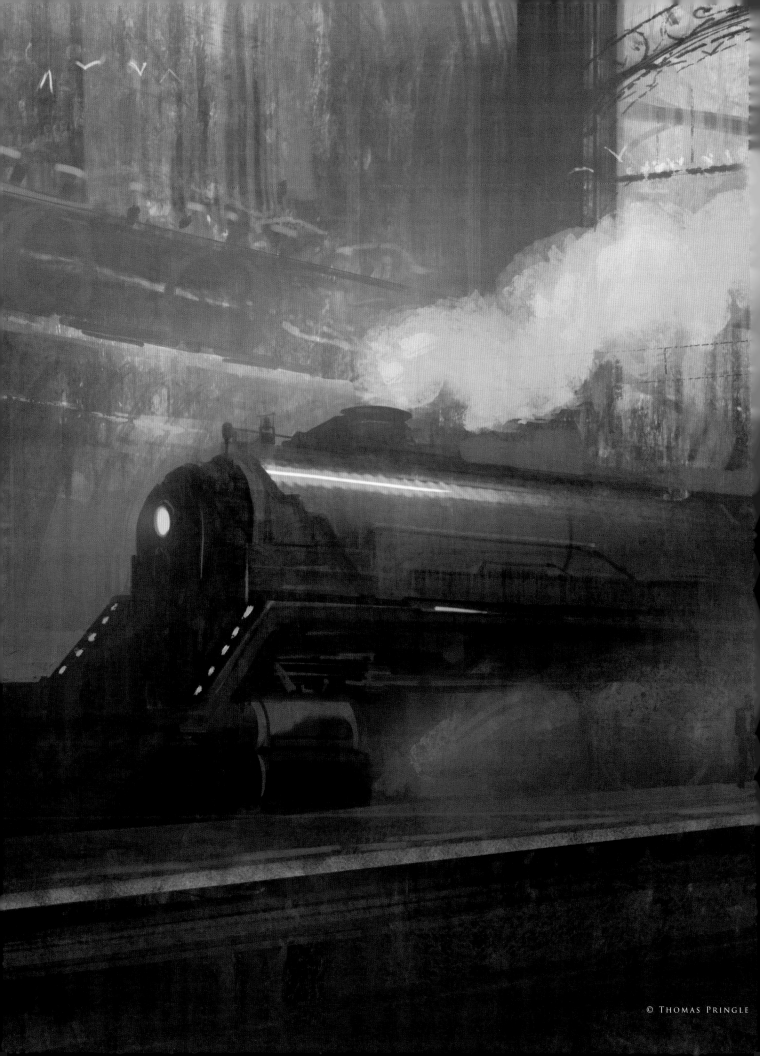

custom brushes

Digital painting can easily feel a bit artificial if you are not careful. Custom brushes give a great counterweight to this. What I like about custom brushes is the freedom they give me to experiment with different mediums all in the same painting. I can approach the painting as if it is oil on a canvas and in the next step paint directly over it with what feels like a ballpoint pen.

In this painting I've integrated several custom brushes to show the range you can achieve when creating various textures. With one brush I can define the semi abstract volumes of the smoke, and with a different brush I can create the smooth reflective qualities of the locomotive. This adds variety and helps entertain the eye. Contrast doesn't necessarily have to mean value or shapes, but can be how you treat the variety of textures in your painting. For this, custom brushes are a great aid.

THOMAS PRINGLE
thomas@pringleart.com
http://www.pringleart.com

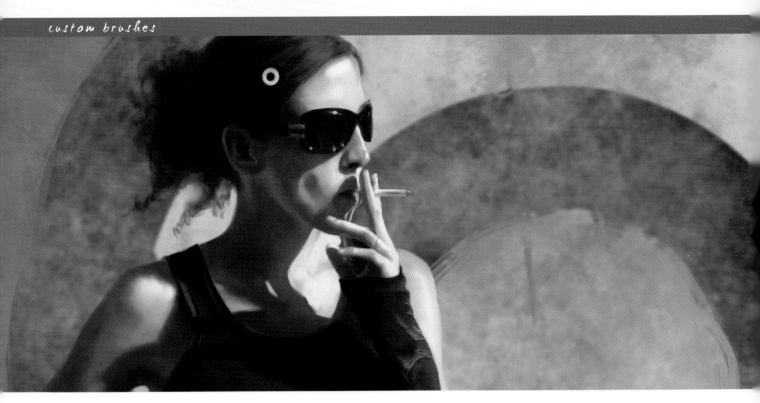

CUSTOM·BRUSHES FOR FABRIC AND LACE
BY NYKOLAI ALEKSANDER

SOFTWARE USED: PHOTOSHOP

INTRODUCTION

Seeing realistically painted fabrics and material is always awe-inspiring. We wonder how an artist achieved it, managing to apply such amounts of details and textures without going insane in the process – those of us who've tried to do it all one stroke at a time have certainly had our brush with insanity (excuse the pun!). Yes, it is manageable, but intensely time-consuming aside from anything else.

This is where custom brushes come to the rescue.

To use custom brushes for fabrics, embroidery and lace is not quite as simple as it may seem at first glance, and still requires some time to get right, but it is a lot less aggravating than having to do it all by hand.

Are you curious to see how it works? Then just keep reading!

PAINTING REALISTIC FABRICS

Let's assume you have painted a wonderful picture with someone wearing a beautiful ball gown, or maybe a pirate in a 17th Century

thrown-together garb, or a beggar in torn cotton rags … Maybe you want to paint a dancer clad in nothing but net and lace, or design a wedding dress that will make jaws drop? The picture is there, but the details are missing to distinguish between cotton and silk, lace and net, wool and linen, or give the garments that extra little kick with extensive embroidery or exquisite brocade.

You've been looking at photos to give you inspiration, you have been to textile shops to look at the real deal, and even raided your own wardrobe to see what certain fabrics look like, but you still find it hard to paint it all. Well, you've been to all the right places. You just forgot to utilize what you saw. Go back to the textile store and buy a small piece of those items you liked, download the free embroidery

patterns you saw online, get a fashion and fabrics book from the library (not for direct copying though, since even though the fabrics are not copyrighted, the photos of them are), and go back to your own wardrobe (or that of a friend or relative) and pick out the pieces that hold something of interest – maybe a piece of lace underwear or net stockings, some torn jeans, a chunky knit top or a dress with some nice flower prints on it. And now you're good to go!

SINGLE PATTERN

Let's start with something simple: a single item to turn into a brush. Here's a photo of a T-shirt of mine that has a nice flower print on it (**Fig.01**). You can see how I made sure that the piece was lying flat, and that I tried to photograph it straight from above. That way, we eliminate any kind of skewed angles and have as few creases as possible, in efforts to avoid the problems they may cause later on.

The first thing we want to do when we open the photo in Photoshop is to desaturate it by going to Image > Adjustments > Desaturate, unless of course the image was taken in black and white, like mine. It will be easier this way to optimize the image before turning it into a brush. Some colors turn into grayscale better than others – the ones of my T-shirt were unfortunately not some of them.

To turn just the flower into a brush, we need to get rid of the T-shirt surround – Photoshop brushes will use anything that is not white, so if we were to turn this current image into a brush, we'd get everything we see in it right now. So we need to get rid of everything but the piece we want to keep. Adjusting the Levels of the photo – Image > Adjustments > Levels – helps to get the desired results, making sure that the surroundings get as pure white as possible, while the flower remains nice and dark but not

too over-saturated (**Fig.02**). Too much contrast here can make the image look very scraggly and too sharp around the corners, which is not very desirable.

We can now crop the image with the Cropping Tool, trying to get as close to the edges of the flower as possible without touching them. We can also adjust the crop rotation if we want to – sometimes it just works better (**Fig.03**). Now that is done, we can adjust the picture some more, if necessary. There may still be some grayish tones where there should be white, and we need to get rid of those.

We can either do this with the Paintbrush – a simple hard round one is usually the best option here, with Opacity set to Pen Pressure and Color to white – or the Eraser Tool (with the same settings). When using the Eraser tool, we need to make sure that our active Background Color is white. We then carefully paint over or erase the bits that need to go (**Fig.04**). Take your time with this, as you want it to be as perfect as you can get it! Leaving a bit of light gray stippling around the immediate edges of the flower is okay; it actually works a

lot better that way once we use it in a painting, as it won't look too "cut out".

Sometimes it can be easier to invert the image's colors (Image > Adjustments > Invert) so everything that was white will be black, and vice versa, as it is easier to see that way where there's still some gray areas in the black, than in white. All you need to do before turning the image into a brush later is invert it again to its original colors. And should you work with the Eraser tool, make sure your active Background Color is of course black, not white.

Essentially, we are now done, but if you feel that the image could use a little more contrast, adjust it once more using Levels. You can also use the Burn tool with the Mode set to Midtones to bring out some of the dark areas a bit more (**Fig.05**).

Now the image is ready to be turned into a brush. Depending on the size of the image, you may have to resize it to be able to turn it into a brush. In Photoshop CS, the brush size limit is 2500 pixels on either side (Image > Image Size).

CHAPTER 6

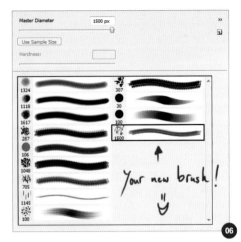

Simply go to Edit > Define Brush Preset, give your brush a name if you like – and you're done (**Fig.06 – 07**). This kind of brush is useful for creating stand-alone embellishments on fabrics, as well as non-continuous repeat patterns.

You can create lots of brushes like this from photos or scanned items. The brushes will stay in your brushes palette until you change your Brush Set, and then Photoshop will ask you if you would like to save the changes made to the current set. You can also create a completely new set with your own brushes, by deleting all the brushes in your current set and then creating new brushes. All you need to do then is to Save the brushes (click that little arrow in the top left of your brushes palette to get the option).

SEAMLESS PATTERN

Let's move onto something a little trickier: a seamless brush; one that, when used, creates a continuous pattern. These can be anything from knitted fabrics to lace borders.

We start pretty much the same way as we did with the previous brush, by scanning or photographing a piece of fabric or clothing. Here we need to make absolutely sure the piece is laid out straight, and that we capture it dead-on from above. No odd angles. Also, we need to make sure to capture enough of it, so the pattern can be "stitched" together without any all-too-obvious seams later.

I photographed a section of cotton lace border (**Fig.08**) that I'd like to use. As the border itself is white, I put it on a black piece of fabric (you

could use anything, as long as it's dark) to get the best contrast. We desaturate as before and then invert the colors (**Fig.09**). This is necessary this time round because we want the lace to be the brush, not the surroundings.

Some adjustments in the Levels may be needed, as before, so work your magic!

The next important step is cropping the image. We need to make absolutely sure that we know

where the pattern starts and ends, so that we can crop it right at that point. If it is a tiny repeat pattern, as in this case, we can choose a larger section to make it less obvious that it's been stitched together later on when used. The more variation the better as it makes it look much more believable (**Fig.10**).

When cropping, it may become more apparent that the pattern isn't perfectly straight – like in this case. To rectify that, we need to transform it a bit to get it straight. If we don't do this, it will not align properly later.

First, we may want to show the Grid, to get an idea of where the lines need to be (View > Show > Grid). We then select the canvas (Select > All), and then go to Edit > Transform > Skew. This will let us straighten the horizontals and verticals out, as well as squish them to make them line up better (**Fig.11**). Once we are done with this, we can crop the pattern (**Fig.12**).

We now proceed as before with making a new brush, and once we've done this we need to adjust it to create a seamless pattern:

We open a new canvas and select the brush. We then open the Brush Presets palette (**Fig.13a**). Click on Brush Tip Shape at the top of the list on the left. You'll see lots of options there, but the one we need to pay attention to is the Spacing (**Fig.13b**). Moving the slider to the right spaces the brush out more and more. Move it until you can see the segments touching each other, instead of overlapping one another. Try the brush on an empty canvas,

as the preview isn't quite that accurate. If there's a gap between the segments, or they still overlap, fine-tune the Spacing manually by increasing or decreasing the percentage. Once you're happy with it, create a new brush preset from the existing one so you don't have to

adjust it every time you want to use the brush (**Fig.13c**).

This kind of brush is useful for large surface texture or embellishment, like lace and embroidery borders.

Adjust manually if necessary.

Create new Brush Preset

CHAPTER 6

By the way, if you cannot tell if a brush is aligned right because your straight line drawing ability is a bit under the weather – like mine – just press and hold the Shift key on your keyboard while you draw the line – it will automatically be straight.

HAND PAINTED PATTERNS

Of course, we can also paint patterns by hand, or even make small brushes such as dotted, dashed or solid circles, swirls, zigzags, or whatever you can think of that will help with painting patterns by hand. I usually like to paint all my patterns, no matter what they are, and then use them as brushes, rather than photographing actual items. Painting and designing your own patterns really gives you endless freedom.

The method for creating a brush for these is the same as the two previously described, depending on whether you want a seamless pattern or a stand-alone/repeat one.

USING FABRIC BRUSHES

Download the Free Brushes with this tutorial and we'll have a look at how to best use the main brushes in the set. You will notice when you open it in Photoshop that I've already adjusted the settings of the brushes so they work as they should, but that shouldn't stop you from playing around with them.

The easiest ones to use are the Single Pattern brushes. I have not provided any settings for these, as they are usually stamped onto an image rather than used to paint. Here are two examples of brushes like that (**Fig.14**).

When using these kinds of brushes, always make sure you use them on a separate layer as they need to be adjusted. Why? Because they need to follow the flow and folds of the fabric they are on, and have to have the right perspective, too.

It's quite simple, really, though you may need a little bit of practice with this.

Here is one of the patterns on fabric with folds (**Fig.15**). If we want the pattern to slightly wrap around something, like the side of a dress, we first need to adjust the perspective of it. To do this, we go into Edit > Transform > Perspective. We now push and pull at the corners and sides of the Transform tool until we get it roughly in the right position. If some of the pattern is going over the edges of the fabric, it shouldn't be of any concern to us at the moment. Let's continue with making the pattern fold. The fun starts here!

If you're working on a small area in a rather big painting, you may want to select the area the pattern is in with the Marquee Tool. This will cut down the loading time of the tool (or filter?) we'll be using next, namely Liquify. You can find it under Filter > Liquify, and it's a small program all in itself (**Fig.16**).

To do what we are about to do, choose the Forward Warp tool and adjust your brush size to what is appropriate for what you need. The brush should be slightly larger in diameter than what we are about to warp. Also make sure you have Show Backdrop ticked at the bottom, and Mode set to Behind, while Opacity should be something between 50 and 70. I personally also like to show the Mesh, as it gives me a better indication of what I am doing.

Now we gently start to push the pattern into the folds of the fabric, using short, one-way strokes, lifting the brush off after every stroke. Resize the brush as often as needed. For large

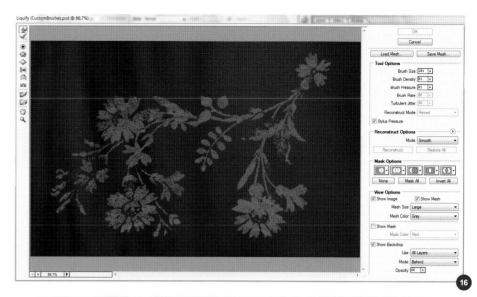
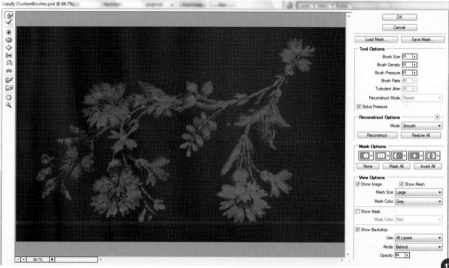
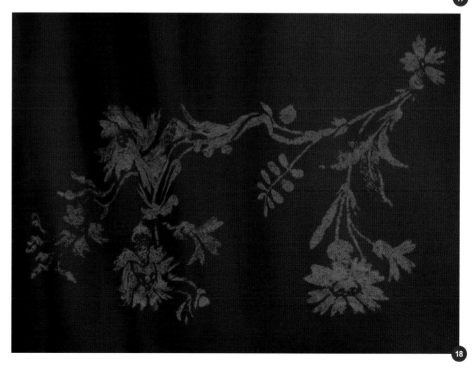

or long areas, such as flower stems, we need to start at one end and slowly work our way to the other end with repeated brushstrokes. It is impossible here to make long strokes as it will only warp the part where you first set your brush down on the canvas (**Fig.17**).

The deeper the folds, the more we need to push the pattern into them, creating the illusion of it bending with the fabric. If folds overlap, it may be wise to first cut the pattern up and actually remove part of it (where the folds would hide the pattern) and then put it back together before using the Liquify filter.

Once we have our result (**Fig.18**), we may have to adjust it some more here and there, as sometimes it is hard to judge where the pattern is going while using the Liquify filter.

At this point, if parts of the texture or pattern go over the edges of whatever they are on, just erase those parts.

This still doesn't look quite right because the pattern is one single block of color; it needs shadows and highlights according to the light source in the painting, and according to the

folds of the fabric. To easily paint over the pattern we click on the little Lock Transparent Pixels icon at the top left of our layer palette (the small checkered square) – this will do what it says: lock all transparent pixels, leaving you to paint happily over everything else on the layer, which in this case is the pattern, until you are happy (**Fig.19**).

This is pretty much what you need to do every single time you use a complete fabric texture or just a pattern – no matter what it is. If it's not a flat surface, it needs to go with the direction of the fabric. There is no way around that. At all!

All the textures and embellishments in the final image of this tutorial were applied with that same method.

By the way, sometimes a brush like these looks even better if you apply the Median filter or a slight Gaussian Blur, just to make textures (especially photographed or scanned ones) look more painted and more part of the image.

So now that we have looked at one brush in action, what do some of the other brushes look

like? I could just refer you to the final image, but figured it'd be nice to see them just by themselves for a clearer view (**Fig.20 – 24**).

CONCLUSION

Working with these kinds of brushes may take some getting used to, but the result is well worth the time taken. I truly hope this little tutorial is of some help in getting you started with it all.

Detailing your paintings should be fun, and with these brushes it will hopefully be just that. And if you're really into it, you may even find yourself keeping an eye open for new patterns all the time, be it when shopping, reading magazines or browsing online. Or, like me, you'll start a whole folder on your computer of hand-painted patterns that you can adjust or modify as you please, when you please. The possibilities are truly endless.

You can download a custom brush (ABR) file to accompany this tutorial from: **www.3dtotal.com/dptresources.** These brushes have been created using Photoshop CS3.

CUSTOM BRUSHES FOR ROCK/METAL/STONE TEXTURES
BY CARLOS CABRERA

SOFTWARE USED: PHOTOSHOP

INTRODUCTION

I have been asked on many occasions how I create the rock textures that often appear in my illustrations – on walls, backgrounds, even on characters. The secret is a rare passion for painting stones… as well as, of course, a set of custom brushes for this purpose, which I am going to now share with you all.

We are basically going to be working with two kinds of brushes: a metal chain brush and a rock/stone brush. So let's begin – starting things off with the stone brush.

ROCK/STONE BRUSH

The first thing we need to do is to find a nice stone picture from our texture library. For this tutorial I'm going to use a free texture from 3DTotal, one of my favorite texture resource sites (Go to www.3dtotal.com > Free Stuff > Textures) (**Fig.01**).

Before we start, you'll need to understand how brushes work. The texture image we are going to be using for our new brush will be desaturated, which means it will have no color at all. White in a brush will represent the transparent color, and black will be a solid one.

The different shades of gray will work as levels of opacity. For our first brush we don't need too many shades of gray because the image will be very transparent, and we need a more solid color for our stone.

Open the texture up in a new Photoshop document (I'm working with Photoshop CS3, but this tutorial can be followed in any version of Photoshop). Press Ctrl + U to desaturate the image (remember that the brushes work in

black and white so you don't need color), and tweak the Levels adjustment (go to Image > Adjustments > Levels) until almost all of the gray tones have been eliminated (**Fig.02**).

We now have a nice black and white texture with the correct Levels for our new brush, so the next step is for us to decide on how our brush is going to look. Select the Eraser tool, and with a soft paintbrush erase anything that you don't want to be part of the brush, trying

to create an irregular shape. To improve our texture we are going to deform it using the Warp function (go to Edit > Transform > Warp). Try to match the shape of that shown in **Fig.03**.

Another way of doing this is using the Liquify tool. Some people prefer this way because it is more visual and you have more settings to tweak, but I always use the Warp tool – it's simple and quick.

The texture is now ready to become a brush. Go to Edit > Define Brush Preset. Give the brush a name, and then hit OK. And voilà! Our brush has now been created. You will find your brush available in the brush menu (you can right-click on the canvas for a shortcut to it).

With the easiest part done, we now need to modify the settings to improve our new brush. So click on the Brushes tab on the top-right of the workspace, and in the Brush Presets select

Brush Tip Shape. In the window that appears on the right of the Brushes tab, we are going to modify the Spacing percentage to 16, leave the Angle at zero, and let the Roundness remain at 100% (**Fig.04**). If we test our new brush we will see that it still needs some more work in the Brush Preset settings – the stroke looks strange and is much too repetitive.

The next preset we want to explore is Shape Dynamics (**Fig.05**), so select it and you'll then be able to set the Angle Jitter Control to Direction, meaning the shape of our brush will now follow our graphics tablet or mouse direction. Getting around the Direction control is one of the most important aspects of this custom brush technique, as we will be able to see later on when we create our metal chain brush.

Moving onto the Scattering options now, we're going to set Scatter to 85%, and we'll leave the

Count at just one. With this preset, the brush will repeat itself and overlay the strokes, as we can see in **Fig.06**.

Now for the fun part! Let's select Color Dynamics now; you'll need to apply the same settings as you can see in **Fig.07**. I'm going to stop here for a moment to explain this preset.

If we compare the previous image (see **Fig.06**) with **Fig.07**, we can see that the stroke is monochromatic, with one color, and lifeless. As

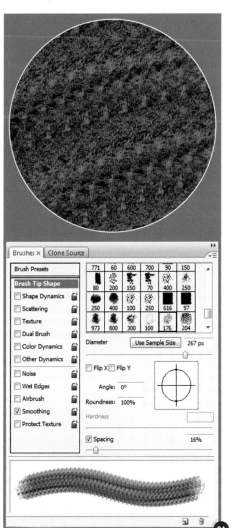

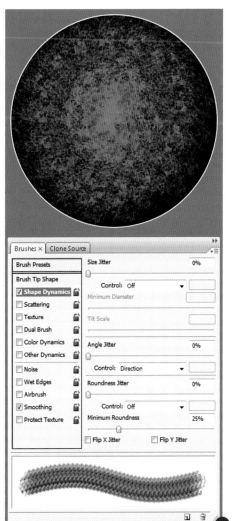

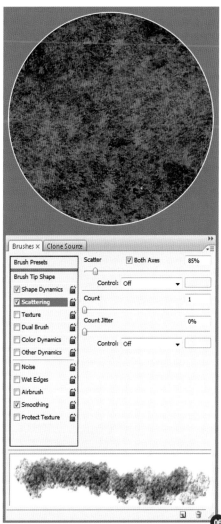

CHAPTER 6

we know from experience, rocks and stones have different color values, light variations and characteristics that make each one unique. Some stones are green from moss growth, or violet from weathering by the elements. Well, with these presets, you can play with the color, brightness and saturation of your brush. In **Fig.07** you can appreciate the different color values and light variations with just a few simple changes on the controls. So at this step I'm going to recommend that you find the value you like the most for your own brush – as you can see it's easy and the possibilities are enormous!

Last but not least, we have the Other Dynamics preset to play with (**Fig.08**). Let's change the control of the Opacity Jitter to Pen Pressure; however, if you're working with a mouse and not a graphics tablet you won't be able to utilize this option.

Right-click on your canvas now and select New Brush Preset so that we don't lose any of the changes we've just made to our new brush. And that's it! – Done! Easy and simple! Here is how our new brush looks (**Fig.09**). If we test it out we'll discover that it has pressure opacity, pen direction and refined color variation – perfect for painting rock and stone textures! Our rock/stone brush is now complete, but there is still the matter of metal to cover, so let's now get started on creating our very own metal chain brush.

ORIGINAL PHOTO

COPY, PASTE & ROTATE

TILEABLE PHOTO

METAL CHAIN BRUSH

The first step is the same as before: find a texture of a metal chain. The difference this time is that we need to make it tileable. To do this, choose the Rectangular Marquee tool and select from the centre point of two links in the chain, as shown in **Fig.10**.

Copy and paste this into a bigger document. By pressing Ctrl + J, you can duplicate the layer; you'll then need to flip it by going to Edit > Transform > Flip Horizontal. See if the chain links are looking correct at this point, and check if they are tileable (**Fig.11**).

When you are happy with your new tileable chain texture, follow the first steps of this tutorial once again as you go through the Brush Presets, finding the right settings for your new brush. Remember to set the Direction Control of the Angle Jitter preset, and focus on the Spacing percentage. For this chain brush I

have gone with a high percentage of Spacing because I need to tweak the space between every link in my chain; if you use a low value your links will be too far apart from one another other. On the other hand, if you use too high a value then you may finish up with a weird shape overall and no links at all! So play around and see what you can come up with, remembering to save the Brush Presets each time you find a brush that works for you – you can save as many variations of one brush as you like, the limitations are endless!

CONCLUSION

The best way to learn with custom brushes is by playing with the settings. As you can see from this tutorial, making your own brushes in Photoshop is not hard at all. I would like you to take this tutorial as a starting point for the future of your custom brush collection (**Fig.12**).

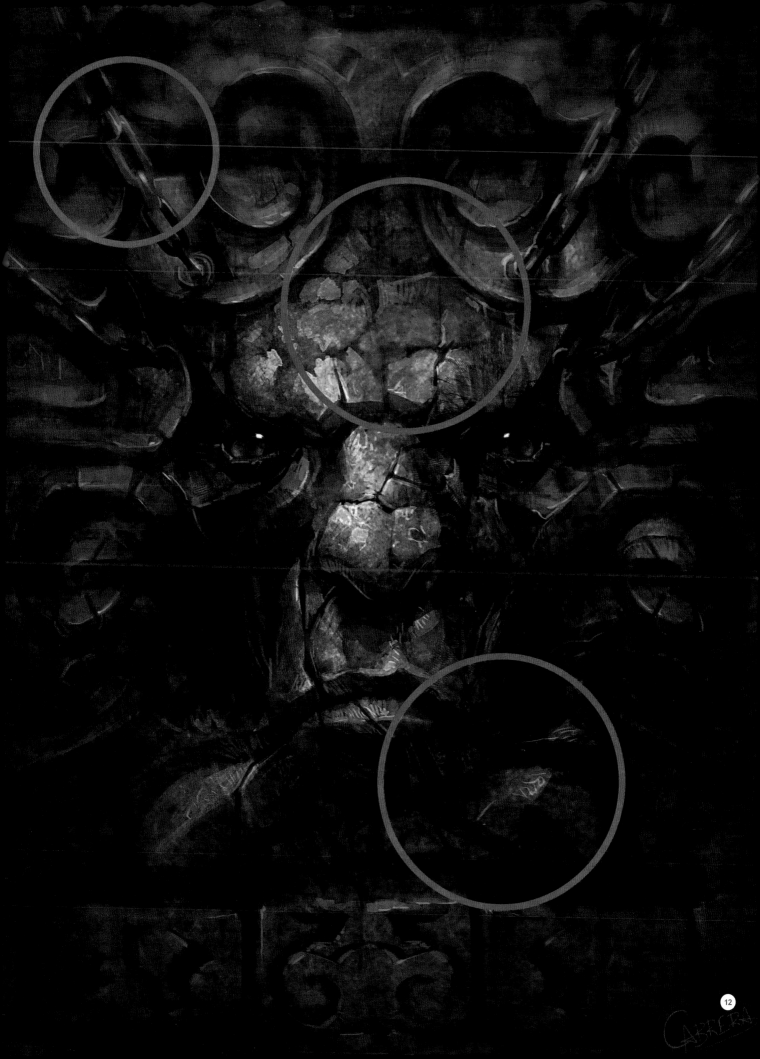

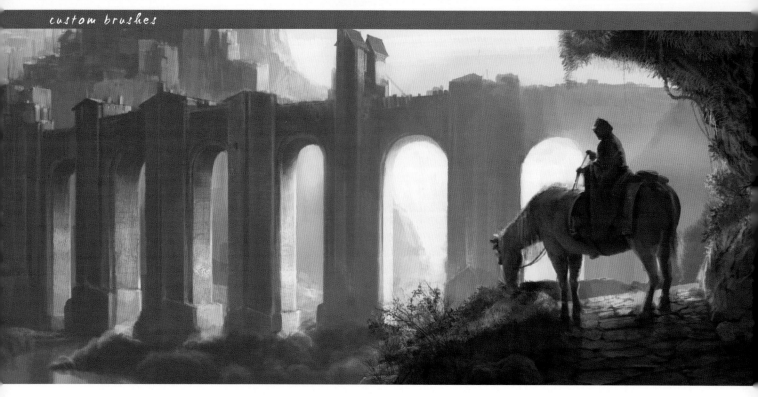

CUSTOM BRUSHES FOR TREES, LEAVES AND BRANCHES
BY ROBERTO F · CASTRO

SOFTWARE USED: PHOTOSHOP

INTRODUCTION

Drawing any type of vegetation is not an easy task! One of the main problems many artists face is the creation of credible trees and brushes for their paintings. The best way to win this battle is to carefully observe the vegetation around us, and to create a set of brushes that will create a good effect on our canvas.

All you need to make a good tree is your graphics tablet, your pen, and this tutorial! I'm sure that advanced painters will find some tips and tricks here, whilst beginners should not fear any of this either! So let's get started.

LIFE DRAWING – PAINTING VEGETATION

Trees and vegetation have been one of the more difficult things for artists to draw and paint. And the reason for this is simple: Like animals or humans, trees have an organic and random structure that can't be easily assimilated. Most of the time, trees in a scene are in the middle or far distance. It's for this reason that I'm going to focus this tutorial on painting trees and vegetation that will not appear too close to the observer.

It is important to understand that leaves, branches and the trunk are all parts of the same element: the tree. In some way, painting foliage is not far from painting clouds or cotton-shaped materials; the leaves gather together

to shape "clouds" of leaves. It may sound very poetic, but keep this in mind as it will be useful for this tutorial.

Quick Tip: Digital art provides artists with a useful weapon: brushes. The creation of adequate brushes is not the solution to a bad drawing technique, but the use of them will make our work faster and more effective. First of all, trust in your head; when you have a clear idea of what you want to paint, use the tools available. These kinds of tutorials are perfect for designing useful tools for your work!

As an example to illustrate this tutorial, I've selected one of my images called "Citadel",

which has a great combination of different types of vegetation elements. I've also selected this particular painting because the tree is one of the main elements of the composition. Moreover, we can see a far-off forest at the bottom of the image, as well as some examples of ground leaves and grass.

CUSTOM BRUSHES TO DRAW LEAVES – ANGLE JITTER AND SCATTERING EFFECTS

First of all, you have to know what kind of tree you want to paint for your scene. Pines, for example are different in shape and structure from oaks or birches. In my own image, I decided to paint a rounded tree with elliptical leaves. The truth is that you don't need more than two brushes to paint tree foliage: one is used to paint the grouped leaves (the compact mass of leaves), and another is used to paint scattered leaves (to paint the leaves of small branches and to give detail and brightness to foliage).

The first step is to select a photograph or image of grouped leaves and convert it to Grayscale mode (**Fig.01 – 02**) (I recommend you gather photos of trees and vegetation to have a good collection of images that will

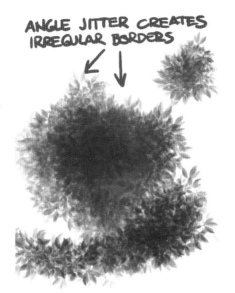

ANGLE JITTER CREATES IRREGULAR BORDERS

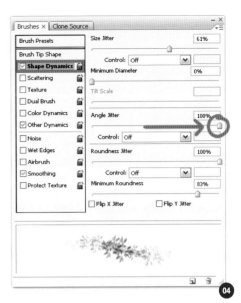

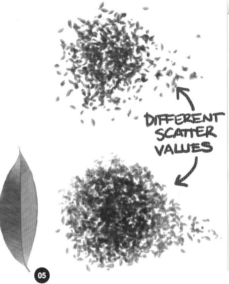

DIFFERENT SCATTER VALUES

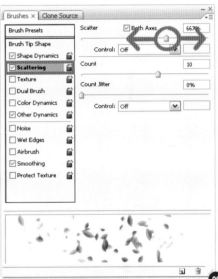

help you to create brushes). We then have to edit the image to define it and finish around its borders (**Fig.03**). Because leaves in the real world are never completely opaque, I recommend that you adjust the image's levels to reach a medium-dark tone of gray.

We convert the image to a brush now (Define Brush Preset in Photoshop's Edit menu) and open up the Brushes Editor. As we want the borders of our strokes to appear irregular, we have to set Angle Jitter to the maximum level. You can also slightly adjust the Roundness Jitter to get a random deformation of the leaves (**Fig.04**). Regarding the Opacity, I usually control this with the Pen Pressure setting. Adjust it to your needs and paint whatever is convenient for you. Once you've completed the editing of your brush, and it feels good on

the canvas, save the brush and name it (I've named mine **foliage brush**).

For the other brush of scattered leaves we need to isolate one leaf in the grayscale image we obtained earlier (**Fig.05**). The parameters in the Brushes Editor are the same as the foliage brush, only with one difference: we have to this time check the Scattering effect. Try the brush with different values to get a suitable result (**Fig.06**). I have named this brush, **scattered leaves**.

BRUSHES FOR BRANCHES – THE DIRECTION CONTROLLER

We only need to design one more brush to create a tangle of branches now. Collect some images of trees without leaves (winter images

of trees are perfect!) as these will be helpful. I prefer branches to be not too dense or complex (**Fig.07**), but this decision depends on the kind of tree you want to paint, of course. After removing the trunk and some branches, we can define our new brush (**Fig.08**).

This brush has a new and interesting effect in that the rotation is now being controlled by the stroke's direction. Photoshop allows us to position the brush image depending on the movement and direction of our pen. You just have to change the Angle Jitter control parameter to Direction to get this working (**Fig.09**). A more precise way to do this is to select Pen Tilt, instead of Direction, but you should note that this is only applicable when using a pen which is sensitive to vertical rotation.

We can try the new brush out now and check how it works using the Direction controller. As a final touch, I adjust the Spacing on the brush, and save it out. In my set of brushes that come free with this tutorial you will find this brush labeled **branches**.

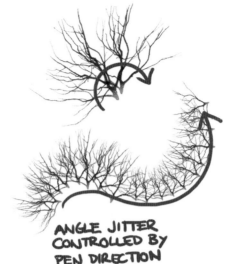

ANGLE JITTER
CONTROLLED BY
PEN DIRECTION

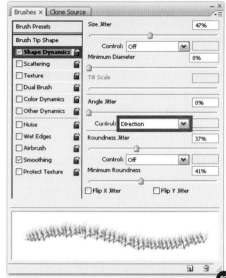

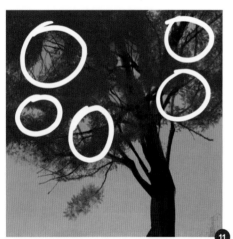

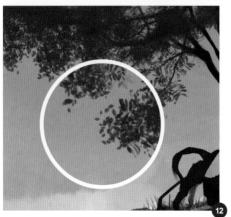

USING THE BRUSHES – DRAWING TREES

The steps to paint a tree are easy, but you're probably going to need some practice before you have full control over your new brushes. Before going any further, we have to create a layer for the trunk and branches, and another one for the foliage.

The first step is to create the branch framework of the tree on a new layer. In my Citadel painting, I draw the trunk on the top of a mound. I then choose the branches brush we designed just a moment ago, and make a clockwise stroke to create the basic branch structure of the tree (**Fig.10**). Don't be afraid of the result of the branches brush; the placement of the leaves in the next step will prevent us from seeing most of the small parts of them.

The next thing we need to tackle is the foliage. The time has now come to prove our painting skills! This may prove to be the more difficult part in this process, so take your time and try as many times as are required to get the results you want.

We select a dark color and start painting on another new layer with spiral motions of our hand, using the foliage brush to apply leaves to the branches of our tree. We must be sure not to create foliage too near the trunk, nor on the border of exterior edges of branches. The best way to do this is to concentrate on the leaves in the central area. As you can see in **Fig.11** I have deliberately left empty spaces where the branches appear through the masses of leaves (marked with circles).

Once we've finished the main mass, select the scattered leaves brush and define the outer border of the foliage (**Fig.12**). When we use custom brushes, keep the Brushes Editor open as a helpful habit. You can modify the Scattering effect (or any other parameter) quickly, according to your needs, at any time.

Finally, select lighter colors to create volume over the mass of leaves. Lock Transparent Pixels on this layer so you can be sure not to add more green mass unnecessarily. Use any brush you consider suitable to give more detail and definition (**Fig.13**). And be careful with the light source in the scene – as you can see in my image, I've created a backlight ambient that shapes the tree with dark tones of green.

THE DISTANT WOODEN MASS – LIGHTING TREE CROWNS

Let's move onto something a little easier now:

the distant mass of trees. As we can see in most landscape paintings, the distant trees and woods are usually represented as an undefined mass without detail. The rule is simple: The longer the distance of an object from the observer, the lower the amount of detail it will have. In the free brushes set that come with this tutorial, you will find several brushes to paint distant vegetation.

So let's now pass from theory to practice. Use the **wooden mass brush** to create the base of your wood. I've simply used a photograph of a tree to create it (**Fig.14 – 15**). By adding a Scattering effect, Angle Jitter and controlling the Opacity with Pen Pressure, you can obtain lots of brushes to create a wooden mass. As mentioned at the beginning of this tutorial, painting trees is similar to painting clouds or cotton!

CHAPTER 6

To define the crown of the trees we have created a brush starting from another new photograph. As we need to see the tops of the trees, we can edit the image and erase the lower part of it (**Fig.16 – 17**). The result is a vegetation arch facing down that will be very useful to provide volume to the plain mass we painted before. All we do with this brush is light the tree crowns. You'll find it in the free set labeled as the **tree border brush**. Note that in the Brushes Editor, I have activated the Direction controller to obtain a more flexible drawing technique.

I have created an example in **Fig.18** so you can see this in action. I have used only two tones of gray to show the advantage and simplicity of using this painting method. In the top image, we start by creating rough stains with the wooden mass brush to simulate volume. We then complete our wood by defining the borders with the tree border brush in the second image. It's easy, really! In few seconds we'll reach a perfect and realistic result without too much effort.

CUSTOM BRUSHES FOR EVERYTHING YOU CAN IMAGINE!

Creating custom brushes is a meticulous task that will bring you a new range of possibilities to your drawing techniques. All the custom brushes I have compiled for this tutorial are used in the Citadel image, and you can download the brushes with this tutorial for free. Explore them and create your own new ones for different tree species for your paintings.

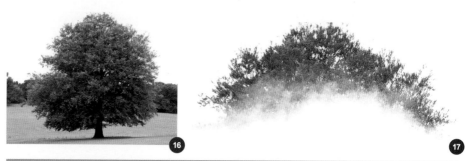

16

17

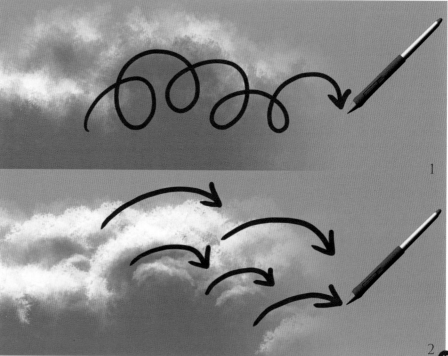

1

2

18

My **trunk roughness**, **grass leaves**, and **light vegetation brushes** are some of the other vegetation brushes I have used, as you can see in **Fig.19**. Take a look and think about the different treatment of the vegetation elements regarding their position in the scene, the lighting, and the perspective (**Fig.20**).

There are lots of possibilities in the creation of custom brushes, and I'll be very pleased if this tutorial serves as inspiration to create new methods to face the difficult work of painting trees and vegetation. We could spend pages and pages explaining how to design brushes for countless purposes, but at the end of it all, the most important thing is not my theory, it's your practice!

Thank you for reading this tutorial, and good luck with your own custom brush creations!

You can download a custom brush (ABR) file to accompany this tutorial from: **www.3dtotal. com/dptresources**. These brushes have been created using Photoshop CS3.

19

CUSTOM BRUSHES FOR CROWDS
BY RICHARD TILBURY

SOFTWARE USED: PHOTOSHOP

INTRODUCTION

Custom brushes are a powerful part of
Photoshop and form a particularly valuable
asset amongst any digital artist's set of tools.
These enable the artist to tailor his or her range
of marks and brushstrokes, adding a new
dimension to the work and injecting the canvas
with a varied and rich dynamic.

Customizing brushes can help condense the
physical qualities of a material or surface within
a few deft strokes, and therefore describe the
subject matter in both an economical and yet
highly effective manner. This technique can
also save much time in the case of repeating a
motif for example.

The subject matter in this image has been
used as a vehicle for showing groupings in one
form or another; in this case people, insects
and birds. These, of course, can be painted
individually but by customizing a brush we

can create a complicated array in a matter
of minutes as well as maintaining a plausible
result.

This is another practical aspect of Photoshop's
brushes which allow specific brushes to
be used to save time; something which
is becoming ever more important in the
quickening pace of today's art and design
industry.

CROWDS

To make this tutorial a little more interesting
I thought it would be better to have a context
for my custom brushes which in this instance

revolve around the theme of crowding and
flocking etc. I decided that as opposed to
a very dry exercise focusing purely on the
process of creating a brush, it would be more
appropriate to use an actual scene.

The first brush I made centred on people as
this is probably the most obvious. As with all of
my painting projects, my first port of call was
the internet in search of reference pictures.
Crowds are a challenging topic as there seems
to be no apparent structure to them other than
shoulders and heads and even these vary
depending on the distance and angle from the
viewer.

When you look at a crowd it seems to be an almost indiscernible mesh of abstract marks and colored dots. The difficulty comes when you try to extrapolate a repetitive motif or shape that consistently describes what you are looking at.

I tried an abstract approach initially using a variety of shapes but in the end it simply looked like a pattern of different sized dots and nothing more. In the end I decided to start with what I knew, i.e. a shape representing the upper torso as seen in **Fig.01**.

It made sense to use a shape that looked correct and then use the brush parameters to create the random array of shapes visible in images of crowds.

Once you have made a template like this you need to save it as a brush in order to use it. To do this, open the brush preset picker (small arrow next to brush tool) and then click on the small square icon in the upper right (**Fig.02**). This opens a dialogue box where you can

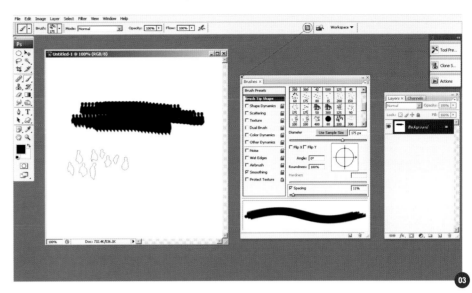

name and save your brush. Once done it will appear at the base of your brush library within the brush presets.

When you select and use your brush it is likely it will not appear as you would wish and this is due to the default settings. To gain access to the brush parameters click on the small icon along the toolbar (ringed in red in **Fig.03**).

It may be that when you drag your brush along the canvas it will produce a solid line as seen in the left window. This is due to the Spacing within the Brush Tip Shape being set to low, 11% in this case.

Some of the settings will need to be modified in order to refine the brush and mean that it works the way it should which I will cover next.

Fig.04 shows the brush stamped four times using a mouse and the resultant pattern it makes without any alterations. I changed the Spacing under the Tip Shape to 138% which overlapped the strokes slightly (**Fig.05**).

I then flipped the X Jitter under Shape Dynamics to add a little variation (**Fig.06**).

I altered the settings under Scattering as seen in **Fig.07** and that about finished the crowd brush.

When put into practice it resembles something similar to **Fig.08**. Obviously legs would need to be painted on the nearest figures or a brush created with the whole body for the extreme foreground.

The brush can be seen here in the final image (**Fig.09**).

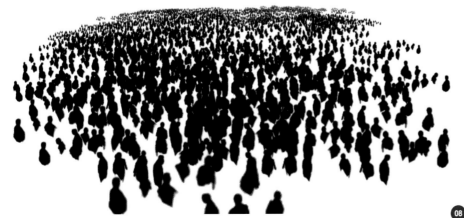

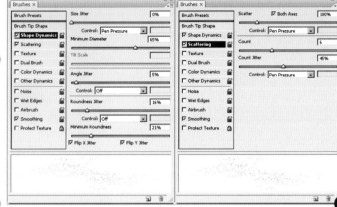

FLOCKS

The next brush I wanted to create was one for painting flocks of birds which has become a very popular icon in both film and digital painting. This is far simpler than the previous brush and the best way to start is to search for some photo references of birds.

Make a selection area around the birds you wish to include in your brush and then fill them in with a pure black. Delete the surrounding areas just leaving the bird silhouettes as seen in **Fig.10**.

Save this out as a new brush as done previously and you will have a brush that now resembles your original pattern (**Fig.11**).

I altered the Shape Dynamics and Scattering to those parameters seen in **Fig.12**. The

Roundness Jitter helps flatten a few birds out as though they are flying "side on" to the viewer and if you didn't want any to appear upside down you could turn off the Flip Y Jitter.

You can see these settings applied in **Fig.13** and how they add randomness to the two brush strokes. The final result can be seen here in **Fig.14** where you will notice a few birds are upside down but from a distance this reads ok.

SWARMS

Another brush I created was aimed at painting insects. I painted in a few abstract shapes that represented some sort of flying bug and then made this into a brush (**Fig.15**).

I then applied the following settings in order to paint a swarm (**Fig.16**).

Quick Tip : Because the brushes palette is so versatile, it is possible to create a handful of different brushes from a single template. I created a variation of this same brush using the following settings (**Fig.17**) which was used itself as a Dual Brush (bottom right). With the Dual Brush applied you can see how it breaks up the brush strokes even more and creates a frenzied mass of bugs (**Fig.18**).

There was one other insect brush I made for this tutorial which would represent any bugs flying nearer to the viewer which can be seen in **Fig.19**.

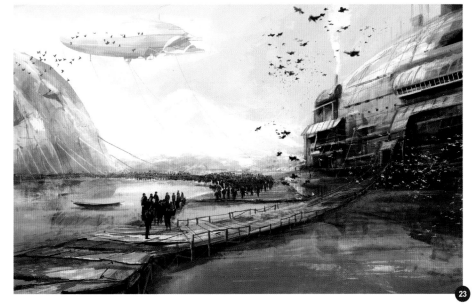

I applied the settings seen in **Fig.20** which ensure that each stroke scatters the insects sufficiently. When a single stroke is dragged across the canvas the insect shapes cover a wide area as seen in **Fig.21**.

These three insect brushes have been used to the right of the foreground as seen in **Fig.22**.

CONCLUSION
I hope that I have at least given you a glimpse into the usefulness of creating and customizing brushes. I feel that these tools are a valuable aspect of Photoshop and can enhance the quality of an artist's work as well as helping to improve on efficiency (**Fig.23**).

You can download a custom brush (ABR) file to accompany this tutorial from: **www.3dtotal. com/dptresources**. These brushes have been created using Photoshop CS3.

painting from a
3d base

My illustration career began in a time when the tools available to an artist did not include anything electronic. Since then the visual arts world has transitioned from analogue to digital. From the early days of relatively simple digital paint systems that cost a fortune, we artists now have access to even the most advance 3D software—right on our desktop computer. The result is a third option added to our previous choices of either drawing from scratch or working from photographs. We can now create a virtual 3D world where the only limitation is our imagination. We are not just painters anymore—we have become architects, sculptors, and engineers.

The artists in this chapter are exploring this new territory. And it is inspiring to see the breadth of imagination the artistic mind is capable of. Limitations? Maybe not.

RON CRABB
ron@crabbdigital.com
http://www.crabbdigital.com

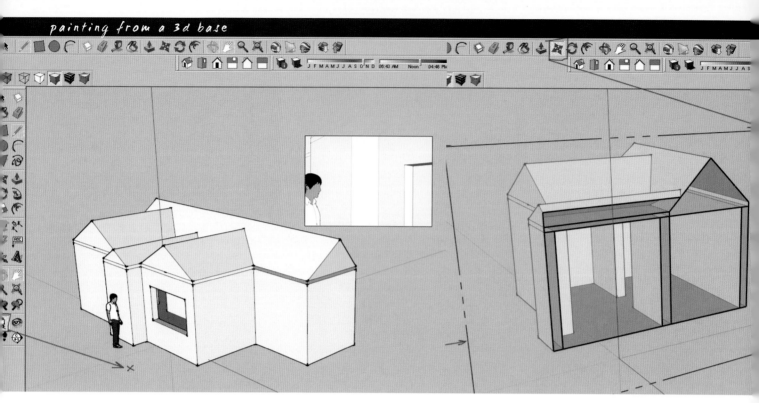

Using Google SketchUp as a Base for Digital Painting
By Richard Tilbury

Software Used: Google SketchUp

Why use SketchUp?

Google SketchUp is a free programme enabling users to quickly and effectively build 3D environments using a number of intuitive tools. Unlike most 3D packages it is very easy to learn and does not require hours of training before decent results are achievable. It is very versatile and with regards to digital painting can prove an invaluable tool in swiftly establishing a correct perspective, as well as offering a moveable camera in order to experiment with alternative viewpoints and compositions.

An object can be made and then duplicated any number of times, so if a structural element is repeated throughout your concept then this package can quickly and accurately create such arrays. It also has a simple-to-use lighting system that enables placement of the sun according to the month and time of day by way of slider bars, thus determining physically correct shadows that can be turned on or off at the click of a button. These functions mean that as an artist wishing to draw detailed or tricky scenes, one can use SketchUp as a valuable starting point to establish a "guide template" on which to paint over.

Installation

In order to install SketchUp, visit **http://sketchup.google.com** and go to Downloads on the left hand menu. Select the free version which is currently version 7 (**Fig.01**). Choose your operating system and then follow the instructions.

Once installed, click on the application shortcut and you will be prompted with the following dialogue box in which you are asked to choose a template (**Fig.02**). The scale and type of your scene will determine which you choose, but for the purposes of this tutorial we will select Architectural Design – Feet and Inches.

TOOLBARS & MENUS

When SketchUp starts you will see a screen resembling **Fig.03**. From the main menu click on View > Toolbars > Large Tool Set; this will access more tools which will appear down the left margin. To change the display mode of the objects in the scene click on View > Face Style; this will show a number of options, as seen in **Fig.04**.

If you also check Views under View > Toolbars you will see six small house icons appear below your toolbar (**Fig.05**). These will provide quick access to orthographic views, as well as isometric. You will notice that I have also checked Face Style in the list (highlighted in green), which has added some cube icons to represent the display modes.

This is basically where you can customize your workspace and add toolsets to speed up your workflow. For additional help go to Window > Instructor; this will open a window providing useful information on whichever tool you have currently selected.

BASIC NAVIGATION

The key orientation tools you will use to navigate in your scene are Orbit, Pan and Zoom, which you will find on the top toolbar and whose shortcut keys are represented by O (Orbit), H (Pan) and Z (zoom). These can be seen in **Fig.06**.

The main tools used to directly manipulate your objects are Move (M), Rotate (Q) and Scale (S). The Scale tool appears on the left hand toolbar which you will see highlighted if you press S on your keyboard.

DRAWING SHAPES

One way of using SketchUp is to create two-dimensional shapes from which you can extrude three-dimensional objects. Select the top view and then the Line tool (**Fig.07**) and

left-click in the viewport to begin drawing. You will notice that as you do so, the points will snap to the green and red axes, thus easily enabling the creation of right-angled structures.

When you finally close the shape by clicking on the initial point you will notice the shape turns blue, indicating a surface has been made; once a shape has become closed you can still edit it. Using the Line tool, add an internal rectangle (see top diagram in **Fig.08**). To now make this edge become part of the exterior shape click on the Eraser tool and then on the outside edge shown in red.

You can continue to cut into your shape or alternatively extend it outwards and then erase the necessary lines by using the Line tool (**Fig.09**). Here I have added a walkway and also a curved section using the Arc tool. You can also draw more organic shapes using the Freehand tool (**Fig.10**).

One other useful function, especially for architectural structures, is the Offset tool which is situated next to the Rotate tool. This enables

a shape to be duplicated in order to create depth – perfect for drawing walls in a building, for example (**Fig.11**).

With an exterior wall depth, click on the large internal shape using the Select tool (black arrow on toolbar) and hit delete. You can then select the Push/Pull tool and then click on the wall and raise it vertically (**Fig.12**). You will notice I have edited the section where the walkway adjoins the building using the Line and Eraser tools so that this was not raised along with the outer wall.

THREE DIMENSIONS

When a shape has been converted into 3D it can be edited further by using a combination of the Line and Push/Pull tools. If you move the Line tool along an edge it will snap to the midpoint between opposing edges (**Fig.13**). You can then make equally spaced cuts, as shown. These new shapes can be pushed inward or pulled outward, or alternatively a new shape can be drawn and this can then be manipulated.

In **Fig.14** I have used the Offset tool to create a window shape in the far left rectangle. To create the same proportioned window in the other sections simply select the Offset tool and double-click in each rectangle. To create the arches use the Arc tool and then erase the horizontal join shown by the dotted line. To create windows use the Push/Pull tool to move the shapes inwards beyond the inner wall surface or until they disappear.

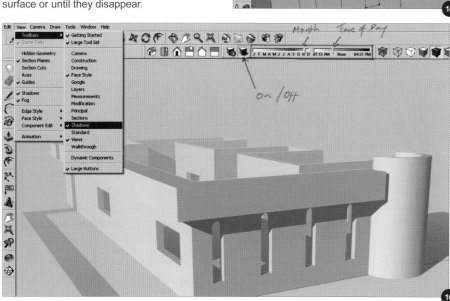

Using a combination of the tools mentioned so far you will have the means through which to create and edit a wide range of forms and design detailed scenes.

ATMOSPHERICS & LIGHTING

You can add atmospheric perspective in the form of fog to your scene. Go to View and check Fog, as seen in **Fig.15**. You will notice that the edges on my building have also been switched off, which you can control in the menu under Edge Style > Display Edges.

To add lighting effects check Shadows which is above the Fog label, and to get more control

over this function go to View > Toolbars > Shadows. This will place two slider bars on your toolbar which denote the month and time of day. By adjusting these you can control the position of the sun and direction of the shadows (**Fig.16**). There is a little icon to switch the lighting on or off, and besides this there is also another icon which opens up some extra parameters that alter the tonal range of the shading. You can also control whether this affects just the object itself or the ground along with it and vice versa.

ADDITIONAL TOOLS

A few other useful tools worth mentioning are the Tape Measure, Protractor and Dimension. The Tape Measure is used to draw guidelines which can then be traced over with the Line tool. In **Fig.17** you can see that the tape measure has created the dotted lines which can be used as a guide to draw the windows an equal distance from the top and bottom of the block. To delete the lines simply use the Eraser tool. The Protractor is used to create accurate angles. Move the tool to the point at which you wish to start the angle and you will see how it snaps to the three axes. Click to establish the correct plane and then click to begin the angle along the appropriate edge. Now you can set the angle using the guideline. In **Fig.18** I have used the near corner as the starting point, which I will mirror on the opposite corner.

Once the guidelines are drawn, trace them using the Line tool, as with the Tape Measure. In **Fig.19** you can see that the two angles have been drawn and then the Push/Pull tool was used to extrude a roof shape across the base block.

The Dimension tool simply adds a label to your scene, showing the distance between two

points. Click and drag from A to B and then drag up or down to set your dimensions, once again using the Eraser tool to delete when necessary (**Fig.20**).

CAMERAS

The camera in SketchUp is initially placed at an average eye level height, so for example when you click on the Position Camera tool it will zoom in and appear around head height from the ground. In this sense scale is an important factor in your scene.

In **Fig.21** you can see a cross where I intend to position the camera, after which the viewpoint will resemble the inset image. The character has been placed in the scene to demonstrate the relationship between the scale of a character and the initial camera height. To adjust your camera, use the Look Around tool represented by the eye icon.

One final tool which may prove useful is the Section Plane tool which allows a view of a cross-section of your object. To use this click on the tool and then align the green icon to the corresponding plane or angle you wish to view. Then select the Move tool and click on one of the corner arrows and drag in the relevant direction (**Fig.22**).

This concludes our overview which I hope has at least introduced the main tools and their functions. There are of course further lessons to learn along with other tools and techniques, such as applying materials, but the main aim here is to introduce the interface and value of the software in terms of building a simple 3D environment which can then be used in digital painting.

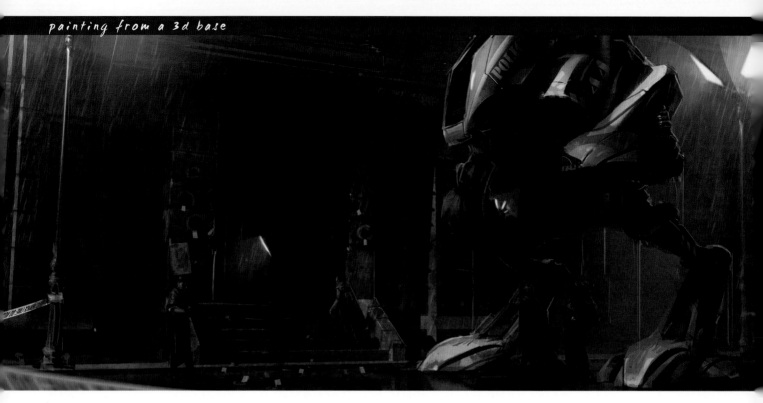

SCI-FI ROBOT
BY CARLOS CABRERA
SOFTWARE USED: PHOTOSHOP, GOOGLE SKETCHUP

INTRODUCTION

In this workshop we're going to be working on a speed painting using base geometry created in the free software, Google SketchUp – nothing too detailed, just a couple of boxes as buildings, and a simple robot creation (created using Google SketchUp).

SKETCHUP

SketchUp Render One

We have two SketchUp renders to start working with. The first one is a base render with the edges turned on (**Fig.01**); this image will be perfect to use to check our perspective lines, buildings and robot shapes over the top

of our painting later on. I can also use the little guy close to the robot's leg, in this case, to help me with understanding the proportions and scale in the scene.

Concept, Mood and Color

The next step is to use your imagination; you have to elaborate in your mind the mood of the painting you are about to work on. In my case, I've envisioned a sci-fi scene like the ones we used to see in the cinema back in the 80s. I

love old sci-fi movies so I've decided to paint something with predominately cold colors, with just simple touches of warm colors.

So, that is my palette and my mood for this illustration defined. Now onto the second render before we start painting.

SketchUp Render Two

For my second render (**Fig.02**), I took away the edges and added more contrast to the image;

you can see how the shadows pop up a bit more and the middle gray appears between the shadows and highlights.

PHOTOSHOP

Add Color!

Now it's time to add some color to our painting, so open up the image in Photoshop (or your favorite painting software) and add two new layers. Fill these layers with cold and warm colors. I fill the first layer with a blue (cold) and the second layer with a brown or sepia tone (warm).

The cold layer is going to be our shadow color. How do we do this? Well it's quite simple: we set the layer blending mode to Overlay and slide the Opacity value to 62%. The shadows become blue with this blending mode, but the highlights remain white.

Next, set the warm color layer to Darken mode, and set the Opacity to 86%. The highlights should now be sepia, but we can still keep the cold shadows (**Fig.03**).

Textures and Perspective

Now that we have our base color implemented, it's time to add some detail. Have a look in your personal texture library for a couple of photos of buildings. I've chosen some free photos from a free online texture library for this piece, because the day I started this tutorial

there was a huge riot in the streets of Buenos Aires and I couldn't take my camera out to grab any textures of my own. It's a great idea though to get out of your "art cave", and go and take some photos of the buildings in your neighborhood for your very own personal references.

With these images we can texture our background. Add each one of these images to a separate layer and set the layer blending mode for each one to Overlay. Play with the Opacity value to mix the buildings with the

building textures with the original SketchUp render. When you switch the layer on with the edges shown on the SketchUp render (SketchUp Render One), the edges will help you to find the correct perspective.

Use the Transform tool (Ctrl + T) to set the correct perspective of the photos; you will see how easily the background will become more and more a part of the final illustration at this stage. Once you've finished with the Transform tool you should have something similar to **Fig.04**. Remember that up until this stage, we've only laid down some textures over our SketchUp render, so we still have all the fun part left to work on: the painting!

Do you see how our painting still keeps the base colors we applied before – the blue and sepia colors? That's the idea of the first step: create the base of our scene to work quietly on the mood, characters and fine detail.

Illustrating the Mood

Now it's time to start working with the mood of the painting. Paint in a couple of streetlights – nothing complicated, just a dark silhouette of a streetlamp. For this step you can pick the color you have in the background to paint your streetlight; I usually use this technique to keep the color gamma balanced without any strange colors coming in.

Use references from sci-fi movies if you want to add a nice touch to the illustration. I'm using the design of some lights featured in a classic movie, maybe one of the best sci-fi movies of all time – do you know which movie it is?

I add another layer for the light halo effect and set the blending mode of the layer to Color Dodge. Never set the Opacity to 100%, try to mix every layer with your background image!

To add a story to this image I've decided to paint with a paintbrush a couple of bullet holes in the walls, to show that a horrible crime must have happened there, or maybe even a gang war of some kind. So now we have a non-textured police robot, some bullets holes, and a nighttime street scene (**Fig.05**) – the perfect mood for our sci-fi image!

The Robot

Time to paint our robot now! With the Lasso tool and the Elliptical Marquee tool, we can start to add shapes to our robot design. Make a selection with these tools and paint with a soft brush (with the Pen Pressure set to Opacity)

inside the shapes. This technique takes some practice to get right, but you'll find it really useful for speed paintings or concept artwork. Use the base 3D model to check the perspective and the shape of the robot; as you can see I'm using the same background palette to keep picking those colors for the robot

(**Fig.06**). The body of the robot is smoother than the 3D model, as I've decided to use curved shapes instead. I want to take my time with this bad boy, working it section by section until I'm happy with the outcome. I also send some layers to the trash can at this stage until I really nail the final design of my robot!

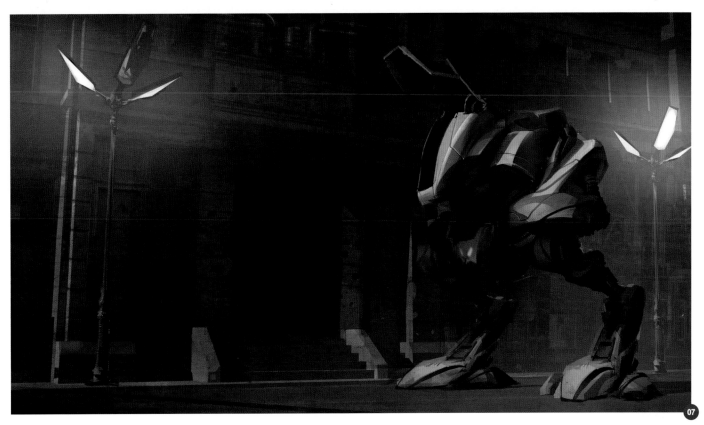

I keep working on the body and start on the front leg. Remember: during this step I'm just using the Lasso tool and Marquee tools with a soft brush to paint inside the selections. The back leg is a copy of the front leg, only I "deform" the shape using the Transform tool until it snaps the correct position of the new leg. Once happy with the body and the legs, I'll continue with the fine detail (**Fig.07**).

Details

On a new layer now I add the POLICE text and the robot's identification number, following the shape of the robot using the Warp tool (**Fig.08**). This is one of the most useful tools in Photoshop!

The last step is to throw some life into the painting, so I'm going to paint some cops looking for clues in the crime scene; one of the policemen is showing his partner the robot (as if it were a car) (**Fig.09**).

With my rain brush I paint on another new layer a rain texture, just over the streetlights (**Fig.10**).

And that's all folks! Here is the final painting (**Fig.11**).

Painting is easy if you know exactly what you want to achieve with it, so keep up the practice – do it every day (I know I do).

You can download a custom brush (ABR) file to accompany this tutorial from: **www.3dtotal. com/dptresources**, along with the base images created using Google SketchUp. These brushes have been created using Photoshop CS3.

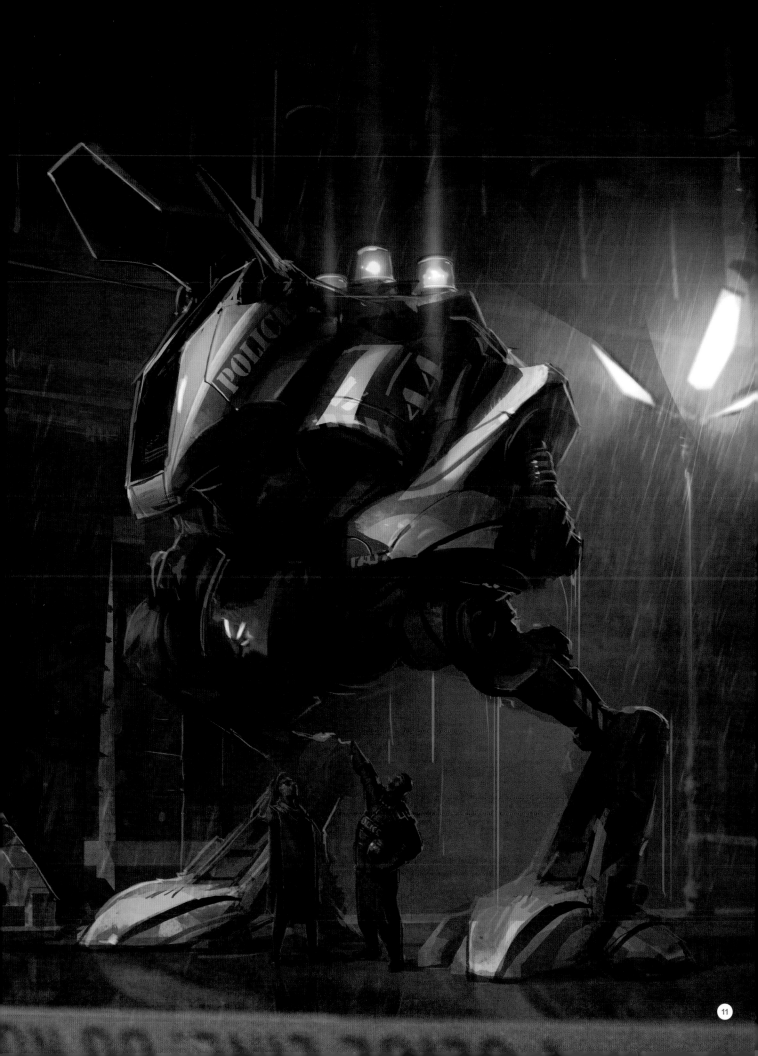

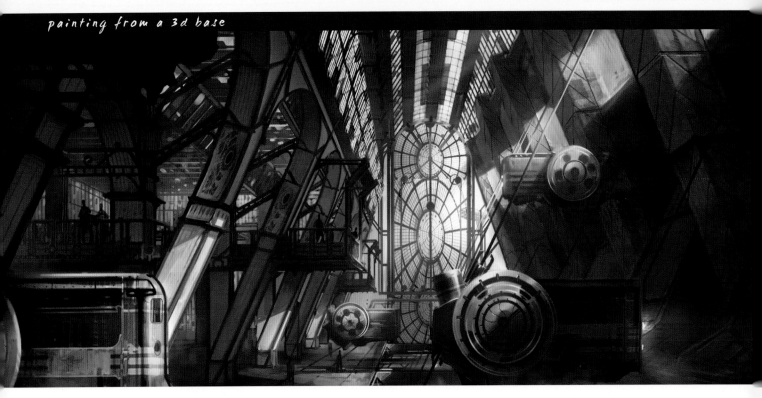

TRAIN DEPOT
BY IOAN DUMITRESCU

SOFTWARE USED: PHOTOSHOP, GOOGLE SKETCHUP

INTRODUCTION

It's always a good idea when creating concept art or illustrations for games, movies and the like, to use whatever means and methods necessary to make your artwork quickly and easily. In the case of this tutorial I will be using a simple 3D base which I'll create in Google SketchUp as a mockup for a Photoshop painting.

GOOGLE SKETCHUP

I start with a simple idea in the back of my mind of a sort of train depot where locomotives are traveling in and out, loading cargo, and transporting people. So to get things moving, in Google SketchUp I begin by building some simple platforms as a starting point (**Fig.01**). I choose a simple profile shape and then extrude

it. I copy the profile section and mirror it so that it's not too far away from the first one. I can then create the intersections, which I imagine to look like strong beams which the locomotives might use to get across to the other side.

I use the Rectangle tool and start making lapped boxes which I will then extrude with the Push tool. After making one section of the beam, I multiply it and move it onto the first mirrored deck. I then make double pillars with a diagonal metal element for the structure above

and in-between them, so that I can give my future painting a believable, industrial look. The other diagonal beams coming from these pillars will sustain the bridged sections. All shapes are created with the Rectangle tool or the Line tool, which can create planes and volumes if used in three-dimension.

On the left side I want to mirror the diagonal feeling from the right side, so I firstly make some pillars, and then create walls for each pair of pillars (**Fig.02**). I play around a bit here with the silhouette of the structure, just to

spice things up a little. When happy, I go on to create a series of open and closed spaces between each wall, for the locomotives, people, and cargo to all pass through – all done using the Rectangle tool. I also create a low ceiling above each of the passageways and close the middle part of the three sections of the wall. On the right part I pull the pillars up to the next floor and add decks for potential people passing through. I also make some intersecting platforms between the left and right structures whilst thinking about accommodating possible functions within a train depot.

To finish off the 3D part of the work in Google SketchUp, I make sure I enable the three-colored Axes under the View menu, select Face Style > Monochrome, and go to the Window menu where I select Styles > Default Styles > Engineering Style. For the Camera setup I choose Perspective from the drop-down menu. I then rotate the scene, searching for some cool viewpoints. When ready I can

then export my chosen view by going to File > Export > 2D Graphic (**Fig.03**).

The cool thing about this 3D scene is that I can always go back and add new levels or find new points of view if I want to make some changes! I export about 10 scenes from Google

SketchUp so I can choose my favorite from those. I decide on a somewhat central perspective for its balance, strong diagonal lines, perspective, and focus (**Fig.03**).

PHOTOSHOP

I take the Google SketchUp scene into Photoshop now where I can start sketching on top of it, on a new layer, to try out some ideas (**Fig.04**). While I was making the 3D image I was already thinking about locomotives, metal arches, cables, glass façades and so on, so here I can start to build these ideas on top of the 3D render. I also decide to widen the frame to give the scene a more cinematic look that I'm trying to achieve with this image.

I never repeat the same process in my images, and it was no different for this image. I start out in black and white to establish my general values, and then add color to the image with Overlay and Color layers (**Fig.05**).

From this point on I start to define the arches and pillars. For contrast I use a white wood material for the pillars and arches on the right-hand side, with a green metal to achieve a more industrial, steampunk look to them (**Fig.06**).

Right now I'm pretty sure of where I'm heading with this image, so I bring in a couple of textures now for the huge stone pillars on the left and for the locomotive in the foreground. I make a few Levels and Color Balance tweaks to get them into place, and then start

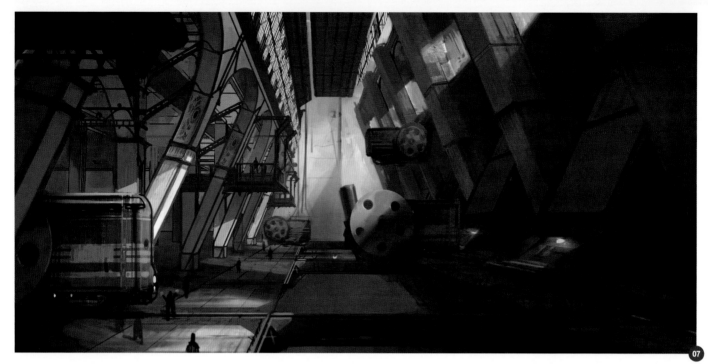

painting on top of them. It's good to have as much texture as possible from the start which matches the kind of look you want, just to give you a good base to build upon. It's also important to decide on your lighting scheme from the start, too. I want a dramatic sunset lighting scenario, coming in from the left of the scene, to get that gold, steampunk feeling across. I knew from the beginning that this kind of lighting would define the space better

between the pillars and give some interesting shadows that fall upon the bottom deck and on the locomotives.

I keep refining the shapes on the right-hand side and bring in some of the white from the left-hand side just to encourage the eye to travel from one to the other. The space at the top of the image is a little disturbing for me though as it's allowing the eye to slip from

the frame, so I'm going to go with a classic steampunk/industrial theme here and add a glass and metal rooftop to my station scene. To do this I paint lots of straight lines on a separate layer and then simply put them in the correct perspective. To stop the eye getting tired from all those lines, I add some colored patches of glass for contrast and interest (**Fig.07**).

Quick Tip: Remember to flip your image from time to time to help you spot mistakes or disturbing areas. People often make fun of me, saying, "You rotated it *again*!" But that's just because, composition-wise, I only decide just before the final save as to which way it looks best.

I add some balconies between the pillars to give it a more familiar look and to add some depth. This also makes the viewer wonder about what actually happens there; whether there are offices or just passageways up there. The next step is to finish the background (which is bugging me). I decide to go for a look similar to old train stations and create a huge, intricate façade of metal and glass, which fills a great space within the frame (**Fig.08**).

I begin to give atmosphere to the image about halfway through the painting process – any earlier and it would have distracted me, and I

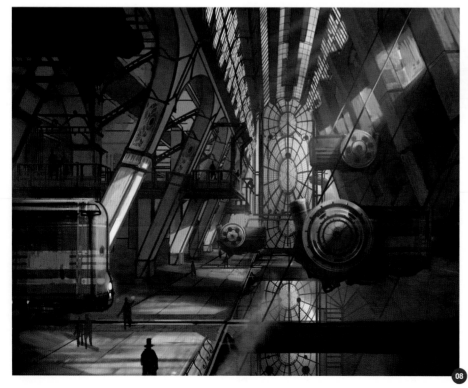

wouldn't want to leave it any later just in case it doesn't fit as well as I imagine it to.

With all these steam-driven machines it was easy to add atmosphere into the scene. It also helps with the depth and the overall way in which the image is read. To add smoke and steam, I usually use a standard soft brush with texture applied, or alternatively the Chalk brush. Generally in my artwork, I use a round brush, the Chalk brush and a soft brush, alongside a few texture brushes which I've collected over the years.

Those huge wheels attached to the locomotives which are pulling the locomotives along those cables (think in terms of cable cars) were under-detailed. So to bring them up to par with the scene, I paint them in whilst thinking of the mechanics of a clock or watch. I found using a Dodge layer very useful to get some stronger highlights on the metal and in highlighted areas.

For the interior of the arched structure I've already decided on a glass roof and walls, so I paint those in, keeping in mind the saturation levels and making sure everything is nice and atmospheric. This helps to punch the image away from the dullness it was in before, before going on and adding the final details and making everything more cohesive (**Fig.09**).

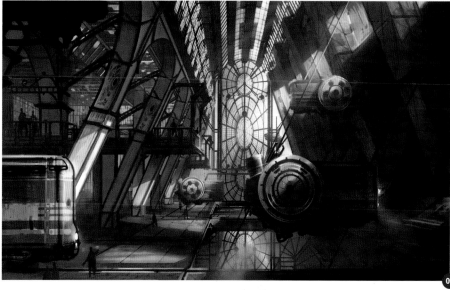

It's not our prerogative to stick to the 3D image that we started with, which is the beauty of experimentation. I haven't followed the original base scene with the pillars on the right; now, between two stone pillars stand some kind of hangars – or perhaps they're just spaces for cargo to be deposited and such? Between those and the pillars are passages for people to pass through. The pillars were a little too plain and so I add some sort of engraved pattern to them to further define them. I also paint some graphics on the cargo bay areas between the pillars to help them "pop-out" more (**Fig.10**).

Because of the lighting scheme I am able to show where the locomotives are going to pass between the pillars and out of the depot; this gives more functionality to the space.

I love scattering human figures around an image: doing the dirty jobs like cleaning pipes or the furnace of a locomotive, or perhaps directing passengers into a building; maybe they're just standing around chatting or laughing about something we have no idea about… They are also great for giving scale to a scene. When people look at an image they will look for human figures to give them a sense of scale of the space.

With a few more smoke trails and steam, some light fixtures on the front of the locomotives, and some more detail on the foreground decks – all those rivets, slabs, stains, etc. – the image can be called "done" (**Fig.11**).

I hope I have been able to get the main ideas behind this image across to you, as well as the techniques involved, and that it will all be useful for your own art creation in the future. Thanks for reading!

You can download a base (JPG) image created using Google SketchUp to accompany this tutorial from: **www.3dtotal.com/ dptresources.**

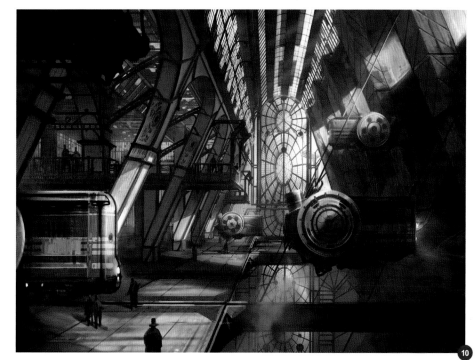

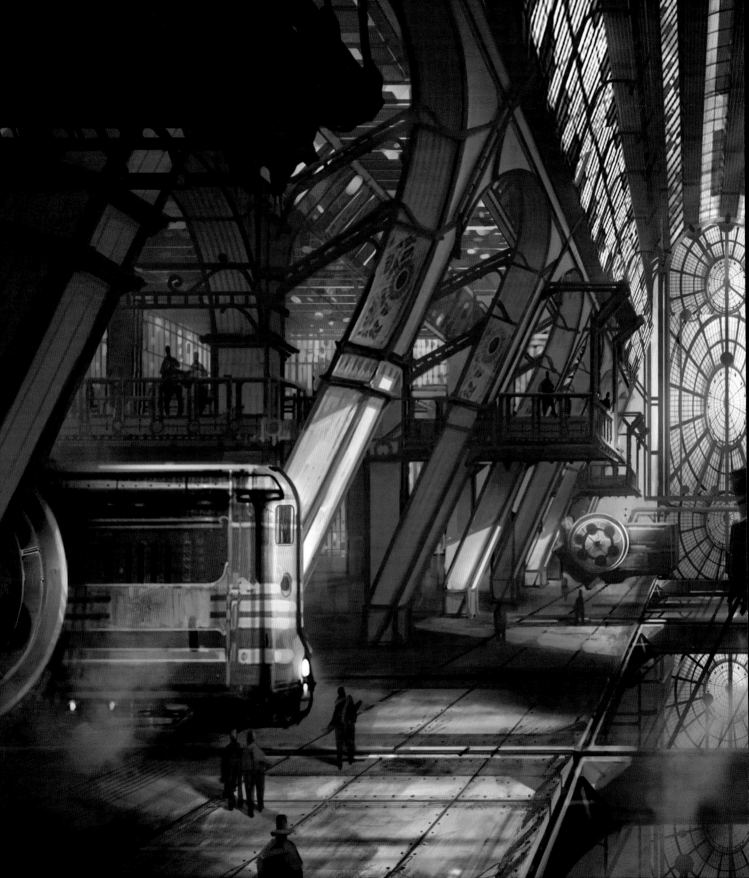

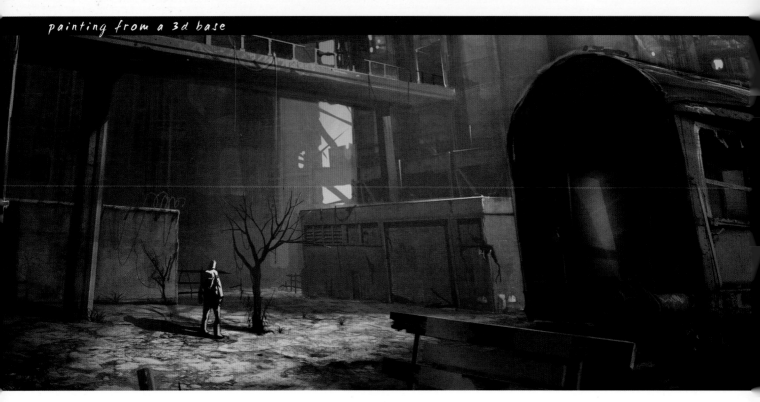

ABANDONED FACTORY
BY SERG SOULEIMAN
SOFTWARE USED: PHOTOSHOP, GOOGLE SKETCHUP

I start out with a simple 3D block-in using Google SketchUp, setting the camera to an extreme angle to give it more depth. After exporting the 3D model as a jpeg, I open it up in Photoshop and resize it to around 150-200 dpi (**Fig.01**).

In Photoshop I then create two new layers for the left and right vanishing points. With the use of the Line tool, set to Fill Pixels (**Fig.02**), I find the vanishing points of the architecture.

To find the vanishing points of the architecture, you first of all need to find your horizon line. The horizon line is basically your eyelevel in the image, or of what you're looking at. In my image I've left a little gap between the two cylinders to make this quicker for the eye to find.

This is where the Rulers come in handy: press Ctrl + R to turn them on and off. With the Rulers turned on, click-and-drag on the top ruler guide to pull down a line guide onto the horizon line (**Fig.03**).

With the horizon line now marked out, you need to find where your two vanishing points

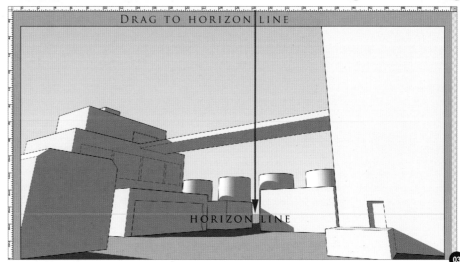

DRAG TO HORIZON LINE

HORIZON LINE

will fall. To do this, use the Line tool and follow along one corner of the structure. Where your line meets the horizon line is your right-hand vanishing point. Mark this with a vertical ruler guide (**Fig.04**).

The same thing goes for the left vanishing point – in my image this one is off the canvas. To find it, you need to zoom out and find where your Line tool meets the horizon line (**Fig.05**).

Now that you have your two vanishing points, use the same Line tool to draw lines radiating from the left vanishing point (**Fig.06** – shown in red), and the right vanishing point (shown in green). Each vanishing point needs to be on its own layer.

The next step is to block in the shadowed sides with red using the Selection tool and filling them on a separate layer. Do the same with the side that is facing the light, also on its own layer (**Fig.07**). I've used these specific colors just because it's easier to see them, and when

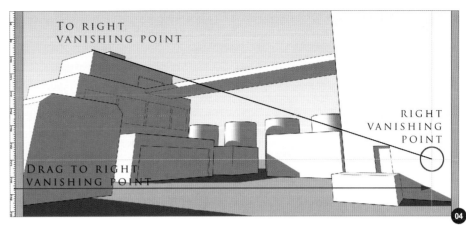

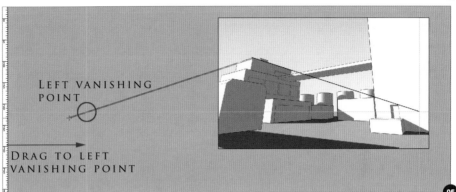

I need to select a side I can simply hold Ctrl and click the layer for an instant selection.

I now have five layers: the 3D base image, two layers for the vanishing points, and two for the shadowed/light-facing sides (**Fig.08**).

I hide all the layers here, except for the two vanishing point ones. On a new layer I then start sketching in some ideas (**Fig.09**). At this point it's a good idea to start thinking and looking for some textures to use, (**tip**: check out 3DTotal's new free texture and reference image library for royalty-free textures: **http://freetextures.3dtotal.com**).

I hide the sketch layer, and on a new layer set to Color I lay down some basic color and

texture with a textured brush, just to get rid of those grays and to start setting the mood of the piece (**Fig.10**).

After gathering textures it's a good idea to then resize them to keep a sense of scale; for example, you'll need to ensure that the windows and doors of a texture are not too small – or too big! – for your scene, always avoid making bricks look like they're about five feet long!

So I'm starting to lay down the textures on the building surfaces now, using the Transform tool (Ctrl + T). Right-click and set it to Distort (**Fig.11**).

I now want to place the texture on the surface and pull the corners of it to fit my vanishing points (**Fig.12**).

I continue to lay down textures on the rest of the buildings now, still using the Transform tool to fit them in the correct perspective. I'm also using a rock-textured brush over the textures to unify them (**Fig.13**). I'm trying not to worry about painting over my textures; they can always be reapplied or replaced if necessary.

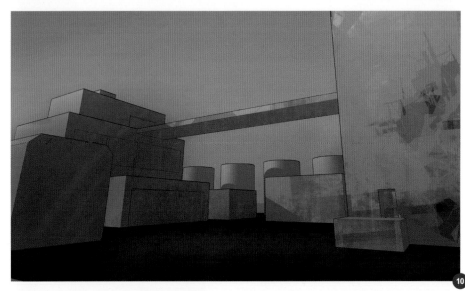

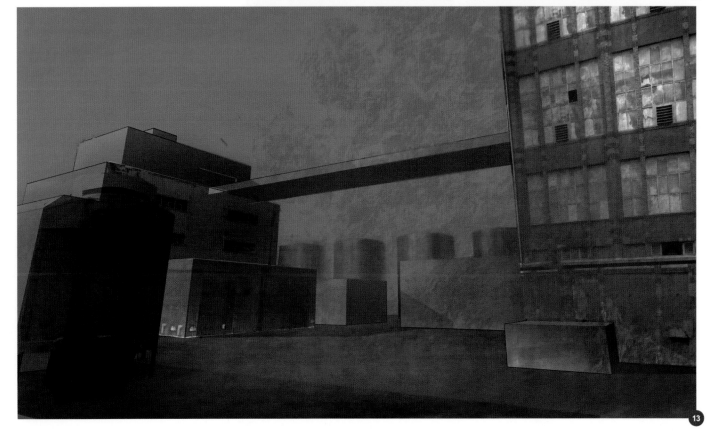

With most of the texture down now, I can start to add more color with the help of a new Color layer. I flip and re-crop the image here to take a little off the left and bring more of the train on the right into view (**Fig.14**). I've found a texture which is very useful for the old train; and while looking for the train texture I also came across a great factory reference image which I have decided to incorporate into my background. I've had to adjust the factory to fit the vertical vanishing point using the Transform tool.

I flip the image, and on a new layer I add some atmospheric fog over the distant factory buildings, as well as applying a few other textures to the walls and ground to bring out more detail (**Fig.15 – 16**).

In the final steps now, I add some haze to the image, along with the kind of light ray you might see coming through the clouds on a cloudy day when the sun is strong! I have done this by simply adding a new layer, painting in my ray of light with a large soft brush, and setting the layer to Screen or Overlay to achieve the right effect (**Fig.17**). This little trick adds more intensity to the focal area!

I tend to flatten the image at this point so I don't get overwhelmed with all the layers. It also helps to make it feel like everything is coming together. And with the image flattened, I can now go in and add detail on a new layer. I'm pretty happy with the right side of the image, but I find the left to be lacking in variation, so I darken the entire wall on the left with the Burn

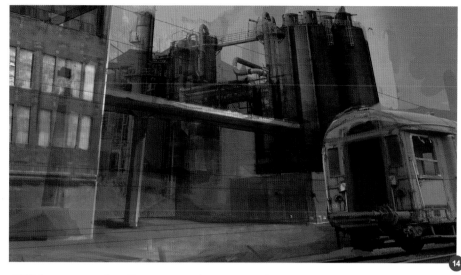

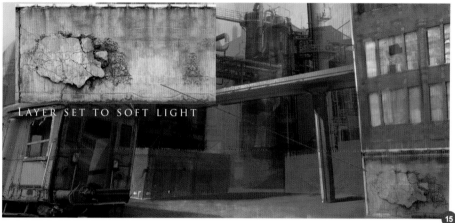

LAYER SET TO SOFT LIGHT

tool, and add some additional broken glass, as well as lightening up the windows. This all helps to balance the image, with the train on the right, and the building on the left (**Fig.18**).

At this stage, it's all about how much detail you want to put in; you can keep adding textures

or painting until you're content with how things look and want to call it done. I'm happy with how things are working with this image now, so I'm calling it "final" and leaving it there. Thanks for reading!

You can download a base (JPG) image created using Google SketchUp to accompany this tutorial from: **www.3dtotal.com/ dptresources.**

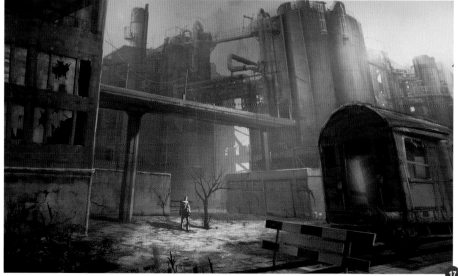

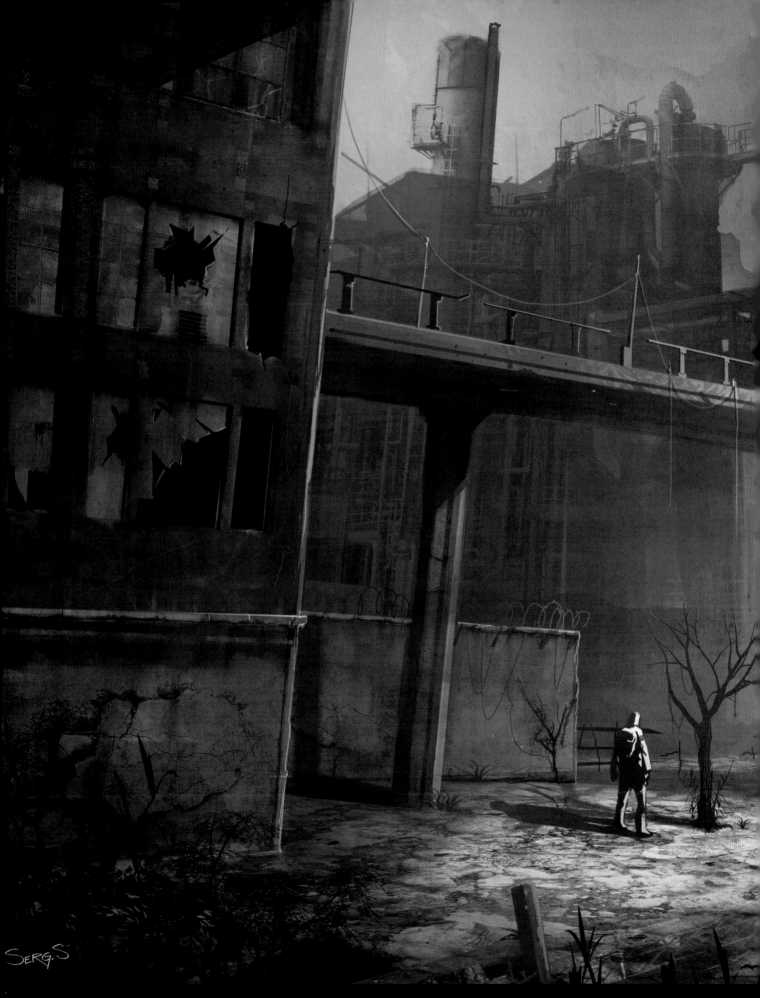

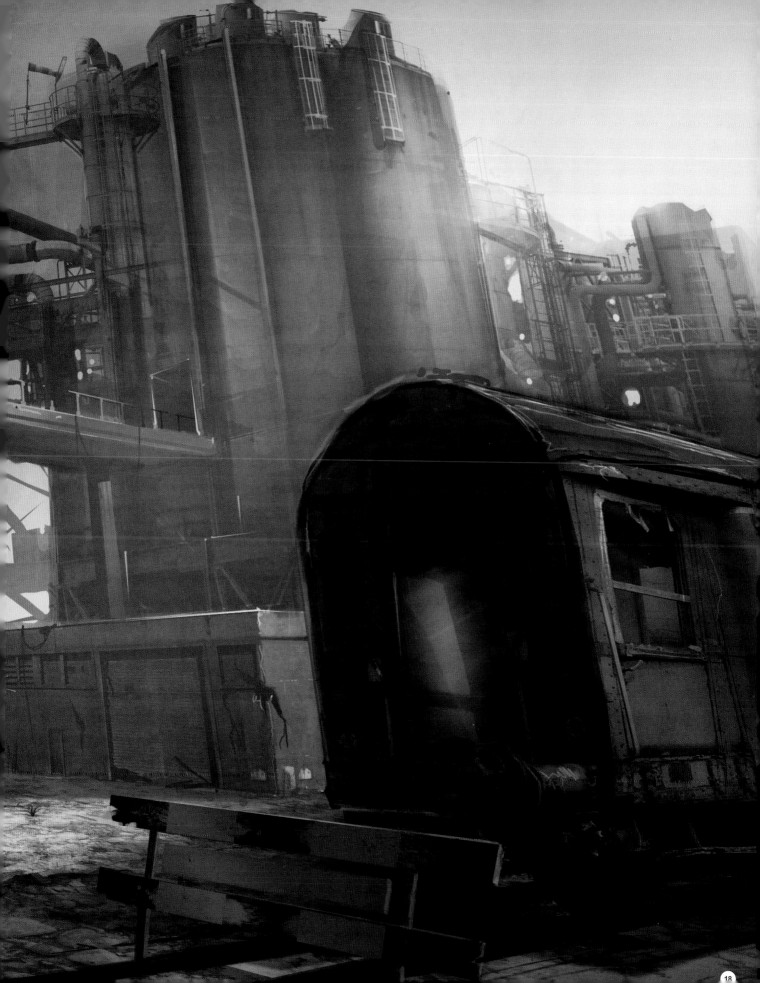

complete projects

As a painter who has not been able to create a personal piece for years now, I took an opportunity to create this piece in my own time. Of course settling on a character instead of a more complex composition was inevitable since I could only spare one day for this work.

Although GI Joe was not a list-topper among my childhood influences, I have to say that I've always found the Snake Eyes character pretty cool. That is how I chose my character for this piece, and then I immediately went ahead and started the reference search. For the character itself, I used one of my Snake Eyes action figures. I do not need to tell you how much time it ended up saving me since the whole thing took 8 hours to finish. In this chapter these artists show us the process they use to create their excellent pieces of art.

KEREM BEYIT
kerembeyit@hotmail.com
http://www.theartofkerembeyit.com

THE MAKING OF "THE BEAST"
BY JAMA JURABAEV

SOFTWARE USED: PHOTOSHOP

OVERVIEW

During one of those ordinary after work evenings, I was sketching some character thumbnails, one after another.

I like to explore new shapes and forms, and to generate something I've never created before. Speaking in general, I manage to capture interesting ideas when I don't restrict myself to anything specific. I find that I am most creative when I have no idea what I am going to create.

Frankly speaking, characters are the most difficult thing for me to draw. I feel more confident drawing environments, but I knew that if I struggle on with the characters I would develop my concept art skills. And I hardly ever give up!

PRODUCTION

So usually, I quickly drop some silhouettes on a blank canvas (**Fig.01**). I like to work with the silhouettes, because silhouettes allow me to concentrate more on the design, than on technical issues such as shadows, highlights, color etc.

01

My main production tool is Photoshop, but I would advise Alchemy to those who are interested in concept-art. It is excellent software for producing interesting shapes that could be used in order to create characters, landscapes, vehicles or whatever one needs.

I have my own set of brushes for Photoshop, though I only use few of them during thumbnailing.

Actually there is no best brush for painting it is all up to the artist. In this painting I used only one brush. I would suggest using the brush that suits your style and your needs.

Some people create masterpieces with a one pixel round brush, and some spend too much time searching for magical brushes in Photoshop. Don`t waste your time just draw as much as you can.

Whilst working in Photoshop I find that the Tool Preset menu is more useful than the right-click brush menu (Fig.02). The right-click menu only saves the brushes, but the Tool Preset menu allows me to save the presets of that specific tool, such as Painting mode, Opacity and Flow. Also the Tool Preset menu simply saves me time; instead of right-clicking and searching through the brushes on the list, I simply select them from the Tool Preset menu that is constantly open on the right side of my screen.

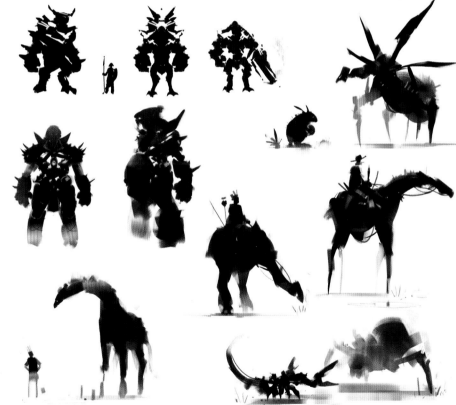

Using a chalky brush I created a dozen of quick thumbnails (Fig.03), the beast with the belly looked interesting to me, so I decided to detail it.

Before detailing the character I wanted to set-up the composition of the whole picture. So using the wide brush strokes I defined the composition and the space around the character. I wanted a simple foggy environment in order to help me concentrate more on the design of the beast itself (Fig.04).

After setting up the whole scene, I created a layer in an overlay mode and introduced some of the colors (Fig.05).

My personal preference is a realistic style of painting. Moreover, I love cinematic scenes. To check if my colors are consistent, I constantly squint in order to see if the color works.

After I had finished laying down the main colors, I started to detail the character. I wanted him to look semi-organic. It seems I am still under the influence of my Quake II adventures, so I created some sort of armor around his chest and head (**Fig.06**).

It may sound weird, but I enjoyed working on the grass more than detailing the character itself. I also added some particles flying in the air in order to reinforce the atmosphere.

POST PRODUCTION

As stated before, I love photorealistic and cinematic stuff, so I can't help myself but add some cinematic effects after the painting is done.

> **Quick Tip:** It is important to understand the main principles of photography. Most of the time one can notice that blurring occurs as you go away from a focal point, so in order to show that, I used the 1 pixel Radial (zoom) Blur.

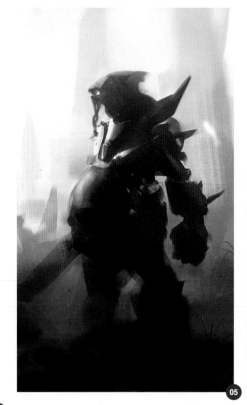
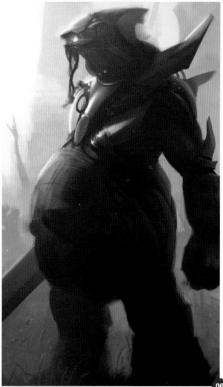

Another trick is in my use of a chromatic aberration. It looks like a shift of the RGB channels, and adds a bit more of the realism to my pictures. Chromatic aberration is used a lot by 3D artists in order to simulate photorealistic effects. I use the Digital Film Effects plug-in for Photoshop for this (**Fig.07**).

And the last thing I use in my art is grain. To fake the photography grain, I created a gray layer, applied noise to it, and then blurred the noise (Gaussian Blur – 1px). I then set it up to Overlay mode.

And here it goes (**Fig.08**).

CONCLUSION

Being self-taught, it was a very serious challenge for me to grow as an artist. I live and work in Tajikistan, a country that has no CG art schools, no cinemas and no modern entertainment. But I never gave up, because what I need for painting is in my head and heart.

I love painting - that is where my heart is. The rest is in my head, so watch movies, play games, read books, travel and enjoy life. Everything can be inspiration for you drawings.

My characters say "thanks" for your attention.

You can download a custom brush (TPL) file to accompany this tutorial from: **www.3dtotal.com/dptresources**. These brushes have been created using Photoshop CS4

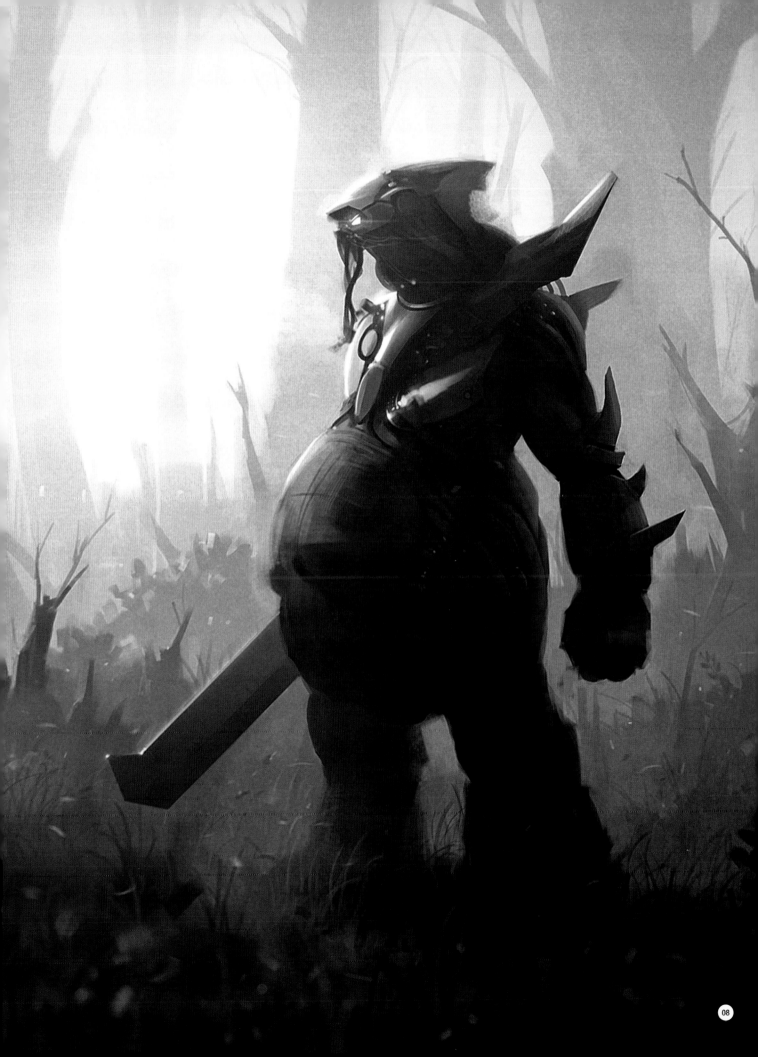

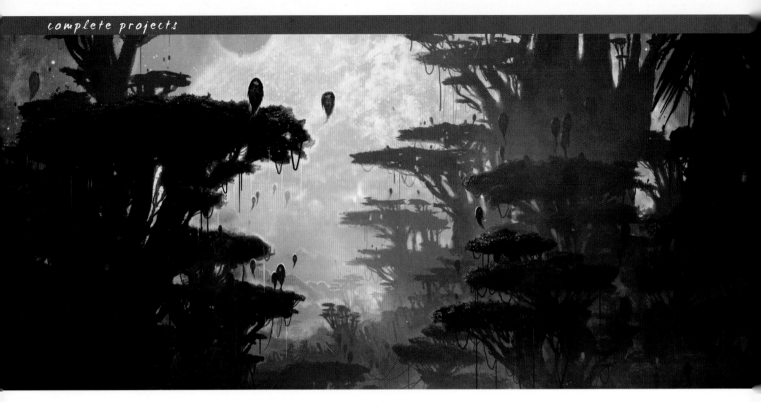

THE MAKING OF "HOT HOUSE"
BY KENICHIRO TOMIYASU

SOFTWARE USED: PHOTOSHOP

This scene portrays the last day on earth in a far-off future, as the sun is over expanding and going nova. Global warming has reached its final stage and has overrun the Earth, transforming its surface to a completely different terrain. This new environment has created trees several kilometers high with flora nearly reaching into the stratosphere. An aggressive genus of ivy now climbs over all the other large plants. Airborne social and sentient plant life have replaced flocks of birds with broods of floating flora. Their floating bodies are mobilized by the lighter than air gas within them. A circulation system of tree sap flows over the terrain from tree to tree, creating a biologically interconnected forest. This sap has replaced water and where there were once waterfalls, now exist running falls of sap.

When I was drawing this, The Last Day on Earth is what I had in mind. Until now there have been many portrayals of The Last Day on Earth but I wanted to do something in which Earth was covered by huge plants. I wanted to create a sense of irony in which the future of Earth looks how it was when it was first conceived. I imagined the Earth would have extremely humid and heavy air, forested with

huge ancient plants, looking quite like the Earth hundreds of millions of years ago. I hope this painting conveys the image of a far and distant future.

First I sketched out an image of what I had in mind. I imagined a place with big trees, an enormous sun and a surface covered by ivy, plants and other greens. Keeping perspective and color concept in mind I created my starting point (**Fig.01**).

I usually start from the background as I feel that it is more efficient working out from the background. I usually use default Photoshop brushes. Keeping composition in mind, I worked on portraying the trees as being huge and massive (**Fig.02**).

I continued this process, and started work on the foreground. As I work I am not afraid to make compositional changes if necessary. Using photo references, I rendered and gave details to the foreground (**Fig.03**).

With repeated slight changes and tweaks I added more details (**Fig.04**). I wanted to make the bottom look dense and the sky empty, so I reduced the volume of leaves on the trees near the top.

I have 15 layers now. I merged the layers according to their depth, adjusted the

brightness and added some fog (**Fig.05**). It is important to keep the layers clean. By keeping the layers clean, it makes further progress easier, by doing this it will be easier to make changes if you need to.

In this final stage, I make slight changes to it as a whole, as well as add more details (**Fig.06**). Using a photo of the galaxy I created an enormous sun. Using the orange flare from the sun, I added tints of orange hue to the foreground to harmonize the image.

I placed significance on how the eyes would move about the image. I created a zigzag pattern for the eyes to move from the foreground to the background in this image (**Fig.07**). To do this I adjusted the brightness contrast according to depth perspective. Brightness and contrast is very important to create a convincing image.

Using these layers, I adjusted the contrast, hue and saturation respectively (**Fig.08 – 11**).

I finally added a Gradient and Noise layer to it. I put a focus on the actual distance between the objects in the image. For example, a distance of 200 pixels in the image may amount to a few kilometers in the dimension of the world I have created. It is of extreme importance to keep in mind the image has its own dimensions and scale and is not just a random 2D image (**Fig.12**).

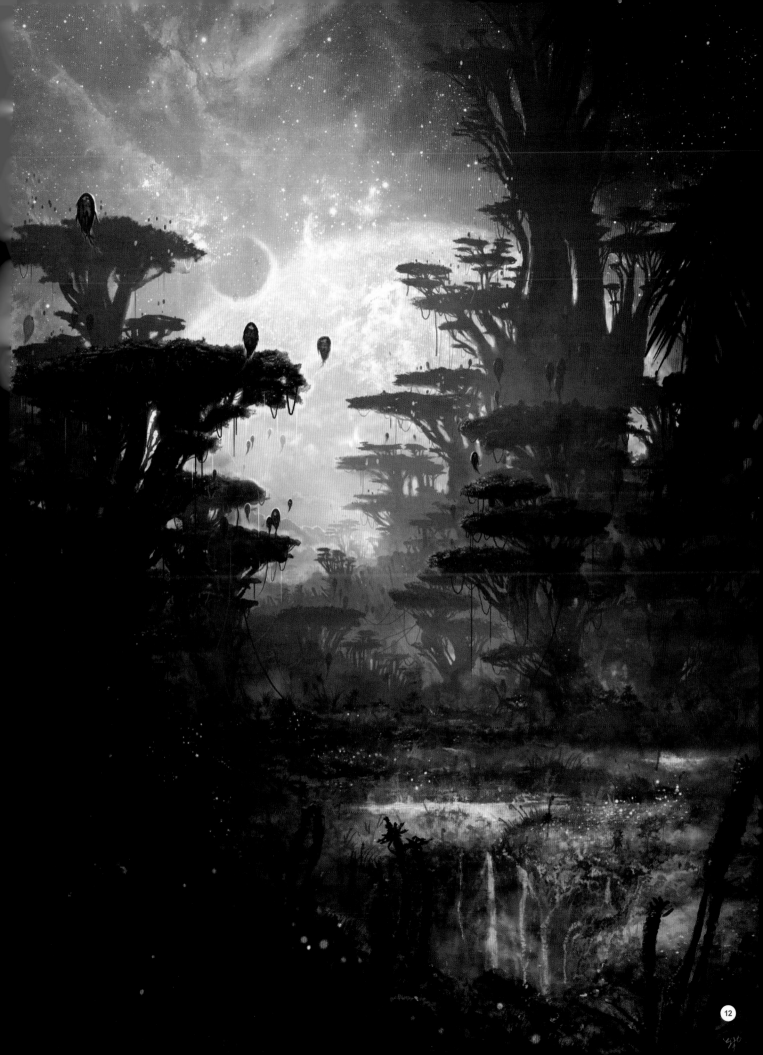

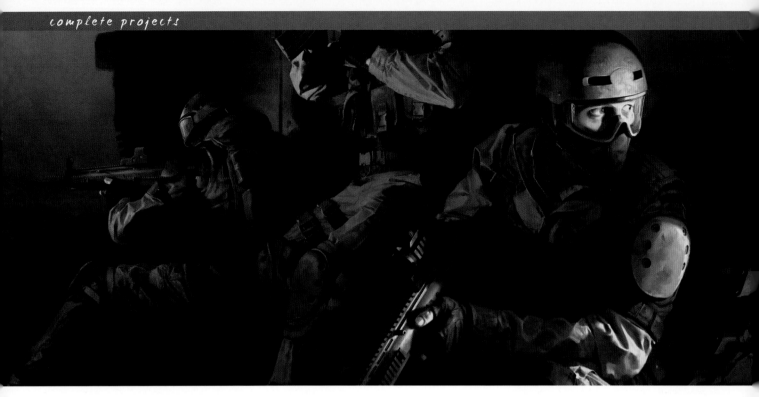

THE MAKING OF "DUST"
BY CHASE STONE

SOFTWARE USED: PHOTOSHOP

With this project the main thing I was interested in was painting an image with a dark, moody atmosphere, with much of it in shadow, and a bright spotlight to illuminate key elements. I was inspired by the work of the great Renaissance painter Caravaggio. I am intrigued by the idea of illustrating a very modern subject, in a more classical style.

I used a few different brushes in this project, but most of the time I stuck to the good old Chalk brush, with Pen Pressure on and Shape Dynamics off (**Fig.01**).

I started off with a very rough black and white sketch (**Fig.02**). When drawing the first thumbnail I don't worry about accuracy, anatomy or even composition. In the beginning, what's most important is getting the gist of the image in my head down on the paper, giving myself freedom to articulate my vision and develop new ideas. I decided I wanted the spotlight coming from the right in order to illuminate the foremost soldier's face as he looks around the corner, and also to create an air of mystery and make the viewer think, what exactly is he looking at? Initially, I wasn't sure how to pose the second soldier, but sometimes

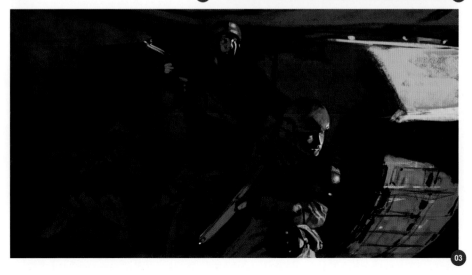

LIGHT
SOURCE 1

LIGHT SOURCE 2

04

one element helps to define another. In this case, the lighting really determined his pose for me. I knew that I wanted his edge lit by the spotlight; for that to happen, he had to be standing, peering over the side of the tank.

I started over and drew up a second, more refined sketch (**Fig.03**). I decided to adjust the angle of the rifles to make them suggest the shape of an arrow pointing toward the foremost soldier's face, to better guide the eye towards him. I giddily realized that, in doing so, I could pick up some of the spotlight on the front guy's hand and rifle (an exciting discovery). I also added a secondary light source from the left and mapped them both out (**Fig.04**).

As I continued working, I didn't deviate much from the color in my initial sketch. I decided a monochromatic look would best convey the gritty, war zone feel I was trying to get across, though in the end I wish I'd deviated just a bit more color-wise.

With the composition, lighting, and poses roughly mapped out, I began to finish the piece. For me, there are two ways to complete a project – keep things zoomed out and work on everything at once, or zoom in and

finish it section by section. I jumped into the latter perhaps a bit too early. Normally, I try to start the final rendering only after nailing down the sketch. But I still wasn't 100% sure about what I had down, and as a result each figure underwent a few variations (not without frustration) before I was finally satisfied.

The first part I began working on was the front end of the tank. I've always felt that reference material is important, but with real-world

mechanical objects, I find that reference is very important. I happened to have a model of an Abrams tank on my desk, which I lit appropriately and directly referenced (**Fig.05**). With my model as a visual guide, this section was the most straightforward to complete.

As mentioned above, the soldiers went through a few variations during the painting process. Originally, the foremost soldier was going to bend forward a bit more, with his face

05

06

uncovered (**Fig.06**). However, I wanted more
emphasis on his eyes, so I scrapped this angle
in favor of a pose that allowed for more light to
hit his face. Knowing the expression in his eyes
was the single most important element – the
key to the project's success – I got a friend to
act it out and snapped a few reference photos
(**Fig.07**). Try to use your photos as references
to simply ensure accuracy. You should strive
to avoid copying photos pixel for pixel and

07

definitely avoid tracing them. The reason behind this is that an image too dependent on photo reference can become pretty stiff. I referenced his eyes pretty closely, but painted the helmet and goggles largely from my imagination.

The second figure was the most time consuming element in the piece, mostly because I just couldn't make up my mind. His head was especially problematic; first I wanted his face uncovered (**Fig.08a**), but I found that to be too personal, so I went in the opposite direction and made him completely anonymous, covering him up with a balaclava and making his goggles opaque (**Fig.08b – c**). That made him feel too disconnected from the primary soldier, so I split the difference and made his goggles transparent and that brought things together for me (**Fig.08d**).

Soldier number three was, thankfully, fairly straightforward. He went through some variations as well, but nothing very drastic (**Fig.09**). With the three figures completed, the background fell into place rather quickly. What I wanted was simple – rubble fading away into a dusty background. The best way to paint rubble is to lay down shapes without thinking about them too much. Real rubble falls randomly, so I believe it should be painted kind of randomly too. After getting those basic shapes down a few minutes of quick noodling will wrap things up.

With everything painted I adjusted the overall brightness and contrast on adjustment layers and applied a very subtle noise grain to the whole thing just to give it a tiny bit of texture. And that's it! Hopefully this tutorial proves helpful (**Fig.10**).

CHAPTER 8

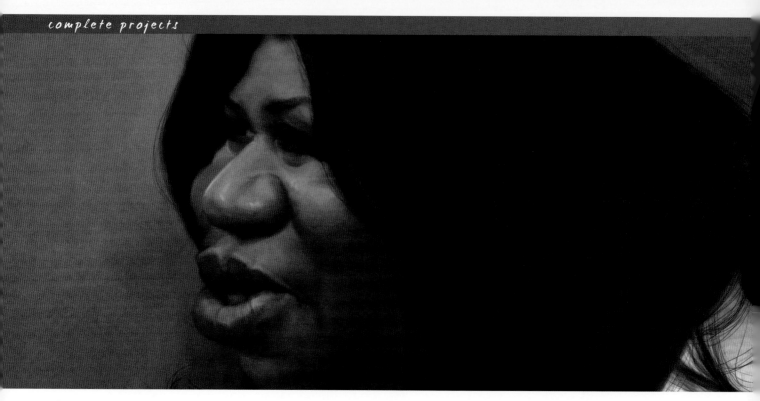

THE MAKING OF "ARETHA FRANKLIN"
BY JASON SEILER

SOFTWARE USED: PHOTOSHOP

INTRODUCTION

These are the steps I took when painting my caricature of 'Aretha Franklin'. The sketch was drawn in Photoshop (**Fig.01**), using a small round brush. For the painting I used Photoshop CS and a Wacom Cintiq; the size of the final painting is 13 inches wide by 14.5 inches high, at 300 dpi resolution.

STEP 1

After I had finished my sketch, I chose Select All and copied that layer and pasted the copy of the sketch above the background layer. I then switched to my background layer, hit Select All again and deleted the sketch from the background layer. I then selected Layer 2, which had the sketch on it, and set that layer to Multiply.

I painted in a flesh tone directly under the sketch layer so I didn't lose my sketch lines. The brush I started with was a size 13 round brush (**Fig.02 – 03**). I made sure that Other Dynamics was turned on and that the Opacity Jitter was at 0%; control was set to Pen Pressure, Flow Jitter set to 0%, and the control below the Flow Jitter was turned off. These settings gave me the control that I prefer. I

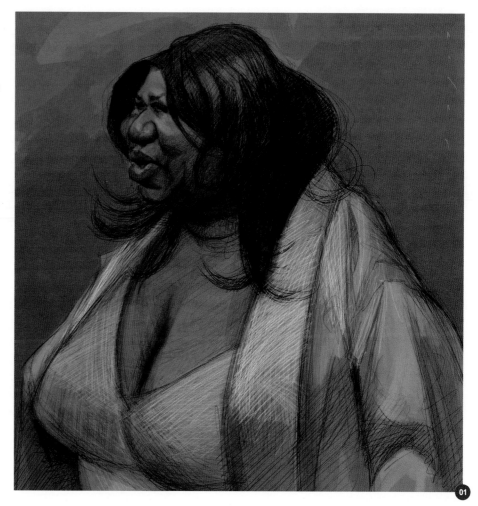

usually paint with my Opacity set to 85-90% and my Flow set to 100%, although this sometimes differs depending on effect.

I made sure that Shape Dynamics was turned off. The flesh color I chose to use in RGB mode was R: 190, G: 124, B: 104. I don't always start with this color. In fact, I rarely start with the same color twice because each subject I paint presents a new mood or feeling that I want to capture.

My photo reference had unnatural lighting and felt too pink. I knew from looking at my reference that I wanted to go in a different direction; I wanted to end up with a warm painting, as well as a painting that looks and feels like a piece of art, rather than a manipulated or distorted photograph. So I chose a violet/red color (R: 98, G: 17, B: 25) that I essentially filled the background with. I

didn't want any whites in my painting just yet, because I tend to paint from dark to light, the background here was used as a foundation to build from.

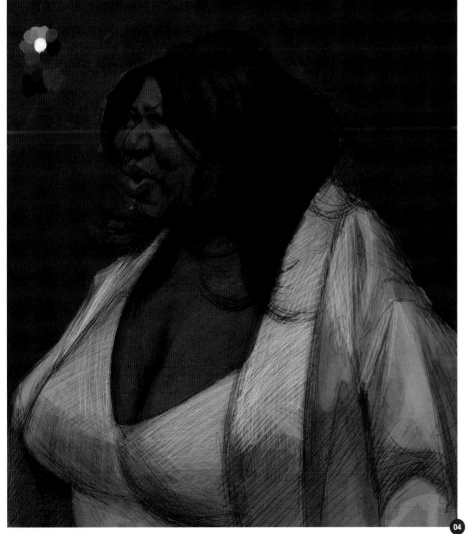

I created a palette layer at this point (**Fig.04**). It's important to create a color palette that has harmony. My main priority was getting the values right and I knew that if I could succeed in that, I could do just about anything with the color. When I paint, I usually create a variation of red, yellow, and blue. With these three colors most colors can be created. You'll notice that in this painting my colors are very warm: reds, oranges, browns, violets, and greens.

To create my palette, I made a new layer that would remain on top of all the layers from this point on. This layer was used as my 'palette layer'. I selected my Eyedropper tool and picked a red/brown color. I then clicked my color picker and chose a few more reds based on the red/brown that I chose, and then I created a small grouping of flesh-like reds and browns. I did this by squinting whilst looking at my photo references, and then choosing color according to the values I saw. When I looked at my photo reference I saw reds, greens, violets, and blues, but I knew that I wanted a warmer painting. So I create those colors and mix my red/brown color into them, therefore creating harmony.

STEP 2

What I typically do at this stage is use my Eyedropper tool to select the color I've created for the background, and then use that color to begin my block-in (**Fig.05 – 06**). At this stage of the painting, I was mostly concerned about painting the correct values. It was also

important, at this stage, to not zoom in too close. I chose to paint from a distance and used large brushes. This way I could focus on capturing shape and values, and merely suggest detail. Next, I created a new layer on top of the other layers and began to slowly paint over my sketch lines. By this point I'd created enough form and structure that I no longer needed my sketch lines. I also began to block in a bit of the background as well.

The background was important to establish early on in the painting; it had to complement the portrait. The colors and values of the background will affect the colors and values in your portrait, so it's important to work back and forth between the portrait and background while blocking in. Think of it as if you are sculpting, chipping away small pieces until the form appears.

I usually save my bright highlights and whites for later on in the painting and start first by establishing my darks and working towards the lighter tones. This stage is simply for me to create a balanced foundation for my block-in. Steps one and two take five to ten minutes – at most – to complete.

STEP 3
I created another layer that went directly under my "palette layer" but would remain on top of all the other layers. I began to paint on top of my block-in; everything up until this point was used as a guide for me to follow as I built up layers of color.

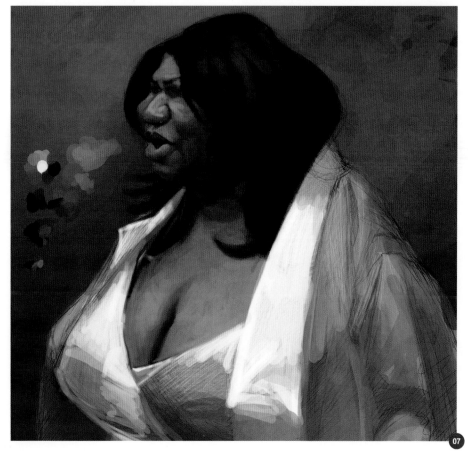

Next, I needed to establish my darkest darks and block those in. There was no need to zoom in; I worked at a distance and continued to use a large round brush. My technique when painting digitally is very similar to how I would paint traditionally with oils: start with bigger brushes, blocking in the largest shapes of darkest color and value; as the painting progresses, I use smaller and smaller brushes. Also, I never stay in one area for too long. Painting from a distance with larger brushes helps you cover more ground in less time.

I established my darkest darks and at this point began to paint lighter values on her face and chest (**Fig.07**). I also started adding lighter, almost pure white to her clothing. Notice that I have not yet added any such values to her face, as I saved those highlights and reflective lights for later on. It's easy to become impatient

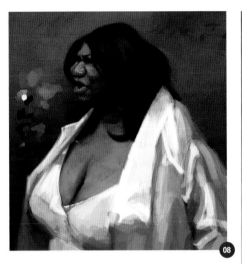

and want to paint in highlights right way, but it's better to not get distracted by them and wait.

The reason I painted the almost white values on her clothing was so that I could later compare the lighter values in her face to the values on her clothing. I knew that there should not be any area on her face that shared values as white as those which exist on her clothing.

STEP 4

As I continued to block in the painting, I found myself unsettled with the composition. This is one of the great things about painting digitally. With the Crop tool, I selected the entire canvas and then added a bit more to the bottom, giving Aretha additional girth (**Fig.08**).

STEP 5

As the painting developed I continued with the same approach, squinting and mixing color to match the value and temperature that I desired for the piece. Still using a round brush, I began to zoom in to paint details. I then started to refine the mouth, eyes, nose, ears, and hair. You can also start to see a softer transition on the edges between values (**Fig.09**).

STEP 6

I removed the palette at this stage because I had enough colors in my painting to work with. If I needed to change the value or saturation of a color that I already had, I simply clicked on the color picker and mixed or adjusted my color there (**Fig.10**).

I began to use my favorite Photoshop brush, #24 (follow the brush settings mentioned in

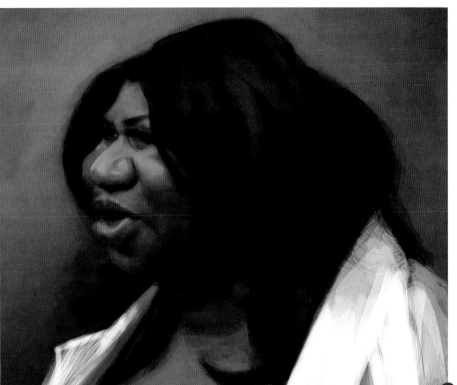

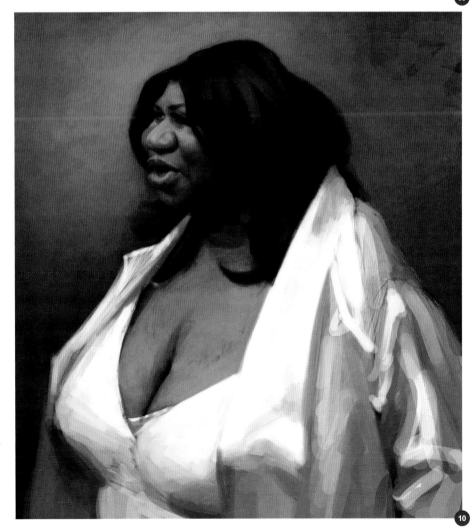

Step 1). Brush #24's marks and strokes feel more like a natural paint brush. This was the brush I used to finish the painting, with the exception of a soft round brush which I used for hair.

STEP 7

I began to focus my attention on Arotha's face (**Fig.11**). Adjustments were made to her nose and right cheek, and I noticed that I could exaggerate her mouth a bit more, so I painted away the mouth and re-painted a new mouth lower on her face. This added more space between her nose and mouth, which is what I wanted. I also extended her mouth and bottom lip out a bit further, which enhanced both the likeness as well as humor. I continued to soften edges, adjust values and introduce additional lighter values to her face and clothing. I also began to soften her chest and hair.

STEP 8

At this stage I freely zoomed in and out – zooming in for details, zooming out to have a look from a distance. It was important to often step back from the painting. With this painting it was not my intention to copy the color I saw in my references. Instead, I wanted to focus on values and color temperature. Squint your eyes for value, and open your eyes to see the color.

I basically finished the face at this stage, and started to detail her chest and clothing (**Fig.12**).

STEP 9

The painting was all but finished in this final step, with the exception of the hair and minor details of clothing and composition. For the

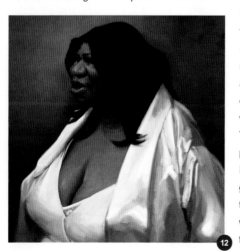

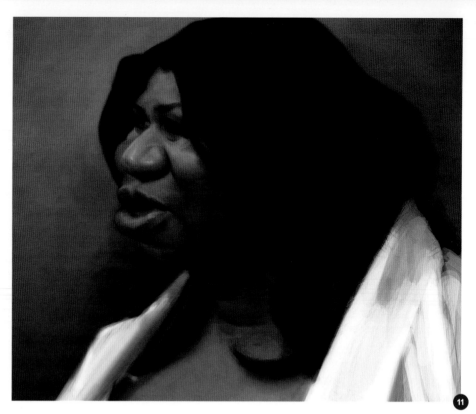

hair, I created a new layer. This way, if I needed to erase a section of hair that didn't feel right, it didn't ruin the rest of the painting. I painted the large mass of value and shape that I saw while squinting my eyes. I then blocked in the basic form or design of the hair a little bit darker than it needed to be. This way, when I painted smaller hairs on top, in a lighter value, it gave the illusion of depth. To add to this illusion, I also changed the size of my brush to differ the widths of the hairs. I used a soft round brush with a tapered point to paint smaller hairs. Keep it simple: study what hair does and then make it more interesting.

My goal with this painting was that it would feel more like a traditionally painted piece, rather than a digitally painted image. To get a more traditional look for the piece, I selected a texture from one of my oil paintings and dragged it on top of my painting. In my layers window, I selected Hard Light and set it to 47%. This effect changed my colors slightly from the previous step. Truthfully, this was something I've never done before; I enjoyed the look I was getting and decided to keep it. Don't be afraid to experiment with some of the tools to see what they can do, but be careful to not abuse the computer. I feel that digital paintings look

best when they're not so obviously digitally created. That's my preference anyway.

The painting was almost finished here, but I felt once more that the composition could be better. So I selected my Crop tool and cropped a bit off the right side of the painting. For the final finishing touch, I wanted to add some noise and additional texture to the painting, so I selected a mid-tone gray, created a new layer and filled that layer with gray, making sure this layer was on the very top. I then selected Noise in the Filter menu and chose Add Noise. When using this tool you'll need to adjust the settings until they look good to you. I then selected Blur More in the Blur settings. I did this to soften the texture of the noise a bit. And finally, I changed my layer to Soft Light and brought the Opacity down to about 17% (**Fig.13**).

FINAL THOUGHTS

Well, that's it. Remember to have fun. Sketch, draw and paint from life as much as you can. Keep it simple. If you look at the design of my portrait you can see that my shapes and forms are basic and simple. When I combine strong values and color to my basic design, the final image appears more complicated than it really is.

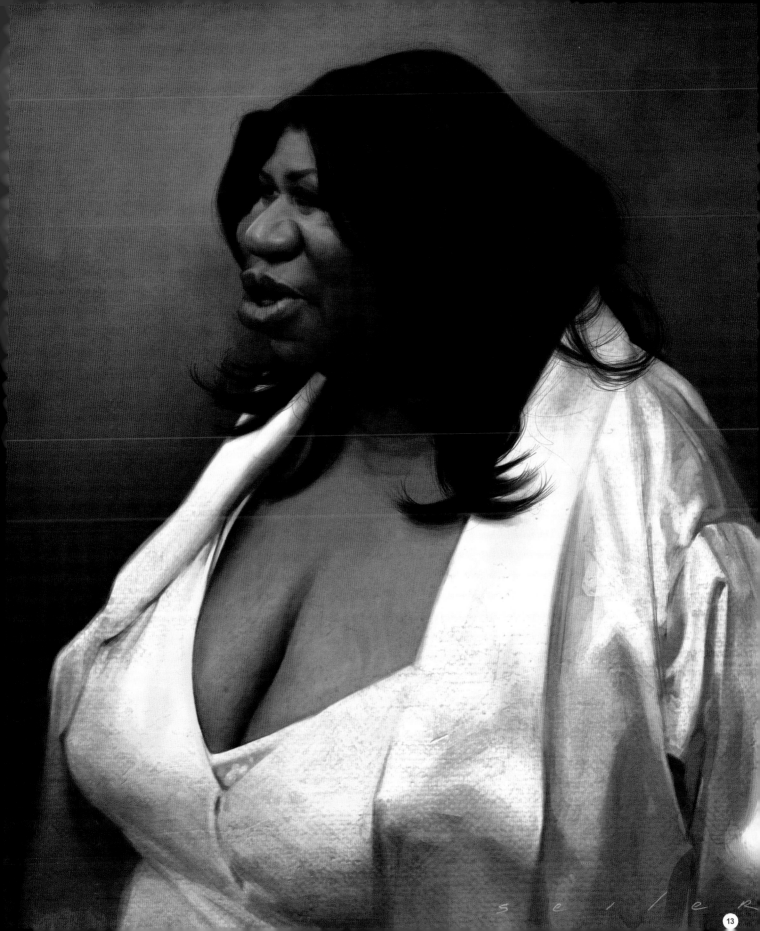

the gallery

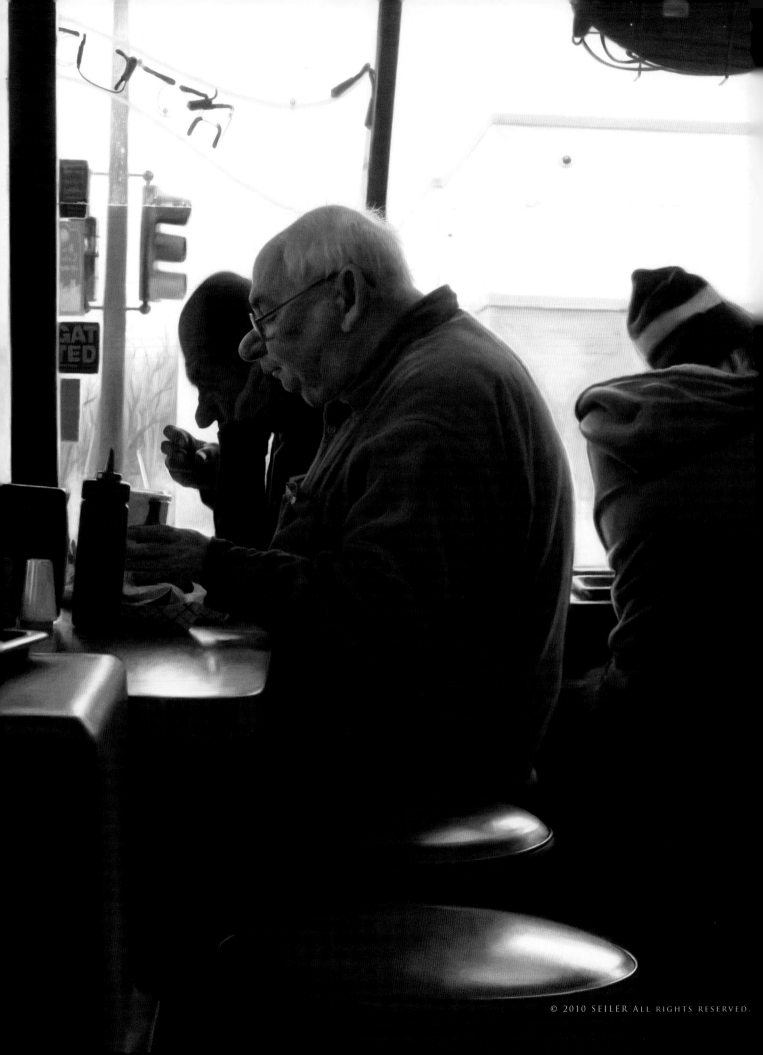

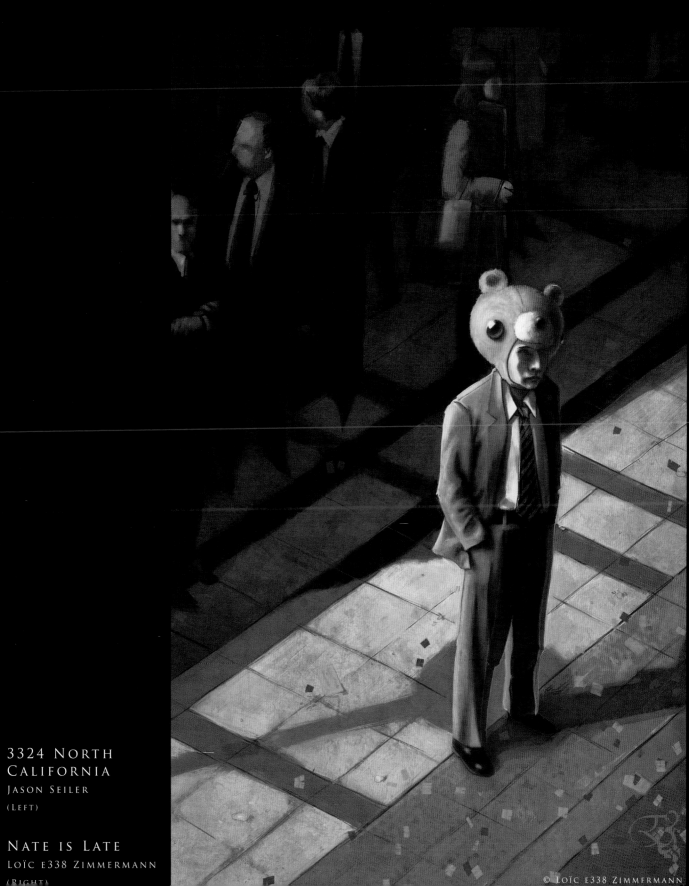

3324 North
California
Jason Seiler
(Left)

Nate is Late
Loïc e338 Zimmermann
(Right)

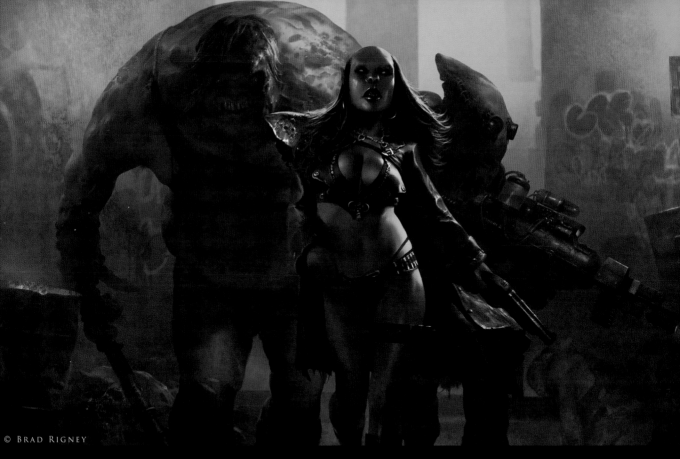

A HOSTILE TAKEOVER
Brad Rigney
(Above)

LIZARD
Craig Sellars
(Below)

PAPA BEAR
Daniel Dociu
(Right)

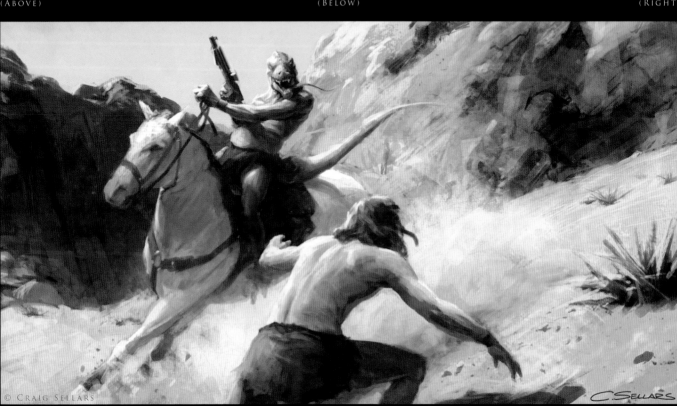

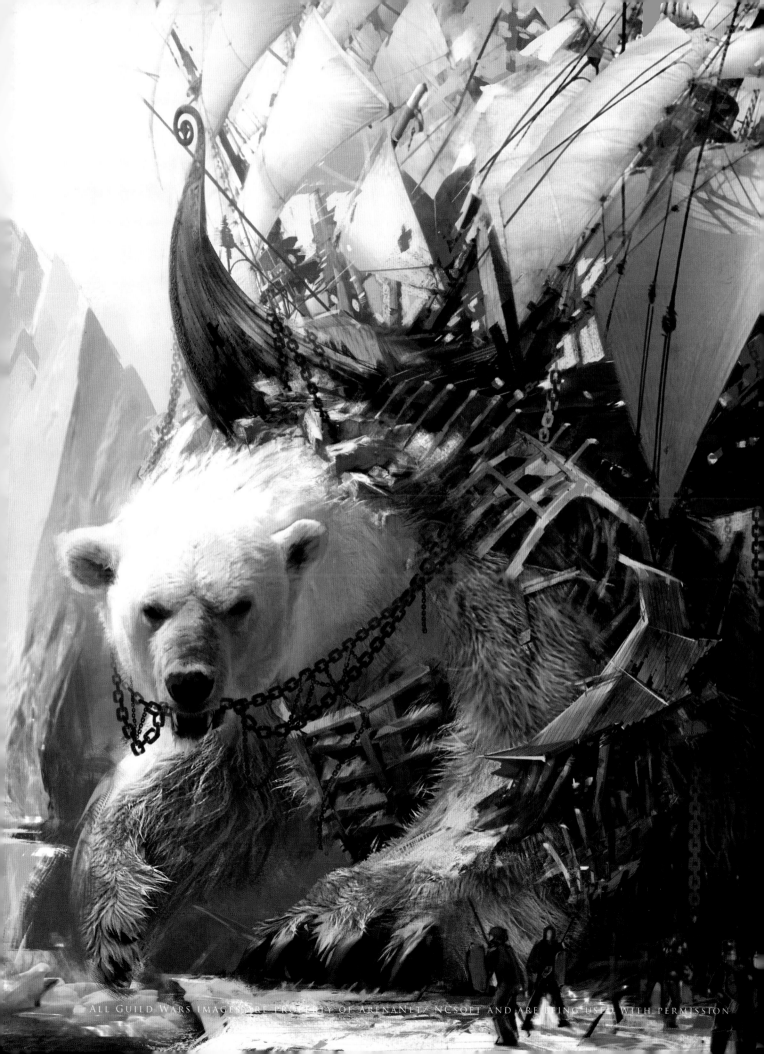

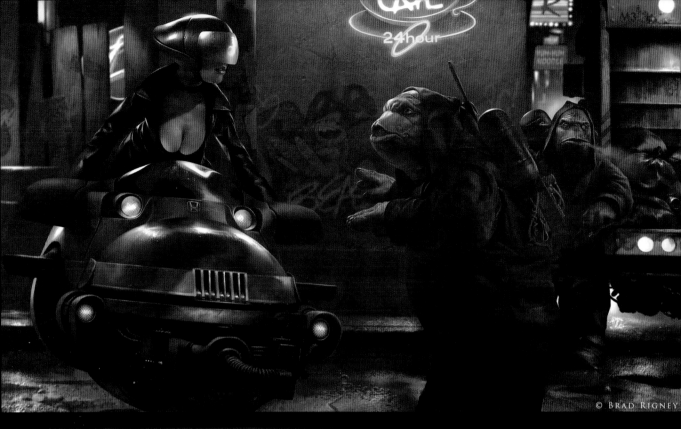

© BRAD RIGNEY

© EDUARDO PEÑA A.K.A CHINO-RINO

STOPPING FOR DIRECTIONS
BRAD RIGNEY
(ABOVE)

INCORPOREO
EDUARDO PEÑA
(LEFT)

A DEADLY ENCOUNTER
DAARKEN
(RIGHT)

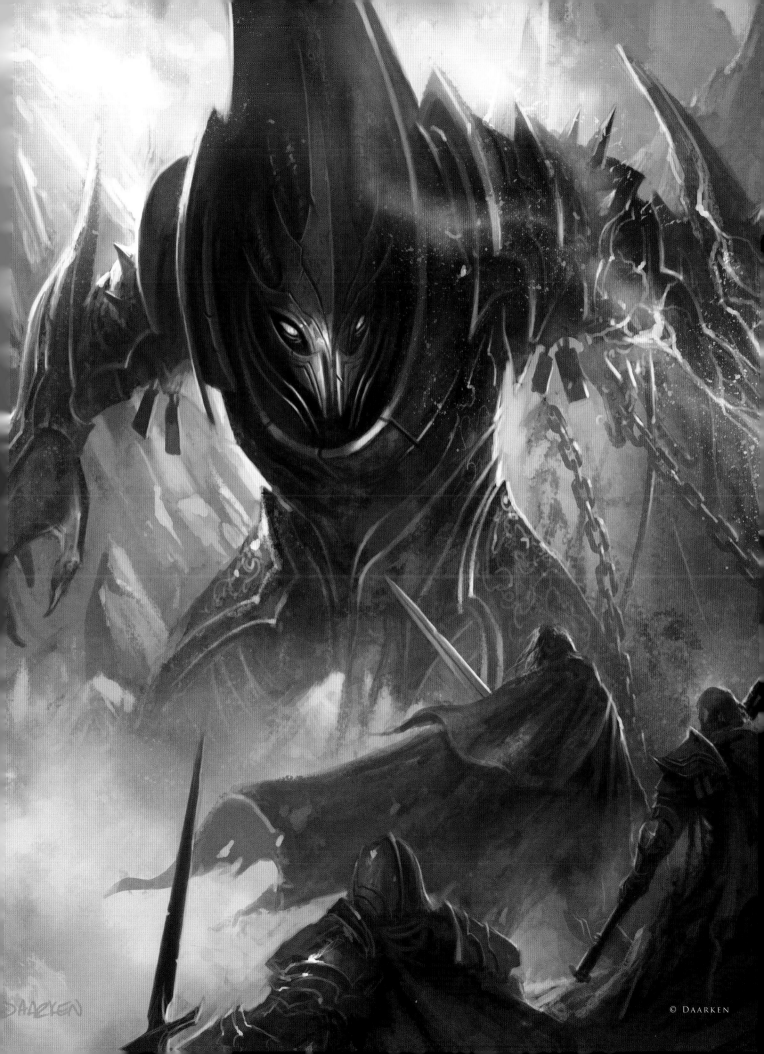

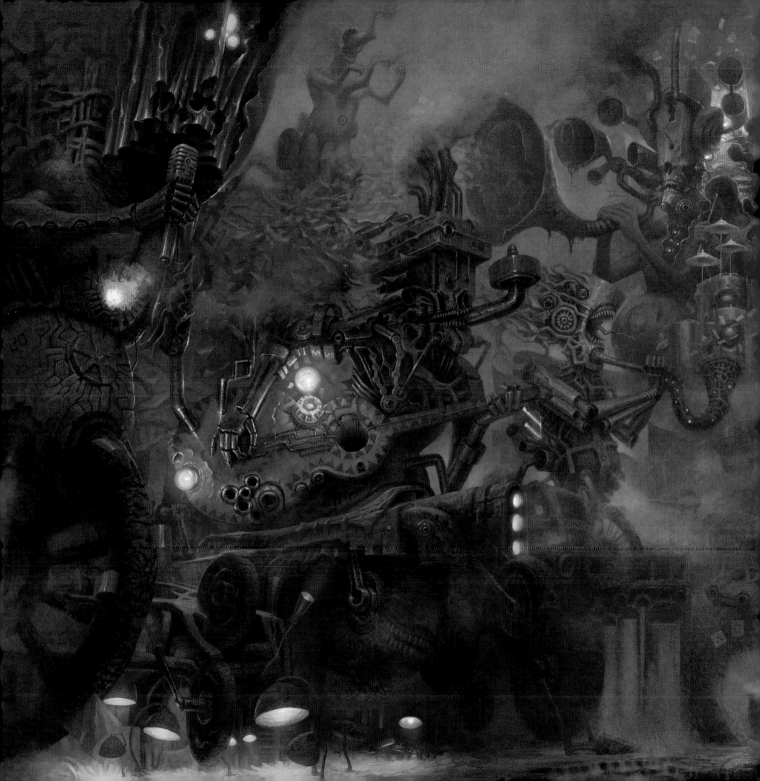

© Yang Xueguo

GRANDMA

CHASE STONE

© CHASE STONE

© STEPHAN MARTINIERE

Dervish House
Stephan Martiniere
(Above)

Space Scene 3
Daniel Dociu
(Above)

Takeoff
Thomas Pringle
(Below)

Machinery of Light
Raphaël Lacoste
(Right)

© CRAIG SELLARS

© LOÏC E338 ZIMMERMANN

STYNA
CRAIG SELLARS
(ABOVE)

BINAURAL
LOÏC E338 ZIMMERMANN
(LEFT)

WELCOME
GEOFFROY THOORENS
(RIGHT)

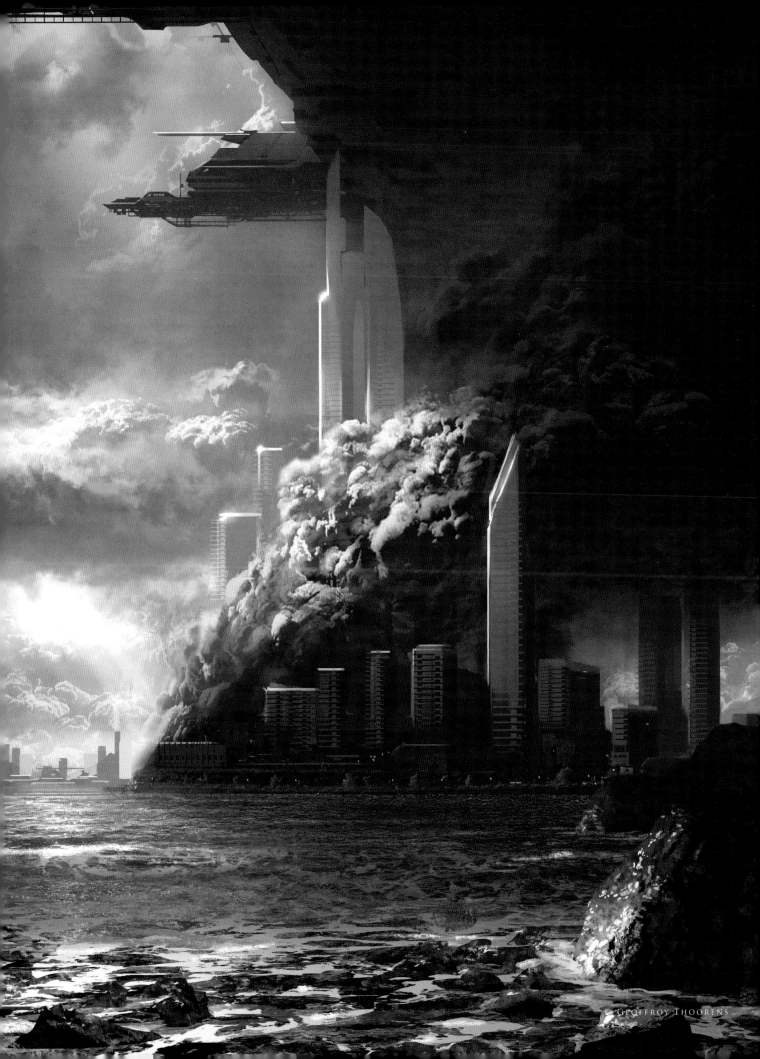

© Thomas Pringle

DRYDOCK
Thomas Pringle
(Above)

Order of Chaos
Daniel Dociu
(Left)

Variable Star
Stephan Martiniere
(Right)

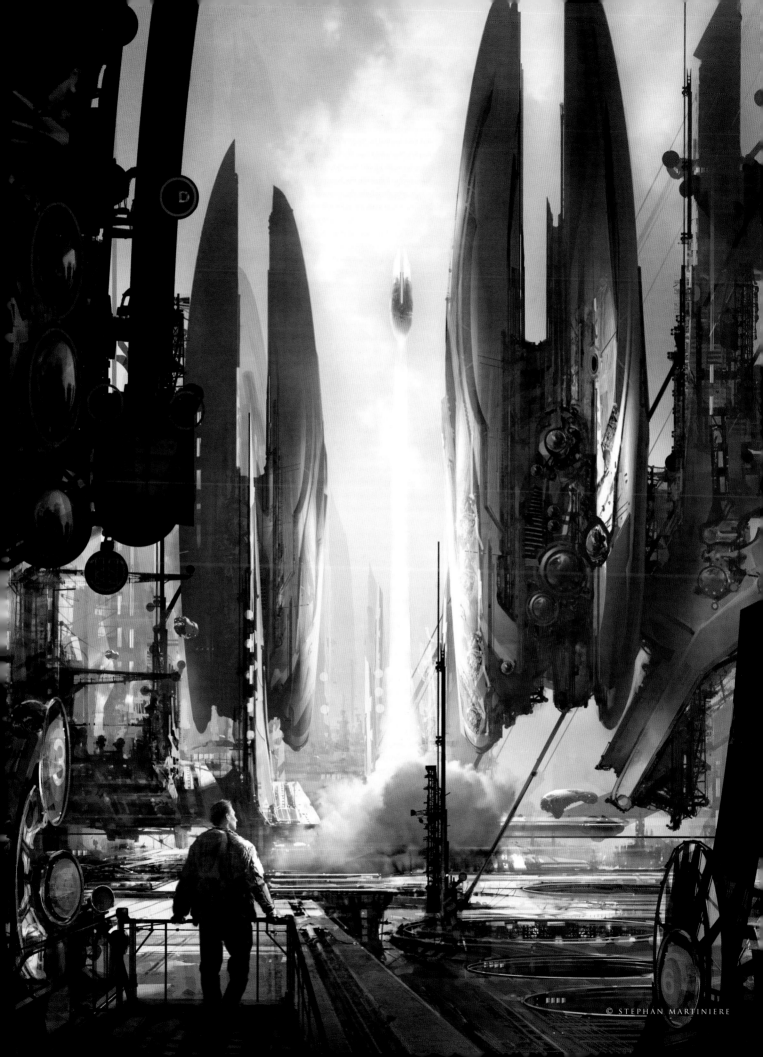

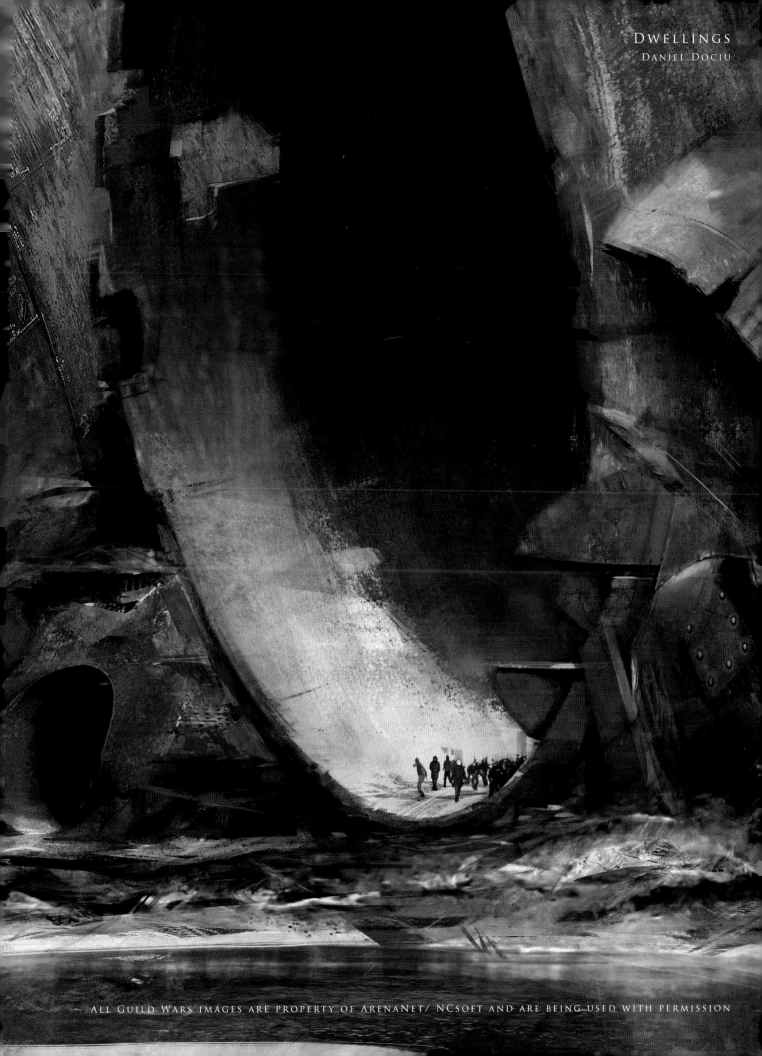

DWELLINGS

DANIEL DOCIU

© Geoffroy Thoorens

© Theo Prins

NORTHERN CONVEYOR
GEOFFROY THOORENS
(Above)

STREET SCENE
THEO PRINS
(Left)

MUSHROOM HUNTER
BOBBY CHIU
(Right)

© Bobby Chiu

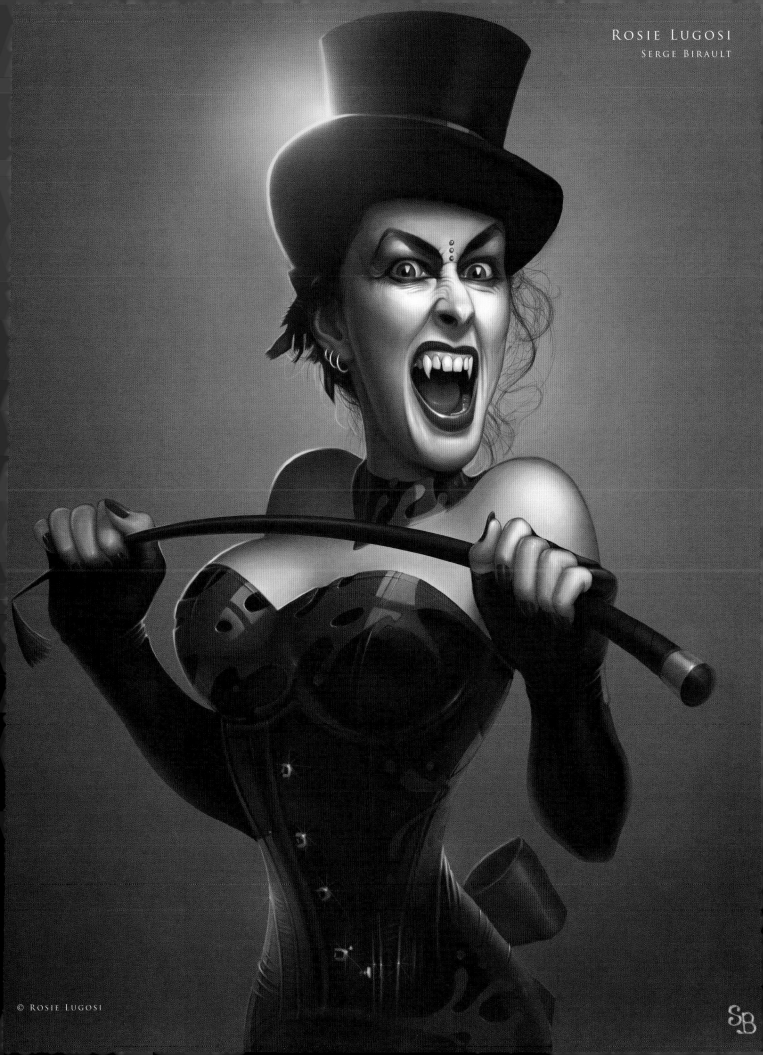

ROSIE LUGOSI
Serge Birault

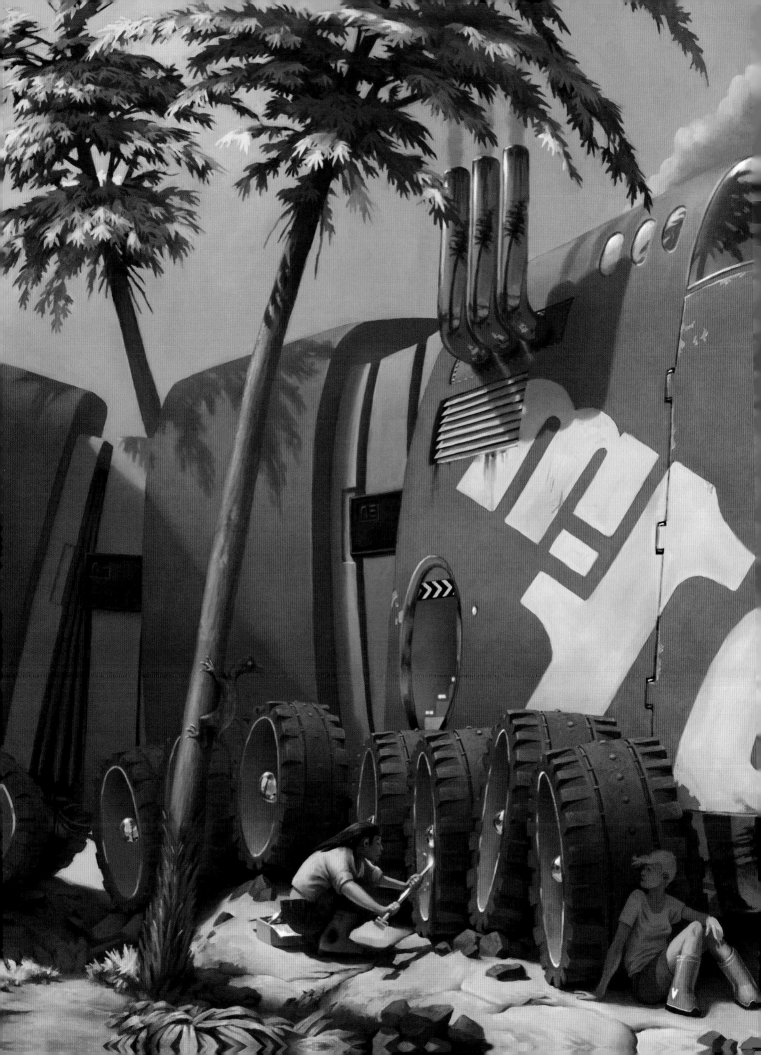

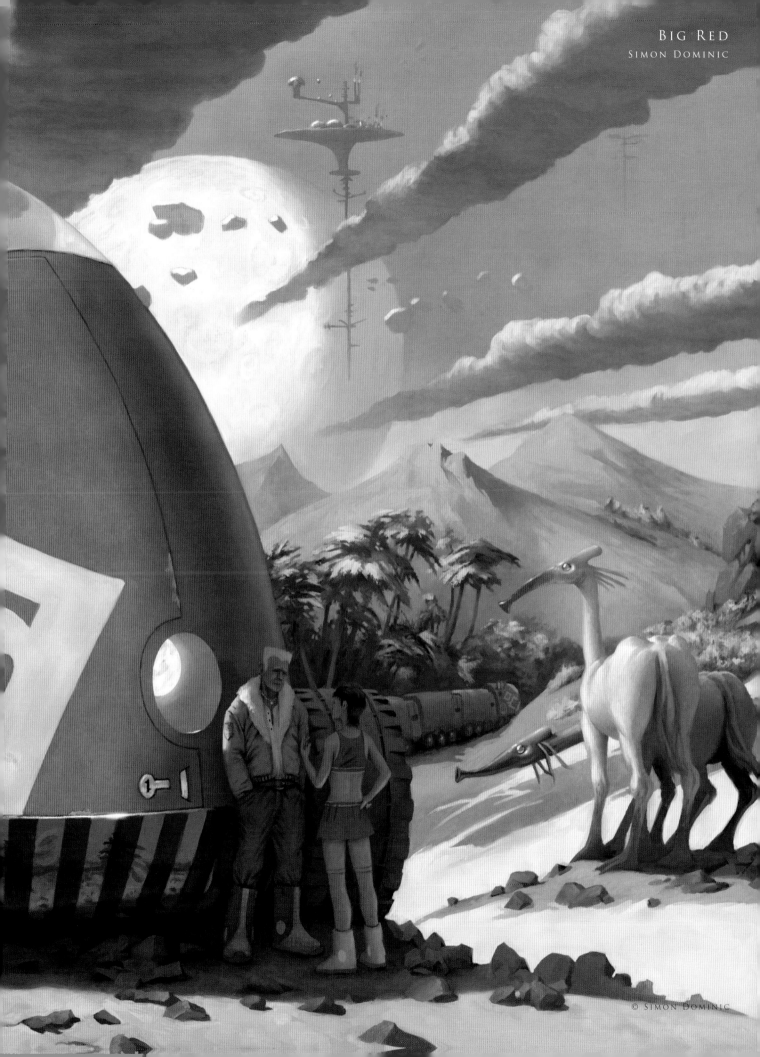

© SIMON DOMINIC

THE TUTORIAL ARTISTS

CARLOS
CABRERA
carloscabrera@gmail.com

http://www.artbycarloscabrera.com

IGNACIO
BAZÁN LAZCANO
i.bazanlazcano@gmail.com

http://www.ignaciobazanart.com

NATHANIEL
WEST
nathaniel@nathanielwest.net

http://nathanielwest.net

CHASE
STONE
chasesc2@gmail.com

http://chase-sc2.deviantart.com

IOAN
DUMITRESCU
jononespo@yahoo.com

http://jonone.cgsociety.org

MATT
DIXON
mail@mattdixon.co.uk

http://www.mattdixon.co.uk

CHEE
MING WONG
chee@opusartz.com

http://koshime.com

JAMA
JURABAEV
jama_art@tag.tj

http://jamajurabaev.daportfolio.com

NYKOLAI
ALEKSANDER
x@admemento.com

http://www.admemento.com/

DAVID
SMIT
david@davidsmit.com

http://www.davidsmit.com

JASON
SEILER
jseiler@jpusa.org

http://www.jasonseiler.com/

RICHARD
TILBURY
ibex80@hotmail.com

http://www.richardtilburyart.com

DWAYNE
VANCE
dwayne@futureelements.net

http://www.mastersofchickens-

cratch.com/dwayne-vance

JESSE
VAN DIJK
jesse@jessevandijk.net

http://www.jessevandijk.net

ROBERTO
F · CASTRO
contact@robertofc.com

http://www.robertofc.com/

EHSAN
DABBAGHI
artistofpersia@yahoo.com

http://dabbaghi.deviantart.com

JUSTIN
ALBERS
albers.justin@gmail.com

http://www.justinalbers.com

SERG
SOULEIMAN
sergdls@gmail.com

http://www.artofserg.com

EMRAH
ELMASLI
hello@emrahelmasli.com

http://www.emrahelmasli.com

KENICHIRO
TOMIYASU
supernova1031@gmail.com

http://www.studiotomiyasu.com

SIMON
DOMINIC
si@painterly.co.uk

http://www.painterly.co.uk/

HOI
MUN THAM
thamhoimun@gmail.com

http://hoimun.blogspot.com/

MARK
MCDONNELL
mark@cre8tivemarks.com

http://markmcdonnell.blogspot.com

THE GALLERY ARTISTS

BOBBY
CHIU

bobby@imaginismstudios.com

http://www.imaginismstudios.com

GEOFFROY
THOORENS

djahal@gmail.com

http://www.djahalland.com/en/home

STEPHAN
MARTINIERE

stephan@martiniere.com

http://www.martiniere.com/

BRAD
RIGNEY

cryptcrawler@comcast.net

http://cryptcrawler.deviantart.com

JASON
SEILER

jseiler@jpusa.org

http://www.jasonseiler.com

THEO
PRINS

theo.w.prins@gmail.com

CHASE
STONE

chasesc2@gmail.com

http://chase-sc2.deviantart.com

LOÏC E338
ZIMMERMANN

loiczimmermann@gmail.com

http://www.e338.com/

THOMAS
PRINGLE

thomas@pringleart.com

http://www.pringleart.com

CRAIG
SELLARS

sellarsart@hotmail.com

http://www.greensocksart.com

RAPHAËL
LACOSTE

raphael.lacoste@gmail.com

http://www.raphael-lacoste.com

WANCHANA
INSTRASOMBAT

vicwanchana@gmail.com

http://www.victorior.blogspot.com/

DAARKEN

daarkenart@daarken.com

http://www.daarken.com

SAM
NIELSON

artsammich@gmail.com

http://artsammich.blogspot.com

YANG
XUEGUO

blur1977@126.com

http://seedsfromhell.blogspot.com/

DANIEL
DOCIU

daniel@arena.net

http://www.tinfoilgames.com

SERGE
BIRAULT

serge.birault@hotmail.fr

http://www.sergebirault.fr/sb

EDUARDO
PEÑA

caareka20@hotmail.com

http://chino-rino2.blogspot.com

SIMON
DOMINIC

si@painterly.co.uk

http://www.painterly.co.uk

a

Adobe, 178, 180
Aerodynamic, 75, 76, 142
Aesthetic, 51, 76, 85, 86
Air, 18, 236, 238, 242
Albers, Justin, 174 - 177
Alchemy, 142, 143, 235
Aleksander, Nykolai, 184 - 191
Allsopp, Matt, 140 - 141
Alpha, 79, 88, 105
Anatomy, 27, 35, 61, 77, 118, 242
Animation, 12, 13, 15, 111
Architecture, 101, 134, 174, 226
Artistic, 34, 40, 86, 87, 113, 209
ArtRage, 66, 67, 68
Atmospheric, 75, 81, 102, 104, 130, 212, 223, 229

b

Backdrop, 69, 87, 110
Background, 17, 20, 25, 28, 29, 94, 216, 222, 245, 248, 249, 250
Backlight, 86, 199
Bazán Lazcano, Ignacio, 50 – 55, 118 - 125
Beast, 13, 32, 235
Beyit, Kerem, 232 - 233
Birault, Serge, 279
Blending, 36, 45, 135, 136, 161, 215, 216
Blocking, 36, 58, 59, 76, 134, 156, 250
Blood, 17, 40, 44, 45, 46, 77, 181
Blur, 60, 63, 81, 88, 113, 176, 236
Branches, 196, 197, 198
Brightness, 138, 194, 197, 240, 245
Brush, 31, 36, 40, 44, 52, 53, 57, 58, 60, 61, 248, 250, 251, 252
Brushstrokes, 120, 190, 204

c

Cabrera, Carlos, 192 – 195, 214 - 219
Capture, 19, 28, 37, 58, 59, 186, 234, 249
Caricatures, 56, 57
Castro, Roberto.F, 196 - 203
Character, 11, 13, 14, 18, 19, 20, 21, 58, 63, 68, 234, 235, 236
Chiu, Bobby, 275
Cinematic, 113, 221, 236
Clouds, 87, 93, 111, 142, 147, 176, 196, 199, 229
Cobblestones, 138
Composition, 16, 17, 18, 19, 20, 23, 25, 29, 155, 174, 251, 252

Concept, 15, 27, 28, 35, 76, 100, 171, 210, 234, 235, 239
Contrast, 19, 28, 29, 48, 69, 78, 93, 175, 222, 240, 245
Crabb , Ron, 208 - 209
Creation, 16, 28, 32, 124, 134, 143, 211, 214, 223
Creature, 27, 28, 29, 32, 113, 167, 180
Crop, 24, 113, 147, 151, 185, 187, 229
Curves, 149
Custom, 36, 40, 44, 73, 121, 184, 190, 204, 207, 217, 236

d

Daarken, 260
Dabbaghi, Ehsan, 170 - 173
Daylight, 104, 105, 127
Definition, 47, 109, 199
Depth, 18, 20, 24, 25, 63, 69, 171, 226, 239, 240, 252
Desaturate, 44, 137, 185, 186, 192
Detailing, 38, 63, 112, 127, 149, 150, 180, 235, 236
Develop, 27, 31, 32, 54, 62, 63, 166, 173, 234, 242
Digital, 25, 60, 73, 75, 110, 118, 124, 213, 252
Dimension, 146, 204, 220, 240
Display, 17, 23, 43, 112, 211
Distance, 13, 20, 57, 62, 96, 102, 123, 135, 240, 250, 252
Distort, 27, 156, 161, 172
Dixon, Matt, 26 - 33
Dociu, Daniel, 259, 266, 270, 272 - 273
Dominic, Simon, 66 – 71, 280 - 281
Doodle, 27, 28, 29, 32, 59
Draft, 85, 86, 109, 155, 156
Drag, 173, 205, 213, 226
Dumitrescu, Ioan, 220 - 225
Duplicated, 46, 97, 138, 210, 212
Dust, 22, 81, 87, 89, 151
Dynamics, 14, 25, 63, 64, 242

e

Ears, 28, 32, 58, 63, 251
Earth, 70, 81, 238
Edge, 15, 22, 25, 97, 212, 213, 243
Editor, 197, 199, 200
Element, 17, 19, 20, 21, 23, 32, 35, 38, 96, 244, 245
Elliptical, 76, 197

Elmasli, Emrah, 178 – 179, 180 - 181
Embroidery, 184, 187
Emotional, 11, 117
Engine, 75, 76, 77, 78, 85, 96, 97, 146, 148, 149, 156
Enhance, 22, 23, 58, 157, 158, 181, 207
Environment, 16, 27, 67, 68, 69, 70, 134, 141, 149, 213, 235, 238
Erase, 67, 81, 113, 161, 173, 179, 185, 190, 192, 200, 211, 212, 252
Exaggerate, 14, 18, 57, 59, 252
Exoskeleton, 77, 85
Experimenting, 15, 45, 134, 154
Expression, 37, 43, 58, 244
Exterior, 75, 198, 211, 212
Eye, 18, 19, 21, 22, 27, 32, 40, 43, 168, 183, 190, 213, 222, 226, 243
Eyedropper, 249

f

Fabric, 22, 35, 36, 85, 121, 186, 189, 190
Face, 15, 17, 18, 22, 24, 48, 56, 57, 58, 242, 245, 250, 251, 252
Facial, 15, 63, 69
Fade, 145, 149
Fantasy, 70, 117, 175
Fashion, 27, 40, 78, 123, 185
Feathers, 27
Feet, 14, 37, 92, 228
Fighter, 75, 109, 112, 151
Film, 15, 34, 110, 206
Fire, 50, 81, 90, 172
Fires, 54, 90
Flatten, 135, 206, 229
Flip, 19, 32, 64, 68, 144, 194, 222, 229
Floating, 23, 32, 38, 156, 238
Flocks, 206, 238
Flower, 185, 190
Flying, 66, 145, 176, 206, 207, 236
Fog, 130, 212, 229, 240
Foliage, 29, 31, 32, 196, 197, 198, 199
Forces, 23, 108, 143, 165
Foreground, 18, 25, 31, 101, 102, 112, 205, 207, 221, 223, 239, 240
Foreshortening, 24
Forest, 180, 197, 238
Fountain, 166, 167, 169
Freckles, 64
Fur, 17, 28, 29, 32
Futuristic, 86, 109, 144, 147, 154

g

Galaxy, 88, 240
Garments, 67, 184
Gaussian, 190, 236
Generation, 110, 111, 113
Geometric, 74, 102, 108
Geometry, 87, 214
Gesture, 13, 15, 39, 40, 181
Glow, 37, 97, 105, 136, 161, 181
Gradient, 36, 38, 46, 240
Grayscale, 36, 51, 185, 197
Greens, 60, 89, 239, 29
Guidelines, 17, 22, 47, 143, 147, 155, 156, 213
Gun, 25, 51

h

Hair, 35, 36, 39, 46, 63, 64, 251, 252
Haze, 103, 129, 171, 229
Helmet, 52, 245
Horizon, 18, 20, 79, 87, 105, 110, 148, 149, 226, 227
Horror, 166, 167
Hue, 31, 37, 93, 97, 240

i

Illuminate, 242
Illustrate, 77, 155, 196
Illustration, 13, 14, 15, 23, 77, 79, 135, 155, 209, 214, 215, 216
Impression, 29, 31, 32, 38
Ink, 75, 76
Insect, 174, 175, 176, 207
Inspiration, 13, 15, 29, 43, 51, 76, 163, 184, 200, 236
Instrasombat, Wanchana, 278
Invert, 162, 185, 186
Ivy, 238, 239

j

Jitter, 193, 194, 197, 198, 199, 205, 206, 248
Jungle, 26, 27, 28, 31, 32, 174
Jurabaev, Jama, 234 - 237

k

Ketaki, Kekai, 10 - 11
Knights, 67, 69, 70, 118

l

Lace, 184, 185, 186, 187
Lacoste, Raphael, 267
Landscape, 17, 23, 25, 69, 70, 93, 113, 199

Lasso, 88, 102, 104
Lava, 50, 51, 54
Layer, 25, 28, 29, 136, 138, 145, 173, 179, 235, 236, 240, 252
Leaves, 17, 22, 28, 32, 73, 196, 197, 198, 199, 200, 239
Leg, 21, 43, 214, 217
Levels, 54, 60, 90, 192, 197, 221, 223
Library, 137, 138, 161, 185, 192, 205, 215, 227
Light, 94, 119, 121, 129, 135, 137, 156, 172, 252, 266
Lightening, 229
Lighting, 13, 36, 68, 70, 81, 88, 103, 104, 180, 212, 243, 249
Limit, 73, 185
Lineage, 85
Lip, 57, 252
Locomotive, 183, 221, 223
Loop, 52, 53
Luminosity, 88, 89, 111

m

Machine, 12, 51, 77, 178
Man, 13, 14, 25, 43, 119, 176
Mandrake, Daryl , 116 - 117
Manipulate, 147, 162, 211
Markers, 75, 76, 77, 86, 87, 93, 154
Martiniere, Stephan, 266, 271
Mask, 44, 48, 79, 97, 105, 136, 138, 178
McDonnell, Mark, 12 - 15
Medieval, 66, 118, 121, 123, 134, 138
Menu, 121, 123, 124, 161, 193, 197, 210, 211, 212, 221, 235, 252
Merged, 137, 239
Metal, 68, 112, 148, 149, 157, 158, 159, 194, 220, 221, 222, 223
Midpoint, 212
Midtone, 166
Modify, 54, 121, 136, 150, 175, 190, 193, 199
Money, 108, 111, 163
Monochromatic, 59, 193, 243
Monster, 26, 27, 28, 29, 31, 32, 34, 35, 169
Moon, 78, 79
Mosquitoes, 174
Motion, 18, 19, 81, 113
Mountain, 172, 173
Mouse, 193, 194, 205
Mouth, 43, 57, 58, 59, 63, 181, 251, 252
Movement, 14, 18, 19, 20, 22, 28, 43, 198
Movie, 19, 21, 111, 216

Multiply, 28, 29, 31, 64, 79, 81, 88, 101, 128, 220, 248
Mun Tham, Hoi, 154 - 163

n

Nail, 216
Nature, 32, 39, 93, 108, 109, 135
Naval, 39, 84, 85
Nebulas, 87, 111
Neck, 44, 45, 64
Needle, 13, 76
Neilson, Sam, 276 - 277
Noise, 60, 236, 240, 245, 252
Nose, 43, 57, 58, 59, 63, 251, 252
Nostrils, 58

o

Ochre, 37, 93, 103
Offset, 211, 212
Oil, 68, 69, 158, 172, 183, 252
Opacity, 31, 60, 63, 111, 136, 137, 157, 162, 192, 194, 197, 199, 215, 235
Opaque, 45, 158, 159, 197, 245
Organic, 86, 87, 93, 108, 109, 141, 196, 211, 236
Outline, 67, 76, 92
Overlay, 16, 37, 43, 53, 110, 122, 130, 160, 168, 193, 229, 235, 236
Oxygen, 76, 97

p

Paint, 25, 36, 45, 53, 130, 149, 157, 197, 198, 199, 206, 209, 210, 223, 245, 249,
Paintbrush, 58, 121, 122, 123, 124, 192, 216
Painter, 69, 172, 178, 233, 242
Paintover, 158, 159
Palette, 31, 36, 63, 67, 81, 89, 90, 93, 174, 175, 180, 187, 249, 250, 251
Particles, 22, 236
Pattern, 28, 85, 161, 186, 187, 188, 189, 190, 205, 206, 223, 240
Peña, Eduardo, 260
Pen, 26, 75, 76, 86, 126, 154, 155, 183, 194, 196, 198, 222, 242
Pencil, 13, 67, 75, 76, 145
Pens, 75, 76, 86, 87
Perceived, 19, 20, 22, 88, 109
Personality, 13, 28, 43
Perspective, 79, 189, 215, 221
Peterffy, Levente, 164 - 165

Photograph, 52, 185, 197, 199, 200, 249

Photos, 122, 149, 168, 184, 185, 186, 197, 215, 244

Photoshop, 19, 170, 174, 178, 194, 196, 197, 215, 217, 220, 221, 251

Picker, 31, 59, 63, 249, 251

Pillars, 220, 221, 222, 223

Pipeline, 154, 162

Pixel, 69, 235, 236, 244, 245

Placement, 16, 17, 20, 24, 25, 57, 59, 198, 210

Planes, 104, 112, 220

Planet, 78, 100

Plants, 32, 238, 239

Pose, 12, 13, 14, 15, 27, 28, 29, 35, 43, 47, 67, 242, 243, 244

Position, 17, 38, 47, 145, 150, 155, 189, 198, 200, 213, 217

Posture, 14, 34, 35, 43, 44, 47

Pressure, 171, 185, 194, 197, 199, 216, 248

Pringle, Thomas, 182 – 183, 266, 270

Prins, Theo, 274

Prototype, 75, 141

r

Race, 78, 142, 144, 151

Radial, 113, 236

Rain, 217

Realism, 51, 85, 112, 151, 156, 236

Realistic, 51, 53, 62, 63, 81, 97, 120, 137, 147, 159, 200, 236

References, 51, 67, 101, 137, 145, 149, , 216, 239, 244, 249, 252

Reinforce, 68, 236

Rembrandt, 12

Render, 31, 149, 156, 159, 214, 215, 221

Resembles, 35, 205, 206

Resolution, 67, 248

Resource, 137, 192

Rigney, Brad, 258, 260

Rim, 90, 95, 112

Rivets, 151, 223

Road, 17, 178, 179

Robot, 214, 216, 217

Rock, 53, 66, 70, 175, 176, 192, 194, 228

Root, 15

Rotate, 20, 27, 32, 37, 113, 194, 221

Ruin, 150, 252

Ruler, 226, 227

Ruppel, Robh, 72 - 73

Rust, 105, 160

s

Sand, 110

Saturation, 69, 97, 149, 194, 223, 240, 251

Scattering, 123, 199, 223

Schematic, 54, 75, 85

Seiler, Jason, 56 – 65, 248 – 253, 256

Sellars, Craig, 258, 268

Sensitivity, 120

Shade, 58, 119, 120

Shadow, 31, 32, 36, 46, 69, 70, 80, 96, 101, 105, 156, 173, 215, 242

Ship, 85, 86, 88, 89, 96, 108, 109, 112, 146, 178, 179

Shooter, 50, 109

Silhouette, 13, 14, 34, 43, 109, 178, 179, 215, 220

Sketch, 25, 27, 28, 29, 51, 56, 57, 67, 165, 166, 169, 227, 242, 243, 248, 250

Sketchbook, 13, 14, 86, 180

Skin, 32, 36, 37, 38, 44, 46, 57, 64, 70, 77

Skull, 56, 57, 60

Slum, 134, 138

Smit, David, 16 - 25

Smoke, 90, 104, 118, 150, 178, 183, 223

Snow, 168, 169

Soldier, 50, 52, 242, 243, 245

Souleiman, Serg, 226 - 231

Space, 18, 19, 62, 75, 78, 100, 101, 108, 109, 112, 166, 178, 179, 252

Spaceship, 75, 85, 146, 178

Spark, 14, 15, 26

Spotlight, 242, 243

Stand, 24, 25, 27, 32, 48, 69, 186, 188, 223

Star, 16, 94, 141

Station, 92, 93, 94, 95, 96, 97, 222

Steampunk, 221, 222

Stone, 67, 68, 118, 121, 122, 168, 192, 194, 221, 223

Stone, Chase, 242 – 247, 264 - 265

Street, 134, 135, 136, 137, 138, 151, 168, 216

Streetlights, 215, 217

Sun, 136, 138, 170, 210, 213, 229, 238, 239, 240

Swarm, 174, 175, 176, 206

Sword, 16, 66, 69, 70

t

Temperature, 59, 60, 251, 252

Texture, 31, 32, 52, 53, 60, 67, 70, 118, 165, 172, 174, 215, 217, 222,

Thoorens, Geoffroy, 269

Thumbnail, 28, 29, 34, 36, 37, 38, 40, 43, 90, 128, 136, 155, 156, 242

Tilbury, Richard, 34 – 41, 42 – 49, 134 – 139, 204 – 207, 210 - 213

Tile, 122, 161

Tomiyasu, Kenichiro, 238 - 241

Tonal, 36, 37, 40, 45, 68, 134, 135, 157, 158, 213

Train, 20, 85, 220, 221, 222, 229

Transport, 74, 75, 76, 77, 78, 103, 104, 109, 110

Tree, 27, 129, 130, 181, 196, 197, 198, 199, 200, 238

u

Underpainting, 67, 68

Upload, 16

Upsize, 67

v

Value, 29, 31, 59, 60, 62, 105, 111, 250, 251, 252

Vampire, 34, 38, 40

Vance, Dwayne, 142 - 153

Van Dijk, Jesse, 126 - 133

Vanishing, 226, 227, 228, 229

Vehicle, 75, 79, 81, 141, 145, 147, 148, 149, 150, 162, 179, 204

Volcanoes, 50, 51

w

Warp, 52, 189, 190

Watercolour, 93

Weapon, 18, 196

Weathering, 157, 159, 162, 194

Werewolves, 43

West, Nathaniel, 166 - 169

Widescreen, 23, 24, 93, 110

Wong, Chee Ming, 74 – 83, 84 – 91, 92 – 99, 100 – 107, 108 - 115

Wood, 70, 199, 200, 221

Workflow, 86, 113, 211

Worm, 17, 18

x

Xueguo, Yang, 262 - 263

z

Zimmerman, Loic, 257, 268

Zombie, 42, 43, 44, 45

DIGITAL ART MASTERS